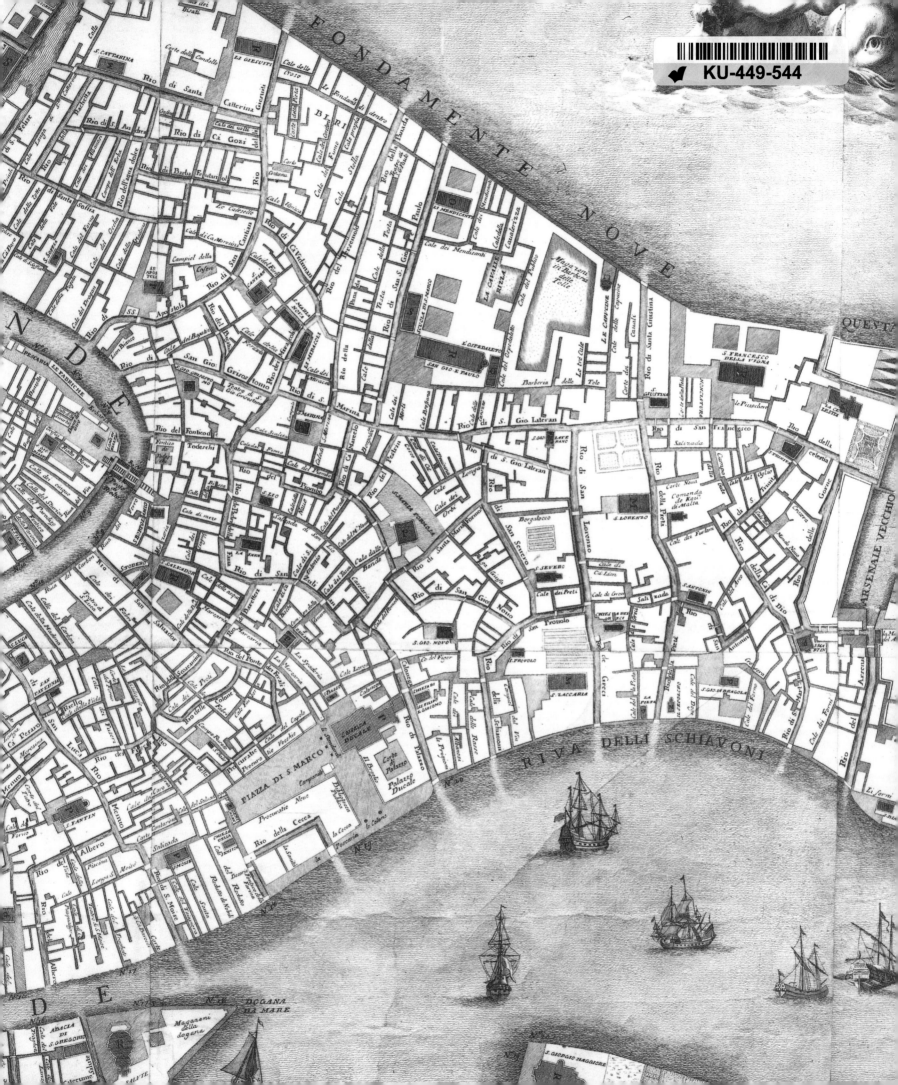

Canaletto

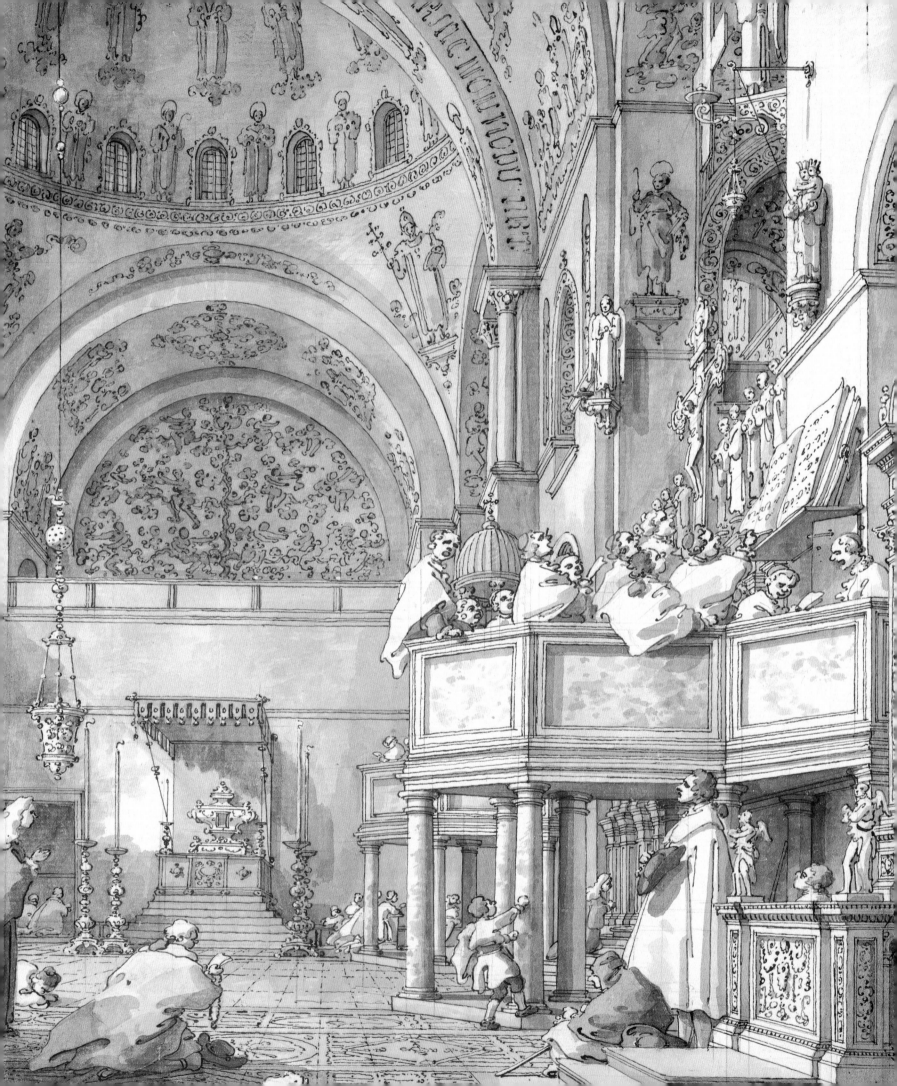

Canaletto

J.G. Links

Phaidon Press Limited
2 Kensington Square
London W8 5EP

Phaidon Press Limited
published *Canaletto* by
J. G. Links, 1982

This edition, first published
1994, completely revised,
updated and enlarged, newly
illustrated and re-designed

ISBN 0 7148 3170 7

A CIP catalogue record for
this book is available from the
British Library

Printed in Hong Kong

JACKET
Plate 140
*London: seen through the Arch of
Westminster Bridge*, 1746-7
By courtesy of the Duke of
Northumberland

FRONTISPIECE
Plate 205
*S. Marco: the Crossing and North
Transept, with Musicians singing*
Signed and dated 1766

Contents

SINCE THE FIRST EDITION of this book was published there have been a number of exhibitions devoted to Canaletto's work in New York and Venice as well as England. These have led to the revision of many established ideas about the artist and the opportunity to incorporate some of them into a new edition has been very welcome.

It remains true, as I wrote originally, that the more that is known of some aspects of Canaletto, the more difficult it becomes to understand others. There is a certain mystery, in the words of one critic, that distinguishes Canaletto from his contemporaries and followers. I make no claim to have penetrated that mystery: the fascination of Canaletto lies in its exploration and this is the purpose of this present volume.

The book has leant heavily on the work of others, as will be evident from the acknowledgements on page 250. I have in addition benefited from personal guidance for which I am particularly grateful to Sir Michael Levey, Sir Oliver Millar, Miss Viola Pemberton-Pigott and Miss Katharine Baetjer.

I have used a number of abbreviations and translations, not always consistently, as for example: 'St Mark's' for the Basilica di San Marco, but 'the Piazza' (rather than 'St Mark's Square') for the Piazza di San Marco. 'The Salute' refers to Santa Maria della Salute, 'the Carità' to Santa Maria della Carità, 'the Doge's Palace' to the Palazzo Ducale, 'the Clocktower' to the Torre dell'Orologio, and 'the Library' to the Libreria Marciana. *San, Santa* and *Sant'* are abbreviated to 'S'; *Santi* to 'SS'. *Di, dei, della* etc. are generally omitted. Those unfamiliar with Venice may find the notes that follow helpful, in conjunction with the plan on p. 7 and the endpapers.

The Molo is the quay which runs west from the Prison; east of the Prison it becomes the Riva degli Schiavoni, which in Canaletto's time was not a wide quay as it is today. Canaletto would have known the Molo as *la Pescaria* (fishmarket). The Piazzetta is the area between the Piazza and the Molo. The Procuratie Vecchie (old, early sixteenth century) and Nuove (new, end of sixteenth century), on the north and south sides of the Piazza respectively, were built for the Procurators of St Mark's, the highest officials after the Doge. In Canaletto's time the two Procuratie met at S. Geminiano, the church on the west side of the Piazza; this was demolished by Napoleon and the west side was rebuilt.

The Fondamente Nuove (new embankments) form a quay along much of the northern part of Venice.

The Bacino (di S. Marco) is the basin, or pool, off the Molo and Riva degli Schiavoni.

A *rio* (plural *rii*) is a canal; within the city only the Grand Canal and the Cannaregio are called *canale* (*canali*). A *campo* (*campi*) is a square (literally 'field') or open space generally near, and named after, a church. A *fondamenta* (*fondamente*) is a paved walk on the banks of a canal; an important *fondamenta* may be a *riva*. A *scuola* (*scuole*) is a guild. A *punta* is a point, a name formerly given to extremities of the city. A *dogana* is a customs house. A *campanile* is a bell-tower; the Campanile is the bell-tower of St Mark's in the Piazza. The Loggetta is the former guardroom at the foot of, now the entrance to, the Campanile.

1
Detail from Lodovico Ughi's plan of Venice, published by Baroni in 1729.

Original 130 x 175 cm (51 x 69 in), etched in eight plates; scale approximately 1:2,400.

Note that the Molo appears as *la Pescaria* and St Mark's (not the cathedral church of Venice until 1807) as *Chiesa Ducale*.

Preface

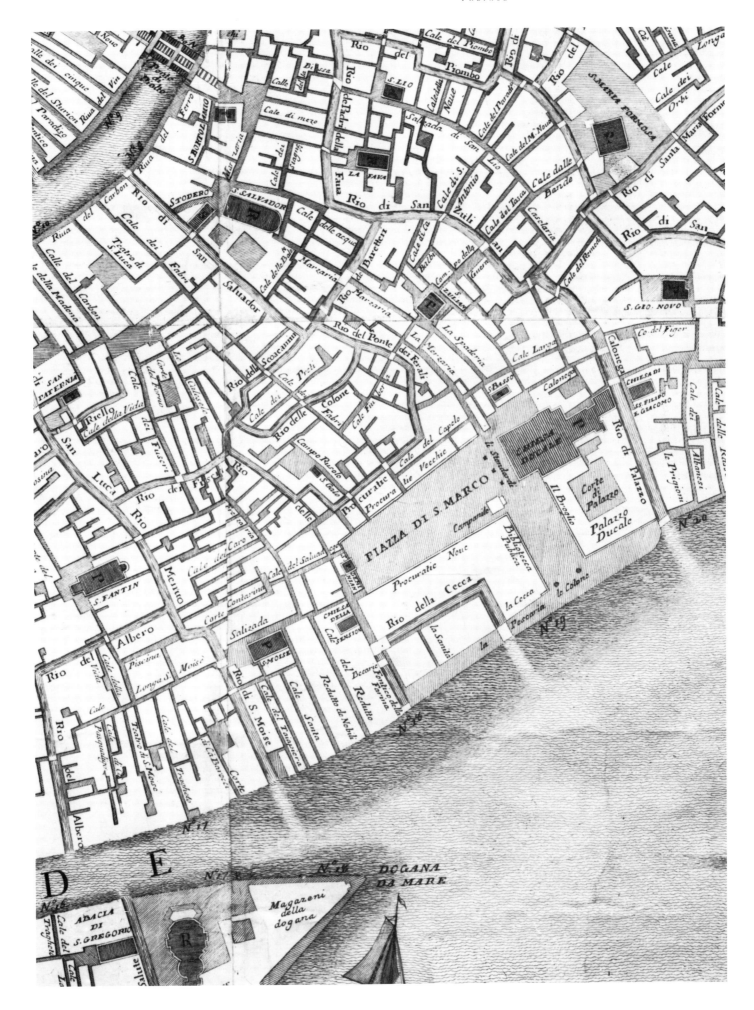

CANALETTO GREW UP in a world of magic. His father Bernardo Canal, who was born in 1674, was a '*pittore da teatro*', a man who spent his time designing or painting stage scenery, sometimes both. Those who were successful in this profession, such as the Bibiena family were for the whole of Canaletto's lifetime, did not confine themselves to creating illusion in the theatre. They were called to various parts of Italy and Austria by the organizers of state occasions, balls, weddings and (particularly) funerals to provide dazzling settings, all designed to deceive. Yet it is really only in the theatre that the artist who is learned in the intricate art of perspective can perform his magic. Here the audience cannot wander around, change its viewpoint and destroy the illusion so cunningly built up. Here the scene painter can utilize a few feet of stage depth to persuade his audience that it is a vast colonnade, in a street of infinite length lined with palaces, or in a garden filled with statuary which might, and occasionally does, come alive. It is but a step to reduce this few feet of stage depth to a few millimetres of paint thickness and transfer the illusion on to canvas. True, it was a step that art had taken only hesitantly. Vitruvius makes it clear that the ancient Romans had come fairly close to understanding vanishing-point perspective on the stage but it was not until 1,400 years later that Brunelleschi exhibited a picture demonstrating much the same ideas as have been followed ever since. Even so, to ensure that the spectator looked at it from the right position, he was made to look through a hole at a reflection of the picture.

Eighteenth-century Venice was itself in a way an illusion. It was as if the Venetians, seeing no hope of restoring the great days of their past, had resolved to spend what was left on creating a make-believe world of gaiety and entertainment. In the event, others were attracted to enjoy the amusement and were happy to contribute to its cost, and the Venetians, long accustomed to catering for the free-spending visitor, found themselves in a remunerative business. They were in a unique position to exploit this desire for play and pleasure for had they not inherited the most incomparable stage set in the world? The foreigner may have believed that the six-month-long Carnivals, with their endless festivals and ceremonies (Pls 3 and 4), were spontaneous outbursts of exuberance on the part of an irrepressibly gay people. The Venetians took care that he should believe this, for his presence in increasing numbers supported seven theatres, 200 cafés and restaurants, more casinos than the Venetians could count and enough courtesans to fill a book (more than one book, in fact, listing their names, addresses and charges). It was by no means left to artists, actors and scene designers to create an illusion in eighteenth-century Venice.

The truth that lay behind this dazzling façade could not be contemplated with ease by any Venetian conscious of his nation's 1,100 years of independence. It had long been in the Venetian nature to put on a show. They believed that by dazzling their visitors with the city's architecture and pomp they could create an atmosphere of impregnability and security and so disguise their lack of territory and land defences. Some visitors observed that behind the marble fronts the palaces

2
Detail of Plate 4.

1 An Age of Illusion

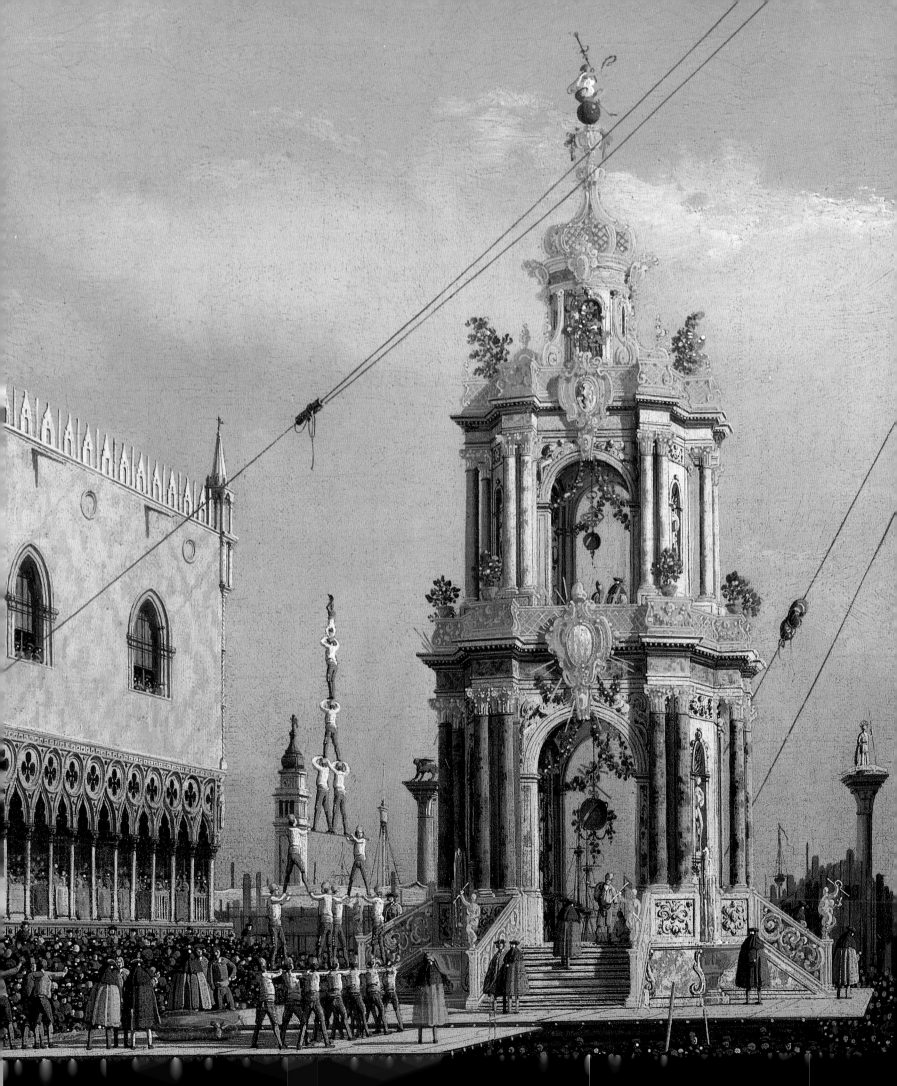

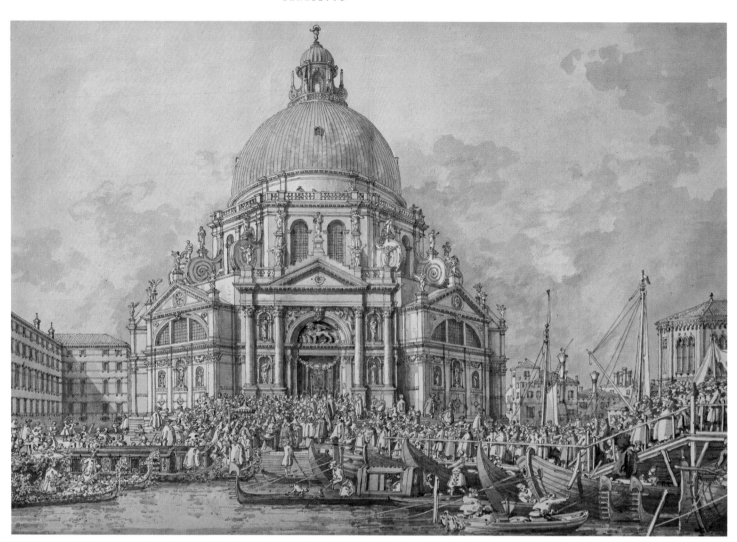

3
Annual Visit of the Doge to S. Maria della Salute
c. 1760

Pen and brown ink with wash,
38.1 x 55.3 cm
(15 x 21¾ in)
Private collection

The visit was to give thanks for the deliverance of the city from plague in 1630 for which the church had originally been built. A bridge of boats, erected on 21 November each year, led across the Grand Canal which normally had no bridge other than the Rialto.

were built of brick; very few noticed that what seemed like marble was often only paint. But behind all the ostentation there had once been a solid base of achievement – a government that, with all its complexity and wiliness, was the envy of Europe; an empire (for the most part won by deceit) capable of supporting a vast merchant navy, which for centuries had brought wealth and power to the tiny Republic; an artistic impulse that had given birth to some of the noblest painting, music and architecture of the Renaissance.

Now it had gone except the island of Corfu and in 1716, when Canaletto was 19 years old, the Turks attacked this last citadel. The Venetians were fortunate in having one of the leading soldiers of his time, Marshal Schulenburg, in their service and he miraculously saved the day. Canaletto was later said to have celebrated the event with a painting but, if true, this was no

doubt based on an engraving. It is certain, however, that Schulenburg became a patron of Canaletto's and commissioned one of his finest pictures (see p. 98). The Government of Venice was still in the hands of the merchant patricians, but few of them bothered to play any part in it. Some of these families were as rich or richer than ever. A number had been admitted simply because of their wealth and outstanding among these were the Labia. They had the taste to employ Tiepolo to decorate one of the rooms of their palace, which was in the course of being built throughout Canaletto's 30-year career in Venice (Pl. 6), but their vulgarity may be judged by the story told of one of their dinner parties. The Labia of the day on that occasion threw all the gold plates on the table into the canal outside crying '*L'abia o non l'abia, sarò sempre Labia*' (whether I have it or not I shall always be a Labia). (To make it worse, his

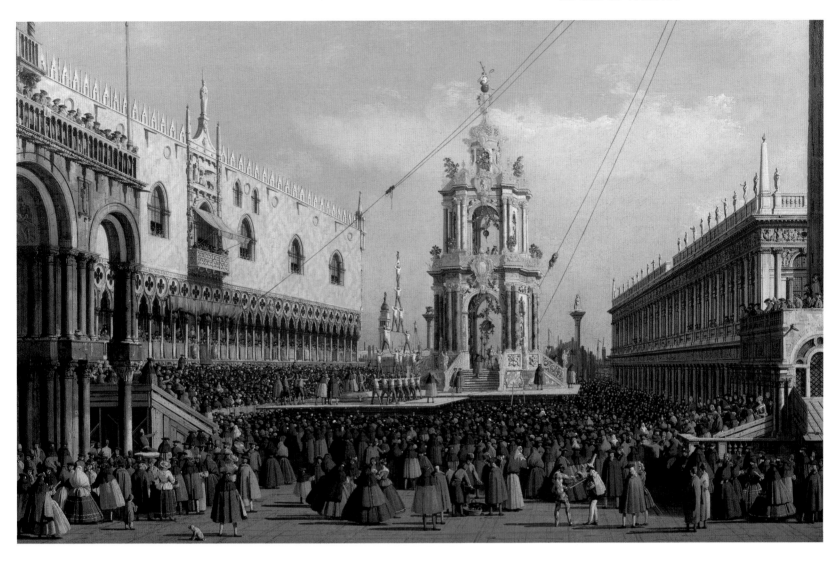

4
Studio of Canaletto
*Venice: the Giovedì Grasso Festival in
the Piazzetta*
c. 1760

Oil and canvas,
58.5 x 92.7 cm
(22¾ x 36¼ in)
London, The Wallace Collection

A man or boy was pulled by a rope
to the top of the Campanile from
which he descended to present
flowers to the Doge on a
temporary structure beside which
is a human pyramid.

enemies claimed that the plates had been thrown
into a concealed net which was drawn up after the
guests had gone.)

Apart from Tiepolo there had been no Venetian
painter of the first rank since Veronese, who had
died in 1588. It is true that Sebastiano Ricci, born
in 1659 in Belluno, had great influence on
eighteenth-century painting but, although trained
in Venice, he did not settle there until he was
middle-aged. Before that he had been travelling,
and it is worth noting that, when it was known
that he intended to compete for the painting of the
dome of St Paul's Cathedral, an Englishman living
in Rome wrote that everyone knew him to be 'no
more than a scene painter'. This was an essentially
English point of view. Other painters of almost
equal skill also worked in the theatre and on the
walls of country houses and no one attacked their
easel paintings for 'theatricality'. An artist could

paint religious or mythological pictures, portraits,
flowers, animals or scenes of daily life (*genre*). A
few could even paint landscapes, although these
were in a distinctly lower category. All were
accepted as artists, whatever they painted and
whatever they painted it on. View painting, it will
be noted, has not been included, for Venetian
view painting in the sense of townscape painting
did not exist.

This does not mean that, when Bernardo Canal
was born in 1674, townscape painting did not exist
outside Venice. In Holland Jan van der Heyden
had already taken as far as it would go the art of
painting the city street and had retired, leaving
only followers, such as the Berckheyde brothers.
Another follower, Gaspar van Wittel, had just left
Holland and settled in Rome and, although there
is not much that can be said with certainty on the
subject, he may well have been the true

forerunner of the Venetian view painters. There had already been plenty of artists drawing views of Rome for more than a century, many of them having gone there from the Netherlands as had van Wittel. They were, though, concerned with antiquities and churches rather than with the streets of the city. Venice itself had also been portrayed by artists, as anyone knows who has visited the Academy of Fine Arts there and seen the marvellous cycle of pictures commissioned by the Scuola di S. Giovanni Evangelista in the 1490s, particularly Gentile Bellini's *Piazza S. Marco* (Pl. 21) and Carpaccio's old *Rialto Bridge* (Pl. 5). Spell-binding as these are to any lover of Venice, they were painted in glorification, not of the city of Venice, but of the miracles of the Holy Cross which the *scuola* owned. The city was the background, not the subject, of the picture. In *veduta*, or view painting, as the term is generally understood today, the artist was concerned with the city as subject, all else being incidental. By their nature such pictures were of greater interest to the visitor than to the resident collector, and no city overwhelmed the visitors as did Venice. View painting has thus become associated with Venice,

and it is paradoxical that it should have had its beginnings with a Dutchman who lived in Rome and spent but a short time in Venice.

Vanvitelli, as van Wittel was called in Italy, seems to have led a fairly secluded life. In 1694, when he was in his 40s, he left Rome for a tour of northern Italy which took in Venice. While there, he must have made a number of drawings from the island of S. Giorgio Maggiore or from a boat moored between the island and the Molo; those that have survived are immensely skilful and original. On his return to Rome he painted a number of large canvases based on the drawings (Pl. 9). These, like his paintings of Rome and its neighbourhood and like those deriving from later visits to Naples and Sicily, are sunny and luminous; the figures have movement, if no great character, and the topography is accurate. They are quite unlike the work of his contemporaries and could easily be mistaken for that of a painter living 50 years later. It seems extraordinary that an artist of such originality and influence should have caused so little stir in his lifetime, which ended serenely in Rome in 1736 (he had at least acquired a nickname, '*Gaspare degli occhiali*', the bespectacled).

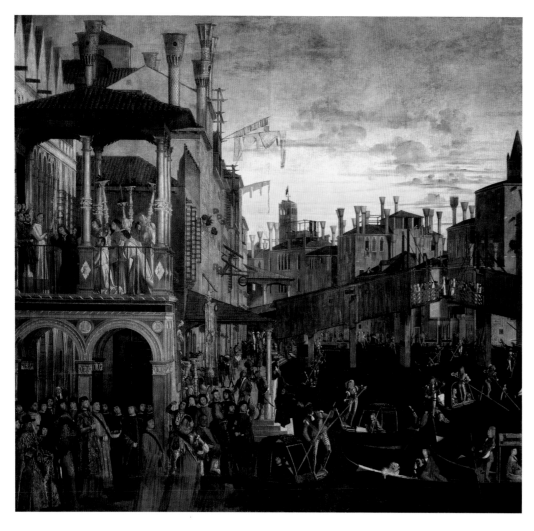

5
Vittorio Carpaccio (active 1490-1523)
Miracle of the Holy Cross
c. 1500

Oil on canvas,
Venice, Accademia

The Patriarch of Grado heals a madman by means of the Holy Cross outside his palace; the old wooden Rialto Bridge is seen in the background. The present bridge replaced it in 1588-91.

6
S. Geremia and the Entrance to the Cannaregio
Late 1730s

Oil on canvas,
47 x 76.4 cm
(18½ x 30 in)
London, National Gallery

The Palazzo Labio is behind the campanile (of S. Geremia); its water-entrance is at the back. Travellers to Venice via Mestre used to disembark at the quay in the foreground.

Or has his influence been exaggerated? Canaletto had not been born when Vanvitelli did his first paintings of Venice; he may have seen them when he was in Rome some 20 years later or even have met Vanvitelli, but there is no reason to suppose that he did. It was not until he had been a view painter for several years, and acquired a considerable reputation for work in an entirely different style, that Canaletto painted in the manner of Vanvitelli and he was by then a much more accomplished artist than Vanvitelli ever became. The probability is that Vanvitelli was not so much a forerunner as a herald of what was to come, a herald unheard by artists who were later to make their own discoveries in similar vein.

Vanvitelli's style is particularly suited to Venice, with its blue skies, its shimmering water and its cool look at architecture which has no need of dramatization. It is only when his other views are seen that we realize his failure to capture the individuality of a particular place; he was a professional view painter and Venice meant no more to him than Rome or Naples.

Carlevaris may have seen Vanvitelli's work and been affected by it, but the results when he

ultimately took to view painting were entirely different. Moreover there can be no doubt of the influence of Carlevaris over Canaletto – they lived in the same city, and more than one of Canaletto's favourite subjects derived directly from Carlevaris's compositions. He was the true founder of Venetian view painting.

Luca Carlevaris was born in Udine in 1663; he was therefore 11 years older than Canaletto's father, Bernardo. He settled in Venice while still a boy and remained there until his death in 1730, when Canaletto was at the peak of his career. He appears to have been a man of some means who liked to be known as a scientist or mathematician rather than a painter (Pl. 7), but no scientific work of his is known. Nor was he a prolific painter, least of all a prolific painter of views. He painted a number of imaginary landscapes and ruins, seascapes, battle scenes and biblical subjects. But his most remarkable achievement was in the field of topography, and not in painting at all. This was a book of 104 etchings designed, according to its title-page, to make known to strangers the splendours (*magnificenze*) of Venice. More than 40 churches and *scuole* were depicted and even more

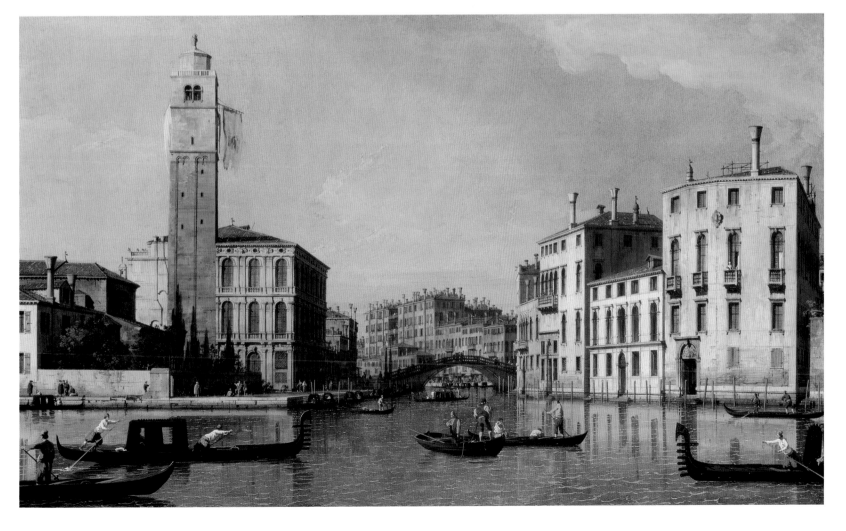

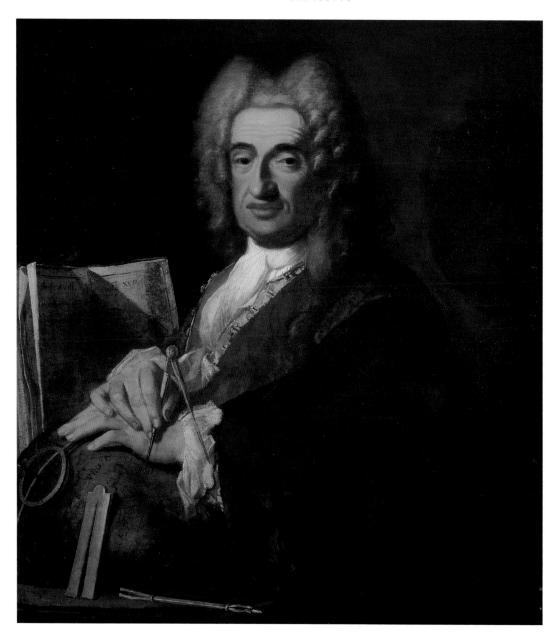

palaces, as well of course as the Rialto and Piazza areas from every possible angle – in the latter case there were views from quite impossible angles too, as if drawn with the aid of a modern fish-eye lens; here perhaps the mathematician came into his own. Most of the 104 drawings were dull in the extreme, mere diagrams in some cases, and Carlevaris may well have been conscious of this himself; some attempt was made to give them life by putting in dramatized skies of heavy cloud and flashing light. By the time the work was finished, Carlevaris must have known Venice better than most Venetians, but he had really done little to make known her splendours to strangers.

It was not until 1707 that Carlevaris emerges with some certainty as a painter. In that year Stefano Conti, of whom more will be said, completed the first stage of his gallery in Lucca, which contained three views by Carlevaris. In the same year the sixth Earl of Manchester commissioned a pair of pictures to mark his reception as English Ambassador to the Venetian Republic (Pl. 11). (His mission was to persuade the Venetians to fight the French: he failed and his comment was that 'the chief part they intend to act here is to amuse the rest of Europe and do nothing'.) Lord Manchester probably took the two pictures back to England with him in 1708, where they have remained ever since. Carlevaris must have had a reputation as a painter to have been given these commissions, but it is impossible to say when he began to acquire it. Nor is it possible to say when his career as a painter ended; Count Colloredo, the Imperial Ambassador, who commissioned a similar reception painting, was received in both 1714 and 1726 and the painting might show either event. These are but two of some 60 or 70 Venice view paintings, virtually all

7
Bartolomeo Nazzari
(1699-1758)
Portrait of Luca Carlevaris
Undated

Oil on canvas
90 x 74 cm
(35½ x 29 in)
Oxford, Ashmolean Museum

The artist is at pains to portray his fellow artist as a mathematician and geographer as well as a painter.

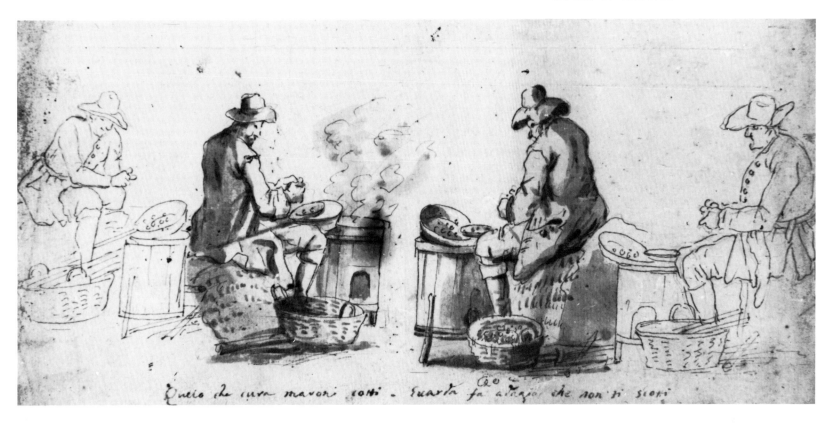

Quelo che cura mavoni cotti . Cuarta fa adaxio che non si scoti

8
Luca Carlevaris
(1663-1730)
The Roast-Chestnut Men

Pen and ink with wash
London, British Museum

An example of the many studies of
figures made by the artist for use in
his paintings. The roast-chestnut
men are still familiar figures in
Venice in wintertime.

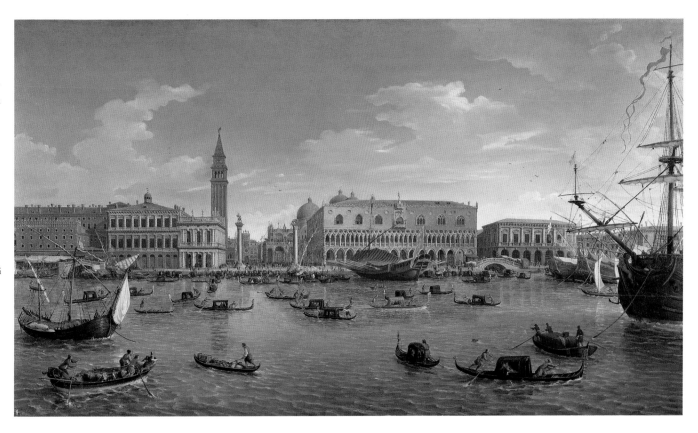

9
Gaspar van Wittel, called Vanvitelli
(1653-1736)
The Molo and Piazzetta
c. 1697

Oil on canvas,
98 x 174 cm
(38½ x 68½ in)
Madrid, The Prado

Signed 'Gas. V.W. 1697', the year
Canaletto was born. Compare
Plate 70, which is almost from the
same viewpoint.

of which portray scenes in the Piazza, in the Piazzetta or on the Molo (Carlevaris had perhaps had enough trudging round Venice for his etchings); none is dated.

The strength of Carlevaris's views lies in the liveliness of the people who populate them. Figure sketches, some in oil, others in pen and ink, demonstrate his fascination with the unique variety of humanity always to be found in or near the Piazza and his skill in pinning them on to paper or canvas; a profusion of such sketches by Carlevaris has survived (Pl. 8) whereas there is but a handful by Canaletto.

Nearly 20 years after Stefano Conti had bought his three Carlevaris views he enlarged his gallery and asked his agent to obtain some more. He was advised to reconsider. There was a new man whose work was astounding everyone who saw it, 'Sigr. Antonio Canal'. 'It is like that of Carlevaris,' Conti was told, 'but you can see the sun shining in it.' That was precisely the weakness of Carlevaris's painting: the skies are blue and the figures have shadows, but the sun that casts them fails to touch the architecture. He was a pioneer to the extent that he painted Venice (one part of Venice) without festivals or receptions, as well as with them; no one in the past, except Vanvitelli, had thought this worth while. But in his heart, we feel, the buildings were still no more than a background to the noblemen and gondoliers, the stall-keepers, merchants, Turks, Jews, and masked ladies. These were the actors: the buildings were painted in paler colours and with less intensity, lest they usurp the proper subject of the picture.

The analogy of the stage set must not be pressed, and there is no reason to suppose that Carlevaris was himself involved in the theatre. But no one could live in Venice without attending the operas and plays which were so important a part of Venetian life ('they go,' wrote an astonished French ambassadress later in the century, 'to *listen*, not to talk as we do'). Carlevaris must therefore have been as impressed as all audiences were by the arrival in Venice, in 1712, of a scene painter called Roberto Clerici, who brought with him the radical ideas of the Bibiena family. This new school had no fears that the scenery might intrude itself upon the actors: for them the actors existed mainly to give scale to the architectural perspectives they designed with such thoroughness and exactitude. Most revolutionary of their innovations was the *scena all'angolo* by which the vanishing point was placed at the side of the stage set, or off-stage altogether (Pl. 10). Before this, depth had always been suggested by a perspective of houses built on either side of an upward-sloping street or an avenue that prolonged the central aisle of the auditorium (Pl. 12). By painting the architecture as if seen at a slant, running diagonally off-stage to undetermined distances, a much more imaginative illusion of distance was achieved. Artists followed the scene painters, or more probably conceived the ideas at about the same time, and Carlevaris, as a painter of architecture, was among the first to use the device in Venice (Pl. 13).

Clerici's visit to Venice must have had a far more profound effect on Bernardo Canal and other men of the theatre than on the easel painters such as Carlevaris. Canaletto himself was by now 15 and would have been working with his father. The new ideas were therefore an essential part of his early training in the art he practised throughout his life, that of creating illusion.

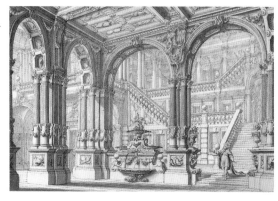

10
Giuseppe Galli Bibiena (1695-1757)
Interior of a Palace

Pen and ink with watercolour,
33.7 x 49.2 cm
(13¼ x 19⅜ in)
Private collection

This design for a stage set is a good example of the vanishing point off-stage.

11
Luca Carlevaris
(1663-1730)
Entry of the Earl of Manchester into the Doge's Palace
c. 1707

Oil on canvas,
132 x 264 cm
(52 x 104 in)
Birmingham Museums and Art Gallery

Signed with the initial L.C. Commissioned by Lord Manchester and taken by him to England.

12
The stage-set of the sixteenth-century *Teatro Olimpico* at Vicenza showing the typical central vanishing-point of the time. The theatre was designed by Andrea Palladio (1508-80) and completed by Vincenzo Scamozzi (1552-1616).

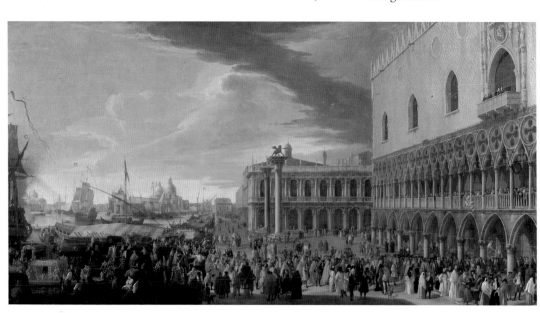

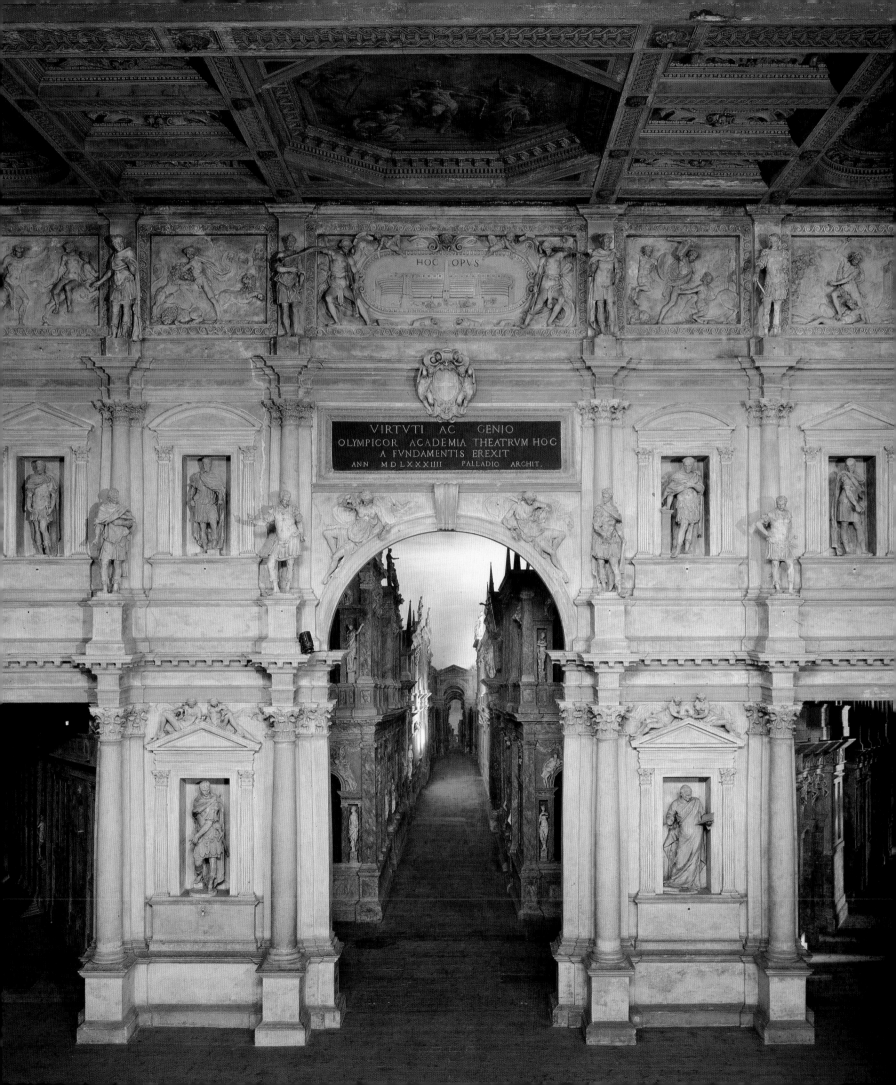

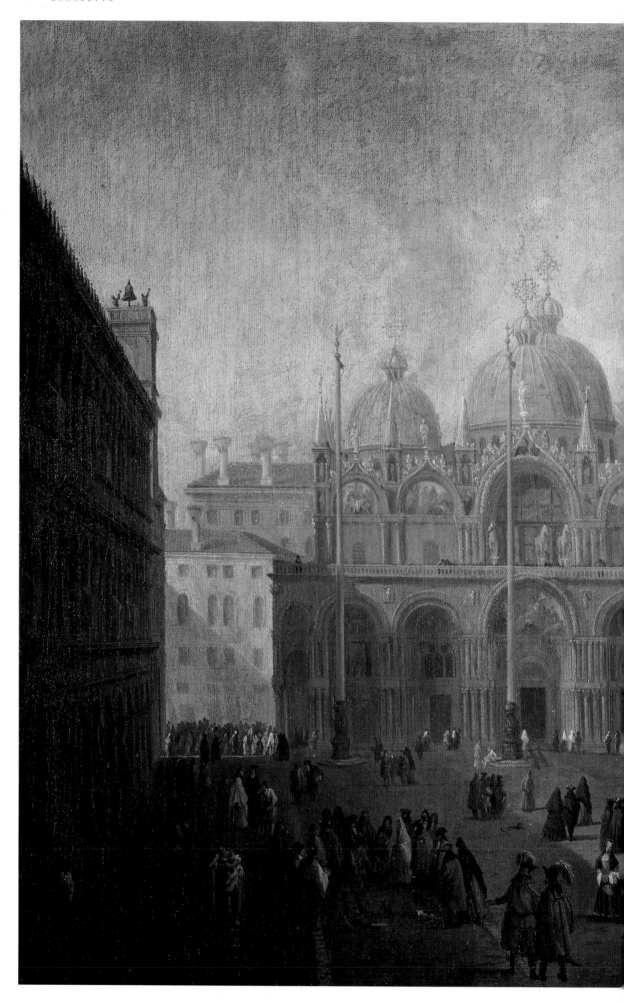

13
Luca Carlevaris
(1663-1760)
Piazza S. Marco: looking East
c. 1722

Oil on canvas,
73 x 114 cm
(28½ x 44¾ in)
Private collection

Perhaps an early example of the
use of the off-centre vanishing
point.

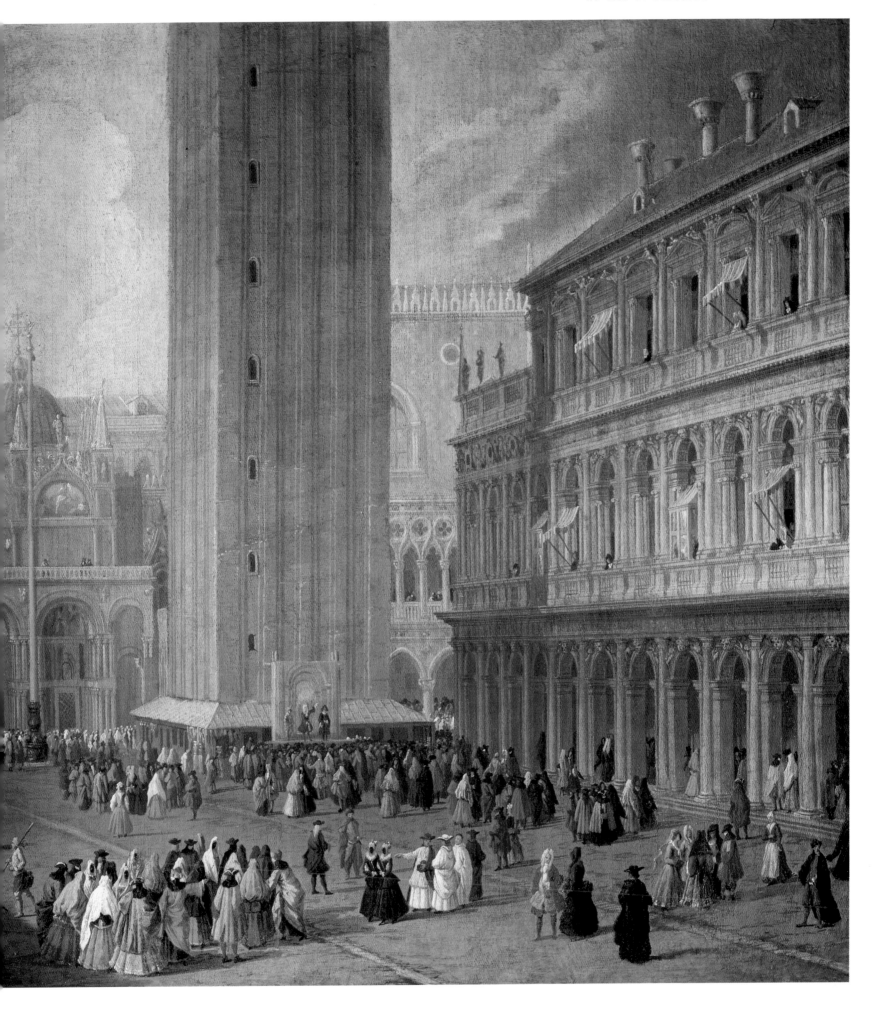

THE CAREER OF CANALETTO set a conundrum to his fellow artists and to those who tried to assess it after his death. He was manifestly a great artist and had been recognized as such by some of the best-informed connoisseurs of his time. Yet his immense success had been due to his appeal to the most unsophisticated taste of tourists who wanted no more than souvenirs of the Venice they had fallen in love with or, in many cases, substitutes for the journeys they preferred not to undertake. It was decided that there could be only one explanation: the English who filled the pockets of Canaletto and his agents with guineas did not really appreciate what they were getting in his view paintings. Only 'those with more understanding [chi molto intende] find great art in them', wrote Anton Maria Zanetti the Younger shortly after Canaletto's death. At another point Zanetti attributed much that was inexplicable to Canaletto's reliance on the camera obscura but, apparently realizing that this explained nothing to those who used their eyes, he ended lamely, 'the experts will understand what I mean'.

But did they? Canaletto was indeed full of contradictions which the 'experts', if they really understood, were incapable of explaining. The first patron to introduce Canaletto to the English, Owen McSwiney, wrote 'His excellence lyes in painting things as they fall, immediately, under his eye', yet the pictures he was selling at the time show that the contrary was true: Canaletto disregarded the way things fell under his eye and considered only the impression his compositions would have on their viewers.

'Accuracy' (aggiustarezza) and 'reality' (la vera) were the words applied to his work by A.M. Zanetti and others in Canaletto's lifetime, just as 'photographic' is sometimes applied today. Yet consider the facts. When composing a picture he would use viewpoints, not only to the left or right of the original, but nearer to and farther from his subject. He would turn buildings round, add others which would be invisible from his main viewpoint, rearrange the curves of the Grand Canal, make his background closer or farther away than it should be, change roof-lines and simplify architecture. He would open up the sides of a view, as if opening the pages of a book, in order to show buildings at the angle that suited him. Almost always, having made his drawings from the ground, he would raise the viewpoint in the final picture, quite often to such an extent that the viewpoint seems to be a high, and non-existent, window. There was no consistency in applying these devices: only he, Canaletto, knew how to achieve his object which was the creation of a work of art. He seldom produced anything less, even when painting the same subject in several versions. Occasionally, particularly when working on a grand scale, the result was a masterpiece.

There was no older artist's studio in which Canaletto could learn how to develop his own ways of view painting: he had to find out for himself. How much of it came by instinct and how much by observation, trial and error, can only be guessed at: Canaletto would probably not have known himself. That he ceaselessly sought different paths to reach his goal is certain, as the most cursory reading of this book will show.

Detail of Plate 14.

2 *The Theatre Renounced*

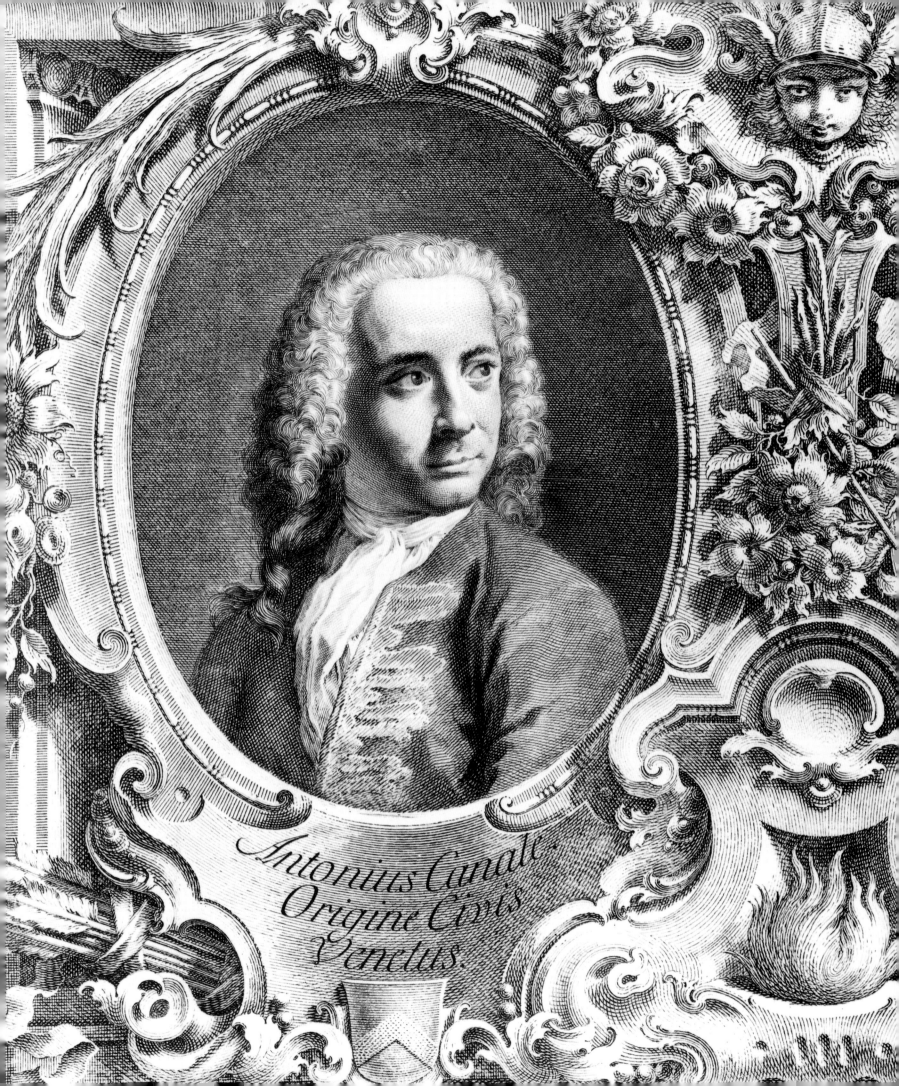

Antonius Canale
Origine Cives
Venetus.

In 1720 two operas by Alessandro Scarlatti were performed for the carnival in Rome, and the printed libretto stated that the scenery was executed by Bernardo and his son Antonio Canal.[1] Canaletto *was* in Rome by 1720. Before that there is nothing certain except that he was born in Venice on 28 October 1697 near the Campo S. Lio, perhaps in the house in the Corte del Perini which was later his home (Pls 87–90) and which now bears a plaque recording this fact (the house belonged to his family before he was born). He was baptized Zuane (the Venetian form of the Italian Giovanni) Antonio Canal and at various times during his life used the names Canale, da Canal, Canaleto and, more usually, Canaletto. Foreigners often called him Canaletti. His great-grandfather had been allowed to call himself *cittadino originario*, which gave him the right to bear arms, and his descendants kept this status so long as they did not become manual labourers. Although a republic, Venice was an intensely class-conscious state, and when, in 1735, Canaletto's portrait appeared side by side with that of Antonio Visentini, who had engraved his paintings, the artist, bewigged and in his best clothes, was described as *Origine Civis Venetus*, while the engraver wore a cap and was simply *Venetus* (Pl. 14). Canaletto was not a patrician, but he belonged to a class which any Venetian would have recognized as immediately below.

There is no painting or drawing which can be said with certainty to have been produced by Canaletto before the early 1720s. Two distinguished Italian scholars, Antonio Morassi and Rodolfo Pallucchini, identified some two-dozen

capriccios in the 1960s and 1970s as early work by Canaletto although they had hitherto been attributed to a variety of artists such as Marco Ricci, Francesco Battaglioli and even Carlevaris. One of these bears a signature in capitals which reads 'IO ANTONIO CANAL 1723' and, although the attribution may well seem tentatively justified, the date is very questionable. The difficulty in accepting these attributions is that hardly any of the paintings have been exhibited since they were published and a number of the owners remain unknown. Reliance therefore rests on photographs, notoriously unreliable, especially in the case of Canaletto, and in the present state of knowledge the attributions cannot be accepted with any confidence.

Nor is there any certainty about a group of 21 drawings of Rome, all except one now in the British Museum. They are all by the same hand, which could be that of a very immature Canaletto, and are inscribed with his name (Pl. 15). Engravings from them, published after his death, attribute the originals to Canaletto. Many drawings and paintings of his middle years, some certainly by Canaletto, seem to have been based on these drawings. They may well be an engraver's copies of a lost album of Roman drawings by Canaletto or they may be by the young Canaletto himself. They indicate what he may have been doing in Rome besides helping his father paint scenery, but they do not provide the firm ground we are seeking.

Two Italian writers and one French gave Canaletto's life a few paragraphs during his lifetime or shortly after his death.[2] They agree that he

NOTES
1 E.J. Dent in *Alessandro Scarlatti* (London, 1905) points out how important the scenery was to the baroque opera from the fact that 'we often find such distinguished artists as Bibbiena and Antonio Canale given in libretti that make no mention whatever of the composer of the music'.

2 P.A. Orlandi, with additions by G.P. Guarienti, *Abecedario Pittorico*, Venice, 1753; A.M. Zanetti, *Della Pittura Veneziana*, Venice, 1791; P.J. Mariette, *Abécédario*, first published in Paris, 1851-60.

14
Antonio Visentini
(1688-1782)
Giovanni Antonio Canal, called Canaletto, and Antonio Visentini
Before 1735

Engraved after G.B. Piazzetta for the title-page of *Prospectus Magni Canalis Venetarium*, containing Visentini's engravings after Canaletto's paintings.

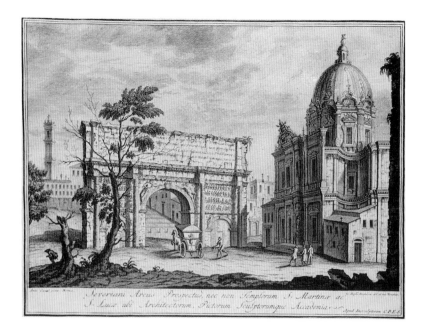

15
Arch of Septimius Severus

Pen and ink with wash,
15 x 22 cm
(6 x 9 in)
London, British Museum

Attributed to Canaletto's early stay in Rome, but more probably a copy of one of his drawings. 22 similar drawings exist, all of which were used for engravings.

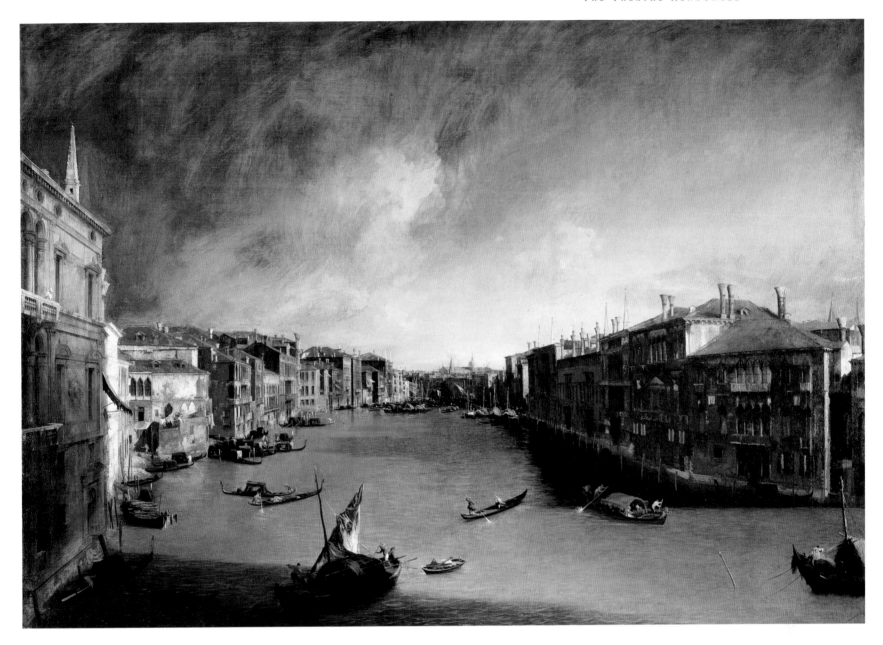

16
*Grand Canal: looking North-East from
the Palazzo Balbi to the Rialto Bridge*
Probably before 1723

Oil on canvas,
144 x 207 cm
(56¾ x 79⅛ in)
Venice, Cà Rezzonico

The viewpoint is the same as that
of *A Regatta on the Grand Canal*
(Plate 69), the stormy weather
giving a very different appearance
to the scene.

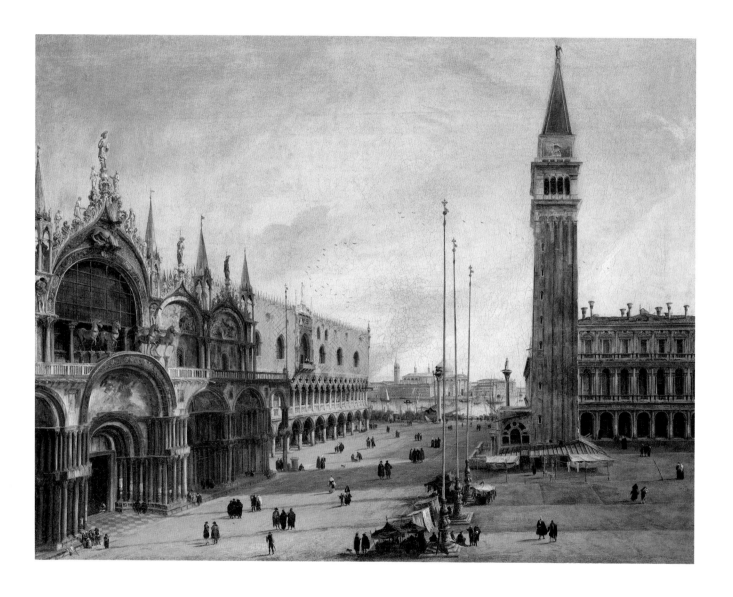

17
The Piazza: looking South
Probably before 1723

Oil on canvas,
73.5 x 94.5 cm
(29 x 37¼ in)
Private collection

Possibly Canaletto's earliest
painting of the Piazza. Compare
with Plates 75, 120 and 121.

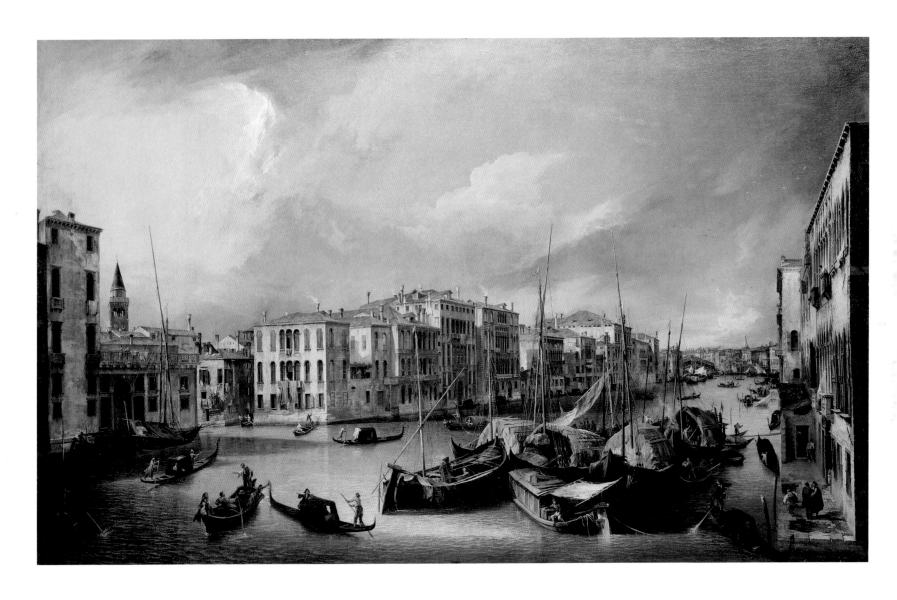

18
*Grand Canal: looking
North-East from the Palazzo Corner-
Spinelli to the Rialto Bridge*
c. 1725

Oil on canvas,
146 x 234 cm
(57½ x 92 in)
Dresden, Gemäldegalerie Alte
Meister

One of an early group of paintings
in Dresden since 1741.

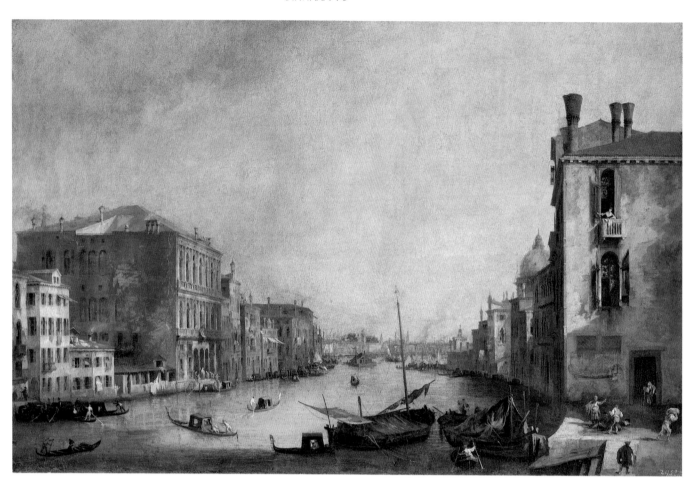

worked in the theatre as a young man, first in Venice and then in Rome. Zanetti gives as his reason for going to Rome a disenchantment with the theatre, which he 'solemnly renounced', but the evidence of the Scarlatti libretto proves that this, like so much contemporary gossip, was not so. Zanetti continues that the young artist 'devoted himself entirely to painting views after nature' in Rome, which is probably true, at least in part; there is no mention of imaginary views, or capriccios. None of the three writers mentions Canaletto's return to Venice, which was probably in 1720; in that year his name appears in the list of members of the Venetian artists' Guild, although it may possibly have been entered while he was still in Rome (his father Bernardo did not become a member until 1737).

Once back in Venice, Canaletto became a view painter, whatever he may have been in Rome. It

would have been illogical for him to have done anything else. Carlevaris had created a market for paintings which studied the scene in or near the Piazzetta, but hardly elsewhere. It is true that none of Carlevaris's patrons can be named except Stefano Conti, and that Conti's pictures cannot be identified; nevertheless there must have been patrons, or Carlevaris would not have continued painting much the same subject in exactly the same style. There was also the occasional commission for a picture to mark some occasion such as the reception of an ambassador or a regatta in honour of some visiting dignitary; these had also been the preserve of Carlevaris. By this time Carlevaris was approaching 60, and painting had never been his sold concern. Canaletto was 23 and had mastered the art of perspective in a good school, the theatre. He had all the technical equipment needed to become a view painter and

19
Grand Canal: looking East, from the Campo S. Vio
c. 1725

Oil on canvas,
65.5 x 97.5 cm
(25¾ x 38⅜ in)
Dresden, Gemäldegalerie Alte Meister

The most frequently repeated of all Canaletto's subjects, often with differences on the wall of the Palazzo Barbarigo.

20
Detail of Plate 19.

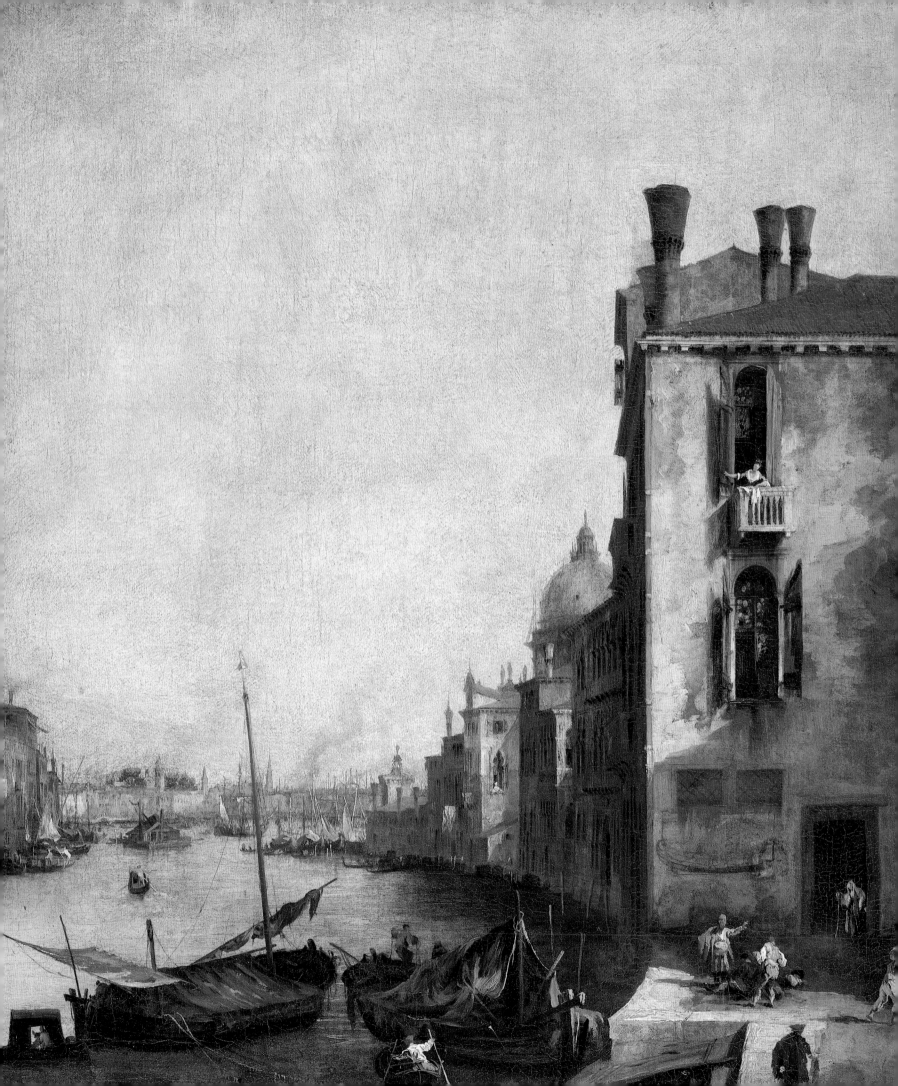

the idea of forsaking the artificial world of plaster and painted colonnades for the solid world that in Venice was hardly less fantastic must have been appealing.

A group of four paintings once in the almost legendary Liechtenstein collection in Vienna were probably the earliest of Canaletto's views. They may not have entered the collection until after Canaletto's death, but it is impossible to identify an earlier owner. Nor can they be dated. One of them shows *The Grand Canal from the Campo San Vio*, a subject which was to prove the most popular of all Grand Canal scenes, more than a dozen authentic versions surviving today. The dome of the Salute appears in mid-distance and scaffolding can be seen on it; the dome was under repair in 1719 and it is just possible that the picture was painted in that year. Much more reliable evidence of date appears in the view of the *Piazza S. Marco: looking East* (Pl. 23). Until 1723 the Piazza was paved in brick, with drainage channels running from east to west, and this is how Carlevaris showed it. In that year the present paving with a white marble design was begun, and Canaletto shows an early stage of this work on the right of his painting. There is confirmation in one of Carlevaris's pictures that this was where the work started, hence both may be dated 'soon after 1723' with some confidence.

Until 1991 it would have been reasonable to state that Canaletto never again showed the old brick paving of the Piazza; next time he came to paint it he avoided precise delineation and after that he showed the floor in its finished state. However, a painting of *The Piazza: looking South*

(Pl. 17) appeared in a New York auction sale in that year, attributed to Marieschi, which again emphasized Canaletto's unfailing power to surprise. The picture unmistakably shows the pre-1723 paving which ceased to exist when Marieschi was 13 years old. Moreover the figures and architecture bear the characteristics of Canaletto's early work. The composition, though, is extraordinary. The left-hand side of the picture shows with more than usual accuracy the scene as it appears from a window in the Procuratie Vecchie: only the island of S. Giorgio Maggiore is made to appear farther away than it is. From that window the Campanile is so close that no more than the lower half can be seen without raising the eyes, nor are the tops of the flagstaffs visible. Canaletto has simply moved both Campanile and flagstaffs far enough away to include them in their entirety without in the least disturbing the spectator's conviction that the scene was in fact as Canaletto had painted it. It was a remarkable feat for a still inexperienced view painter. Perhaps even more remarkable is the fact that Canaletto seems to have been dissatisfied with it. In several later paintings, some as late as 1744 (Pl. 120), he reverted to showing the lower part of the Campanile as the disproportionate stump that accuracy would demand and as Carlevaris had almost always made it appear. (When Francesco Guardi took over he overcame the problem by making it needle thin.)

For whom was the picture painted? Not for an English visitor to Venice: these were not yet among Canaletto's patrons. Probably not for the grander international collectors who were

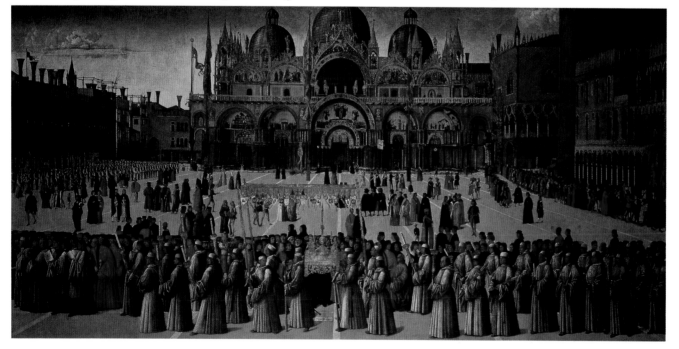

21
Gentile Bellini
(1429-1507)
Miracle of the Holy Cross in the Piazza S. Marco
1496

Oil on canvas,
about 3.6 x 7.2 m
(12 x 24 ft)
Venice, Accademia

The S. Orseolo hospital on the right, which preceded the Procuratie Nuove, was flush with the Campanile. Otherwise the scene is little changed.

22
Rio dei Mendicanti: looking South
Probably before 1723

Oil on canvas,
140 x 200 cm
(56¼ x 78⅜ in)
Venice, Cà Rezzonico

The view from the Fondamente
Nuove towards the Scuola di
S. Marco, which can be seen in
the left background. In the left
foreground is the church of
S. Lazzaro dei Mendicanti.

23
Piazza S. Marco: looking East
Before 1723

Oil on canvas,
142 x 205 cm
(56 x 80¾ in)
Madrid, Thyssen-Bornemisza
Collection

Canaletto's first version of the
subject, painted before the present
paving of 1723 had been completed.
Formerly in the Liechtenstein
collection.

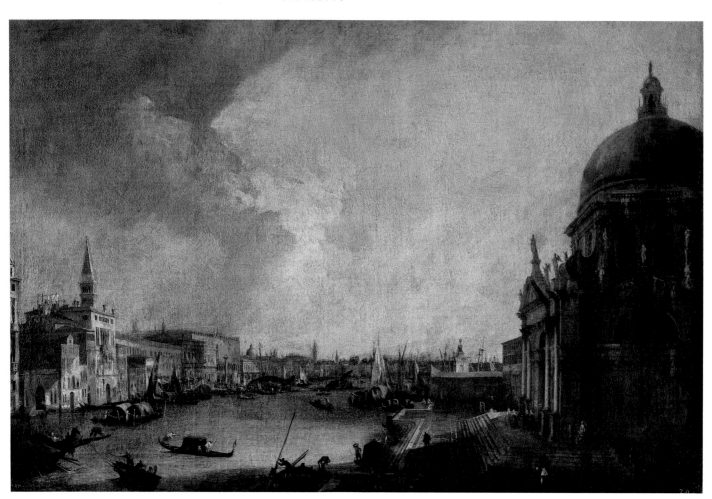

gradually recognizing the young artist's merits: they would surely have required a view from a window of the Clocktower from which most visitors look out with wonder on to the Piazzetta and S. Giorgio beyond. It seems more likely that a Procurator, having seen how Canaletto could bring life to the buildings which, to Carlevaris, were merely a background, commissioned a record of the familiar scene from his own apartment or offices. We can but guess.

To return to the four Liechtenstein paintings, a view of the Piazza and one of the Grand Canal would be natural choices to complete the Liechtenstein quartet, but none of them was chosen. Instead Canaletto stood on the Fondamente Nuove and depicted the dull façade of S. Lazzaro dei Mendicanti with the *rio* leading to the Campo SS. Giovanni e Paolo and a seedy-looking row of buildings on the right. It was an

astonishing choice and, even more astonishingly, the result was a masterpiece (Pl. 22).

So was the Piazza painting (Pl. 23). When in 1496 Gentile Bellini painted his huge and celebrated *Miracle of the Holy Cross in the Piazza* (Pl. 21), now in the Venice Academy of Fine Arts, he showed the procession with the sacred relic as it would be seen from the centre of the Piazza; the Procuratie Vecchie on the left appear from the same viewpoint. But the rest of the picture is from a viewpoint on the extreme left of the Piazza, in fact where the Caffè Quadri is today. From here the Campanile retreats to allow the corner of the Doge's Palace to be seen, and even a glimpse of the entrance to its courtyard under the Porta della Carta. St Mark's is now facing the spectator with its domes and pinnacles symmetrically placed. From an artist's point of view the scene has a harmony and balance which the Piazza itself

24
Entrance to the Grand Canal: looking East
c. 1725

Oil on canvas,
65 x 98 cm
(25½ x 38½ in)
Dresden, Gemäldgalerie Alte Meister

Probably the first of many versions of this subject. On the extreme left, part of the present Europa Hotel.

25
SS. Giovanni e Paolo and the Scuola di S. Marco
c. 1725

Oil on canvas,
125 x 165 cm
(49¼ x 65 in)
Dresden, Gemäldgalerie Alte Meister

Possibly bought by the Imperial Ambassador from the annual display outside the Scuola di S. Rocco (see Plate 26). For another version see Plate 35.

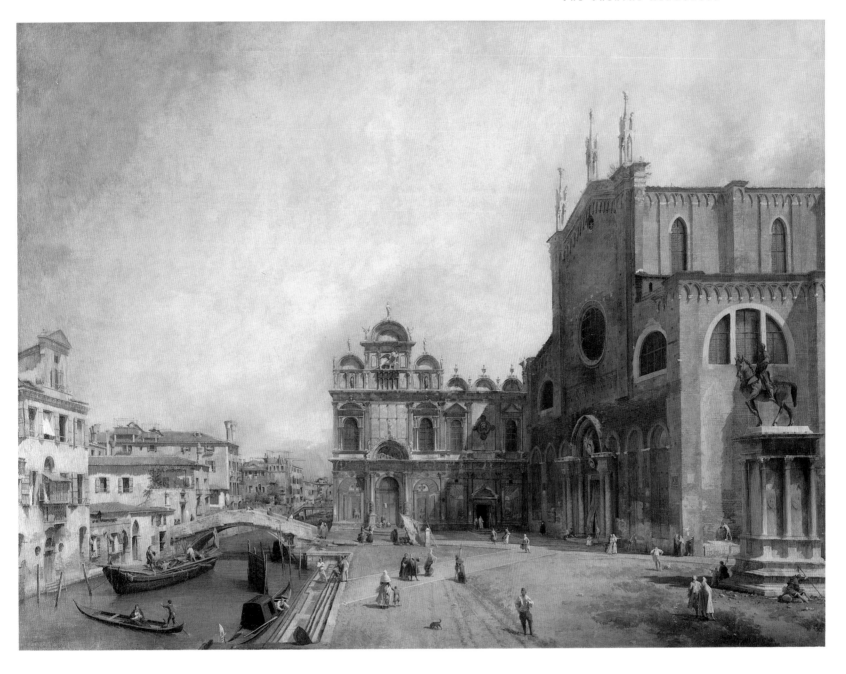

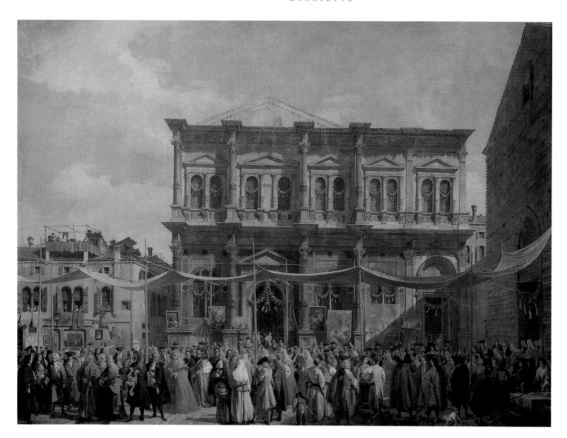

conspicuously lacks, having grown over the centuries rather than being planned as a whole.

No one learnt better than Canaletto how to use the same device to serve his own ends: it is rare indeed to find a painting or drawing by him in which the viewpoint has not been changed at least once. In this case, though, he has not followed Gentile Bellini's precedent, nor does he do so in any of his later pictures of the Piazza towards St Mark's. The Campanile in his painting is slenderer and tapers more than is the fact; St Mark's is a little higher, a shade less squat. Otherwise, this is the scene that confronts an observer from what is now the first-floor entrance to the Correr Museum – every arch and every window in precisely the right place. But this is no factual record: the camera's response to the scene is entirely different. There is a sense that something is about to happen in Canaletto's Piazza, a tension, a feeling of

anticipation. In short, we see what might be a stage set; we are in darkness and look down on a brilliantly lighted piece of scenery. Nor is there any attempt to conceal the shabbiness which has descended upon the central point of the dying Republic. The sunblinds are falling apart; coarse sailcloth is used for shade. Washing is hanging out to dry – washing in the Piazza S. Marco! This was no picture painted to please the passing tourist. It was a Venetian's expression of the drama of his native city, with the contrasts that combine to give an illusion of reality.

Even less would the *Rio dei Mendicanti* (Pl. 22) appeal to a tourist. Every conscientious visitor would look up this *rio* towards the northern Lagoon after studying the tombs of the doges in SS. Giovanni e Paolo and while examining the extraordinary façade of the Scuola di S. Marco (and those who wanted to buy a Canaletto of the

26
The Doge visiting the Church and Scuola di S. Rocco
c. 1735

Oil on canvas,
147 x 199 cm
(58 x 78½ in)
London, National Gallery

Another festival at which the Doge and his retinue annually gave thanks in the Church for deliverance of Venice from a plague.

27
Detail of Plate 26.
An exhibition of pictures was held on the same day, and one in Canaletto's own style is shown beside a door. Sales of both his work and Bellotto's from this exhibition are recorded.

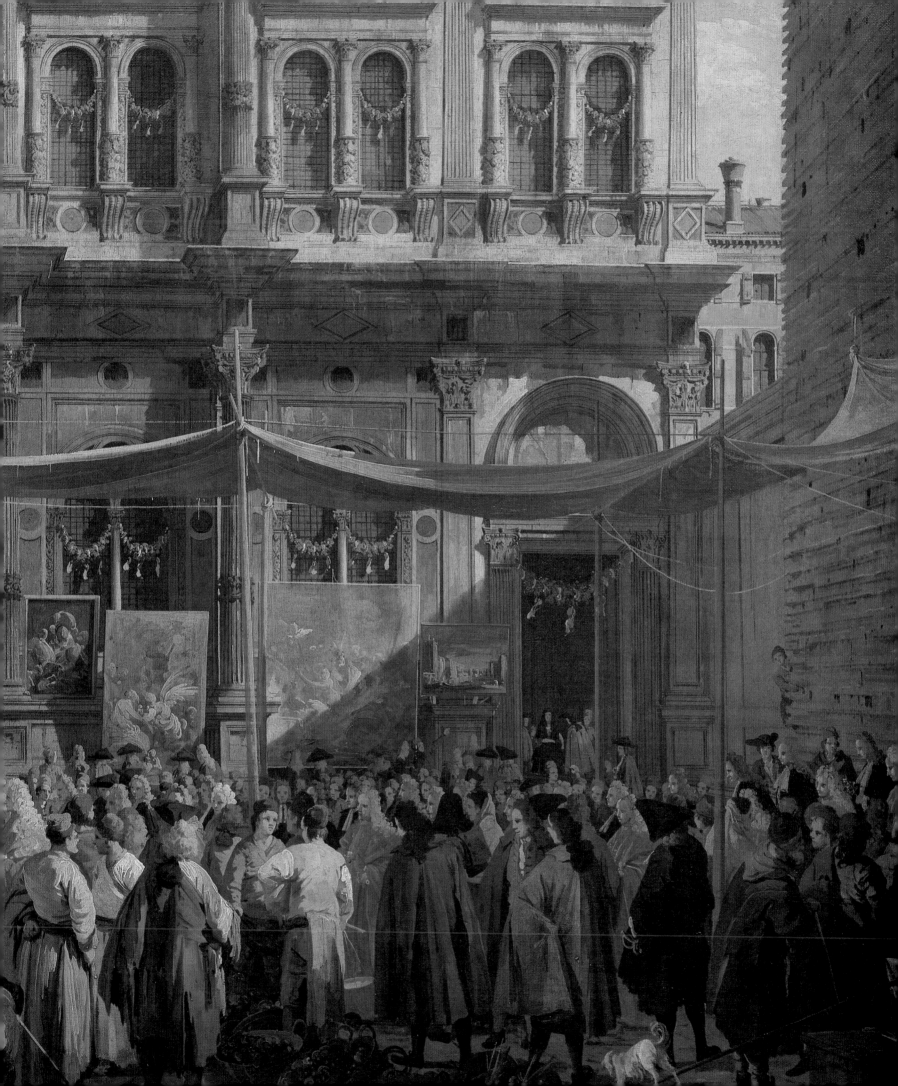

subject would not have long to wait). Visitors, though, would approach from the south or the west, occasionally from the east, but hardly ever from the north, unless their gondolier wanted to overcharge them. Yet this was the corner of Venice Canaletto chose to paint, almost certainly before he had tried his hand at the nobility of the Doge's Palace or the monuments of Sansovino or Longhena. It seems to have been the crumbling stucco that appealed to him, perhaps the picturesqueness (although the word had not yet reached the artist's vocabulary) of the *squero* from which the gondola is being launched back into service after its periodic scraping and overhauling. The other three paintings of the Liechtenstein group provided subjects throughout Canaletto's career, but when the *Rio dei Mendicanti* was finished the artist had said all that he had to say for his own satisfaction and no patron called on him to return to the scene.

It is not easy to believe that the *Regatta on the Grand Canal* (Pl. 69), painted at the peak of Canaletto's career as a topographical artist, is by the same artist and from much the same viewpoint as the Prince of Liechtenstein's *From the Palazzo Balbi to the Rialto Bridge* (Pl. 16). Nothing can better illustrate the contrast between the work on which Canaletto's fame was to depend and the beginnings of his career as a view painter. The threatening clouds and deep shadows of the early painting give the Grand Canal an atmosphere a Venetian would recognize immediately, very different from the sun-drenched spectacle which the visitor was expected to regard as normal. It is a startling picture, yet not altogether satisfactory; the emptiness of the Canal and the timid handling of some of the palaces betray the fact that the artist was still lacking in experience.

The view *From the Palazzo Corner-Spinelli to the Rialto Bridge* (Pl. 18) provides a complete change of emphasis. It is one of a group of paintings that entered the collection of the Kings of Saxony in Dresden during Canaletto's lifetime but, as with the Liechtenstein pictures, there is no certainty as to the original owner. The scene is a little higher up the Grand Canal than Plate 16; Canaletto imagined himself at a window (which does not exist), looking down on the landing-stage of the S. Angelo ferry (now the S. Angelo waterbus stop). Instead of leaving an almost empty expanse of water in the foreground, as in the Palazzo Balbi painting, he has now filled it with a group of shipping of a variety and interest unsurpassed in any later picture. Virtually every building from left

to right is still standing today, including the campanile of S. Polo next to the Palazzo Barbarigo della Terrazza, but an artistic spell has been cast over the scene which takes it out of the realm of reality. No other painting in the group has this air of fantasy and one is tempted to speculate on the reception it had from its original owner. Perhaps he protested at the licence that had been taken. Perhaps Canaletto himself felt he had gone too far if he was to gain a reputation as a painter of recognizable Venetian views; he returned to the subject only once and then painted it in the most matter-of-fact way he could.

There are two more Grand Canal scenes in the Dresden group. One shows the view looking east from the Campo S. Vio as did one of the Liechtenstein pictures. The scaffolding is no longer on the Salute and this may well be evidence that it was painted later. But there is still a rough picture of a boat which someone had painted on the wall beside the door (Pls 19 and 20). Canaletto was to paint this scene a dozen times within the next ten to 15 years, never again with this *graffito*, if that is what it was. It is impossible to doubt that he painted it because it was there and left it out when it was no longer there. There were to be other alterations to this wall, the entrance to the Palazzo Barbarigo (now disfigured by the modern mosaics of a glass manufacturer). One of the round-topped windows was partly blocked up and shutters added; one of the balconies was later taken away. Canaletto would not hesitate to change his viewpoint so that two versions of the same subject might contain different buildings, but when it came to minor changes in a wall, such as that of the Palazzo Barbarigo, he seems to have felt a compulsion to record them in meticulous detail, returning again and again to the scene rather than relying on earlier drawings.

The other Grand Canal painting in the Dresden group (Pl. 24) is Canaletto's first version of a subject he was to repeat almost as often as the Campo S. Vio (and which became even more popular with his imitators). We are looking down from a window in the Abbey of S. Gregorio on to the steps of the Salute with the quay of the Dogana (formerly the marine customs house) and its tower surmounted by a ball ahead of us. On the left is the entire procession of buildings from the Giustinian Palace (now the Europa Hotel), past the Piazzetta and along the Riva degli Schiavoni, to the distant area of Castello. It was the left foreground that Canaletto varied in later versions. Sometimes he began even farther up the Grand

28
Part of the letter written by Canaletto to describe Stefano Conti's first two paintings, Plates 29 and 33. Compare his formal hand with that on his sketches (Plates 34 and 153) and note his signature, *Venetiano*.

134

Adi 25 Nouenbre 1725 Venetia

Dichiaro con la presente mia sottoscritta e atesto auer dipinto
due quadri di uedute di Venetia del Canal Grande, sopra
due telle di lungezza quarte otto e meza et per altezza
quarte cinque e meza; Nella prima il Ponte di rialto
dalla parte che guarda uerso il Fontico de Todeschi, che
resta dimpeto la Fabrica de Magistrati de Camerlengi; et
altri piu Magistratti con altre fabriche uicine che si adimanda
dell'erbaria, doue sbarca ogni sorte derbazi e frutami per dispensare
alle arti per la Città Nella Mettà del Canale è dipinto una
Peotta nobile con figure entro con quatro gondolieri che uà scorendo;
et pocco uicina una gondola à liurea del Ambassiator del Imperator;

Nel secondo quadro continuando l'istesso Canale che si adimanda le
Fabriche sino le pescherie; il Palazzo Pesaro e nel fondi il campanile
di S. Marcola, dall'altra parte del Canalle, che uicino il Palazzo di Cà
Grimani e continua altri Pallazzi cioè Rezonico e Sagredo e molti altri.

Per il prezzo delli due sudetti quadri mi fù ordinatti e pagatti dal Sig:
Alessandro Marchesini per ordine e comissione del Ill.mo Sig: Steffano Conti
di Lucca in Cechini trenta per cadauno con la riserua che li cechini
presentemente ualle lire uentidue luno, per ciò tengo in comissione
per altri due della stessa misura et l'istesso prezzo che deuo
farli, e tanto farò l'istesso Atestatto per li due altri susequenti,
e per segno di autentica uerità, e Giuramento di mia Mano
mi sotto schriuo

La sudt.ª riserua circa il prezzo uignifica che ne pretende
qualche cosa di più g. regalo

Io Antonio Canal
Venetiano

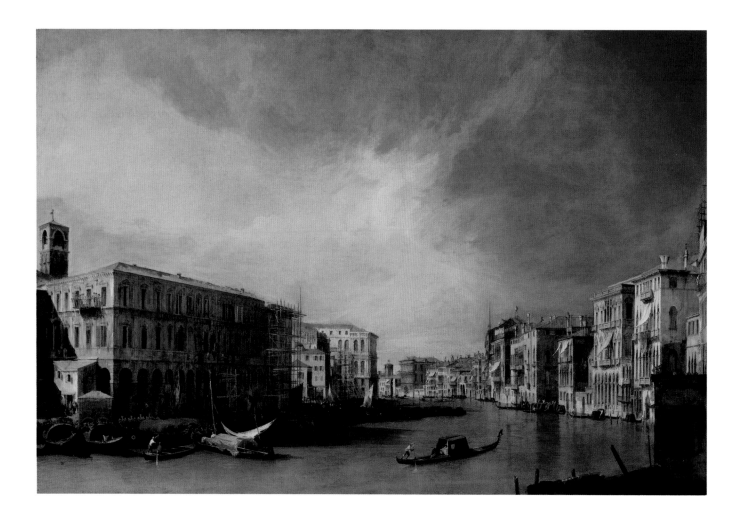

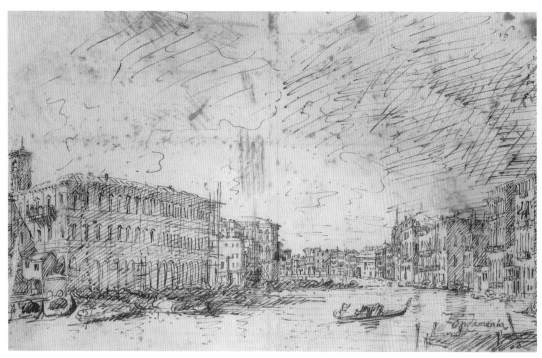

29
Grand Canal: looking North from near the Rialto Bridge
1725

Oil on canvas,
90 x 132 cm
(35½ x 52 in)
Private collection

Canaletto's own description of this picture and its companion, painted for Stefano Conti, is reproduced as Plate 28.

30
Grand Canal: looking North from near the Rialto Bridge
1725

Pen and brown ink,
17.7 x 30.1 cm
(7 x 11⅞ in)
Private collection

Almost certainly the preparatory drawing for Plate 29. Note the scaffolding, left of centre, which corresponds with the painting.

31
Detail of Plate 29.

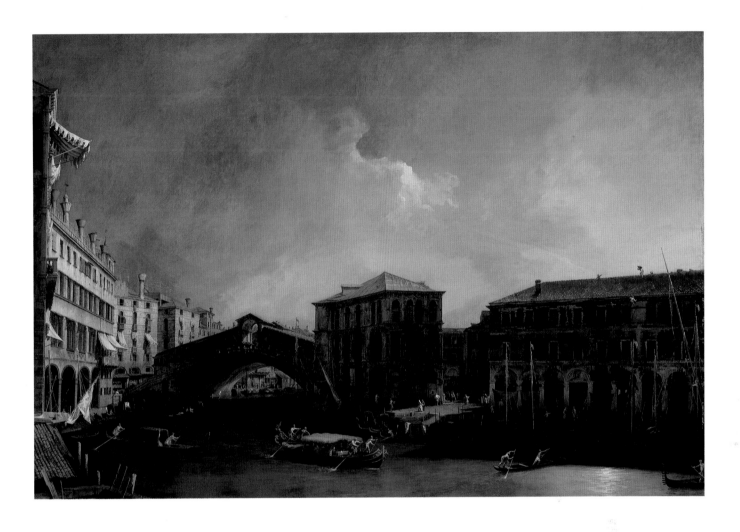

32
Detail of Plate 33.

33
Grand Canal: the Rialto Bridge from the North
1725

Oil on canvas,
91.5 x 134.5 cm
(36 x 53 in)
Private collection

Painted for Stefano Conti. This, and its companion (Plate 29), were the first of many versions of the subjects.

34
Grand Canal: the Rialto Bridge from the North
1725

Pen and brown ink,
14.1 x 20.2 cm
(5½ x 8 in)
Oxford, Ashmolean Museum

This must be a preparatory drawing for Plate 33. Note the word *Sole* where the sun strikes the water in the painting.

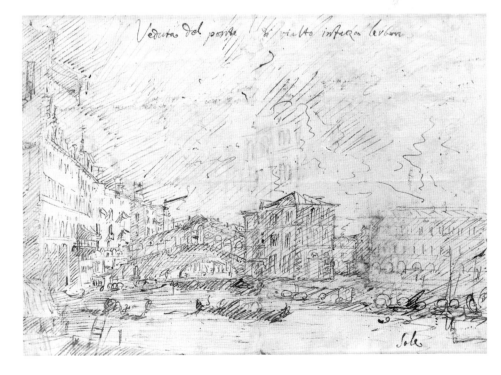

Canal, with the present Regina Hotel; sometimes he eliminated everything until the Zecca (the Mint, now part of the Marciana Library) was reached, so enabling him to show the Doge's Palace, the Prison and even the Danieli Hotel in great detail. In no case does the view conform with that seen by a spectator who does not move his eyes a great deal. In the Dresden picture the emphasis is on the dramatic lighting effect, not quite convincing in that the position of the sun is left in doubt, but wholly effective in the artist's prime object at this period – to produce a work of art based on a regrouping of some of the best-known buildings in Venice.

For the remaining pictures of the group Canaletto left the water in favour of the land. There was a Piazza S. Marco, unhappily now lost, but probably the earliest handling of the subject after the Liechtenstein version. There was the little

campo of S. Giacomo di Rialto, now entirely occupied by market stalls, a subject to be left alone for 20, perhaps 30 years. Finally there was *SS. Giovanni e Paolo and the Scuola di S. Marco* (Pl. 25). This subject will be considered with the paintings of Stefano Conti, who had a very similar version of it. There is however a tantalizing reference in a letter from Conti's agent in which he writes that Canaletto had exhibited 'his view of S. Gio. et Paolo' at the annual display of pictures outside the Scuola di S. Rocco, that it had 'made everyone marvel' and that the Imperial Ambassador had bought the picture. We know this exhibition well from Canaletto's masterpiece in the National Gallery, London, showing the annual visit of the Doge and his retinue to the church of S. Rocco (Pl. 26). The saint had saved the city in 1576 from one of its many plagues and the Doge had accordingly been commanded to attend Mass in

35
*SS. Giovanni e Paolo and the Scuola di
S. Marco*
1726

Oil on canvas,
91.5 x 136 cm
(36 x 53½ in)
Private collection

We are looking up the Rio dei
Mendicanti towards the
Fondamente Nuove, from which
Plate 22 was painted. On the right,
the statue of Bartolommeo
Colleoni.

his church on 16 August every year. After the service everyone visited the *scuola*, where an exhibition of the work of living and dead painters took place (Pl. 27). By Canaletto's time the exhibition had either overflowed into the *campo* itself or been transferred there in its entirety. Only one of the pictures in his great painting could be intended to represent a work of his own and this is certainly not *SS. Giovanni e Paolo*. Yet the story that he showed such a picture and that the Imperial Ambassador bought it must be believed. It is indeed tempting to assume that the Ambassador took the picture back to Vienna with him and that it ultimately found its way into the King of Saxony's collection, possibly via the Prince of Liechtenstein. But the history of the Dresden Canalettos prior to 1754 is extremely vague and there is nothing to confirm such an assumption. It must be confessed moreover that there is no topographical evidence, as there is in two of the Liechtenstein views, for dating them before, rather than immediately after, 1725; on balance the style seems to indicate a date before Conti's pictures.

Canaletto's paintings up to 1726, including those for Stefano Conti, have much in common. They were almost all large – one and a half to two metres wide, more than twice as wide as the average painting now associated with his name. They were painted on a dark ground, which modern analysis has shown to consist of several layers of red-brown or yellow-brown pigment ground with oil. Unlike many artists, Canaletto never wanted the weave of his canvas to show through his paint, but the dark ground is essentially of his early period; later in his career he covered it with a lighter paint layer. The pictures are freely, sometimes loosely, painted; the figures are small, particularly their heads, and, in spite of often being quite sketchy, they are full of life. Above all, the sense of the theatre is ever pervasive. Often he gives the impression of standing close to his subject in order to get a dramatic effect of perspective, although already there are cases where this is obtained by using more than one viewpoint; the criticism of 'exaggerated foreshortening' is invited, but there can be no doubt that this was a calculated distortion to heighten the dramatic effect. They were pictures painted in Venice rather than pictures of Venice; pictorial quality always took precedence over topographical accuracy (this can be said of almost any Canaletto, but later on he

was at pains to give an impression of topographical accuracy, however much he might rearrange things to suit his purpose).

All these characteristics are most conspicuous in the four pictures commissioned for Stefano Conti in 1725, the first of Canaletto's works for which there is any documentation at all. The correspondence between Conti and his agent, Alessandro Marchesini, an artist who had been born in Verona and was living in Venice at the time, leaves no doubt that there were already a considerable number of Canaletto views in existence by 1725. Apart from the comparison of Canaletto and Carlevaris, quoted earlier, Marchesini referred to Canaletto throughout as an established view painter highly regarded by those who already owned examples of his work. There was, as we know, the Imperial Ambassador, with his *SS. Giovanni e Paolo*. Conti's son, Giovanni Angelo, had himself seen a Canaletto view in the house of Zaccaria Sagredo, who was the most distinguished art patron in Venice; unfortunately Marchesini gave no title to this. Conti had no claim to the kind of connoisseurship of Zaccaria Sagredo and it was certainly his growing confidence of being in the best of company that led him to order a second pair of paintings before the two originally commissioned had even been begun.

Canaletto must have had plenty of work still in hand. The order for a pair of views was placed in the summer of 1725 after a certain amount of bargaining over the price, but work had not been started by September. By this time Conti had ordered the second pair, and Marchesini was having such difficulty in explaining the delay that he was driven to assuring Conti the pictures were in hand when he knew perfectly well that this was untrue. Even when Canaletto did start work he foresaw difficulties in finding the blue pigment he was accustomed to using. He also mentioned its expense and may well have been leading up to a demand for more money. There is evidence that Canaletto was never paid as much as he thought his pictures were worth in these early years, nevertheless he seems generally to have demanded more than his patrons expected to pay. Accordingly they were apt to describe him as grasping, and did so in writing. If Canaletto ever wrote a letter it has not survived, but there can be little doubt that he regarded them as mean. No significance need be attached to the normal bargaining between buyer and seller, particularly when, as in these cases, the buyer is acting for a

third party and wishes to appear to be serving his principal well.

The reference to blue pigment is of particular interest in the light of recent discoveries. When Canaletto's paint pigments were analysed it was found that he invariably used Prussian Blue. This was a synthetic colour discovered some years earlier, but no other artist is known to have been using it at the time. Canaletto even used Prussian Blue as a mix for his greens; he told Marchesini that his green was particularly long-lasting and so it has proved to be. At the time he was thought to be procrastinating, and it is agreeable that over 250 years later he should be proved to have been justified.

The first picture for Conti was to show the view up the Grand Canal, apparently from the Rialto Bridge (Pls 29 and 30). There is no single point from which Canaletto's view would in fact be obtainable, but from each viewpoint he showed the scene as it was. Thus, on the left, we see the Palazzo Corner della Regina shrouded in scaffolding, and records show that the Corner family did indeed demolish their palace on this site and start building a new one in 1724. In later versions of this subject Canaletto shows the building at a more advanced stage and, finally, complete. His home was but a stone's throw away but it is pleasant to think of him returning to the scene, as he must have done in the case of the *Campo S. Vio* and elsewhere, to check the changes that had occurred since he had last painted it.

For the companion picture Canaletto took up a position on the Grand Canal, turned and showed the Rialto Bridge itself (Pls 33 and 34). Stefano

Conti always demanded a description of his paintings from each artist, and we cannot do better than read Canaletto's own description of his picture (Pl. 28); there is no other occasion, except in the case of Conti's second pair, when we shall have an opportunity of doing so. The bridge was shown, he wrote, from the place which looks towards the Fonaco dei Tedeschi (the warehouse which had long been given over to the Germans by the Republic for trading purposes and which, when rebuilt after a fire, had had frescoes by Giorgione and Titian on its façade) and, on the other bank (the right-hand side of the picture), the building of the Camerlenghi Magistrates. From this place you looked down upon the Vegetable Market, where they landed all kinds of vegetables and fruits to be shared amongst the traders in the City. In the middle of the Canal, he continued, he had painted a nobleman's gondola with sails; this had figures painted in it and four gondoliers going at full speed. Close to it was a gondola with the livery of the Emperor's Ambassador.

For a moment one wonders why Conti should have wanted Grand Canal scenes as his first paintings from Canaletto instead of views of the celebrated buildings of the Piazza and Piazzetta such as the Doge's Palace, St Mark's or Sansovino's Library. It must be remembered that he already owned three paintings by Carlevaris, almost certainly of these subjects since Carlevaris painted little else. In fact Canaletto avoided Carlevaris's subjects until he had become even more firmly established as a view painter. He may have felt it advisable to strike out in an original field. Other patrons may, like Conti, have had

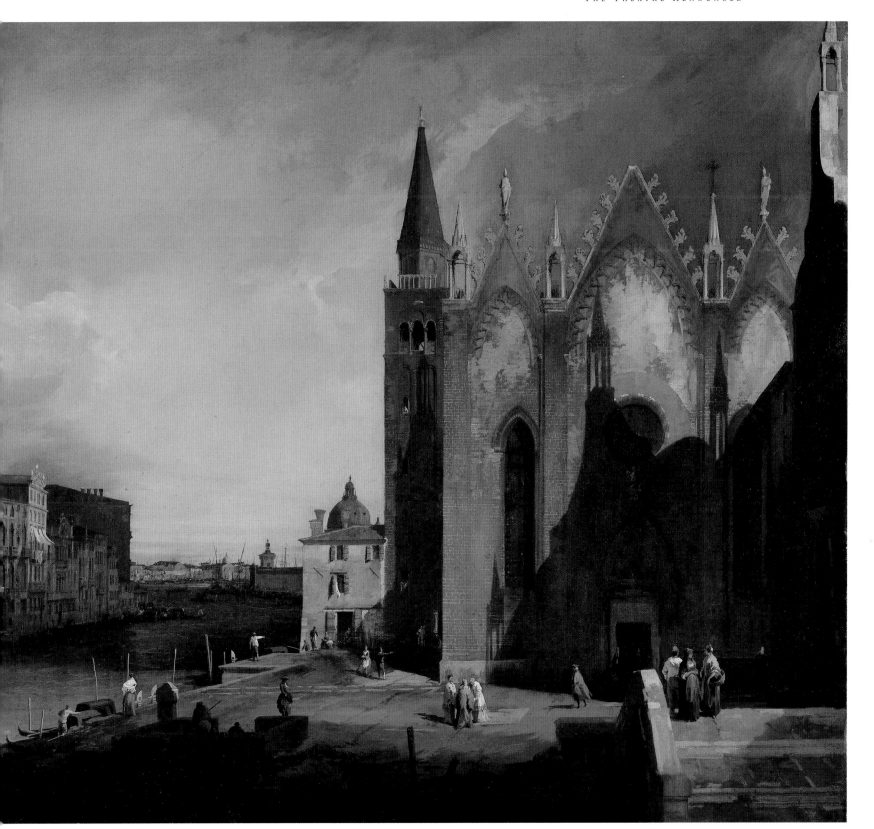

36
*Grand Canal: from S. Maria della
Carità to the Bacino*
1726

Oil on canvas,
90 x 132 cm
(35½ x 52½ in)
Private collection

The church now houses the gallery
of the Academy of Fine Arts. On
the left (with smoke rising) is the
viewpoint of '*The Stonemason's Yard*'.

37
Jean-Baptiste van Loo (1685-1745)
Portrait of Owen McSwiney
c. 1738

Oil on canvas,
112 x 84.5 cm
(44 x 33¼ in)
Private collection

Van Loo arrived in England in
1737, two years after McSwiney's
return from Italy, and is recorded
by Vertue (see page 160) as having
begun by painting McSwiney, a
'noted man about playhouses, etc.
in his white or grey hair'.

enough paintings of the great monuments of
Venice. Whatever the explanation may be,
Canaletto kept to the Grand Canal and one or
two *campi* as a rule until he began painting for
the English.

Marchesini reported another excuse for delay
in delivering the two Rialto Bridge paintings to
Conti. Canaletto, he wrote, did not paint from
imagination in the studio, as was Carlevaris's
practice, 'but this he always does on the spot and
paints everything from reality'. He repeated this
when Conti himself suggested a subject for one
of the second pair he had commissioned.
Whatever the proposal was, Marchesini assured
Conti that it was impracticable. 'He paints on
the spot,' he wrote again, 'instead of at home as
Carlevaris and, wishing to do this, a fixed spot
is required and a permanent one, of which there

is no possibility [there].' This cannot be taken
literally; painting out of doors was almost
unheard of at the time. One or two minor
French artists made oil sketches which have
survived, and Claude was said to have worked
from nature in Rome. There is no evidence
that Canaletto, or any other artist in Italy,
indulged in a practice that was, in the nineteenth
century, to become an article of faith among
artists. Nothing resembling an oil sketch by
Canaletto has survived, and Conti's finished
pictures bear every mark of having been
produced in the studio. Either Marchesini was
finding an excuse for Canaletto's dislike of his
patron's proposal or he was accounting for the
sense of reality to be found in his views. Canaletto
worked from on-the-spot drawings and by some
miracle the drawings for both the Rialto Bridge

paintings have survived (Pls 30 and 34).

The drawing for *The Rialto Bridge from the North* (Pl. 34) made its first appearance in the mid-nineteenth century when it was bequeathed to the Ashmolean Museum, Oxford, by a collector who evidently knew nothing of its history. It must have been given, or sold, by Canaletto to someone, for it has *Veduta del ponte del Rialto infaza lerberia* (View of the Rialto Bridge opposite the Vegetable Market) written across the top, a description he would hardly have needed himself. Of more importance, it has the word *Sole* written exactly where the sun strikes the water in the Conti paintings. It can be said with near certainty that this is the preparatory drawing for the Conti painting and no other version. In the case of the other drawing, which appeared in a London auction sale in 1984, also with no known history, near certainty becomes certainty for there is unmistakable scaffolding at the near side of the Palazzo Pesaro which was erected for the construction of the Palazzo Corner della Regina begun in 1724. This scaffolding appears in the Conti painting (Pl. 29) and in no later painting of the same view. In the righthand bottom corner Canaletto has written *Fondamenta* where one appears in the picture: contemporary maps show that it was then possible to walk a short distance on the north side of the bridge. No caption appears on this drawing so Canaletto probably kept it himself, at any rate for some time, and seems to have used the paper for some calculation in the top right-hand corner.

Conti's second pair, after all the discussion about the subjects, proved to be another Grand Canal picture and, in Canaletto's words, 'the Church of SS. Giovanni e Paolo with the campo and the equestrian statue of General Bartolommeo of Bergamo and various other figures, namely a Councillor in a red robe going into church, another of a Dominican friar and various other small figures' (Pl. 35). The statue, of course, is of the *condottiero*, Bartolommeo Colleoni, who on his death in 1475 bequeathed to the Republic much of the fortune it had paid him as a mercenary on condition they would erect a statue to him in the Piazza S. Marco. (This was unthinkable, so the Venetians took the money and put the statue outside the *Scuola* di S. Marco, telling themselves that this might have been what he really meant.) The *SS. Giovanni e Paolo* is the least successful of Conti's four paintings and leaves an impression that it may have been completed in a hurry. If, as seems probable, the

King of Saxony's (possibly the Imperial Ambassador's) version now in Dresden preceded it, there is no other explanation for the greater sensitivity and more perceptive painting of the earlier picture. It is instructive to compare the row of houses on the left of the Dresden *SS. Giovanni e Paolo* (Pl. 25) with the same row as seen in the opposite direction in the Liechtenstein *Rio dei Mendicanti* (Pl. 22); the wooden bridge, although not all the houses, appears in both paintings. Here is a splendid demonstration of the affection for decaying stucco and worn brickwork which occupied an abiding place in Canaletto's heart.

Conti's purchase was completed by the view of *The Grand Canal: from S. Maria della Carità* (Pl. 36). Like the other Grand Canal pictures, this was Canaletto's first version of a subject he was to repeat several times, although not on the scale of the *S. Vio* view, which he explored almost obsessively. Again Conti demanded, and got, the artist's description. The church, which is today part of the Academy of Fine Arts, was accorded its full name, the church of the Patri della Carità Rochetini, and its *campo* was raised to the degree of '*la sua Piazza*', a rare example of a Venetian applying the word to any square other than the Piazza S. Marco (all the others are *campi*). In it, Canaletto went on, he had disposed many small figures and he referred especially to the two priests, 'of the same order', who are discoursing with a learned man in a violet-coloured robe. The cupola which could (only just) be seen was the principal one of the church of the Salute, he concluded. '*Io Antonio Canal Pitor*' was the proud signature in contrast to the signature following the earlier description in which he was, perhaps with equal pride, '*Venetiano*'.

On the same day, 15 June 1726, Canaletto signed a receipt for ten sequins, which was an honorarium above the 80 sequins in the contract for the set of four. This had been promised as a compromise between the 80 sequins Marchesini told Conti he had agreed and the 100 sequins Canaletto had asked. There were artists no doubt willing to paint metre-high pictures for less than ten pounds sterling, roughly the equivalent of Canaletto's price for each, but one with the reputation he had earned by this time could scarcely be called avaricious for insisting on such a price. As his fame spread in the following years, his price seems to have remained much the same – but for a much smaller picture.

THE TWO MEN who now entered Canaletto's life were both from England, but had little else in common. Owen McSwiney (Pl. 37), who would also sign himself as Swiny or Swinny, with or without a 'Mc', seems to have been an engaging Irishman with a taste for art and theatre and a proneness to financial disaster. He had left England in 1711 after being made bankrupt and was now making a living in Italy as an agent for London impresarios and one or two art collectors. By far the most important of these was the young Earl of March, son of the first Duke of Richmond. The Duke, who had received his title at the age of three from his father, King Charles II, was an attractive but unstable character who in 1719 had married Lord March off to a 13-year-old heiress to settle a gambling debt and then sent him on a continental tour with his tutor, Tom Hill. McSwiney had become acquainted with the couple; he gained and kept Lord March's confidence both then and after he had succeeded to the dukedom on his father's death in 1723.

McSwiney's most ambitious scheme was for a series of allegorical paintings of tombs to commemorate the great men of recent English history, a 'strange and fanciful scheme' as it was described by a contemporary admirer of McSwiney's 'sound knowledge of good pictures, books and antiquities'. Three painters were to collaborate on each picture, and by 8 March 1726 McSwiney was able to tell the Duke of Richmond, as he now was, that 15 pictures had been started and six finished. One of these represented the tomb of Lord Somers (Pl. 39), Lord Chancellor of England, who had died in

1716, and another that of John Tillotson (Pl. 40), Archbishop of Canterbury until his death in 1694. In both these the 'perspective and landscape' were, he wrote, 'painted by Canaletto and Cimaroli' and the figures by Piazzetta and Pittoni respectively. Tillotson's tomb awaited only the figures and the Duke was sent regular news of its progress until February 1728, when it was at last dispatched with two others, much of the delay having been due to McSwiney's plan to have engravings ('Chiaro Scuros', as he called them) of all the paintings.

There is no further mention of the Somers painting, which was not identified with certainty until the 1950s; it was not engraved and may never have been included among the ten which were bought by the Duke and kept in his house at Goodwood, Sussex, until the end of the eighteenth century. If, as seems probable, Canaletto was responsible for the architecture and Cimaroli for the trees and foliage it is the more interesting of the two since it is an architectural capriccio of considerable imagination. In the Tillotson picture the emphasis is on the trees and mountains in the background. Both paintings are highly theatrical – but McSwiney, like Canaletto, was a man of the theatre and the project must have appealed to both. Too little is known of the dates of completion (or of Canaletto's part) to draw any firm conclusions, but it should not be forgotten that in March 1727, when the Somers painting was finished (and presumably only recently finished), Stefano Conti's commission had been completed for less than a year.

On 28 November 1727 McSwiney provided far more significant news of what Canaletto had been

38
Detail of Plate 62.

3 *Change of Course*

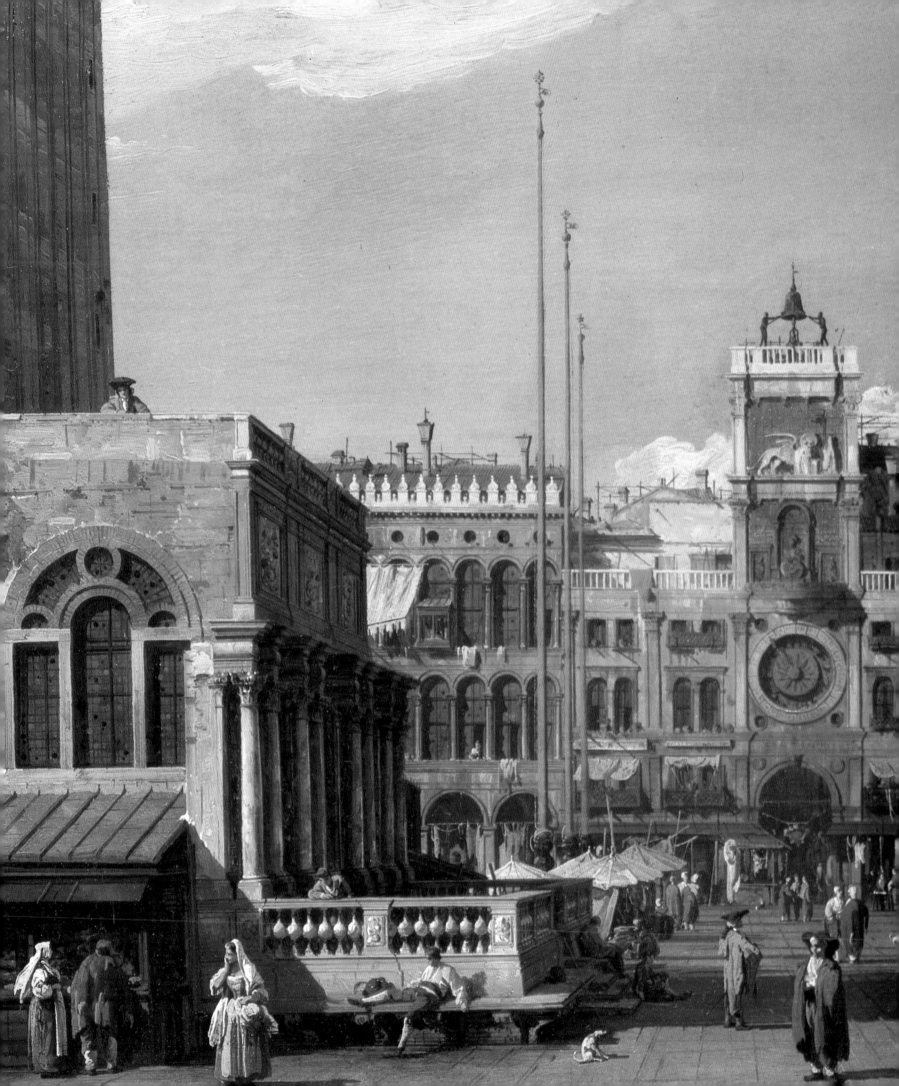

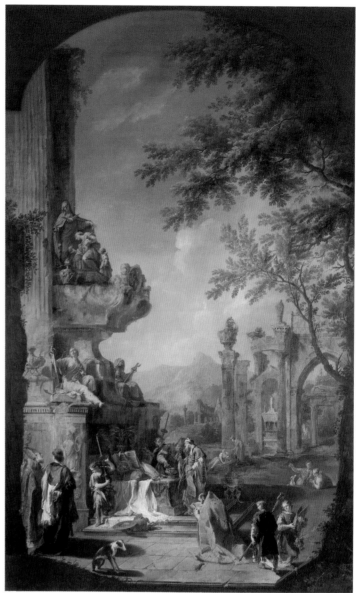

39
Canaletto, G.B. Cimaroli and
G.B. Piazzetta
*Capriccio: Tomb of Lord Somers, with
ruins and landscape*
1726

Oil on canvas,
218.5 x 142.2 cm
(86 x 56 in)
The Earl of Plymouth

One of 24 allegorical paintings
commissioned by Owen
McSwiney.

40
Canaletto, G.B. Cimaroli and
G.B. Pittoni.
Capriccio: Tomb of Archbishop Tillotson
1726
Oil on canvas,
218 x 138.5 cm
(85¾ x 54½ in)
Private collection

One of the ten allegorical paintings
bought by the Duke of Richmond
from the 24 commissioned by
McSwiney.

41
Detail of Plate 40.

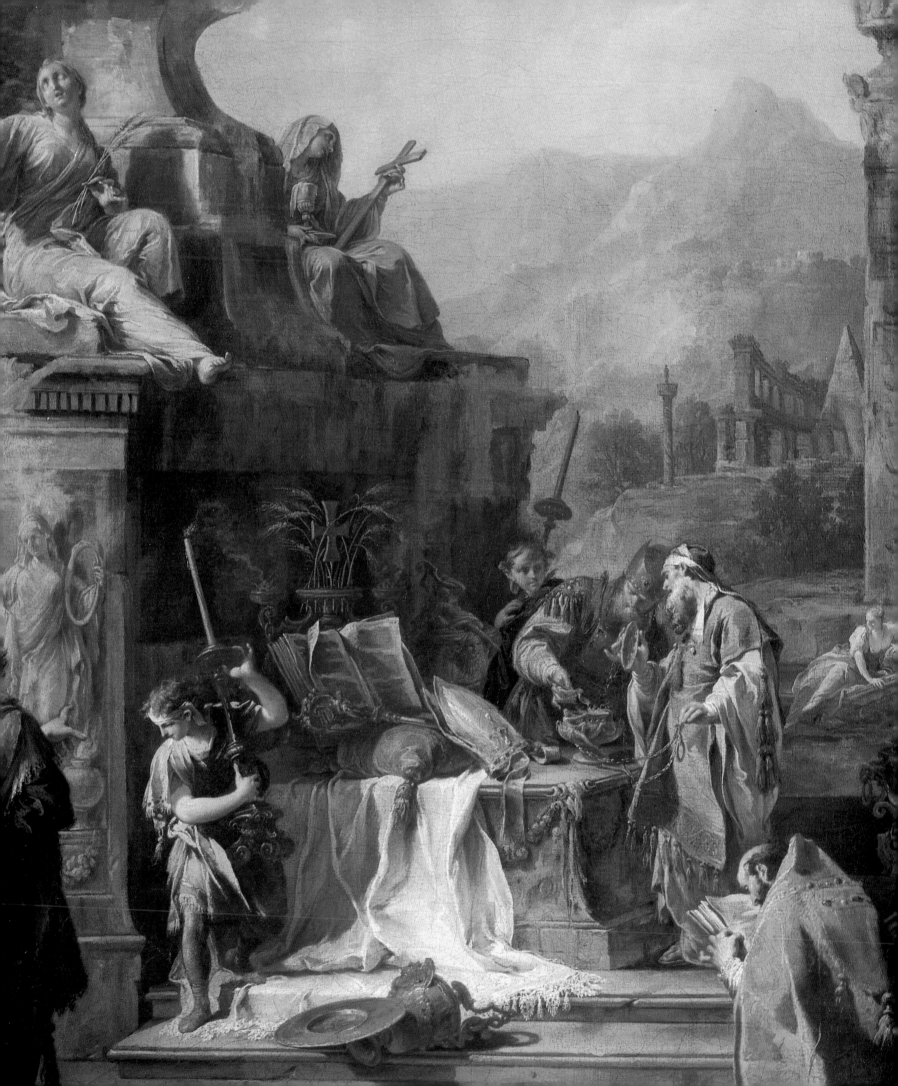

doing during that year. In a letter written on four quarto pages he begins with a reference to the Duke's complaint that four pictures had not been sent although they had 'been paid for above a Twelve-Month'. Detailed explanations follow together with plans for more tomb paintings, including one of King William III, who had died in 1702. 'And so much for this,' he concludes before turning to a reply to what seems to have been a question from the Duke about some pictures he had seen or heard of. He continues:

The pieces wch. Mr. Southwell has (of Canal's painting) were done for me, & they cost me *70: Sequeens.* The fellow is whimsical, and vary's his prices, every day: and he that has Mind to have any of his Work, must not seem to be too fond of it, for he'l be ye. worse treated for it, both in the price, & in the painting too.
He has more work than he can doe, in any reasonable time, and well; but by the assistance of a particular Friend, of his, I get once in Two Months a piece sketch'd out and in a little time afterwards finished, by force of Bribery.
I send yr Grace by *Captn Robinson* (Comandr. of The Tokeley Gally) who sails from hence tomorrow, *Two of the finest pieces*, I think, he ever painted, and of the same size with Mr. Southwells little ones (which is a size he excells in) and are done upon copper plates: They cost me *Two and Twenty Sequeens*, each. They'l be delivered to yr. Grace by Mr. John Smith, as soon as they arrive in London.

McSwiney goes on to write about a picture by Rosalba Carriera, whose pastel portraits were at this time enjoying immense fame throughout Europe (to be tragically ended by Rosalba's blindness in later life). He promises to find a fine gold frame for it which, with the picture, will cost 24 or 25 sequins. Then he returns to Canaletto:

I shall have a View of the Rialto Bridge, done by Canal, in Twenty days, and I have bespoke another view of Venice, for by the by, his Excellence lyes in painting things, as fall, imediately, under his eye.
The four pieces of Canal come to *88 Sequeens*: & the Rosalba &c. to 24. wch. comes to abt. Fifty Six Guineas sterlg. & if yr. Grace will permit me to charge four Guineas, for The Freight, and Expences in packing 'em up & sending 'em on board wth. ye. Customs &c and some former Expences of the same nature, the same will amount to Sixty Guineas wch. Ill draw for at Twice as yr. Grace desires.
I draw for Thirty Guineas, this night, and in six weeks or Two Months' time I'll draw for the remaining Thirty. Mr. Smith says that The Hanover Galley was taken by a Spanish Man o War [3], and carried into the Groyne: in all probability the ship and Goods will be restored, if we are to have peace wth. Spain; if not, they will be declared prize. A lettr. from The Secretary of State, or from one of The Spanish Ministers (at The Hage or [?]) will, certainly, procure their delivery to yr. Graces order. They were directed to yr. Grace in London.
For God's sake see that the Bill of Two & Twenty pounds or thereabouts laid out (for postage of lettrs. & pacqts. of Musick &c) ... be pd. to Mr. John Smith.

McSwiney ends, as might be expected, with news of the latest opera and signs himself, on this occasion, 'Owen Swiny' (as well as his capricious spelling of his surname he was apt to call himself 'Eugenio' when the fancy took him).

So for some time Canaletto had been working for McSwiney on a very different kind of picture

from any of those we have been considering. Two weeks after his November letter McSwiney was able to tell the Duke that 'the two copper plates done by *Canal* are very fine' and that they had been forwarded to London – thence, no doubt, to Goodwood House, where they are still hanging (Pl. 42). Nor were they by any means the first of those small, sunny view paintings to which McSwiney had diverted Canaletto from the large, sometimes sombre, and always dramatic pictures he had been painting – was perhaps still painting. The pair done for 'Mr Southwell' (Edward Southwell was in Italy in 1723; his son, also Edward, was there in 1726) had had time to reach England and be seen, or at any rate heard of by the Duke. A regular delivery 'once in two months' had been established. There can be little doubt that Canaletto's course was changing, or had already changed, and it may well have been McSwiney who had first conceived the idea of commissioning small paintings for the English from him.

In January 1728 McSwiney was able to write that 'Canaletto has, just, finished the piece of the Rialto Bridge and as soon as it's companion is done, I'll forward 'em to you'. At the end of July he had to admit: 'I wait for yᵉ companion [to a copper plate] which Canaletto is now, about, for you: as soon as I get it, out of his hands, I'll forward 'em all to you' [another Rosalba was to be included, hence the 'all']. A year and a half later, on 1 October 1729, he acknowledged that he had received payment for the second pair 'several months ago' but could say no more than that 'Canaletto promises me to let me have 'em on my

return from Rome, which will be about the middle of January'. That is the last surviving letter to the Duke referring to Canaletto but it was not McSwiney's last word on the subject, as will appear later.

Two phrases from McSwiney's November 1727 letter have been so frequently quoted that they have become part of a Canaletto legend – the artist's whimsicality and the field in which his 'excellence' lay. The first need not be taken very seriously. McSwiney may have been telling the truth when he claimed to have paid 35 sequins for Mr Southwell's copper plates or he may have been persuading the Duke that at 22 sequins he was getting a bargain. Either way, Canaletto was in demand and naturally justified in charging as much as he could get – no more than Rosalba was getting for a pastel portrait. As to the difficulty of extracting a picture from the busy artist, McSwiney was echoing the words of Marchesini, words that were soon to be heard again in connection with Canaletto (and which agents traditionally use to their principals both in and outside the world of art). The statement that Canaletto's excellence lay in painting things as they fall immediately under his eye tells us in fact more about McSwiney than about Canaletto. Certainly nothing could be farther from the truth in relation to anything Canaletto had been painting for the past six years or so. McSwiney was more likely to be claiming to have discovered a secret that no one else had penetrated, one that he was ready to exploit for the benefit of those who wanted to have on their walls the nearest they could get to a piece of Venice itself. Canaletto was

43
Piazza S. Marco: looking West
c. 1726

Pen and ink,
18.1 x 23.2 cm
(7⅛ x 9⅛ in)
The Royal Collection

Perhaps the original design for Plate 44, which was considerably altered before the painting was finished, particularly by the addition of the Campanile and Loggetta.

44
Piazza S. Marco: looking West
c. 1726

Oil on canvas,
133.5 x 170 cm
(52½ x 67 in)
The Royal Collection

One of Joseph Smith's six great Piazza paintings, his first commission to Canaletto. The church of S. Geminiano at the west end of the Piazza was demolished in 1810.

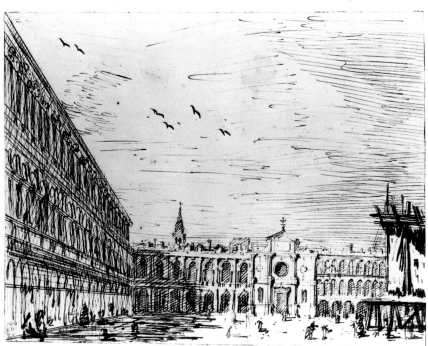

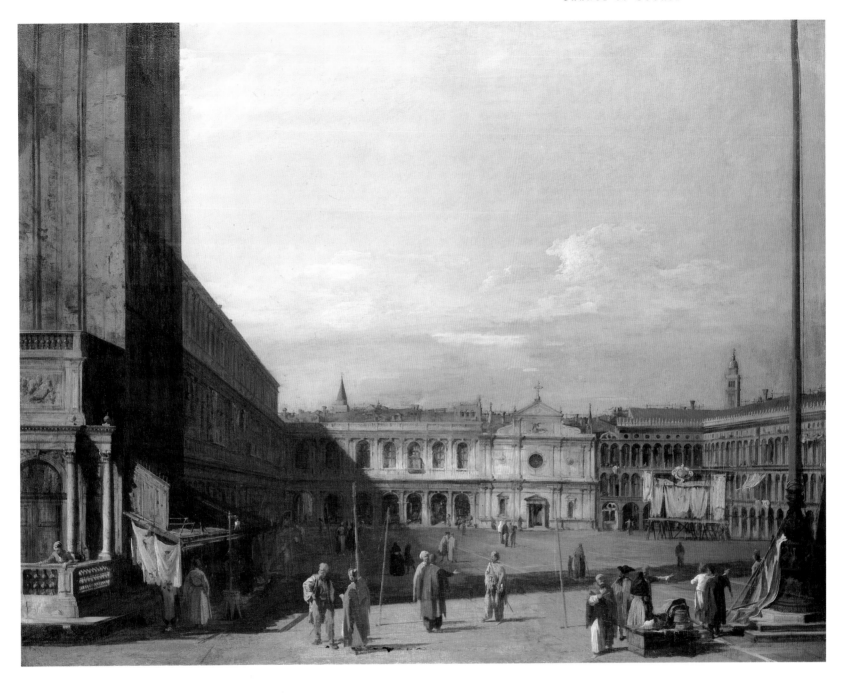

45
Piazza S. Marco: looking East
c. 1727

Pen and ink,
18 x 23.4 cm
(7 x 9¼ in)
The Royal Collection

Drawing related to Plate 46, in
which Canaletto has painted out
one of the domes of St Mark's,
which is shown in this drawing.

46
Piazza S. Marco: looking East
c. 1727

Oil on canvas,
133.3 x 170.7 cm
(52½ x 67¼ in)
The Royal Collection

Probably Canaletto's first return to
this classic subject since Plate 23.
There is a particularly beautiful
passage on the right, where the sun
strikes the Doge's Palace.

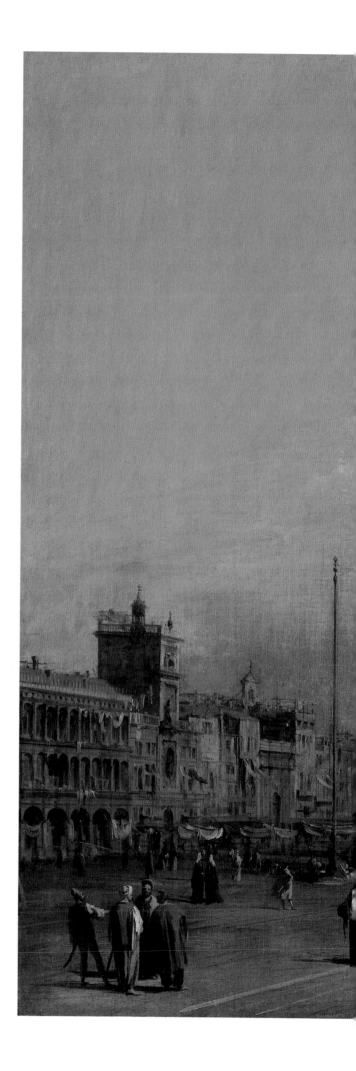

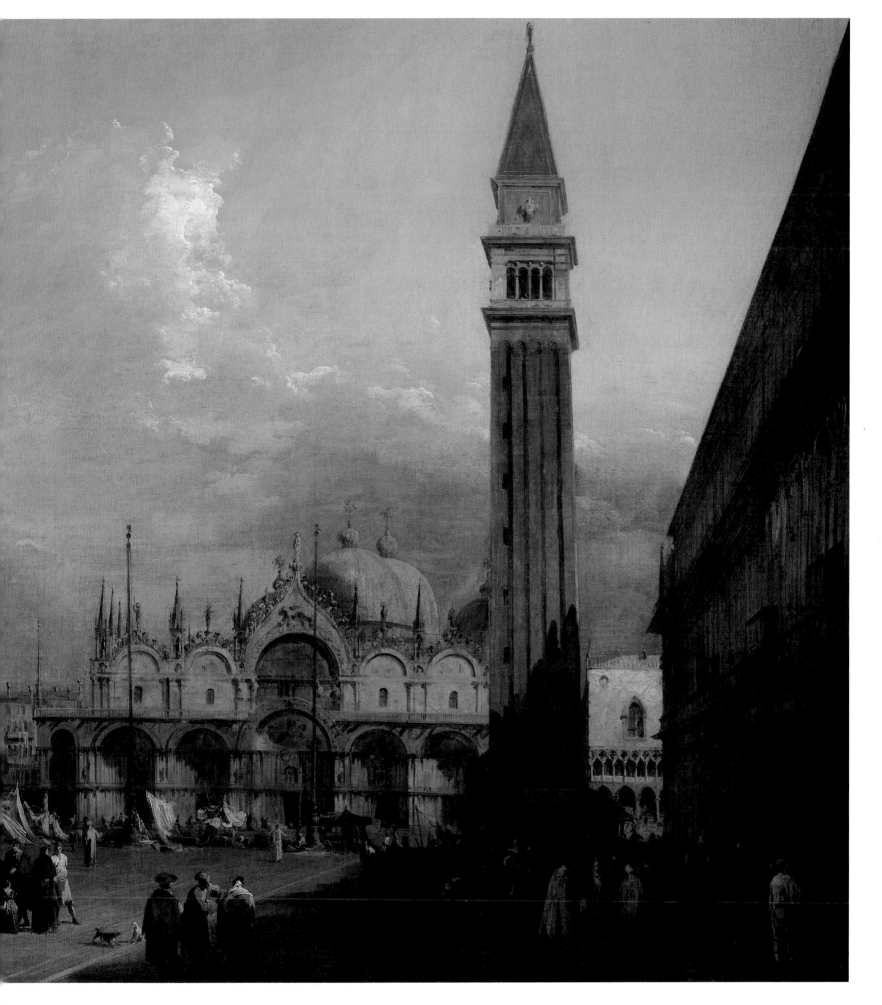

47
Entrance to the Grand Canal: from the Piazzetta
c. 1727

Pen and ink,
23.3 x 18.2 cm
(9⅛ x 7⅛ in)
The Royal Collection

The column of St Mark on the left
was replaced by a sail in the
painting (Plate 48) and the
Column of St Theodore placed in
front of the Library instead.

48
Entrance to the Grand Canal: from the Piazzetta
c. 1727

Oil on canvas,
170 x 133.5 cm
(67 x 52½ in)
The Royal Collection

The Dogana (customs house) and
church of the Salute are in the
background; in the right
foreground is a corner of
Sansovino's Library and the
Column of St Theodore.

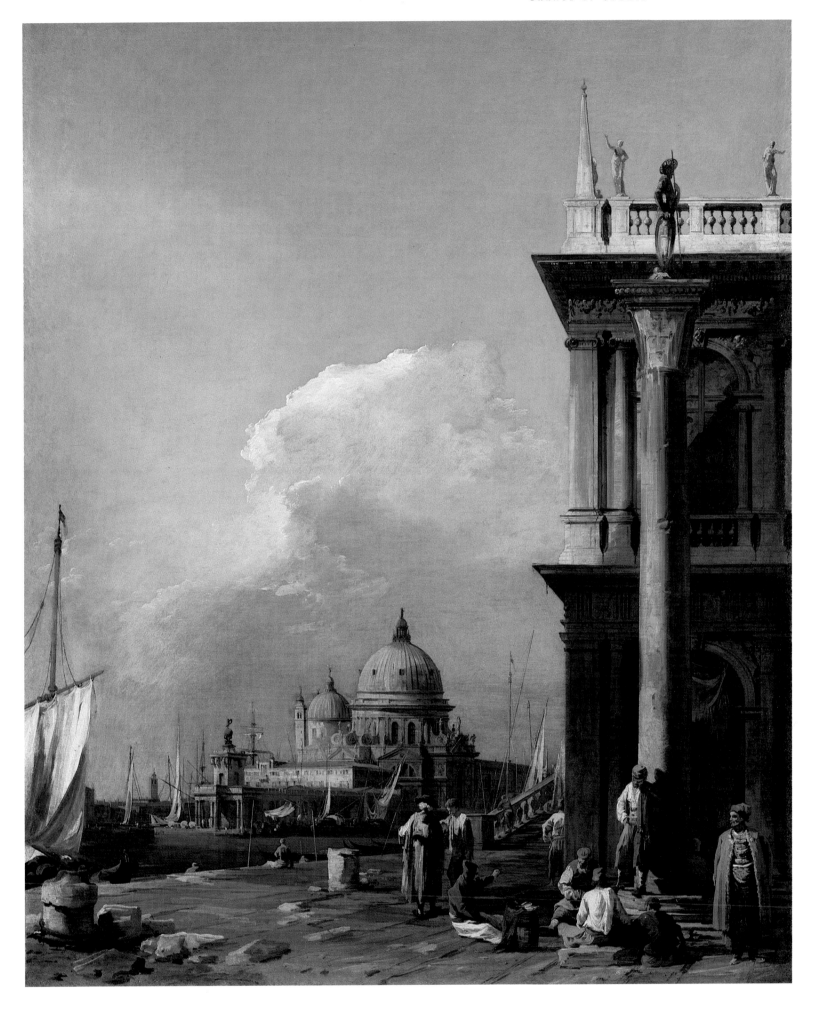

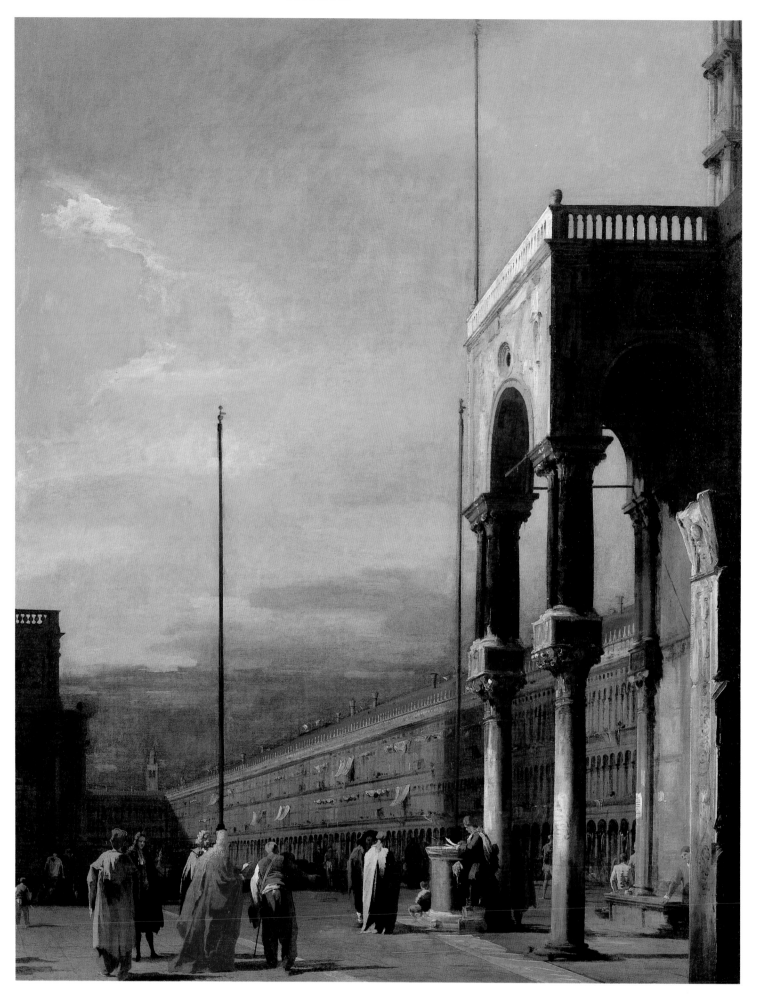

49
Piazza S. Marco: looking West from the North End of the Piazzetta
c. 1727

Oil on canvas,
170 x 129.3 cm
(67 x 51 in)
The Royal Collection

At the base of the southwest column of St Mark's is the Pietra del Bando, a porphyry column-base from which proclamations were read.

50
Piazza S. Marco: looking West from the North End of the Piazzetta
c. 1727

Pen and ink,
23.4 x 18 cm
(9⅛ x 7 in)
The Royal Collection

A broad pen has been used and the pen-strokes run together for the shadows.

ready to supply the market, but he had his own ways of deluding McSwiney and the English into believing that they were seeing what fell immediately under their eye in Venice.

'By the assistance of a particular Friend of his...' McSwiney had written in connection with the difficulty of getting a picture out of Canaletto. There can be no doubt as to the identity of the particular friend. Mr John Smith of London, to whom the Duke's pictures were consigned, had an elder brother in Venice, Joseph Smith. McSwiney had known him since before 1722, when he was already writing to the Duke that his own knowledge of accounts was due to his having lived in Smith's house in Venice.

Joseph Smith, by far the most important influence on Canaletto's life, was a very different man from McSwiney. McSwiney was always in

debt (even, when he died, to Smith) whereas Smith was successful in business from his early days in Venice until some 60 years later. McSwiney made friends easily (he was an Irishman) whereas hardly anyone had a good word for Smith. He was pompous, snobbish and self-seeking. Yet there is no reason to doubt his honesty and he remained loyal to Canaletto at a time when the artist was in dire need of a loyal friend. As for taste, no one knows what sort of collection McSwiney would have built up had he ever been able to buy anything for himself; he was certainly no philistine. Smith, on the other hand, was in a position to buy more or less whatever took his fancy and he was an obsessive collector. As well as paintings he collected prints, drawings, coins, gems, but perhaps above all, books. Horace Walpole said that he knew nothing of his books except their title-pages, but this was manifest

51
The Piazzetta: looking North
c. 1727

Oil on canvas,
170.2 x 129.5 cm
(67 x 51 in)
The Royal Collection

The red-robed figure is a
Procurator. In the background is
the Torre dell'Orologio
(Clocktower), which in fact faces
towards the right of the picture.
The three flagpoles are also in a
fanciful position.

52
The Piazzetta: looking South
c. 1727

Oil on canvas,
170.2 x 132 cm
(67 x 52 in)
The Royal Collection

The straight-sided steeple of the
campanile of S. Giorgio Maggiore,
in the background, was demolished
in 1726-8 and replaced by one of an
onion shape. This gives a clue to
the date of the six paintings.

nonsense. Smith loved books and was so closely connected with the publishing firm of G.B. Pasquali that he is generally thought to have owned it, together with a bookshop in the Campo S. Bartolomeo which became a meeting-place of scholars. The greater part of Smith's collection was sold to George III in 1762, and the books later became the foundation for the King's Library in the British Museum. His picture collection is one of the few private collections to have remained intact and can therefore be judged in terms of present-day taste. He was scarcely a discriminating collector of Old Masters ('I don't think the pictures are worth much,' wrote Lord Northampton when he heard about the sale: neither he nor Smith knew there was a Vermeer among them). Against this, he did almost as much for Zuccarelli as for Canaletto; he had several capriccios by Carlevaris, 15 pieces by Rosalba and

work by both Sebastiano and Marco Ricci. He could well claim to have been an enlightened patron of his contemporaries, and it is remarkable that he should have ignored Tiepolo – as all contemporary Englishmen did.

It is inconceivable that a collector such as Smith should have known Canaletto in 1727, and have helped McSwiney get work out of him, without himself buying his pictures. Possibly it was Smith and not McSwiney who first diverted the artist to small, topographical views such as McSwiney was buying at the time. More probably, though, the work that Canaletto was involved in for Smith consisted of six magnificent paintings of the Piazza and Piazzetta, far closer to Stefano Conti's group, and Canaletto may well have been producing these at about the same time as he was experimenting with McSwiney's 'copper plates'. Some of them may have been painted before

53
The Molo: looking West
1730

Oil on canvas,
58.5 x 102 cm
(23 x 40 in)
Tatton Park, Cheshire,
The National Trust

On the right the Library with the Zecca (Mint) and Granary beyond. Painted for Samuel Hill and the earliest recorded sale by Smith.

54
Detail of Plate 53.

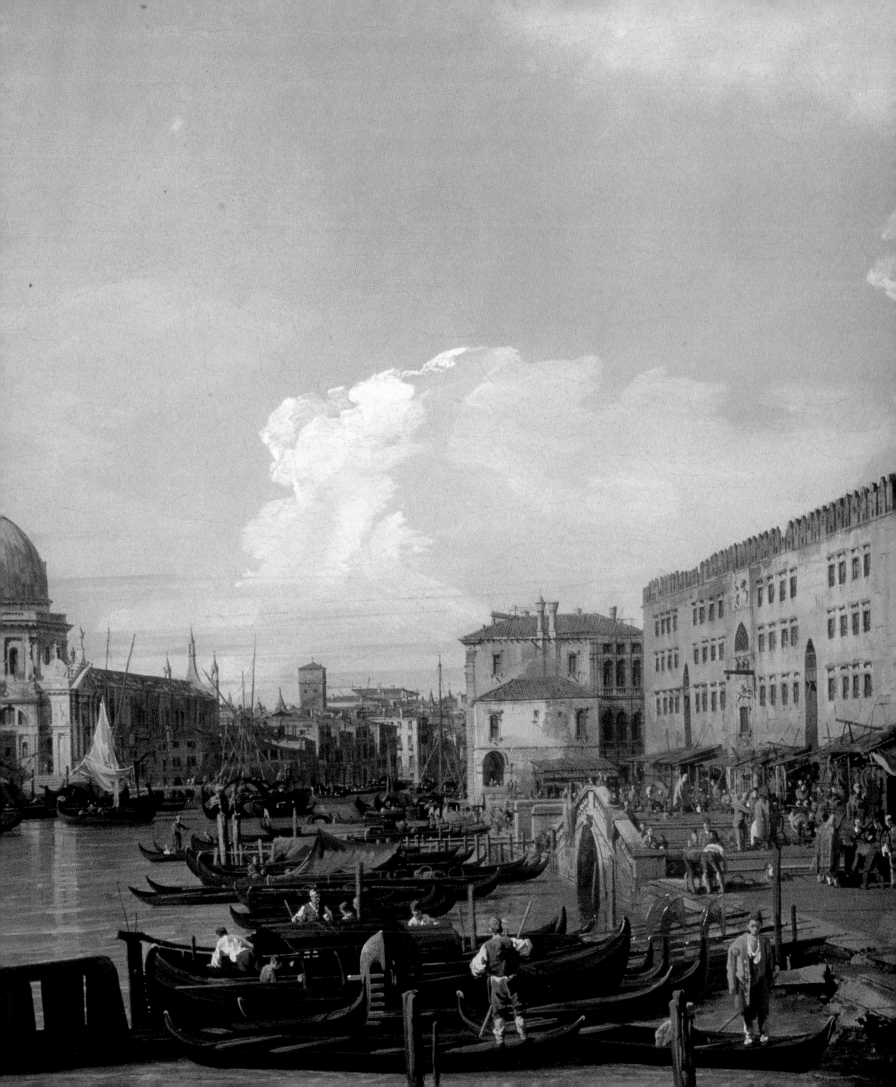

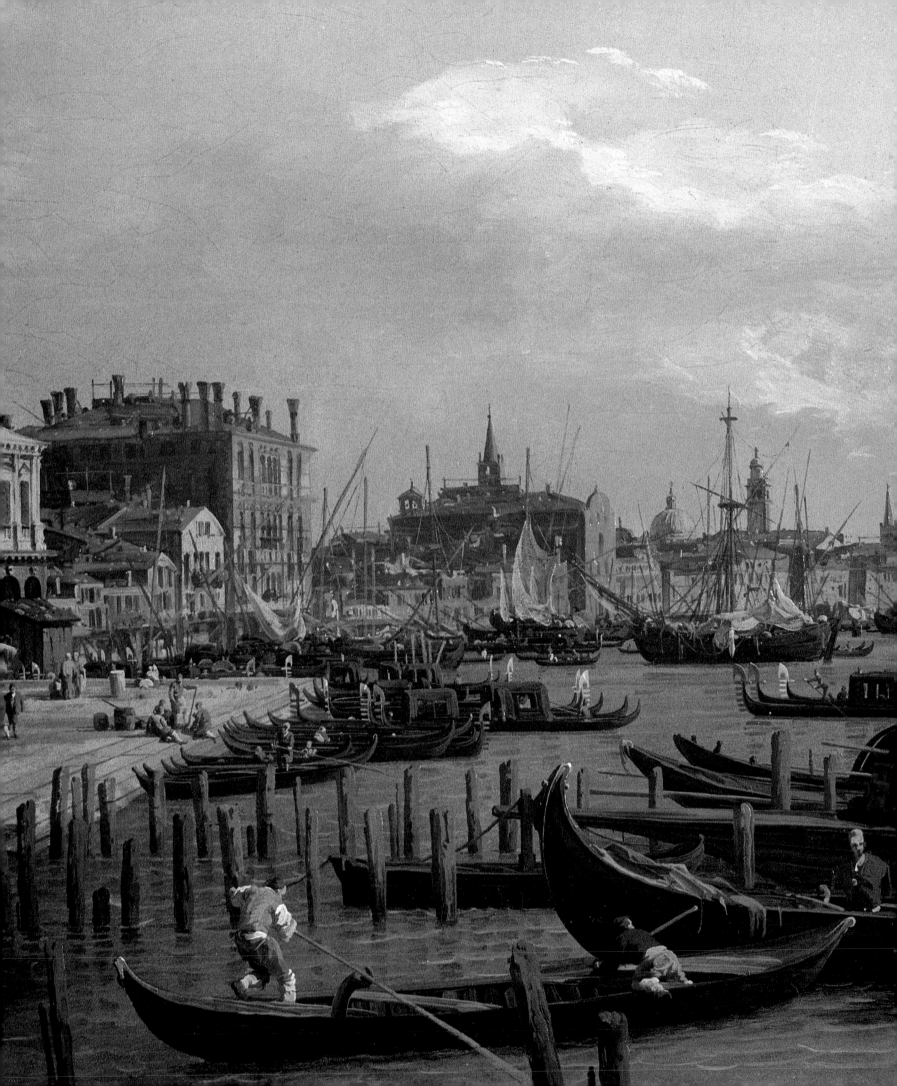

55
Detail of Plate 56.

56
Riva degli Schiavoni: looking East
1730

Oil on canvas,
58.5 x 102 cm
(23 x 40 in)
Tatton Park, Cheshire,
The National Trust

In the foreground the Molo and
Doge's Palace; the Prison and
Palazzo Dandolo (now the Danieli
Hotel) are on the Riva beyond.

Conti's commission was begun, or have been part of the cause of the delay in completing it. Some may have been still unfinished when McSwiney wrote of his particular friend prising a picture out of Canaletto every two months or so. Perhaps Smith had already hatched a plan to take over McSwiney's idea of exporting saleable Canalettos. All that is certain is that Smith acquired six of the finest paintings that marked the close of the artist's early style and that he kept them in his own collection for almost 40 years.

For each of the paintings, Canaletto made a drawing for Smith. These drawings were not preliminary sketches made on the spot, such as the sketches for Conti's Rialto Bridge paintings. They were made, or at any rate completed, in the studio, possibly to show Smith the kind of picture that was proposed, possibly a working-out of the composition for the artist himself. The differences

between drawing and painting, where they occur, are always illuminating.

Two of the paintings are horizontal, almost two metres (173 centimetres) wide; one shows the Piazza towards St Mark's, the other, in the opposite direction towards S. Geminiano, the little church demolished when Napoleon rebuilt the west end of the Piazza. In the S. Geminiano picture (Pl. 44) the left side is dominated by the lower part of the Campanile and part of the little Loggetta (through which we enter the Campanile if we want to take the lift to the top). On the right is one of the flagpoles and in the far corner of the Piazza is one of the stages which were put up for a few performances and then dismantled. In the foreground are large figures, freely painted but beautifully modelled, which immediately catch the eye.

Canaletto's first intentions, as revealed by recent restorations, were quite different, much closer to

the drawing. As in the drawing (Pl. 43), there was neither Campanile nor Loggetta, both of which have been painted over the end of the Procuratie Nuove (Scamozzi's end, built in 1586 and continued by Longhena in 1640, now the Correr Museum). The figures were originally much smaller, but have been painted out and replaced by the present figures. These were changes made after this part of the painting had been finished. If the rest of the drawing shows the original intention, as it does in the case of the left side, there were other changes: the flagpole is an addition and the stage has been moved farther into the background. S. Geminiano itself is lower and wider than in the drawing, which was closer to its appearance in earlier pictures by Carlevaris and others and even to later paintings by Canaletto. From the care he took with this part of his painting, and the small changes made, it seems to have been one of his favourite passages and the departures from reality were deliberate. Finally, a small but odd change: birds in the sky have been painted out. Canaletto seems to have renounced birds in his paintings from now on as solemnly as he had renounced the theatre, although his drawings continued to be full of them.

The view in the opposite direction, towards St Mark's (Pl. 46), provides the most classic of all Venetian subjects, yet this, so far as is known, was Canaletto's first return to it since the Liechtenstein painting (and the lost one from the Dresden group). He now took up a viewpoint more to the right and lower than previously. As before, he has had to make the Campanile smaller than it should be in order to include it all (Carlevaris could not

accept this solution and preferred to cut off the top). He has had trouble with the subsidiary domes of St Mark's and has painted out one of them which appears in the drawing (Pl. 45), correctly, and was at first in the painting. He does not show the new paving of the Piazza (nor does he in the S. Geminiano view), for this seems to be a detail he does not want to dwell on; it is certainly not shown in its old form, as in the earlier view. On the whole the picture corresponds with the scene from a window of the present Correr Museum entrance and there is no change of viewpoint, as there is in the case of the S. Geminiano painting.

The four remaining pictures are of much the same size, but upright. It has been plausibly suggested that the whole set might have been designed to hang in predestined positions, as a decorative ensemble; in three cases the emphasis is on the right side of the picture and in the others on the left. There are fewer *pentimenti* (covering up of passages) in the upright series, which suggests that they may have come later, when Canaletto was painting with greater assurance. This suggestion must not be pressed too strongly, though; there are more departures from fact in the upright group than in the horizontal, not all of them explicable by changes of viewpoint. In the view towards the Salute from the Piazzetta (Pl. 48), for example, the Ponte della Pescaria has been brought forward many paces: it would scarcely be seen at all from the purported viewpoint.

But what is the purported viewpoint? Canaletto's original intention was to place the column which carries the lion of St Mark on the

57
Riva degli Schiavoni: looking East
March 1729 (dated)

Pen and bistre,
21 x 31.5 cm
(8¼ x 12⅜ in)
Darmstadt, Kupferstichkabinett

The Column of St Mark is in front of the west face of the Doge's Palace (unusually) as in Plate 56 but rises above it. Drawn from just above the water.

extreme left of the picture, as it is in his drawing (Pl. 47). There could be no reason for this except to provide some sort of balance with another picture intended to hang alongside: the column and the Library could never be seen in these positions at the same time. This strange intention was even carried out, but the column must have looked so incongruous (as it does in the drawing) that it was decided to cover it over and paint in a mast and sail on the left instead. St Theodore's column was then put in front of the Library façade, but was made to seem lower than the Library whereas it is in fact as high, and naturally looks higher to anyone standing on the ground. The group of figures round the base of the column and those standing on the left of them are as finely painted and conceived as anything of Canaletto's, before or after. They did not come easily, though, as the alterations make clear.

Each picture shows similar rearrangements of the Venetian monuments. In *The Piazzetta: looking North* (Pl. 51) the three flagpoles have been put where the artist wanted them, not where they are. The Torre dell'Orologio (the Clocktower) faces the spectator directly, whereas to see it in that position he would have to stand beside the Doge's Palace, not where he appears to be standing in the painting; in fact it is only by moving to the Doge's Palace that he can see the Clocktower in its entirety and not masked by the Loggetta.

The view of the Piazza from the corner of St Mark's (Pl. 49) is the least satisfactory of the six pictures: some of the figures and the whole of the north side of the Piazza are quite perfunctorily painted. As we can see from the drawing (Pl. 50),

it was intended to include part of the Campanile on the left, but this does not appear in the painting. The far end of the Piazza has an effective shadow cast across it – but to see it at all the spectator would have to take up a quite different position.

Finally, there is *The Piazzetta: looking South* (Pl. 52). Like the others this has its inconsistencies (there should be one window of the Doge's Palace showing, not two, and there are at least three viewpoints). But here there is a topographical feature of some interest: the straight-sided steeple on the campanile of the island of S. Giorgio Maggiore in the background, which appears in both painting and drawing, was demolished between 1726 and 1728 and an onion-shaped steeple was then built in its place (the present straight-sided steeple was built in 1774). Here then is some confirmation of a date before 1728 for these superb and important paintings – but confirmation is hardly needed. It can be (and has been) argued that Canaletto may have shown the old steeple of S. Giorgio Maggiore in a painting even after it had been demolished and this of course is true; topographical evidence of this kind is seldom reliable. On the other hand, as has been said earlier, the pictures may have been begun well before 1728. The earlier the group can be dated the more plausibly they fit into the known facts and the more easily the changes and hesitations on Canaletto's part can be understood.

When Horace Walpole saw these six pictures hanging in the hall of Buckingham House, the London home of George III, in about 1780, he

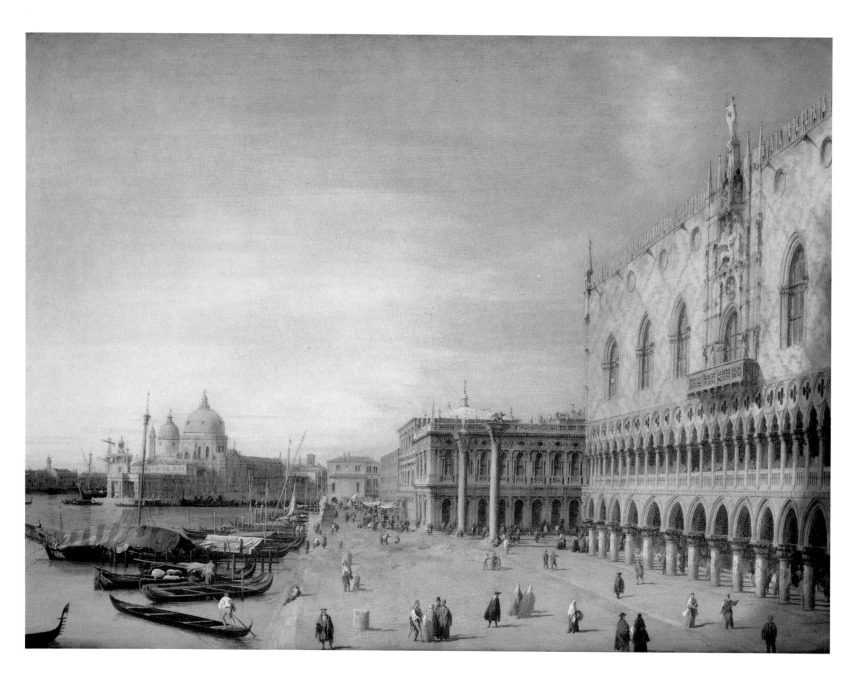

58
The Molo: looking West
c. 1727

Oil on copper,
43 x 58.5 cm
(17 x 23 in)
Private collection

Companion to Plate 59. The
purported high viewpoint would
be unattainable in practice.

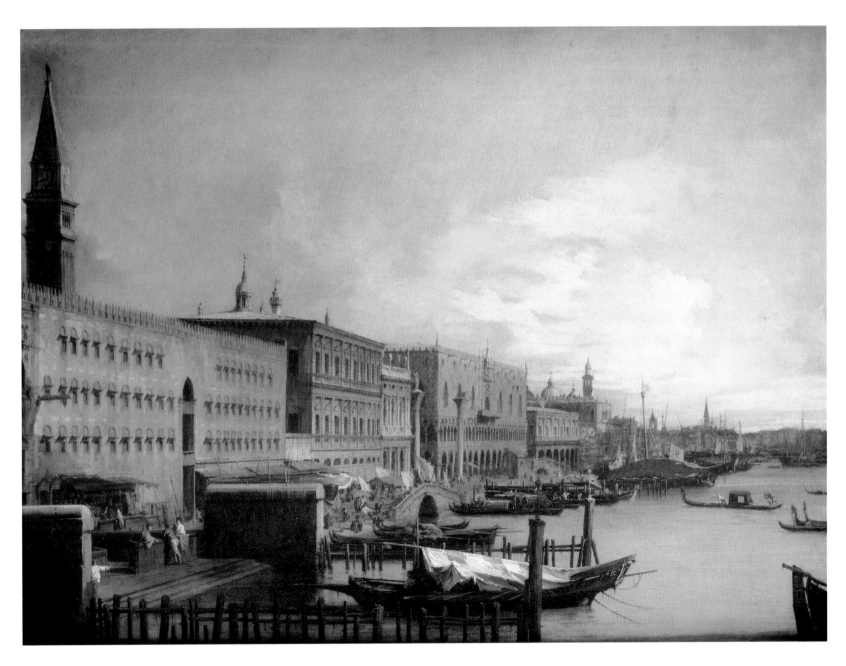

59
The Molo and Riva degli Schiavoni:
looking East
c. 1727

Oil on copper,
43 x 58.5 cm
(17 x 23 in)
Private collection

An unusual view from the Granary
with a small harbour in the
foreground. One of a pair
belonging to Sir William Morice,
in Canaletto's *buon gusto* according
to McSwiney.

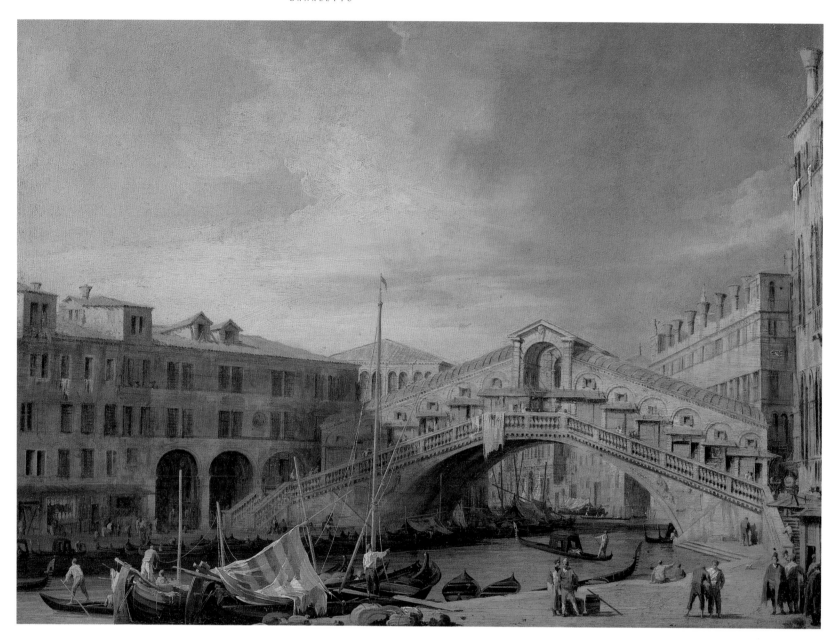

described them as 'bolder, Stronger & far superior to [Canaletto's] common Works & either done before he engaged to Mr Smith, or particularly for him'. The common works were, of course, the kind of view which McSwiney had already proved was to the taste of the English collector, particularly the Englishman who had included Venice in his Grand Tour and been enchanted by its beauty. We cannot be any more sure than Walpole as to how far Smith's plan to take over from McSwiney had progressed when the six Piazza pictures were finished but he was now ready to launch Canaletto on his new career. Smith was better equipped than McSwiney in that he already had an organization able to handle the packing and shipping of goods of all kinds. He had a wider range of contacts with the English, most of whom used his services for other purchases (true, he lacked the Duke of Richmond, who was

McSwiney's preserve, but in the event Smith's buyers proved more profitable to Canaletto). Above all, perhaps, he had more patience than McSwiney, more experience in buying and selling and, with his palace on the Grand Canal and his country house at Mogliano, altogether more weight (bottom, as it would have been called a little later in the century).

Smith's first surviving mention of Canaletto came in a letter of 17 July 1730 to Samuel Hill of Staffordshire, whose nephew, Samuel Egerton, had been apprenticed to Smith for the past year. Smith had been shipping various works of art to Hill and paying for them on his behalf. Now he was able to write:

At least Ive got Canal under articles to finish your 2 peices within a twelvemonth; he's so much follow'd and all are so ready to pay him his own price for his work (and which he

60
Grand Canal: the Rialto Bridge from the South
c. 1727

Oil on copper,
45.5 x 62.5 cm
(18 x 24½ in)
Holkham Hall, Norfolk, Viscount
Coke (descendant of the Earl of
Leicester, the original purchaser)

Beyond the Bridge on the right is
the Fondaco dei Tedeschi (the
German warehouse).

valuues himself as much as anybody) that he would be thought in this to have much obliged me, nor is it the first time I have been glad to submitt to a painter's impertinence to serve myself and friends, for besides that resentment is lost upon them, a rupture with such as are excellent in their profession resolves 'em either not to work for you at all, or which is worse, one gets from them only slight and labour'd productions, and so our taste and generosity is censured – tho' both unjustly.

The grudging tolerance of an artist's need to live shows the less likeable side of Smith's character – or perhaps of the image of himself he wished to create in the eyes of his client, Samuel Hill. So does the following paragraph of his letter in which he boasts of spending more than £500 on the house at Mogliano, part of it an allowance from his landlord. But, he adds, there is a motive in the case: he has a mortgage on the house which his landlord will never be able to redeem. (He was still there over 30 years later, so his judgement was shrewd.) He ends with a promise of two books which will be sent to Hill and a sentence which has caused much discussion since it first came to light: 'The prints of the views and pictures of Venice will now soon be finish'd. I've told you there is only a limited number to be drawn off, so if you want any for friends, speak in time.'

This can only refer to the set of engravings which Smith had commissioned Antonio Visentini to engrave after 14 Canaletto paintings. In the event they were not published until 1735 and then in the form of an album bearing the title *Prospectus/Magni Canalis Venetiarum./addito Certamine Nautico et Nundidi Venetis*. The last line, 'A Nautical Contest and Venetian Market added',

refers to *A Regatta on the Grand Canal* (Pl. 69) and *The Bucintoro at the Molo on Ascension Day* (Pl. 70) (a market on the Piazzetta being part of the celebrations and a feature of the picture). These were much larger paintings than the 12 of the Grand Canal and cannot have been completed before 1732 (one of them shows the arms of a Doge who did not reign until that year). However, they were, as the title-page suggests, probably afterthoughts – as may well have been the idea of making the set into an album instead of selling the prints separately. Smith may have exaggerated the state of the project when implying to Hill that all the Grand Canal paintings and most of the engravings from them were finished, but he could hardly have made the statement unless some of the paintings were ready, if not most of them.

The claim that he, and only he, could get work out of Canaletto for his clients need not be taken any more seriously than earlier claims by Marchesini and McSwiney; as middlemen all were naturally inclined to put a high value on their services. Nevertheless, this is the third reference in six years to Canaletto's success and leaves no doubt that his work was in fact in great demand.

Hill's pictures were ready by December – at least, his nephew wrote to say that they would be ready within 15 days and they were certainly delivered at some time, for they are now hanging in the house which Samuel Egerton later inherited from his uncle. They show the views in both directions from a point in the Lagoon just off the end of the Piazzetta (Pls 53 and 56), the first of a series of similar subjects which were, not surprisingly, to become very popular. Copper as a

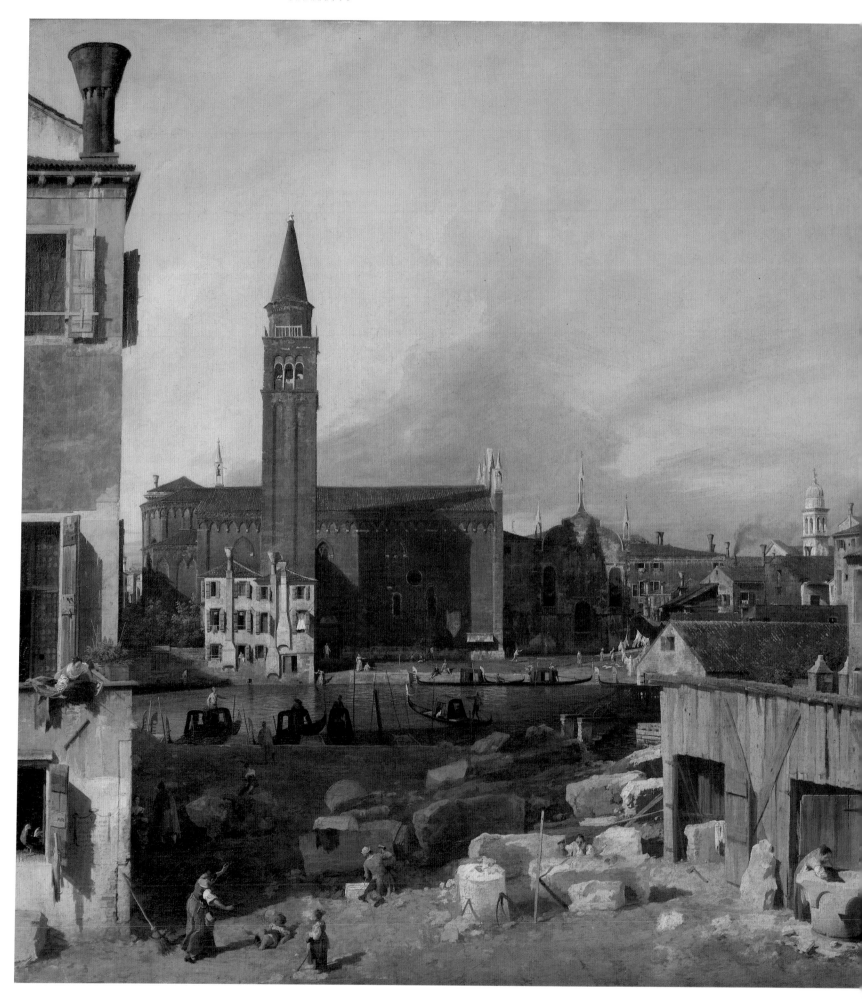

61
Grand Canal: 'The Stonemason's Yard';
S. Maria della Carità from the Campo
S. Vidal
c. 1728

Oil on canvas,
124 x 163 cm
(48¾ x 64⅛ in)
London, National Gallery

Compare the view of the Carità in
Plate 36. The Accademia Bridge
now rises from near the house on
the left.

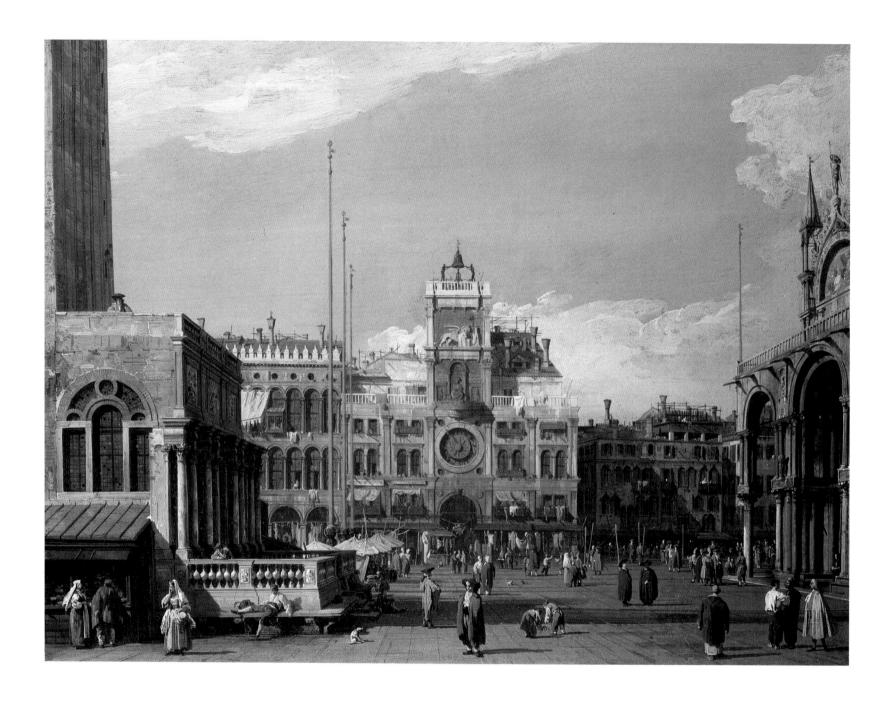

support had now been abandoned and these, like all subsequent paintings, were on canvas. They were just over a metre wide, larger than the copper plates, but very much smaller than Smith's own great Piazza paintings. The paint is thicker and the handling less free. The figures are smaller, full of vitality, the architecture painted in greater detail, and the sunlight streams down over the kind of scene that stay sin the mind of every visitor to Venice. Now, too, for the first time since the sketches for Conti's *Rialto Bridge* (Pls 30 and 34), there appear a handful of drawings, quite unlike those in Smith's collection in that they bear every mark of having been made in preparation for a painting or for a finished drawing. Such a sketch bearing the date 1729 (Pl. 57) may well have been used for Hill's painting of the view to the east and may have been made from the end of the pontoon used for gondolas to embark or disembark their passengers.

Two months after Smith's letter to Hill, McSwiney makes a momentary reappearance. He is writing from Milan to John Conduitt, the Master of the Mint in London, in reply to a letter forwarded 'by my friend Mr Smith'. After discussing a proposed monument to Sir Isaac Newton (Conduitt's uncle by marriage) he continues:

> I'm glad you have given yᵉ commission to Mr Smith for yʳ pictures of Canaletto, & I hope you'l like 'em when they are done; I am, it may be, a little too delicate in my choice, for of Twenty pieces I see of him, I don't like eighteen & I have seen several, sent to London yᵗ I wou'd not give house room too, nor Two pistols [less than two pounds sterling] each. He's a covetous, greedy fellow & because he's in reputation people are glad to get anything at his own price. Tis above three years yᵗ he has Two copper plates on his hands, for yᵉ D. of Richmond & I thought it wrong to sett him at work on new work till he had delivered wᵗ he has been obliged to do so long since.
> The Two cooper plates of the D. of Richmᵈ Two of Mr Southwell & Two of Sir Wᵐ Morice are in his buon gusto – nay compare these with any other you know & you'l soon discern yᵉ difference.

So the Duke had still not had his second pair, although one of the pictures was said to have been finished two and a half years earlier, in January 1728. Sir William Morice's copper plates can be identified with certainty, an unusual view of the Riva degli Schiavoni and the Molo from the water opposite the Granary (Pl. 59) and one in the opposite direction, apparently from the air above the Molo (Pl. 58). There is a strong possibility that

Mr Southwell's pair ended with the Duke of Devonshire and that they are still at Chatsworth, again the Molo in opposite directions and not unlike Samuel Hill's pair. We have already discussed the Duke of Richmond's pair, of and from the Rialto Bridge (Pl. 42), and there remains only his second pair, probably never delivered to him but ending with the Earl of Leicester instead. This proved to be a view of the Rialto Bridge (as promised) but from the south side (Pl. 60) and yet another view from the Campo S. Vio, the third or fourth.

They are all fine pictures, some with brilliant passages among the figure groups. But McSwiney's suggestion that each pair was the only survivor out of 20 pictures, the remaining 18 not worth house room, was an expression of mood rather than of judgement. He must have been in a state of great pique towards Canaletto to have allowed himself so wild a mis-statement, perhaps even towards himself for letting the artist slip through his hands and into those of Smith.

For there can be little doubt that it was during these very years from 1726 to 1730 that Canaletto's understanding of the true potentiality of the Venetian scene as a subject for his art was most actively developing. It was then that the fluid strokes of his brush seemed to fall without effort into shapes and colours that grew on his canvases into plaster and marble and brick, into water and sky, all enlivened by the moving shadows and reflections of the Venetian light as it strikes the water and is thrown back on to the land. Everything that the visitor saw half consciously must have been recalled to his mind; the peeling inscriptions and the posters on the walls, the multifarious uses of old sailcloth, the unique skyline formed by the chimney pots, the shrines and bollards and booths that give each corner its own character. It was in these years that Canaletto's sense of design enabled him to place each figure where it would play its own part in the making of his picture, the aloof Senator, the kneeling child, the man urinating against the wall of the Rialto Bridge, the argumentative Turk, the bored stall-keeper, each happening to be clothed in the colour that was needed in the area he occupied. The buildings stand firmly despite the decrepitude of centuries and the spectator knows there are interiors behind the windows, just as he knows how the street or canal continues by the flash of reflected sunshine which is all he can see.

'*The Stonemason's Yard*' (Pl. 61) is often thought of as the culmination of Canaletto's ability to fuse

62
The Clocktower in the Piazza S. Marco
c. 1730

Oil on canvas,
52.7 x 70.5 cm
(20¾ x 27¾ in)
Kansas City, Mo., Nelson-Atkins Museum

On the left, the Loggetta at the foot of the Campanile; in the background the Torre dell'Orologio (Clocktower).

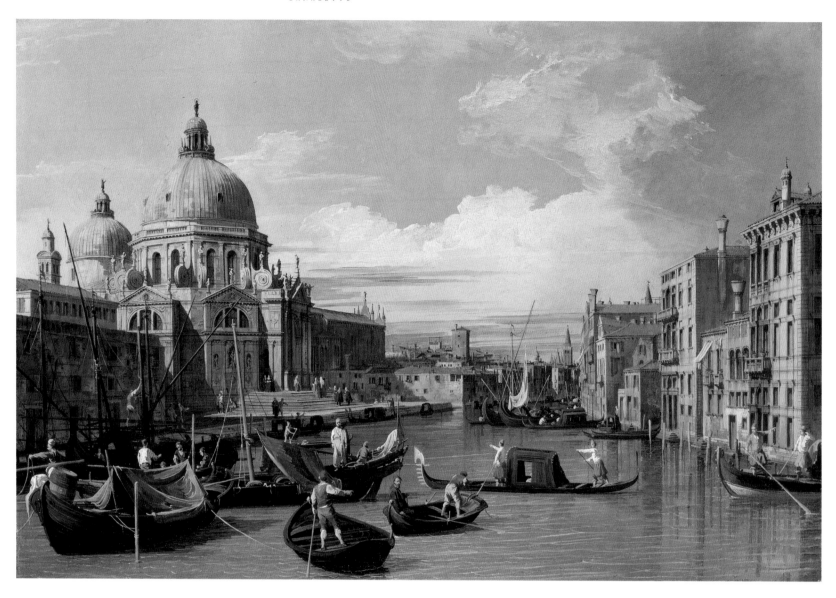

the poetic vision of his early years with his intimate observation of the heart of Venice. He certainly never gave a stronger impression than in this marvellous picture that he was painting for himself and no one else, not even another Venetian. But there are many pictures he painted for the stranger to Venice in which the same hand and the same heart are unmistakably present. The owners of such pictures may have wanted nothing more than a straightforward topographical record and may often have thought that that was what they were receiving. After all, they were not able to compare their pictures with a photograph and so were spared the surprise of so many later admirers of Canaletto's subtle manipulation of the facts to achieve greater reality.

Where are these pictures of the 1726 to 1730 period that McSwiney so intemperately rejected? Since two in 20 can be traced, it should be easy

enough to find most of the other 18. In fact it is not at all easy and the likelihood seems to be, despite McSwiney, that no great number of paintings was leaving Canaletto's studio during these years. They were years of experimenting rather than of following a well-tried recipe and there must have been failures as well as successes. In the successes the paint flows freshly in a way that make them readily identifiable as of the period; the qualities are perhaps summed up in *The Clocktower in the Piazza S. Marco* (Pl. 62). The failures, it must be concluded, merge into that amorphous body of works that seem to bear some of the marks of Canaletto's hand but still cannot be accepted without misgivings.

The one witness who could throw light on these years is Smith, but he remains silent to posterity until his letter of July 1730 to Samuel Hill. By then, as the letter makes clear, he had long

63
Entrance to the Grand Canal: looking West
1730

Oil on canvas,
49.5 x 72.5 cm
(19½ x 28½ in)
Houston, Texas, Museum of Fine Arts

Bought by Hugh Howard, who kept a copy of the receipt from Smith for £18 7s. 11d. for the picture and its companion Plate 64; they cost 35 Venetian sequins.

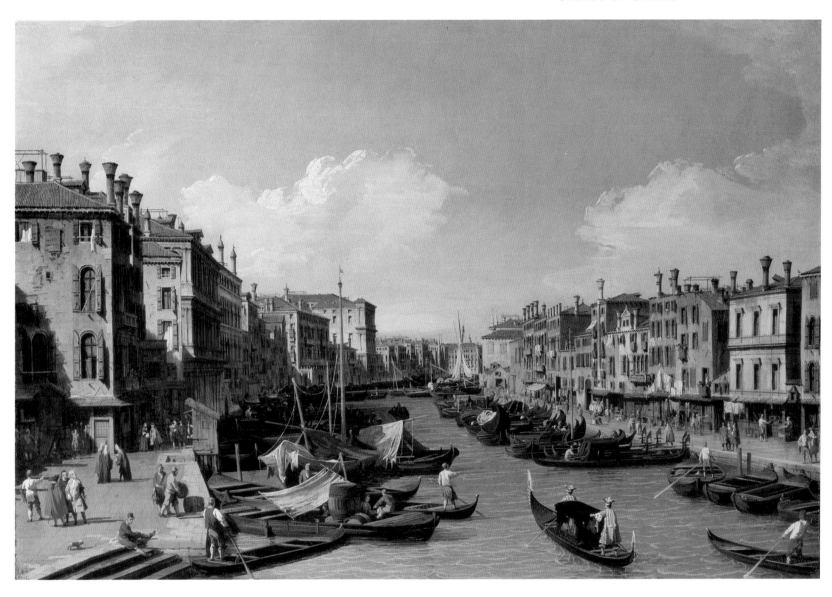

64
*Grand Canal: looking South-West from
the Rialto Bridge to the Palazzo Foscari*
1730

Oil on canvas,
49.5 x 72.5 cm
(19½ x 28½ in)
Houston, Texas, Museum of Fine
Arts

With its companion (Plate 63) and
Plates 53 and 56, this is the only
picture in which Smith's agency
can be proved.

been dealing with Canaletto and confirmation appears in a document preserved in the Howard family archive. It is a copy of a bill dated 22 August 1730 headed: 'Recd two pictures of Canaletto from Venice' and records that £18 7s 11d was 'Pd Mr Smith Mercht 35 Venn. Zecni'. Freight, customs charges and frames (£1 14s) bring the total to £23 0s 11d. Two pictures which remained with the buyer's descendants, the Earls of Wicklow, for 200 years must assuredly be those referred to; one shows *The Entrance to the Grand Canal: looking West* (Pl. 63) and the other the view *From the Rialto Bridge to the Palazzo Foscari* (Pl. 64). Both subjects had been painted before and their cramped appearance is difficult to account for. Perhaps the sizes had been specified to fit a pair of panels which were in fact too narrow to take the subjects comfortably.

From the Rialto Bridge is of particular interest

because it is with his subject that Canaletto's tour of the Grand Canal begins, the 12 paintings of which prints, Hill had been assured, would soon be finished. The project was not perhaps as advanced as Smith wished Hill to believe in 1730, but it was certainly well in hand. Between the *Prospectus* version of *From the Rialto Bridge* (Pl. 66) and the version which had been delivered to Howard in 1730 (Pl. 64) there had been time for the house in the right foreground to have lost its façade with pointed (perhaps rounded) windows and receive an apparent refurbishment with straight-topped windows and modern sunblinds. There had also been time for Canaletto's new course to be charted by Smith, a course on which he was by 1730 in full sail.

'PRESENTLY WE SAILED into the city and went along the Grand Canal as far as the Rialto, where on each side of us we saw buildings of wonderful height and beauty.' So wrote Felix Fabri in 1483, and a few years later, in 1494, his words were echoed by Philip de Comines, French Ambassador to Venice: 'We went through the principal street, which they call the Grand Canal. It is the fairest and best built street, I think, in the world and goes quite through the city, which is the most triumphant city that I have ever seen.'

The Grand Canal was not always the visitor's first sight of Venice. Those who left the mainland at Fusina would arrive at that great constellation of buildings which greeted them as they disembarked at the Piazzetta. After this, anything would be an anticlimax except only the Grand Canal with its astonishing medley of buildings. Some were already 600 years old by Canaletto's time. Many others had been built in the great years of Venetian expansion, when the merchant patricians vied with one another to give the Gothic sculptors and craftsmen the opportunity to express their faith in God and Venice. Some were still being built – the Labia (Pl. 6) and Corner della Regina (Pl. 29) palaces – or were not long finished; among them were the most lavish and impressive of all, despite the fact that the Republic had long passed its moment of power and influence in Europe. One thing all these palaces had in common: they rose directly out of the water of the Grand Canal and, unless they had the water of a minor canal beside them, they formed with their neighbours on either side their own part of an unbroken line in this fairest and best built street.

No visitor whose eyes had been dazzled by this unique experience could fail to want a memento to carry home with him or at least to know that a picture he had commissioned would soon follow. Nor would the desire be less on the part of those unfortunates who could not afford £10 or £20 for an oil painting by Canaletto. For them – the young nobleman's bear-leader perhaps, or even his valet – an engraving would have to suffice. Joseph Smith's services were soon available to meet the demands of all.

If Smith's Grand Canal series was begun in 1726, and if it began with the view *From the Rialto Bridge to the Palazzo Foscari* (Pl. 66), the first engraving in *Prospectus* (neither is certain, but both seem probable), then Canaletto had quickly mastered this aspect of his new style. We are looking down towards the great bend which the Canal makes at the Palazzo Foscari – *la volta del canal* to Venetians. On the left the sun falls on the northern walls of the palaces, contrasting the light reflected by the stucco, brick and marble surfaces. The rigging and the lowered sails of the barges and the variety of craft moving on or moored beside the Canal are painted with a Venetian's understanding of nautical matters. On the right, receding from the foreground house, which has not yet received the facelift shown in the Howard-Wicklow version (Pl. 64), is the long row of shops now replaced by cafés and restaurants. Each has a projecting roof to shelter the passers-by. Each roof projects at a different angle, is of a different size and seems almost to be made of a different material. Is this one of the pictures McSwiney derided as not being in Canaletto's *buon gusto*? It is

65
Detail of Plate 70.

4 *An English Merchant*

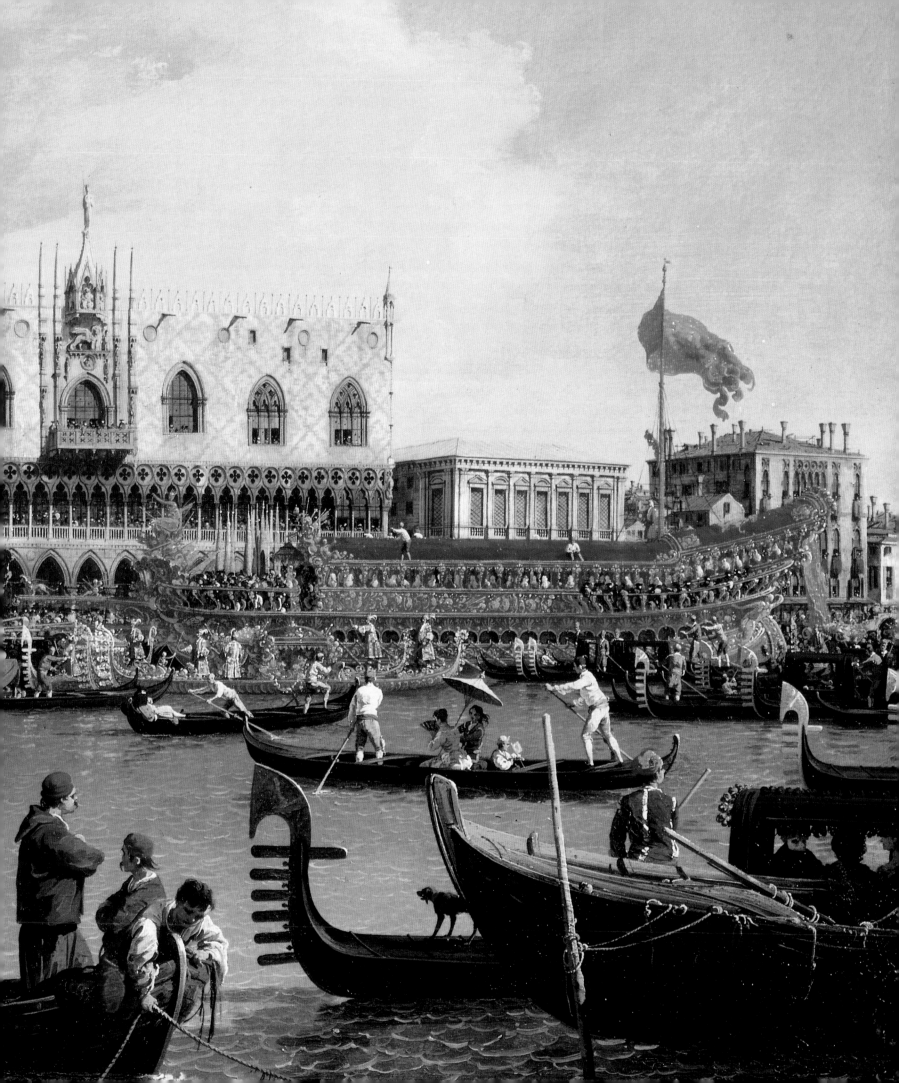

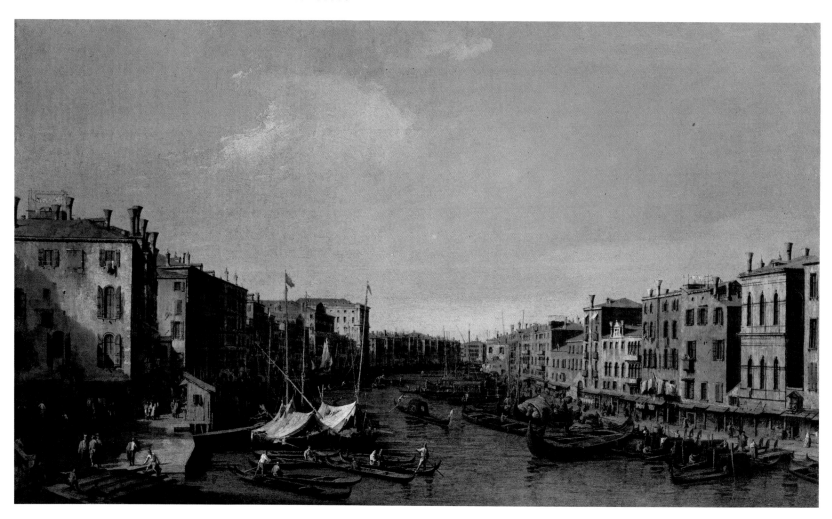

66
*Grand Canal: looking South-West from
the Rialto Bridge to the Palazzo Foscari*
c. 1727

Oil on canvas,
47 x 78 cm
(18½ x 30¾ in)
The Royal Collection

Prospectus Magni Canalis ... began
with Visentini's engraving from
this painting, probably among the
first to have been executed.

67
*Entrance to the Grand Canal: looking
East*
Published 1735

Pen and ink,
27.3 x 43.2 cm
(10⅞ x 17 in)
London, British Museum

Visentini's drawing for one of his
engravings, the fifth in *Prospectus*.
Although Canaletto's viewpoint is
much the same as Plate 24, the
lefthand side shows the Molo
buildings instead of those of the
Grand Canal.

true that the light and the shadows cast by the sun are by no means consistent. It is also true that the figures are sketchy and hesitant; Canaletto had not yet learnt how to give the same body and vitality to the figures peopling his small canvases as he so brilliantly gave to the Procurators and loiterers of the six great Piazza paintings (this was also a noticeable flaw in some of the copper plates McSwiney so much admired). With these reservations the picture was indeed an auspicious start to the series.

No longer did Canaletto make changes while he was working, as he had done in the Piazza paintings; everything must have been worked out before he started, and he proceeded with total confidence. Buildings, sky and water were broadly blocked in and then the sky finished off. The skyline, always a most intricate and important part of the view, was then completed in detail so that the sky can often be seen to go underneath the upper parts of the buildings. Finally, after the buildings had been finished off with all their details, came the foreground figures and shipping, painted where necessary over the water, the quay, or the bases of the buildings.

These are but the technical means by which Canaletto accomplished his prime object, that of converting his canvas into a window.

A man that looks on glasse
 on it may stay his eye
Or if he pleaseth, through it pass
 and then the heav'n espie

wrote George Herbert. Few spectators stay their eye on the surface of a Canaletto painting. They allow it to pass through, as he intended, and in the distant focal area they espie, if not 'heav'n', a piece of Venice beckoning to them. The journey towards that distant area counts for more than the arrival. It is one of endless variety and fascination, passing shops and churches and palaces ranging from the noble Grimani to quite modest dwellings with small claim to the name of palace (and, in Canaletto's day, the word was hardly ever applied to any but the Doge's Palace, the others being merely *Casa* or *Cà*). Accompanying us on the voyage is a profusion of craft almost as rich in their variety as the buildings themselves. All this is brought into order by the artist's power of constructing his own view of Venice from the components at his disposal, changing the angle of a building which jarred with its neighbours, giving the Canal a sharper or a gentler curve, sometimes closing off a vista to give prominence to a

particular piece of architecture and at others almost suggesting a glimpse of what lay around a corner.

For this first view (Pl. 66) Canaletto found an ideal viewpoint on the Rialto Bridge. From here he could look down on to the Riva del Ferro (iron) on the left and the Riva del Vin (where the wine was unloaded) on the right. He was at about the height of the balcony of the main floor of most palaces and this suited him admirably. He was also over the water, but closer to one bank than to the other; this also suited him since the view from the centre of the Canal tended to give a sense of symmetry quite alien to Venice, where nothing is symmetrical.

Once the journey down the Canal for the succeeding views was begun, convenient viewpoints such as the Rialto Bridge were no longer available. They therefore had to be imagined. Far from raising any difficulties, this gave Canaletto greater freedom to marshal the elements of his scene to produce the essential image of Venice, which concerned him more than topographical accuracy. The view from one bank is combined with the view from the other, not necessarily immediately opposite; distant points are brought in closer or made more distant, roofs raised or lowered, a campanile moved to punctuate an otherwise dull skyline. The height above the water is kept fairly constant so that the spectator can see himself at the masthead of a barge or, just occasionally, on the balcony of a non-existent building, as the wonders of this 'best built street' reveal themselves.

Following the order of the engravings in *Prospectus*, we pause at the Palazzo Foscari, the Carità and the Campo S. Vio before reaching the Salute (Pl. 67), from which we see the whole length of the Riva degli Schiavoni. We then turn and look up towards the Carità before taking a leap back to the Rialto Bridge for new versions of the pair of views painted first for Conti and then for the Duke of Richmond. Just as we first looked down from the south side of the Bridge before setting off to explore that part of the Canal, so we now, after studying the view from the north side, proceed up and reach the end by five stages. (The second edition of *Prospectus*, not to be published until 1742, began at this point and retraced the journey back to the Bridge, this time in seven stages, followed by three views only on the south side.)

There must always be controversy over the date when the 12 Grand Canal paintings were begun,

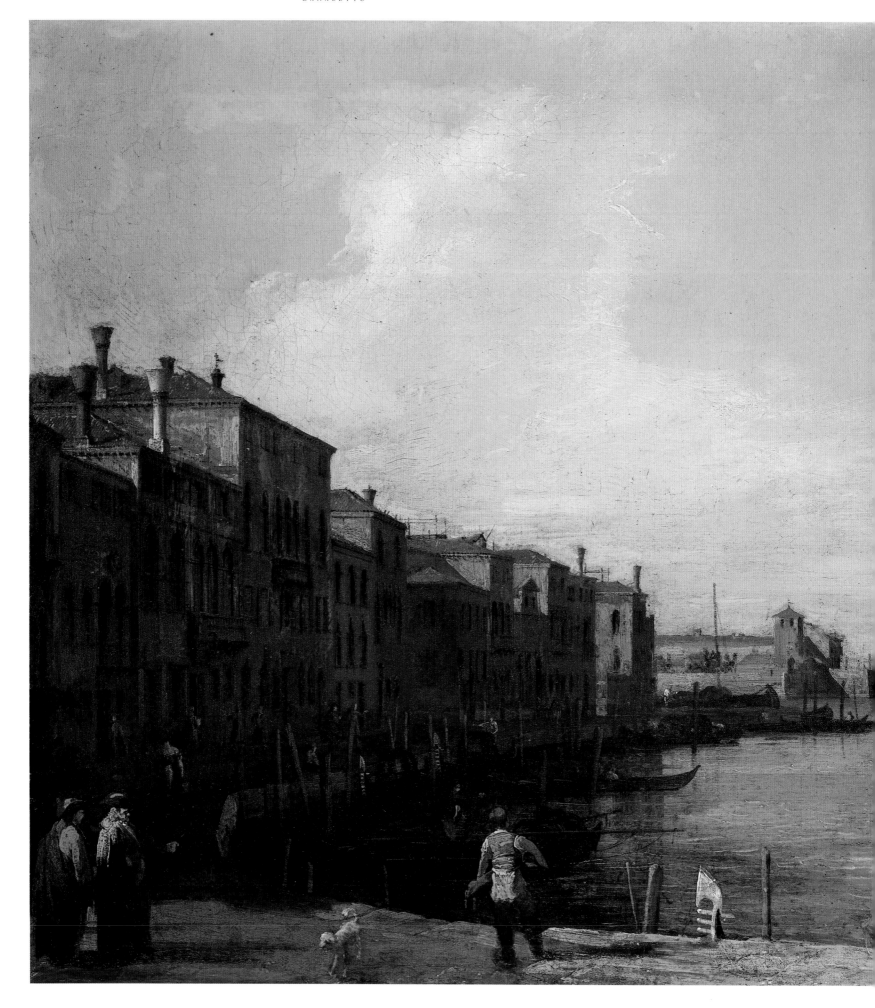

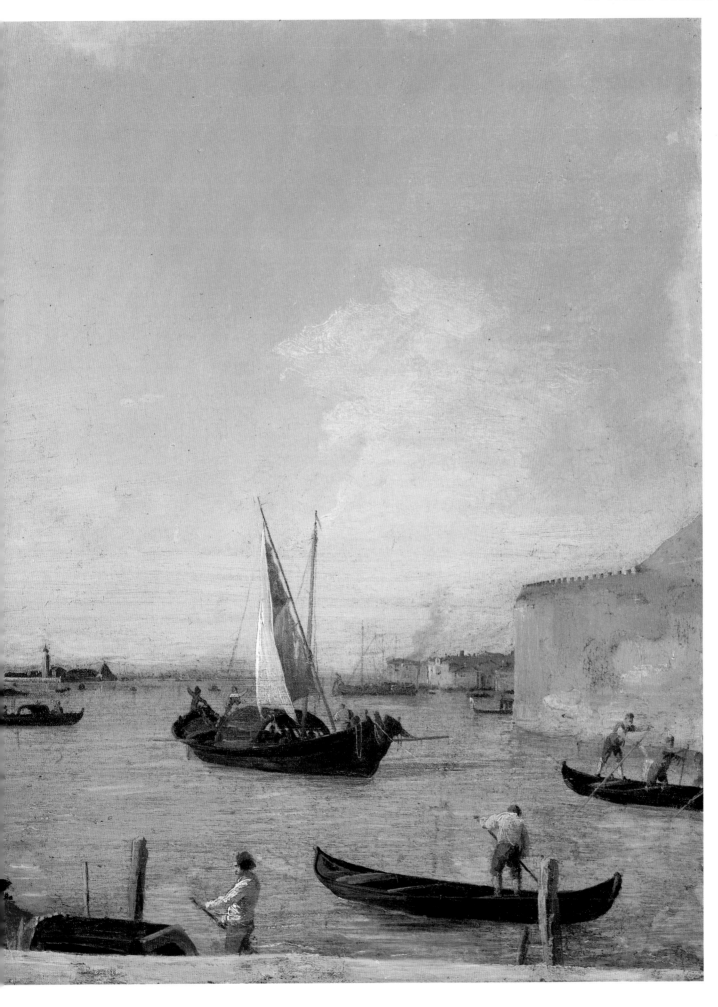

68
S. Chiara Canal: looking North-West from the Fondamenta della Croce to the Lagoon

Oil on canvas,
46.5 x 80.6 cm
(18¼ x 31¾ in)
The Royal Collection

Last of the 12 Grand Canal paintings engraved in *Prospectus*; impossible to date on account of its condition.

when they were finished, and the order in which they were painted. Naturally they vary in quality, but it would be hard to place them in an order to show consistent development. Those reproduced towards the end of *Prospectus* tend to be more accomplished than those at the beginning, especially in the painting of the figures. On the other hand, *From the Rialto Bridge to the Palazzo Foscari* (Pl. 66), the first of all, is in some ways unsurpassed by any, and the last, *The S. Chiara Canal* (Pl. 68), is so different in style that it lies uneasily with its companions.

With the end of the Grand Canal series all doubts disperse. Canaletto had now reached the peak of his powers in the art to which he had decided to devote his career.

The *Regatta on the Grand Canal* (Pl. 69), it has already been said, cannot have been painted before 1732 if the evidence of Doge Carlo Ruzzini's arms is to be believed. These could have been added later but the engraving, and the preliminary drawing for the engraving, would also have had to be altered and there is no sign that they were altered. More important than the arms is the quality of the picture and of its companion, *The Bucintoro at the Molo on Ascension Day* (Pl. 70); the Canaletto of the early Grand Canal views could not have painted figures of such substance and vigour as those that fill these two canvases. The Canaletto of the even earlier Piazza pictures could, it is true, bring life to his figures to a startling extent, but the free, nervous stroke of the brush in the earlier pictures is entirely different from the firm and confident handling of the later pair.

There is every reason to suppose that they were completed between 1732 and the publication date of Visentini's engravings, 1735, and that the idea of including them in the album of Grand Canal views was not even in Smith's mind when he wrote to Samuel Hill in 1730.

As to the whereabouts of the 14 paintings, no supposition is needed. They were all in Smith's own house. We know this, not only because they were still there in 1762 when his collection was sold to George III, but because the title-page of the engravings used those very words – *in Aedibus Josephi Smith Angli*, in the house of Joseph Smith, Englishman. Quite clearly, *Prospectus* was intended to fill more than one function. In the first place it was a book to give pleasure by its own artistry. Visentini was incapable of transferring the light and vitality of Canaletto's paint-brush to the engraver's burin. On the other hand he was a first-rate craftsman, if not a first-rate artist, and he had a splendid series of paintings to work on. Consequently he produced an album that must have delighted those who did not know Venice and had never seen a Canaletto as well as those who knew both. Even Mr Woodhouse, father of Jane Austen's *Emma*, a difficult man to comfort if ever there was one, was shown by Mr Knightly books of engravings 'to while away the morning' and was 'exceedingly well amused' although he 'had only accomplished some views of St Mark's Place, Venice' by the time an interruption came.

There is a strong hint in the title-page of a second function of the album. This was to act as an invitation to those interested in Canaletto's work to visit the house of the Englishman, see the

69
A Regatta on the Grand Canal

Oil on canvas,
77 x 126 cm
(30¼ x 49½ in)
The Royal Collection

Compare Plate 16, in which the temporary structure on extreme left is missing. Companion to Plate 70, both probably added to *Prospectus* as an afterthought.

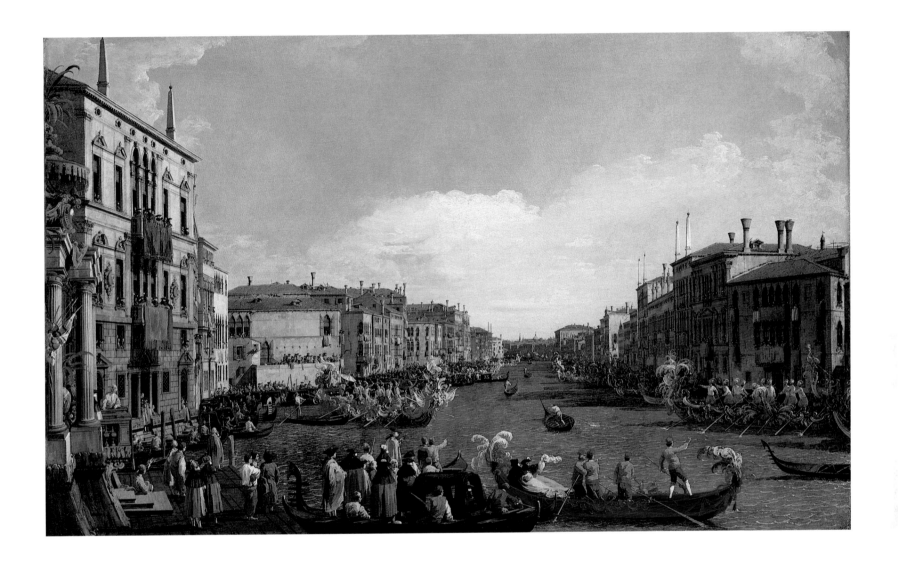

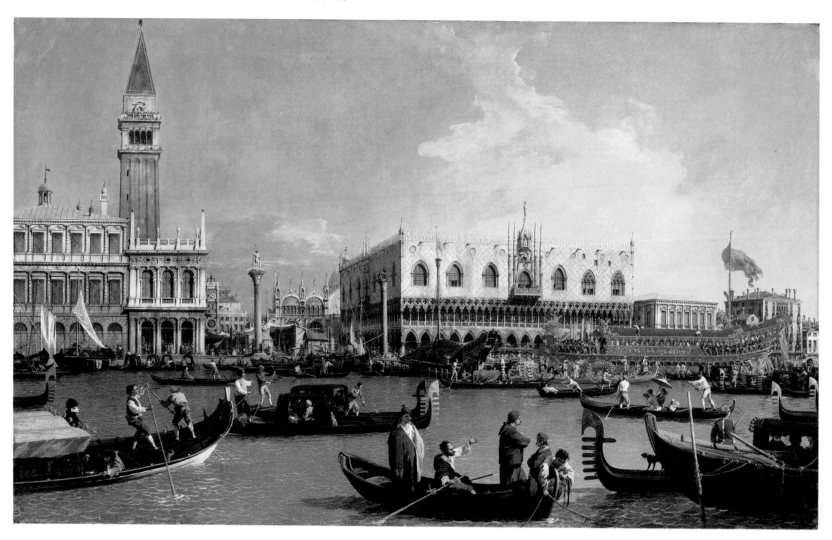

originals, and perhaps order others like them. They were not for sale and they remained in Smith's house throughout his life as a *marchand amateur* (which he certainly was and almost certainly would have admitted to being). This is not easy to explain. The six Piazza paintings must surely have been specially commissioned by Smith, perhaps, as has been suggested, as part of a decorative scheme; they would have had a special place in his heart. Nor is there much likelihood that an English collector would have been interested in pictures that were so little characteristic of the Venice he remembered or had heard about; no English collector did in fact buy one of Canaletto's early paintings (unless '*The Stonemason's Yard*' was in England long before its first appearance in 1808). The Grand Canal pictures, on the other hand, were undoubtedly painted as a commercial proposition, to introduce

Canaletto to English buyers, as well as to decorate the walls of the leading English merchant in Venice, whose services were at their disposal in so many directions.

In 1742, when the tide had at last turned against Canaletto, Smith issued a second edition of *Prospectus*. As well as the original Grand Canal series and the festival pair, this contained two additional groups, the first forming another tour of the Grand Canal, followed by new versions of the scenes towards east and west along the Molo, the second showing ten *campi*, churches or *scuole*, followed by views of the Piazza in opposition directions. As with the first series, the original paintings of the pairs which closed the new groups were on a much larger scale.

The title-page of this second edition repeated the words '*in Aedibus Josephi Smith Angli*' (Pl. 71) but, with one exception, the new paintings were

70
The Bucintoro at the Molo on Ascension Day
c. 1732

Oil on canvas,
77 x 126 cm
(30¼ x 49½ in)
The Royal Collection.

The Doge has returned in his State Barge from the Lido after the ceremony of the Marriage of the Sea.

Ant: Visentini Inv. Del. et Sculpsit: *Angela Baroni Ld. Sculpebat:*

71
Title-page to the second edition of
Prospectus.
The Plates have been 'elegantly
recut' but the pictures are still in
the 'house of Joseph Smith,
Englishman'.

no longer there. Some had been sold to the Duke
of Bedford, some to the Duke of Leeds, some
singly or in pairs, and quite a number to an
unidentifiable member of the Duke of
Buckingham's family.

It is exasperating that the extensive archives of
hardly any of these great families yield any
information about the purchase of what would
have proved to be among their best investments.
Those of the Duke of Leeds were sold in the
1920s, the originals of the two from *Prospectus*
being now in Rome. The Duke of Buckingham's,
if they were in fact bought by the Duke himself,
became the property of a kinsman, Sir Robert
Grenville Harvey, and were also dispersed; they
are generally spoken of as the 'Harvey collection'.
Only the Duke of Bedford's remain intact and
may still be seen at Woburn Abbey, where they
have hung since Bedford House in Bloomsbury,

London, was demolished in 1800. We are
fortunate in having some record of these, recently
discovered among the Bedford papers. Three bills
were drawn by 'Jos Smith' and accepted by the
Duke of Bedford in 'February 1732/3' (i.e., 1733
by the 'New Style' calendar), 'January 1734/5'
(1735) and 'April 1736' for £27 1s 8d, £55 6s 5d
and £105 14s 2d respectively. Each requires the
money to be paid to Mr John Smith, Smith's
brother in London, 'and placed as per advice from
Jos Smith'. Compared to the price of about £11
each, inclusive, for the Howard pictures (see p. 79)
the total of £188 hardly seems enough for the 22
pictures of uniform size and certainly not if the
two festival pictures are included. There may well
have been a payment recorded elsewhere (perhaps
a deposit paid by John, fourth Duke of Bedford,
when he was in Venice in 1731). The dates are of
interest and about as would be expected. (From

the same archive comes an interesting letter from an artist called John Richards to whom the Duke had evidently complained that he was asking 'more than He gave Canaletti for some of his Views'. Richards replies that he would not suggest his own work 'equal to so great a Master's' but points out that 'a Man can paint a Picture in Venice for five guineas, which he could hardly eat by in London & have twenty for'. The suggestion that the cost of living was four times as great in London as in Venice cannot be taken seriously but that there was a difference should be borne in mind when Canaletto's years in England come to be considered.)

No subject is duplicated in the Bedford and Harvey groups and this can hardly be coincidence. It seems likely that together they formed part of Smith's stock from which buyers were able to make their selection, either taking the original or

ordering a new version. The Duke of Bedford finally had 22, 12 of the Grand Canal and ten of the Piazza area, *campi* and churches; there were 21 in the Harvey group, 11 of them Grand Canal views. All were the same size as the first *Prospectus* series, and nine or ten of these were engraved for the second and third editions. The Bedford group was rounded off with a much larger pair, a *Regatta* and an *Ascension Day* scene. These were not used for *Prospectus* (Smith's own, finer, versions had already appeared), which ended instead with two views from the Molo and two of the Piazza, the originals belonging to the Duke of Leeds and Earl Fitzwilliam respectively.

Nothing represents better the Canaletto of the Smith period than these 50 or 60 pictures, particularly the views of the lesser-known parts of Venice as opposed to those of the Grand Canal. The Bedford *Arsenal: the Water Entrance* (Pl. 72)

72
The Arsenal: the Water Entrance
c. 1732

Oil on canvas,
47 x 78.8 cm
(18½ x 31 in)
Woburn Abbey, by kind permission of the Marquess of Tavistock and the Trustees of the Bedford Estates

One of the 24 views painted for the fourth Duke of Bedford, some of which were engraved in the second edition of *Prospectus*.

Overleaf:
73
Campo S. Angelo
c. 1732

Oil on canvas,
46.5 x 77.5 cm
(18¼ x 30½ in)
Private collection

One of 21 views, of which nine were engraved in *Prospectus*; this was not one of them, although Visentini made an engraver's drawing of it for the purpose.

shows on the left the triumphal archway of 1460, the first truly Renaissance building to be erected in Venice. On the right is the former Oratory of the Madonna dell'Arsenale and between are the towers leading to the vast dockyard, which so impressed Dante that he used it for his description of the *Inferno*. The wooden drawbridge which runs across the foreground has now been replaced by an iron one.

The *Campo S. Angelo* (Pl. 73) of the Harvey collection is full of the detail Canaletto so loved to portray, as well as the palaces surrounding the *campo*, the church of the Angel Michael, no longer standing, and the little Oratory of the Annunciata: two rings for tying up horses, which can be seen in the painting, are still in the wall.

The *Campo S. Maria Zobenigo* (Pl. 74) (or *del giglio*, of the lily, as it is called) is another of the Harvey pictures. We are standing in front of the church which, with S. Moisè, so horrified Ruskin as 'the most remarkable in Venice for their manifestation of insolent atheism'. It was the 'strutting statues' of the Barbaro family (who paid for the church) and their trophies which so upset him. When he and his wife Effie found two old brothers, the last of the Barbaros, living at the top of their palace, which had been let to rich friends of the Ruskins, he smugly wrote to his father, 'so they have been brought to their garrets justly'. The church looks on to a narrow *calle* so that it is impossible to stand more than a few yards away from it, but this has not deterred Canaletto. His imagination has carried him to a point far enough away to see, as well as the entire façade in comfort, the campo to the left and even (a nice touch, this)

a glimpse of the far side of the Grand Canal.

It is surprising how little direct evidence there is of Smith's handling of the large number of Canalettos bought by the English. We know he sold paintings to Samuel Hill and to Hugh Howard and, according to McSwiney, to John Conduitt, but until quite recently there was no proof that even the Duke of Bedford's collection went through his hands. However, circumstantial evidence is often preferable to direct evidence from an unreliable witness.

Examples of such unreliable sources are Horace Walpole and the Swedish Count Tessin. Walpole, like many others, found Smith void of charm and referred to him as 'the merchant of Venice' (which he indubitably was, but Walpole did not mean it in a kindly way). He wrote that 'Mr Smith engaged Canaletto to work for him for many years at a very low price and sold his works to the English at much higher rates'. Tessin, after a visit to Venice, wrote in 1736 that Canaletto would sell a '*tableau de Cabinet*' for 120 sequins and was engaged to work exclusively for four years for '*un marchand Anglais, nommé Smitt*'. Both statements, although direct contemporary evidence, are demonstrably untrue, and the price of 120 sequins attached to a small Canaletto is quite implausible. It is true, as will shortly be seen, that Marshal Schulenburg paid Canaletto 120 sequins for the magnificent *Riva degli Schiavoni* now in the Soane Museum but this was no '*tableau de Cabinet*'; Schulenburg's accounts also show him paying Canaletto 30 and 32 sequins for paintings, less than £10 sterling.

There can be little doubt that, except for big collectors such as Schulenburg, the man to go to if

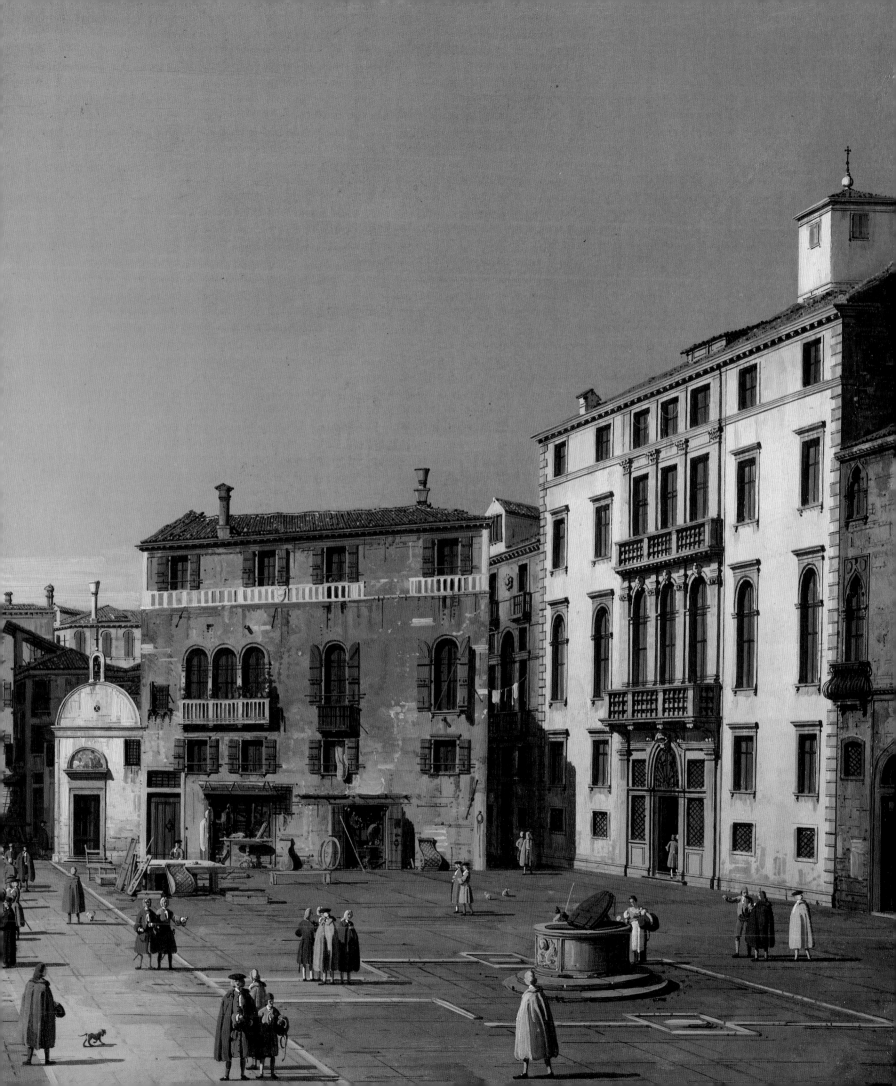

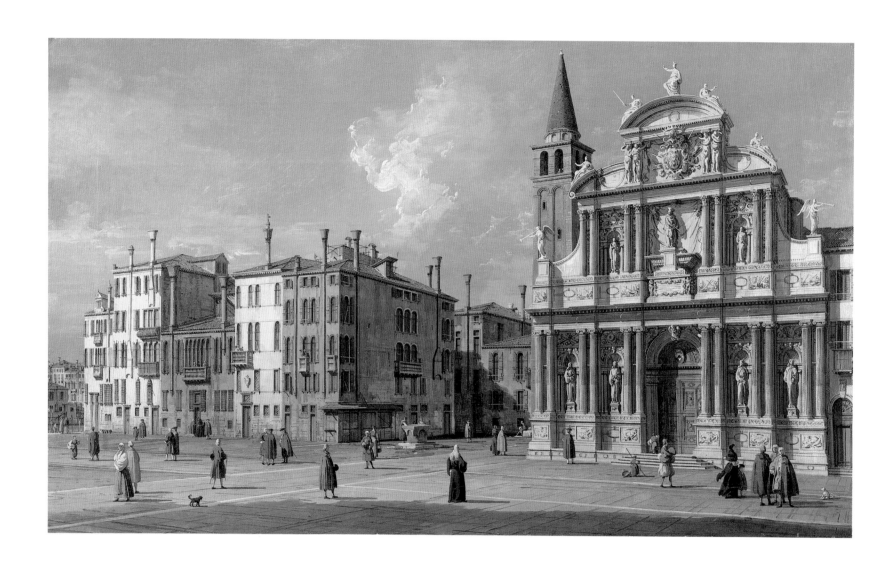

you wanted to buy a Canaletto was Joseph Smith, as Hill and Howard and Conduitt had found.

Smith would ensure that your pictures were delivered in reasonable time, that they were properly framed and packed, and that they were consigned to a reliable ship's captain. He would advance money to pay the artist and charge a fair rate of interest until it was convenient for him to be reimbursed. All these services were part of his business on which he quite properly made a fair profit. He may well have charged a commission, although no such charge appears on Hugh Howard's bill. Given these suppositions, it is a reasonable assumption that all the pictures engraved in *Prospectus* went through Smith's hands and many, many like them as well.

Although it was possible to buy a Canaletto without going through him, there is good reason to believe that Smith provided yet another and most valuable service: he would ensure that your picture was painted by Canaletto, not by an assistant or copier (and the very existence of 14 engravings of Canaletto subjects by 1735 provided material for a host of skilful, hungry, but uninspired copiers). He might even see to it that it was not an authentic Canaletto painted on an off-day. It would not be accurate to suggest that all the paintings associated with Smith are of equally high quality, but they do maintain a standard markedly higher than the average Canaletto that reaches the salerooms, even those which are undoubtedly by Canaletto's hand.

The Earl of Carlisle may well have been a patron who thought he could do better than buy his pictures through Smith (or who disliked the man so much that he preferred to avoid him). Very little is known of the origins of the extraordinary collection of 17 paintings labelled 'Canaletto' which used to hang at Castle Howard, the Carlisle seat, until it was damaged by fire in 1940, and some of the pictures destroyed. Family tradition, that most unreliable supplier of provenance, has it that the fourth Earl bought them from Canaletto himself, but that cannot be true of a good many of them which were far below Canaletto's standard. It seems more probable that Lord Carlisle preferred an agent who was easier to get on with than Smith, but who lacked Smith's connoisseurship. Such an agent may well have had his own sources for view paintings, but he or Lord Carlisle must have gone to Canaletto for three pictures of the collection. Two of them are signed with the artist's initials, an unheard-of practice before the 1740s. These are fine examples of their kind, an unusual view of *The Piazza: looking South-East* (Pl. 75) and an even more unusual *Entrance to the Grand Canal: from the West End of the Molo* (Pl. 77), both given by Barbara Hutton to the National Gallery, Washington, in 1945. The third egg to be placed in the nest by this capricious cuckoo was no less than *The Bacino di S. Marco: looking East* (Pl. 78), now in Boston. Of a very different kind from '*The Stonemason's Yard*', and painted much later, this is nevertheless a masterpiece in its own right, perhaps Canaletto's most endearing response to the multifarious shipping and the shimmering light which every eighteenth-century visitor to Venice must have carried in his mind's eye for the rest of his life.

74
S. Maria Zobenigo
c. 1732

Oil on canvas,
47 x 78 cm
(18½ x 30¼ in)
Private collection

Left, a glimpse across the Grand Canal; behind the church is the campanile which fell in 1774, the stump remaining today.

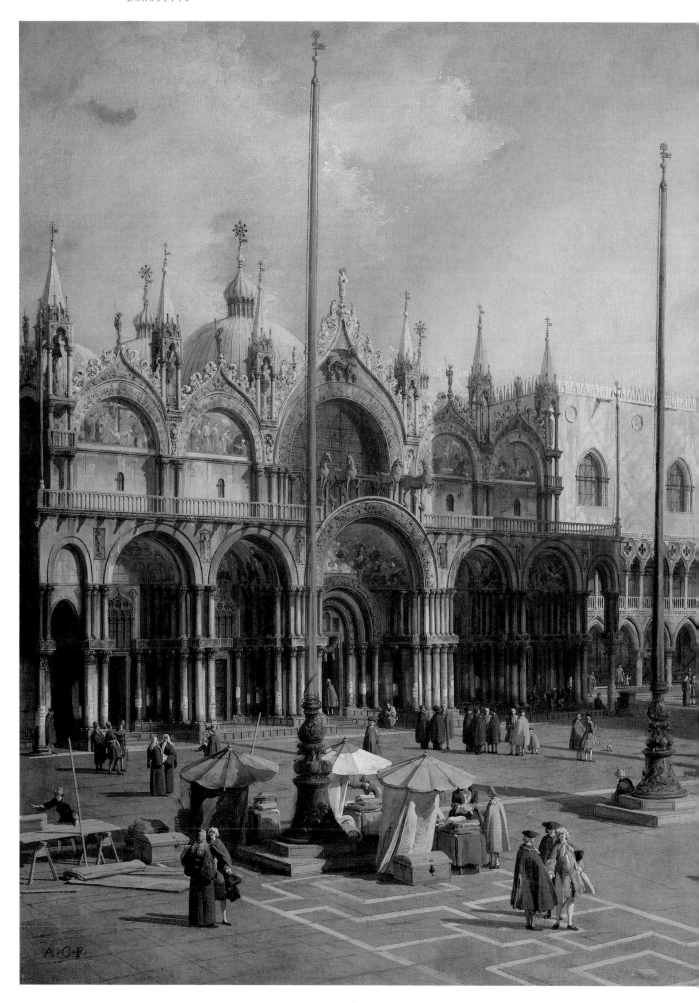

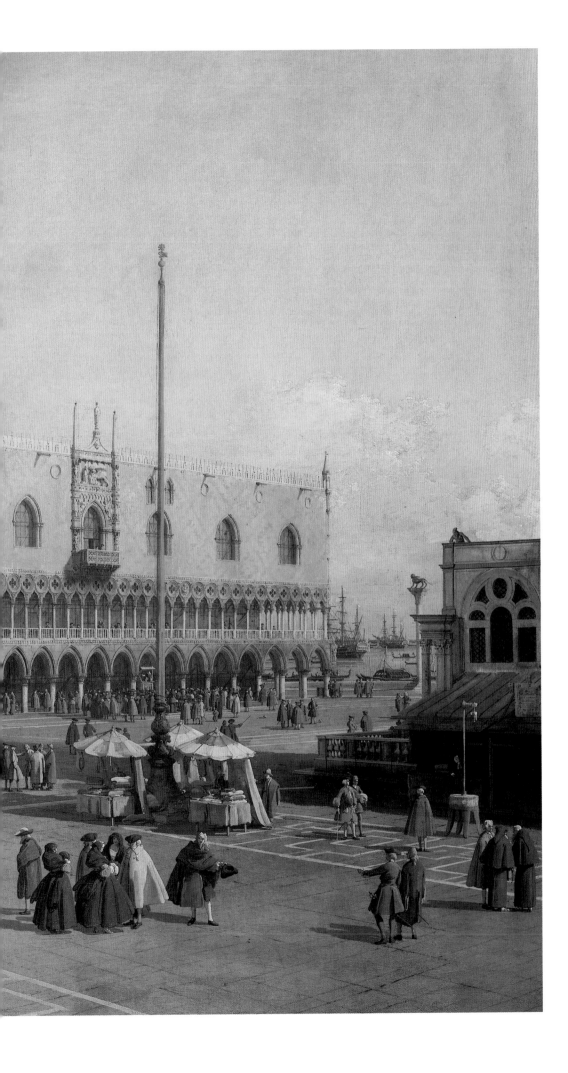

75
Piazza S. Marco: looking South-East
1735-40

Oil on canvas,
114.2 x 153.5 cm
(45 x 60½ in)
Washington, DC, National
Gallery of Art (Gift of Mrs
Barbara Hutton)

A lively scene including much that
the visitor would want to
remember – St Mark's, the Doge's
Palace, the Loggetta and a glimpse
of the Lagoon.

The high quality of *The Bacino* makes it as unlikely for the collection to have gone through Smith's hands as the low quality of most of the other Castle Howard pictures. For Smith, it seems, did not sell masterpieces: he may well have felt that it was safer to treat all his clients alike. An example of this is afforded by the *Riva degli Schiavoni: looking West*, now in Sir John Soane's Museum, London (Pl. 76). There is a small version of the picture in the Vienna Gemäldegalerie which may well have passed through Smith's hands; it is Smith's usual height of 46 centimetres (18 inches) but less wide than usual for him. The only evidence for the Smith assocation is the existence in his collection of two drawings of the subject, but this is quite strong evidence: there are many examples of drawings kept by him of paintings which he had sold. The Soane Museum version was bought, or perhaps commissioned, on the basis of the Vienna version, by Marshal von Schulenburg who had saved Corfu for Venice (see p. 10) and was, in the 1730s, living in Venice in a palace provided, together with a pension, by a grateful Republic. Schulenburg had begun collecting paintings and sculpture in 1724 and he had built up a huge collection before his death in 1747 at the age of 87. Apart from the lost painting of Corfu, he owned two small Canalettos of the Piazza and two *capriccios*. There is a payment in his accounts on 23 February 1736 of 100 sequins 'on account' of a bill for 120 which must refer to the *Riva* painting for it is described in detail. This was

a high price – half as much again as Conti had paid for all four of his 91 centimetre (36 inch) pictures ten years earlier – but the *Riva* is 122 centimetres (48 inches) high and painted in the minutest detail. It happens to be one of the very few non-Smith Canalettos the history of which can be traced from origin to the present day. It was offered, together with 125 other Schulenburg pictures, by his family at Christie's, London, in 1775 but was withdrawn at 199 guineas (just over £200 against the under £60 paid by Schulenburg). It was then bought by C-A Calonne, the Finance Minister of France, who sold it, again at Christie's, in 1795 for 165 guineas. The buyer was William Beckford, the rich eccentric noted more for his buildings than his writings, and in 1807 Sir John Soane bought the picture at a seven-day sale of Beckford's house, Fonthill, and its contents for 150 guineas. Moved to Soane's house in Lincoln's Inn Fields in 1819, it has remained there ever since, perhaps the most neglected of Canaletto's few large masterpieces, until restored to its full glory in 1992 and at last fully appreciated. As for the view itself, it is one that many visitors to Venice today must leave without ever having seen, for the canal in the foreground leads only to the Arsenal, a desolate area visited by very few. How this would have amazed the Venetians of the great days when the Arsenal was one of the very first sights distinguished visitors were taken to.

The view in the opposite direction to the Sir John Soane Museum *Riva*, that is to say from the

76
Riva degli Schiavoni: looking West
Before 1736

Oil on canvas,
122 x 201 cm
(48 x 79 in)
London, Sir John Soane's Museum

The bridge in the foreground is over the *rio* which leads to the Arsenal. Beyond it are the Military Bakeries, which still exist although the nearer house has been demolished.

Molo towards the Arsenal, was a familiar one to visitors and, no doubt for that reason, often repeated by Canaletto. Apart from the earlier Vienna version there was no repetition of Schulenburg's painting. In other cases where Canaletto was impelled to reach a step above the standard he normally set himself there was, as with the Boston Museum's *Bacino*, no repetition at all. In the National Gallery, London, there are three examples of this. '*The Stonemason's Yard*' (Pl. 61), *The Doge visiting S. Rocco* (Pl. 26) and the *Scalzi with S. Simeone Piccolo*, (Pl. 92), Canaletto's only large-scale Grand Canal painting of the 1730s, which is almost exactly the same size as the Soane *Riva*. There is no evidence that Smith even saw any of these. His own six Piazza paintings were bought for himself and never repeated or engraved. His first 12 Grand Canal pictures, and their two festival companions, were no doubt

bought as examples of the work Canaletto was prepared to make available to other buyers. But Smith was a collector as well as a man of business and there is nothing sentimental in suggesting that he kept them because he could not bear to part with them. The only other original he kept from the *Prospectus* series was the *SS. Giovanni e Paolo* (Pl. 79), an imaginative evocation of a much loved corner of Venice, which it is plausible to suggest he kept for the same reason. This is one of Canaletto's most successful pieces of picture-building and a description of the process, as far as it can be judged, is be found on page 105. We have already seen two versions of the scene from a window of the house on the extreme right (Pls 26 and 35): here we are looking east but many 'adjustments' have been made to produce this enchanting and apparently realistic composition.

77
Entrance to the Grand Canal: from the West End of the Molo
1735-40

Oil on canvas,
114.5 x 153 cm
(45 x 60¼ in)
Washington, DC, National Gallery of Art (Gift of Mrs Barbara Hutton)

Companion to Plate 75.

Canaletto has put his initials on the wall of the small harbour which was seen in Plate 54. At the end of the Molo is the Fonteghetto della Farina.

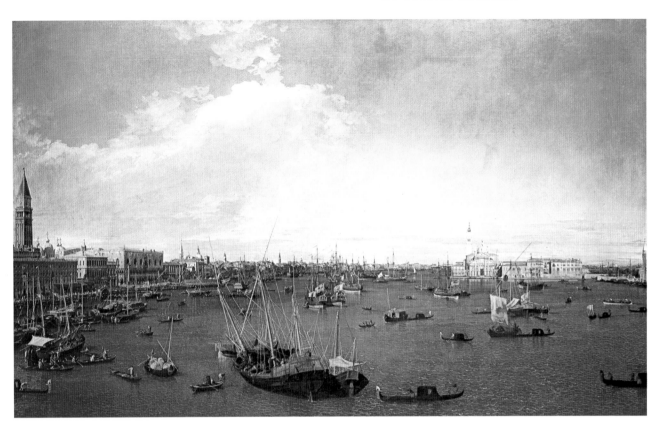

78
The Bacino di S. Marco: looking East
c. 1735

Oil on canvas,
125 x 204 cm
(49¼ x 80¼ in)
Boston, Museum of Fine Arts

With Plates 75 and 77, part of a
group probably bought in Venice
by the Earl of Carlisle. This is
approximately the view from the
Dogana (customs house).

79
*SS. Giovanni e Paolo and the
Monument to Bartolommeo Colleoni*
c. 1735

Oil on canvas,
46 x 78 cm
(18 x 30¾ in)
The Royal Collection

This picture has been imaginatively
constructed from several
viewpoints. On the right is the
house from which Plate 35 was
painted.

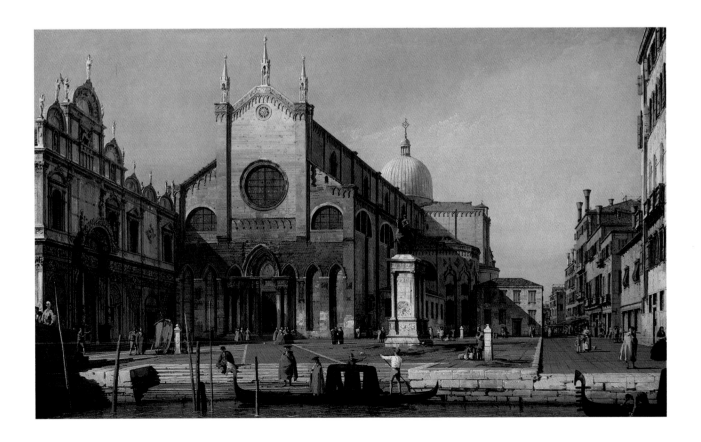

THERE WAS CONSOLATION for the paintings Smith's business instinct impelled him to part with. Canaletto was a draughtsman of the highest calibre and during the 1730s there was not a drawing that fell into any hands but Smith's. 'Drawing' in this sense means anything from the 'working out' designs, such as we have already seen in connection with the six great Piazza paintings, to the finished drawing intended as an independent work of art. It does not include the diagrammatic notes, sometimes very detailed, which we shall come to later. Nor does it include the first sketch for a painting or drawing, such as those prepared for Stefano Conti's *Rialto Bridge* (Pls 30 and 34) or Samuel Hill's *Riva degli Schiavoni* (Pl. 57). These preliminary sketches or drawings generally seem to have been drawn from the height of a man's eyes, whereas the 'working out' drawing is from a higher, more interesting viewpoint, and the final product, whether painting or drawing, from higher still. The few that have survived often bear inscriptions of their subjects, which would have been obvious to any Venetian; it may have been that Canaletto gave them away to visitors as mementos – possibly even as trade cards to remind them where to go if they wanted a painting. There may possibly have been another stage, a perspective drawing, made entirely with a ruler, according to the rules in books on linear perspective. There is only one of these in existence, one which Canaletto also seems to have given away, and its interest is in the inscription which reads: 'the year 1732, the month of July, for England'. The drawing, or rather exercise, coincides with a painting of the Piazzetta to the

north in the Duke of Bedford's collection and gives some confirmation of the approximate date of his pictures.

No visitor seems to have wanted, or perhaps been allowed to buy, a finished drawing of Venice. Later on, a number of drawings found their way to other collections, but so long as Canaletto remained a Venetian view painter anything he committed to paper, other than sketches, went to Smith. The drawings were not engraved, nor are they mentioned by contemporary writers, and we do not know whether Smith paid for them or took them as a form of commission on the paintings he sold.

This last suggestion is not entirely without foundation. Of the 50 or 60 drawings concerned with Venice that Smith owned, only one coincides with any painting that he kept after the Piazza group of six. Some of the remainder appear to be free and atmospheric sketches which closer examination soon shows to have been studio products made with the help of ruler and dividers. *The Molo: looking West* (Pl. 83) is one of these and its close relationship to Hill's picture (Pl. 53) is apparent. Smith owned a similar drawing of the companion picture, *The Riva degli Schiavoni*, but he kept no painting of either of these most popular and desirable subjects.

There were also highly finished drawings of some of the Grand Canal subjects which had been sold to the Duke of Bedford or which were in the Harvey group. In the view *Looking North-East from S. Croce to S. Geremia* (Pl. 82) we are looking down the Grand Canal (after it has taken its great turn towards the north) and are at the point which

80
Detail of Plate 85.

5 *Pen and Ink*

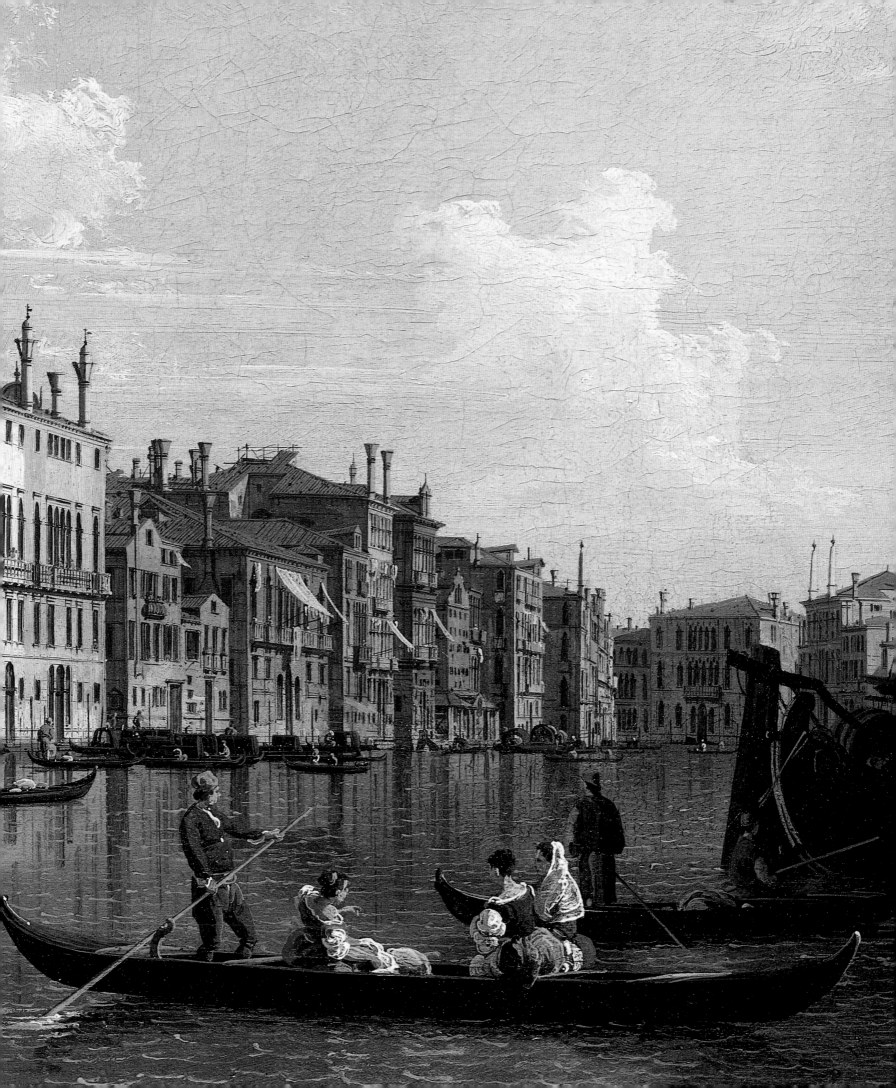

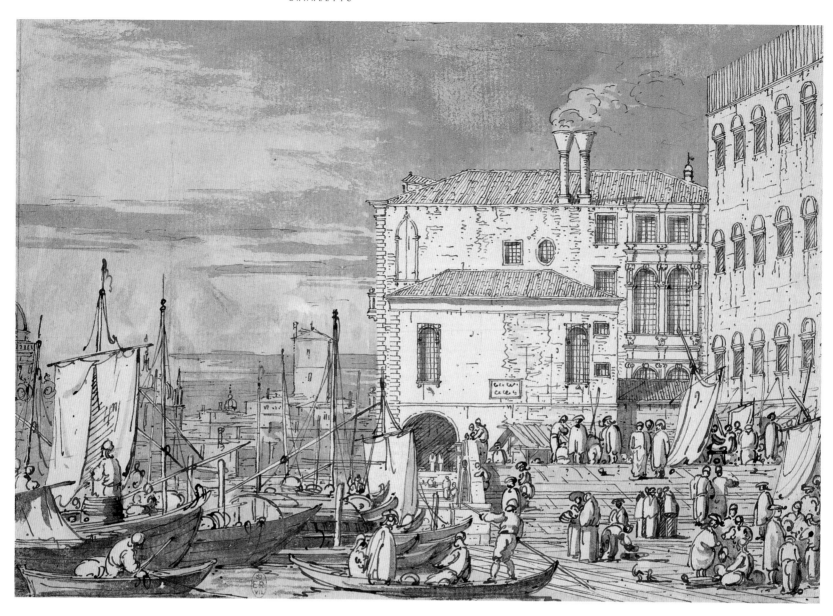

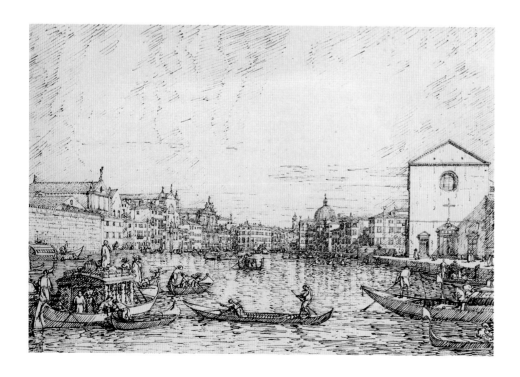

82
*Grand Canal: looking
North-East from S. Croce to
S. Geremia*
c. 1732

Pen and ink,
27 x 37.7 cm
(10¾ x 14¾ in)
The Royal Collection

On the left is the *burchiello* about
to enter the Grand Canal from the
S. Chiara Canal on its way from
Padua. The campanile of S.
Geremia can be seen in the
background.

81
*The Molo: looking West, with the
Fonteghetto della Farina*
c. 1735

Pen and ink with wash,
18.7 x 26.7 cm
(7⅜ x 10½ in)
The Royal Collection

The Granary on the right has been
replaced by gardens. The arch
remains, although blocked in, and
the bridge has been replaced by
another to the left of the one
shown.

formed the background of the splendid view with
the Scalzi and S. Simeone Piccolo, which is now
in the National Gallery, London (Pl. 92); both
churches can be seen in the background. On the
left are the buildings demolished for the railway
station and on the right the church of S. Croce,
also demolished, its white façade flooded with
sunshine. In the left foreground is the entrance to
the S. Chiara Canal, which we saw in Plate 68,
now part of the Grand Canal.

In Smith's day this was a fashionable part of
Venice and the British Resident, whose post he
longed for, lived here. It must have been a wrench
for him to part with the original painting to the
Harvey family's predecessor, but he received a
brilliant and sensitive drawing in compensation.

Later in his career as draughtsman Canaletto
found the use of a grey wash more suitable for his
shading. It certainly involved less effort than
hatching with the quill pens he used, but he
probably also found it more flexible. In his early
experiments with this medium, probably in the
mid-1730s, he redrew a few successful subjects
using a wash where he had at first hatched in
the shadows. *The Molo: looking West, with the
Fonteghetto della Farina* (Pl. 81) is such an example.
In this case Smith is unlikely to have handled
either of the two known paintings of the subject;
one is too early and the other not quite good
enough. But he needed some record of this
attractive little scene for his collection and no
doubt welcomed one version without wash and
another with. Once Canaletto had mastered the
use of wash, he adopted it for the majority of his
finished drawings.

The preliminary drawings were the artist's first
thoughts on the composition of a picture, and it is
a pity so few of them have survived. We are
fortunate to have instead more than a hundred
sheets of the sketches which preceded them,
including a complete sketchbook, which is now in
the Academy in Venice. Annotated as they are
with notes in his handwriting, these provided the
raw material for many of his pictures and are
evidence of his determination to make small details
accurate. He would note the name of each palace,
and his affection for shops can be seen from his
notes of the kind of shop he was drawing –
peruchier, epicier or *botioro* (the last perhaps a gold-
beater's). More important still were the notes on
the colours and materials of the buildings – dull
red with stains, or old boarding. And there were
corrections after a comparison of the sketch with
the subject itself – 'wider', 'not so high' – together
with indications of where two separate pages of
the books should be joined together to produce a
continuous drawing, sometimes following a
change of scale. Some of the pictures which he
later produced could be drawn on only three pages
of the sketchbook whereas others needed up to
ten pages.

For his painting of *SS. Giovanni e Paolo and the
Monument to Bartolommeo Colleoni* (Pl. 79)
Canaletto used two leaves of the sketchbook for
the right-hand side and two more for the façade of
the church (Pl. 84). In both cases he stood on the
campo, whereas he makes his painting appear to be
from a viewpoint on the far side of the Rio dei
Mendicanti. There is no sketch for the façade of
the Scuola di S. Marco, which appears (from a

83
*The Molo: looking West, the Library
Right*
c. 1729

Pen and ink,
19.5 x 30.1 cm
(7¾ x 12 in)
The Royal Collection

Close to, but from a lower
viewpoint than, Plate 53. A
preliminary sketch is likely to have
preceded this drawing, no doubt
made in the studio, despite its
freshness and movement.

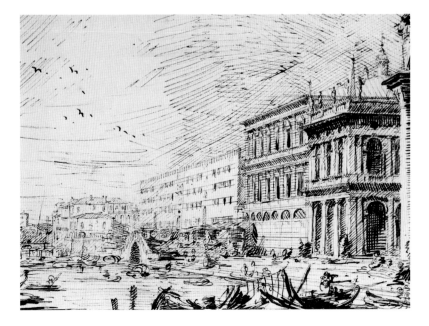

a

b

different viewpoint) on the left of the painting, nor for the upper part of the façade of the church. Canaletto has gone to the trouble of drawing a dotted line to show the relative heights of the chimney on the right and the transept of the church, but has ignored this in the painting. Much more perversely, he has drawn a shadow line across the transept and the little house next to it. He has not only followed this in the painting but he has added a corresponding shadow to the church façade (not in his sketch). In weaving these parts into a whole he has shown the sun shining on the side of the *scuola*, which faces northwest, and put the shadows cast by his figures to their south. The sun therefore appears to be very near the north. Carlevaris had virtually laid out the composition for Canaletto in one of his etchings, but more reasonably placing the sun in the south. Inexplicably, an anonymous draughtsman in

Lovisa's *Gran Teatro di Venezia* of 1721 had set a precedent for Canaletto's unconvincing shadow lines – one that was still being followed by artists in the nineteenth century.

Wherever the Academy sketchbook is opened, the eye is caught by something of interest (the Academy authorities are unlikely to let it be handled indiscriminately, but those who can lay their hands on an inexpensive facsimile published in 1956 can enjoy the pleasure vicariously). Five double pages are devoted to drawings of both sides of the Grand Canal beginning with the Palazzo Grimani on the left and the Palazzo Coccina Tiepolo on the right, each page from a different viewpoint, some from more than one (Pl. 86). (The story goes that a Grimani approached the Coccina who owned the palace bearing his name for his daughter's hand, only to have it pointed out that the Grimani, illustrious though they were and

c

d

84 a-d
SS. Giovanni e Paolo

Leaves from Canaletto's
sketchbook,
each 22.8 x 17 cm
(9 x 6¾ in)
Venice, Accademia

Compare Plate 79, in which the
diagonal shadow line has been
followed but not the dotted line.
Coto represents 'baked' or 'brown',
R *rosso* (red) and B *bianco* (white).

with a dozen palaces in Venice, had no palace on
the Grand Canal. From this taunt grew the present
Grimani palace, enabling the young Grimani to
boast that any one of its principal windows was
bigger than his father-in-law's main portal; it later
became the Post Office, had the rare distinction
for a Renaissance building of earning John
Ruskin's approval, and is now the Court of
Appeal.)

Canaletto has written the names of the principal
palaces and such notes as '*scuro*' (dark), '*Cn*' (for
Cenerino, ash-coloured) and '*questo*' on a dotted
line to show the correct height. He has noted the
name '*Teatro di S. Angiolo*' which he must have
known well, and probably worked in, for it was a
leading theatre from 1676 until 1748. On the third
double page of drawings of palaces he has added
some barges, but he has devoted the next to much
more detailed studies of shipping and rigging, as

well as more instructions to himself on relative
heights. It is tantalizing that on the same pages are
detailed figure drawings of a kind quite unknown
elsewhere in Canaletto's work and the impression
is inescapable that the book had at some time
fallen into the hands of an artist who amused
himself by drawing his own figures in the master's
sketchbook. The last double page of the series (not
illustrated) was able to take in all the right side of
the Canal.

There is no doubt whatever that the painting
which eventually stemmed from these sketches
(Pl. 85) is the one that was bought by the Earl of
Normanton in the nineteenth century. On the
right-hand side of the picture is a group of barges
which correspond quite astonishingly with the
studies in the sketchbook. That is not all: some of
the rigging in the sketch is missing from the
painting and, when the painting was recently

a
b
c
d

85
Grand Canal: looking South-West from the Palazzo Grimani to the Palazzo Foscari
c. 1735

Oil on canvas,
57. 2 x 92.7 cm
(26½ x 36½ in)
Private collection

The Grimani palace, its main portal as high as the neighbouring house, is now the Court of Appeal.

86 a-f
Grand Canal: ... to the Palazzo Foscari

Leaves from sketchbook.
Venice, Accademia

In this case Canaletto has used his sketches of shipping as well as those of the palaces for the painting opposite.

86 g-h
The barge laden with barrels is a continuation of Plate 86f. The figures may have been retouched by another hand.

restored, this piece of rigging was found under the surface. Canaletto had followed his sketch faithfully, but found this minute detail disturbing to his eye and so painted it over.

Canaletto's sketchbooks contain for the most part a series of annotated diagrams which provided him with invaluable information in his studio. There is evidence that he kept one of them for at least 30 years and many more of this type of sketch must have existed than survive. They were in no sense intended as works of art although the term, vague as it is, is certainly appropriate to one or two of the drawings. It is to Smith's collection, though, that we must turn to judge Canaletto's qualities as draughtsman and he emerges as a master.

Before leaving his drawings of Venice we must share with Canaletto a pair which falls into no category and which must have been carried out simply for the pleasure of drawing.

We know that Canaletto's mother owned two houses in the Corte Perini, as it is now known, close to S. Lio, and that he died in one of them. There is no evidence as to where his studio was, although it is generally assumed to have been here. A drawing (Pl. 87) in pen and brown ink with brown and grey washes long lay in the British Museum with no identification but 'roofs and chimneys in Venice', and when another drawing (Pl. 88) was exhibited in 1963 it was recognized as a companion. A visitor to Venice, remembering the second drawing, also recognized part of the

church of S. Maria della Fava in it while he was looking out from the top of the Campanile. A visit to the top floor of the Canal family house at S. Lio left no doubt that the two drawings were made while Canaletto was sitting at two of the windows of this house (Pls 89 and 90).

They may have been begun as aimless doodles, but the scene, unpromising though it appears, seems to have captured the artist's imagination. Perhaps it was the woman laying out her washing in one, or the figures on the balcony and at the windows of the other, that appealed to him; perhaps the work being carried out to the campanile of S. Lio in the background. Whatever it was, the drawings ended by being highly finished, even to the extent of having two colour washes added and an enclosing ruled line as if intended as collectors' pieces. Then they were separated and disappeared for at least a century. It is seldom that we can compare a purely domestic scene in Venice as Canaletto looked out on it with its appearance today, so little changed except for the television aerials. Moreover there are few better examples of his skill in showing the fall of light on decaying brick, plaster and board. Here is no diagrammatic sketch, worked up in the painter's studio. The two drawings provide *plein air* studies of irresistible fascination and recall Marchesini's words to Stefano Conti – *esso depinge sopra il loco e non a idiea a casa*, he paints on the spot and not to a design at home. For once he was able to do both at the same time.

e

f

g

h

87
Roofs and Chimneys in Venice

Pen and ink with wash,
30.3 x 43.8 cm
(12 x 17¼ in)
London, British Museum

Recently identified as companion
to Plate 88. In the background is
the campanile of S. Lio under
repair.

88
*View from Canaletto's Window in
Corte Perini, S. Lio*

Pen and ink with wash,
30.4 x 44.4 cm
(12 x 17½ in)
Private collection

On the left is part of the church of
S. Maria della Fava.

89
Modern photograph, taken from
a window, of the view seen in
Plate 87.

90
Modern photograph, taken from a
window adjacent to that in Plate
89, of the view seen in Plate 88.

THE PERIOD BETWEEN 1730 and 1742 was the most productive of Canaletto's career; it was in these years that almost all the paintings of Venice by which he is best known were completed. Yet until 1742 hardly anything is known of his life or of the chronology of his work. The publication of *Prospectus* in 1735 proves that the paintings reproduced in it were finished by that date – but we have good reason to believe that some of them had been finished many years before. Joseph Baudin's engravings, published in London in 1736 and 1739, are of even less use for dating: they include two of McSwiney's paintings on copper of the 1720s and others known to be as early or earlier. They are likely to have belonged to a collector for many years before they were engraved and there is a temptation (but no real evidence) to name that collector as Elizaeus Burges, British Resident in Venice until 1736; it is he who is said to be the figure being bowed into his house on the S. Chiara Canal in one of the originals (another version of Smith's view of the same subject). Finally, there is the second edition of *Prospectus* in 1742, with 24 engravings added to the original 14. The puzzle in this case is to understand why Smith should have waited so long to publish engravings of pictures which had probably long since been hanging on the walls of their English owners.

In 1730 Canaletto was painting the light, the life and the buildings of Venice with a perceptiveness and luminosity that far transcended the require-ments of topographical art as it was generally understood. By the early 1740s he was signing and dating pictures for the first time and, for all their skill, they betray a sad falling off. They have become hard and lifeless, the figures mechanical, and the light could as well be that of Naples or Rome as that of Venice. It must be reasonable to assume that the decline had been gradual and that work of the second half of the 1730s was generally inferior to that of the first half.

There were of course exceptions. *The Bacino di S. Marco* (Pl. 78), the painting the Earl of Carlisle found himself with among the generally second-rate collection he bought, must, on topographical evidence, have been painted nearer to 1740 than to 1730. In this case one cannot do better than quote the words of W.G. Constable, who secured the picture for his museum in Boston and wrote of it in his definitive work on Canaletto: 'In delicate precision of touch, in subtle gradation of tone and colour, and in the skilful use of light cloud shadows to help bring multifarious detail into unity… it ranks as a masterpiece of one kind of painting, as does "*The Stonemason's Yard*" of another.' *The Grand Canal with S. Simeone Piccolo* (Pl. 92), on the other hand, is a conventional view painting, although two metres wide, and hangs beside '*The Stonemason's Yard*' and *The Doge at S. Rocco* in the National Gallery, London. Yet its quality allows it to stand comparison with such distinguished rivals. The shabby palaces, with the paint peeling from their façades, are given the same loving care in the portrayal of textures as the newly rebuilt church of S. Simeone Piccolo (which dates the picture after 1735). The sense of distance in the background seems to beckon the spectator to a magical canal and to invite him to explore its delights. There was to be only one more important view of the Grand Canal in the 30 years that Canaletto's career had still to run.

91
Detail of Plate 92.

6 *The Eye is Deceived*

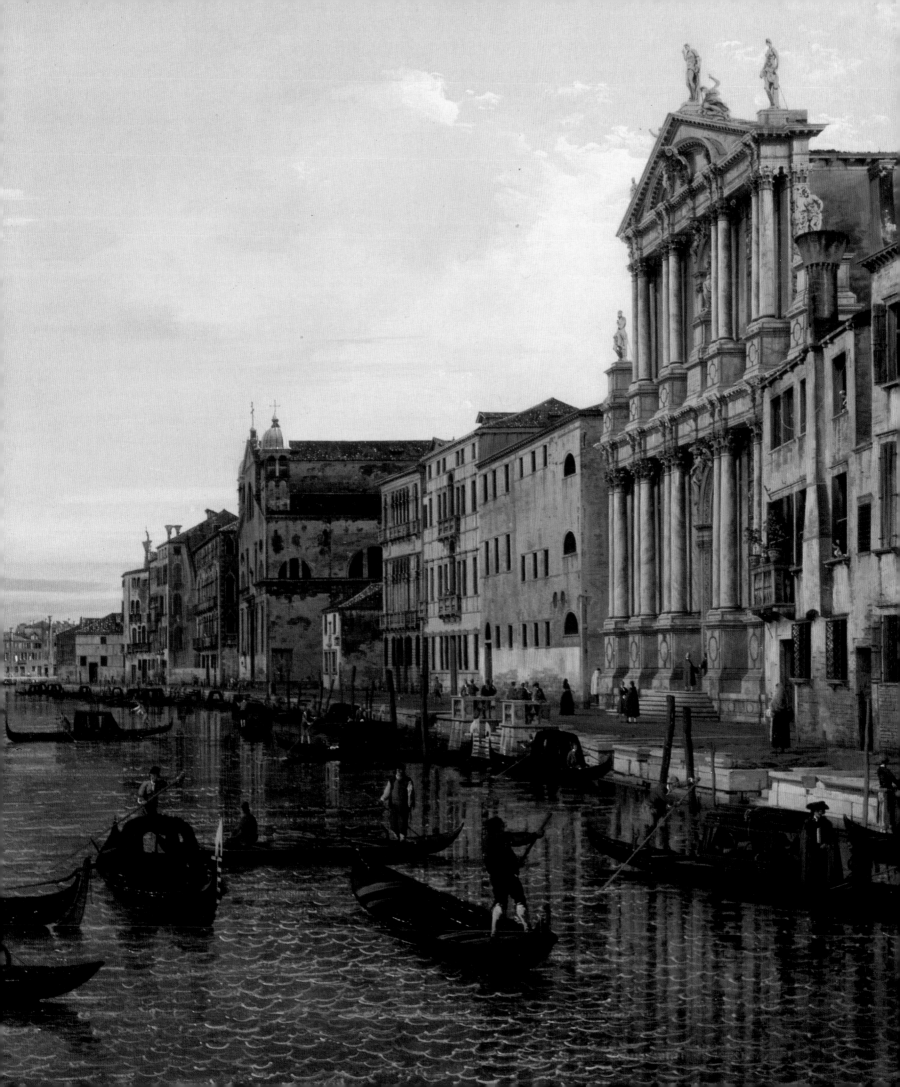

For by 1740 the long partnership between Canaletto and Smith to supply the needs of the English tourist was drawing to a close. There can be little doubt that it had been a partnership in a true sense, Smith doubtless persuading the English of their need to own a Canaletto. McSwiney had conceived the idea of diverting the artist from his spectacular set-pieces to a cool look at the wonders of the man-made Venice, but McSwiney lacked the patience, the organization and the contacts to exploit the idea successfully. It is also questionable whether he had the taste. Smith had everything and, as a sensible businessman, he realized the advantages of being able to add the services of so fine an artist as Canaletto to everything else he was able to offer the English visitor.

He could not please everyone. Lady Mary Wortley Montagu was to ask her daughter to send books direct to her rather than through Smith; 'he makes so much merit of giving himself the trouble of asking for it, that I am quite weary of him,' she wrote. James Adam found Smith, when an old man, 'literarily eaten up with vanity' and described the 'flummery' with which he was received at Smith's house at Mogliano. Yet a Venetian poet found him 'a man as remarkable for his rare talents, his goodness and sweetness of temperament as for the love which he feels for the fine arts'. Moreover he earned, and kept, the confidence of a host of aristocratic visitors to Venice who were very exacting in their demands. Perhaps above all he kept the confidence of Canaletto, whom everybody found difficult, from Marchesini and McSwiney, and Smith himself, to Charles de Brosses, the president of the Burgundian *Parlement*. 'As a view painter,' de Brosses wrote of Canaletto, 'he surpasses everyone there has ever been,' but the English offered him three times as much as he asked for his pictures, 'so that it is impossible to do business with him.' Canaletto was not a man to be exploited easily, and Smith, in spite of his detractors, was not a man to exploit him.

It was natural that Canaletto's success should have inspired others to imitate him. The publication of Visentini's engravings, and the ease with which the originals could no doubt be seen in Smith's house, provided an open invitation to artists of limited talent to meet the demand which the whimsical and capricious Canaletto would not himself supply. There are far more imitations of the 12 Grand Canal views of *Prospectus* than of other Canaletto subjects. This may have been one of Smith's reasons for delaying publication of the 1742 edition; it would have presented the copyists with

another pattern book to ease their task. In the event the demand had almost evaporated by the time this edition was published and so, naturally, had the number of imitations.

None of these imitators was capable of producing work that could be seriously mistaken for that of the master. By no means every painting that left Canaletto's studio between 1730 and 1740 is a masterpiece, but there is an unmistakable gap between an authentic work that falls short of his best and that of even the most competent imitator. The degree of studio assistance employed by him is more difficult to assess.

There is no reason to suppose that Canaletto had a team of assistants in the sense that Rubens and Reynolds had. If one arch of an arcade in his pictures is painted with feeling and skill the others are equally so, not mere repetitions by apprentices. There are extremely few replicas of his paintings, but many variations on some of his themes. On the other hand it would be too much to expect an artist to paint every identical twirl in the representation of water at a time when he had 'more work than he can doe in any reasonable time and well', to quote McSwiney's words. An assistant or two for the more menial tasks would have been invaluable during the busy years, and it must not be forgotten that in 1730 Bernardo Canal was only 56 years old and had another 14 years of life ahead. He was a professional artist and was still active enough in 1735 for Canaletto to be refused membership of the Painters' College on the grounds that father and son could not both be members if working together. Until recently no work could be securely attributed to Bernardo Canal but in 1987 a painting of the Piazza, looking towards S. Geminiano, appeared in a Venice sale-room with the inscription *Bernardo Canal fecit 1735*. It was of mediocre quality, as one might expect of an artist who apparently made no mark for himself as a view painter, but there was no reason to doubt its authenticity and it did establish, as has always been assumed, that he was perfectly capable of lending a hand to his overworked son and it would have been illogical for him not to have done so.

Bernardo Bellotto's continued presence in the studio cannot be doubted from the time he entered it. He was the son of the eldest of Canaletto's three sisters, Fiorenza Domenica, who had married Lorenzo Bellotti. Bernardo, their second son, was born in 1721. He was already a member of the Painter's Guild (*Fraglia*, or *Collegio, dei Pittori*) by 1738 and must therefore have been apprenticed by 1735 or a very little later. There are some two

92
Grand Canal: looking South-West from the Chiesa degli Scalzi to the Fondamenta della Croce, with S. Simeone Piccolo
c. 1738

Oil on canvas,
124 x 204 cm
(49 x 80½ in)
London, National Gallery

Most of the palaces on the right have been demolished to make way for the railway station.

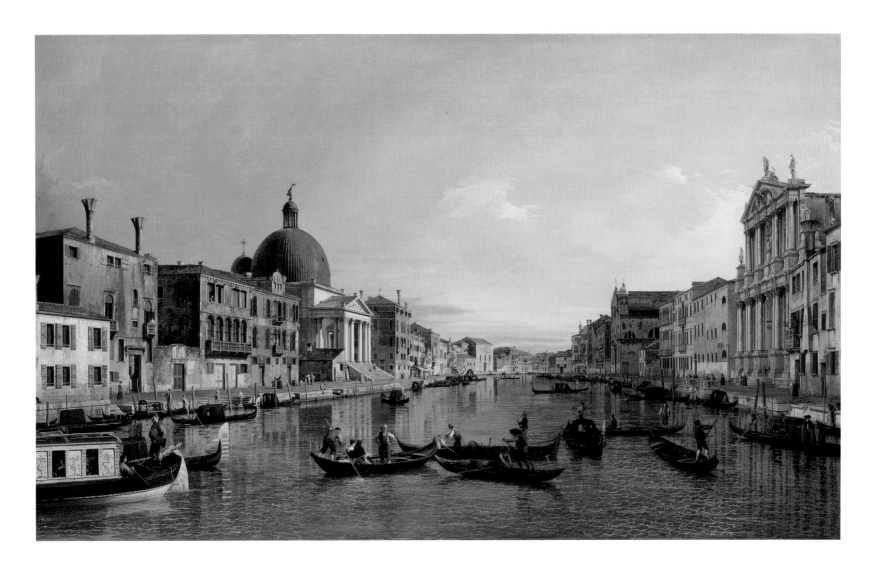

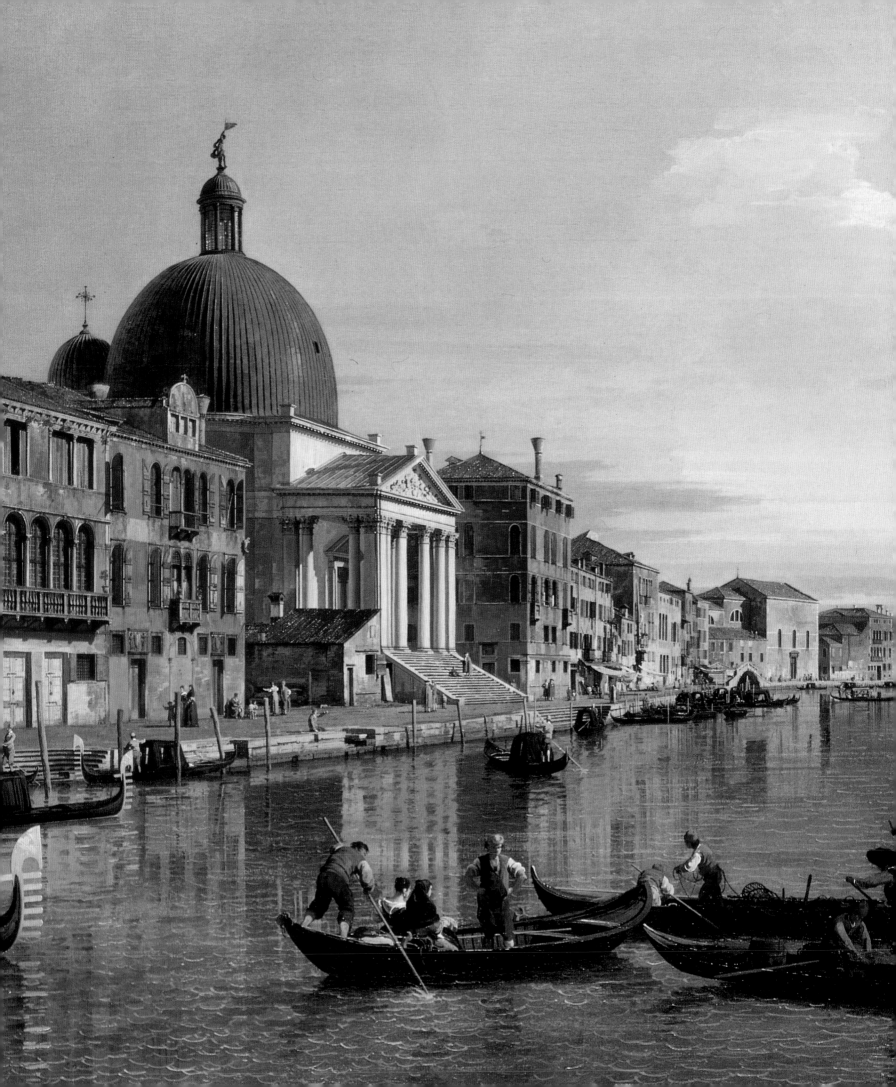

dozen drawings by him of Venetian subjects, all copied from, or based on, Canaletto drawings or paintings. These do not include a rather larger number of drawings which Bellotto made around 1740 when he travelled on the mainland with his uncle. There is no painting of Venice which is known to be by Bellotto and the attachment of his name to any painting cannot be treated as more than an expression of opinion.

Some of these opinions are based on detailed and informed study by scholars who have earned the highest reputation for the scrupulousness of their approach and who have finally submitted their conclusions to the judgement of the world. Unfortunately, though, they have by no means always reached the same conclusions. How could they, when no authenticated painting of Venice by Bellotto exists to provide a criterion? The characteristics generally attributed to him in the days when he was working in Canaletto's studio include a greater contrast between light and shade than that of his master and a thicker application of paint – in short a heavier hand than Canaletto's. The only Venice painting given to Bellotto by a consensus of authorities (by no means unanimous) is the *Rio dei Mendicanti* (Pl. 95) in the Venice Academy and this happens to be the only Venice painting attributed to Bellotto without a Canaletto composition waiting for him to follow. This alone casts doubt on the attribution and the fact that the composition is extremely subtle, cleverly combining the scene from two quite distant viewpoints, makes it extremely unlikely that Bellotto was capable of designing it before he left Venice for good in the 1740s. He may well, though, have been largely responsible for the execution.

There is no need to labour the problems facing anyone who would claim to be able to distinguish a Bellotto from a Canaletto while the young artist was still in his uncle's studio learning his trade. The most reasonable assumption seems to be that he entered the studio in the mid-1730s, when it was at its busiest, and became increasingly useful as an assistant, developing in the early 1740s as a fully fledged artist in his own right and, not much later, as a view painter who could bear comparison with any in the world, sometimes surpassing his own master. It is possible that he had a hand in most works completed in the second half of the 1730s. When the phrase 'studio assistance' seems appropriate for a work of that period, there is a probability that Bellotto, perhaps aided by Bernardo Canal, played a considerable part in its

execution. But these are tentative suggestions, made in the absence of any firm evidence.

There is no contemporary support for the belief, now frequently expressed, that Canaletto relied on a large team of assistants. His reliance on the camera obscura is also referred to in almost every study of his work, but in this case modern commentators are following the words of Canaletto's contemporaries. To what extent they are justified in doing so is a difficult matter to decide.

> By his example [wrote one of them, Antonio Maria Zanetti the Younger] Canal taught the correct way of using the *camera ottica*; and how to understand the errors that occur in the picture when the artist follows too closely the lines of the perspective, and even more the aerial perspective, as it appears in the camera itself and does not know how to modify them where scientific accuracy offends against common sense. Those learned in this art will understand what I mean [*Il Professore m'intendara*].

Zanetti was a reliable writer, but in this case it is *not* easy to understand exactly what he means. Antonio Conti was less reliable and even more obscure. He wrote that Canaletto used the camera obscura (*ottica*) for his perspective views of a canal in Venice with its buildings and that it enabled him to transfer on to his canvas vistas taken from more than one viewpoint. This, he added, produced so lively an impression that at first sight of the picture you would be persuaded that you were looking at the view itself.

Here perhaps is a clue to the impression Canaletto's paintings made on those who had seen nothing like them before. G.P. Guarienti, who edited a dictionary of painters which was published in Canaletto's lifetime, wrote much the same about the effect, but was wise enough not to try to explain how it was achieved. 'He paints with such accuracy and cunning,' he wrote, 'that the eye is deceived and truly believes it is the real thing it sees, not a painting.'

The writers and critics must have longed to penetrate the secret. Those of them who knew Venice well could see how Canaletto manipulated the proportions, and often the position, of buildings so that his perspective seemed at times to vary from that of other artists. Those who knew about Art could see the gentle transitions of tone, the light and atmosphere that drenched his pictures, above all the sense of movement. Yet they knew they were not looking at the real thing but at something static. What could be the explanation?

93
Detail of Plate 92.

The celebrated connoisseur, Francesco Algarotti, must surely have hit on the answer when he wrote: 'the best modern painters among the Italians have availed themselves greatly of [the camera obscura] nor is it possible they should have otherwise represented things so much to life.' To see Venice through Canaletto's paintings was as if it was seen through the lens of a camera obscura. That, it must have seemed to follow, was the way Canaletto had himself seen it.

A camera obscura is a camera as we know it today, lacking only the film that preserves the image. It had existed in one form or another for centuries, varying only in the kind of aperture through which the image was projected and the screen on to which the image was thrown. The aperture could be a pinhole, which needed no lens, or a larger hole, which demanded a lens for focusing the image. The screen could be a white-painted wall or table or it could be a piece of ground glass or oiled paper; in the latter event the image would be reversed if you looked through the ground glass or paper, so a mirror might be inserted to correct the reversal. The kind of instrument used by artists (and it *was* sometimes used by artists, for the most part amateurs or those in a hurry to complete their preliminary sketches and get back to their studios) generally took the form of a small box, sometimes mounted on a tripod. Two such boxes are preserved in the Correr Museum, Venice, bearing the names of Canaletto and Guardi respectively, although no one seriously believes they belonged to either artist (Pl. 94). The type that is mounted on a tripod is occasionally seen in eighteenth-century engravings, and drawings exist

of most elaborate portable rooms, although there is no evidence that such contraptions were actually built. One essential of all forms of camera obscura is that the image must be seen in the dark. Unless, therefore, the viewer is in a darkened room (literally a '*camera obscura*') he must create his own by shrouding his head under a dark cloth. Another essential is that the light must be strong enough to project the image on to the screen; as every photographer knows, this means that a large aperture is needed except in bright sunlight and a large aperture means that only part of the image will be in focus. A camera obscura has its limitations.

If all these are overcome, the resultant effect is powerful, almost magical. On the two-dimensional screen the viewer sees a three-dimensional scene, in its natural colours, fully animated, reduced in size and neatly framed. (Science has since learnt to preserve that image, even keeping its animation and colour, to transmit it to or from the moon and farther, and to project it on to a cinema screen or a box in the home.) Some modern lenses can 'see' more than the human eye if necessary – a greatly magnified image or a much wider angle of vision. An eighteenth-century lens would normally project just what the human eye saw from the same viewpoint, no more and not much less. There were no 'errors' such as Zanetti said must be modified, and if, as Conti wrote, vistas were to be seen from more than one viewpoint there was no alternative but to move the instrument to the various viewpoints from which they were to be seen. The image was in fact the equivalent of a photograph and showed what McSwiney described as 'things

94
Camera obscura bearing
Canaletto's name

Lens diameter 3.3 cm
(1.3 in); image thrown on to ground
glass 19 x 21 cm (7½ x 8¼ in).
Venice, Correr Museum

There is no known authority for
the appearance of Canaletto's name
on the instrument.

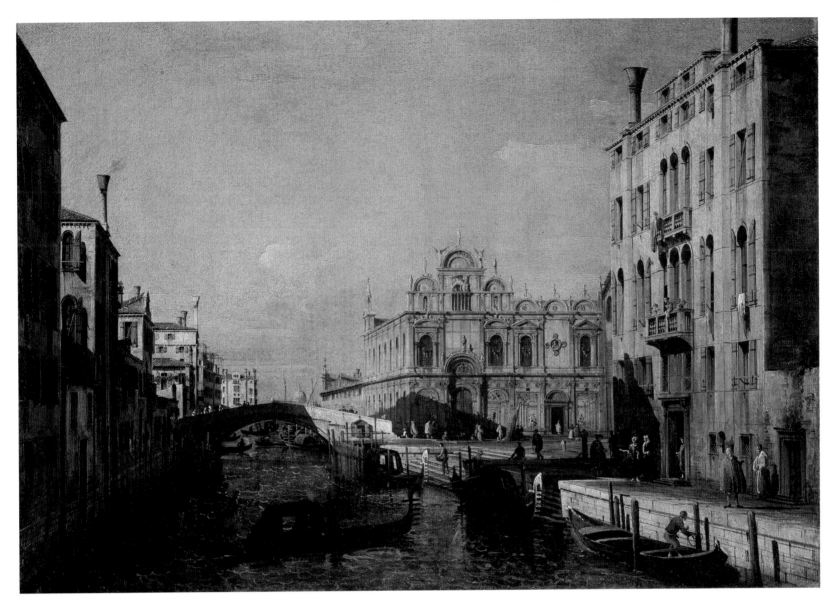

95
*Rio dei Mendicanti and the Scuola di
S. Marco*

Oil on canvas,
39 x 69 cm
(15⅜ x 27⅛ in)
Venice, Accademia

Generally, but without certainty,
attributed to Bellotto. The house
on the right appears in Plate 79
and provided the viewpoint for
Plate 25.

that fall immediately under the eye'. An artist's view of a scene, certainly Canaletto's view, is in fact very different from a photograph and it is readily apparent in most cases that it is *not* a reproduction of the view seen through a lens. Sometimes it is apparent on physical as well as artistic grounds – where the purported viewpoint is unattainable because there is no window for the artist to sit at (Pl. 18) or because it is above the water (Pl. 53) or for other reasons. But there are also instances where a camera obscura *might* have been used – a dull and lifeless picture which merely reproduces the subject photographically. There are those who claim to recognize pictures for which a camera obscura *must* have been used, but they have difficulty in passing on their ability to others, and even in explaining it.

This is not a subject that calls for dogmatism, however confidently it may have been treated from the time of Zanetti and Algarotti until the present

day. Canaletto never hesitated to use mathematical instruments such as rulers and dividers, and if optimal instruments could have helped him he would no doubt have used them. A convex glass can simplify a subject for an artist and if the glass is black (sometimes called a 'Claude glass') it helps him to see in terms of light and shade rather than colour. This can be useful in working out a composition. For a complicated skyline a piece of tracing paper held over the ground glass of a camera obscura might save much raising and lowering of the eyes, and provide a useful *aide mémoire*. In the true creation of illusion no instrument can be a substitute for an understanding of the rules of perspective and an artist's eye – especially an eye such as Canaletto's. We shall never know whether the camera obscura or other optical instruments played any part in his equipment, but we can be fairly confident that, if they did, it was an insignificant part.

IN 1742 CANALETTO signed and dated five upright paintings of Rome for Smith (Pls 113–115). They were even larger than the original Piazza and Piazzetta pictures and of an entirely different type. There was no question here of creating an illusion of being in Rome itself; they seem to have been designed as decoration rather than as an artist's response to light and atmosphere and may well have hung in a dining-room rather than in a picture gallery. However, Canaletto was still at the height of his powers and incapable of painting architecture without displaying his mastery of the subject. No one can examine the pictures without admiring the technical skill, which shows through in every brushstroke. And, as a bonus, the eye of faith may discern in the corner of one of them a self-portrait of the artist.

The Rome paintings mark a change in the course of Canaletto's painting career as abrupt as that brought about by the advent of McSwiney in the 1720s. There were to be no more paintings of Venice such as those engraved by Visentini and shipped off to England in pairs, fours or dozens. In the same year, 1742, the second edition of *Prospectus* was published and for the first time engravings were available of 24 pictures of the Grand Canal and various *campi* and churches as well as of the original 14. They were still described as in Smith's house, but most, if not all, had by this time been sold and, if the artist was prepared to accept commissions for new versions of them, it is unlikely that any were forthcoming. Smith may well have decided that, although the market for such paintings may have become saturated, there was no reason why the engravings should not find

willing buyers in Venice; his firm of Pasquali was in business to meet such a demand, as well as printing their other books.

The outbreak of the War of the Austrian Succession in 1741, spreading to Italy in the following year, no doubt contributed to the loss of trade – in pictures as in many other exports from Venice. Moreover, the English may have bought enough view paintings and Canaletto may have felt he had painted enough. Whatever the combination of circumstances to have changed the situation, a change certainly took place and Canaletto was left with virtually only one patron. It is difficult to say just when it took place – Algarotti's brother wrote to him from Treviso at the beginning of 1741 that Canaletto still demanded high prices and took years to finish paintings, but it is doubtful whether he was up to date with the position in Venice. Nor can Canaletto's movements just before 1742 be pin-pointed. It is reasonably safe to say, though, that at the beginning of the 1740s he abandoned painting for a time and devoted himself to drawing and etching. In the absence of any certainty it will be assumed for present purposes that he made a tour of the Brenta Canal, ending at Padua, accompanied by his nephew Bellotto in 1740–1, that Bellotto then went to Rome and returned before the end of 1742, that Canaletto then painted his Roman subjects and that throughout the period he was working on his etchings, which were not completed for another year. This may not be the exact sequence of events but it cannot be a long way out.

Before the Brenta tour Canaletto made four

96
Detail of Plate 97.

7 *New Fields*

97
Venice from the Punta della Motta
c. 1740

Pen and ink with wash, 15.7 x 34.6
cm
(6¼ x 13¾ in)
The Royal Collection

This immensely wide view is still
obtainable from the Sant'Elena
vaporetto (water-bus) station.

98
View on the Outskirts of Venice

Pen and ink with wash,
15.5 x 34.5 cm
(6⅛ x 13¾ in)
The Royal Collection

The dome and campanile of S.
Pietro di Castello are on the right;
little of the rest of the view
remains. The viewpoint is close to
that of Plate 97 but looking north.

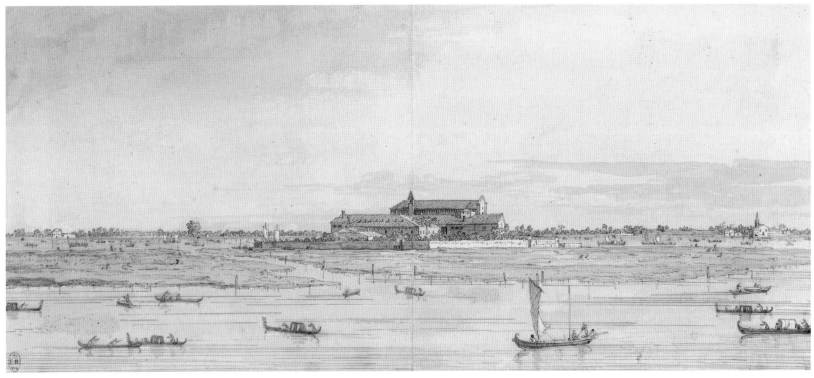

99
Islands of S. Elena and Certosa

Pen and ink with wash,
15.6 x 35 cm
(6⅛ x 13¾ in)
The Royal Collection

Looking east from much the same
viewpoint as Plates 97 and 98.
Certosa remains an island but S.
Elena is now part of Venice itself.

100
*Island of S. Elena, the Lido in the
distance*

Pen and ink with wash,
15.8 x 34.7 cm
(6⅛ x 13¾ in)
The Royal Collection

Looking southeast from near the
church of S. Anna, Canaletto could
then see the church of S. Elena and
(on the right) S. Maria Elisabetta
on the west of the Lido.

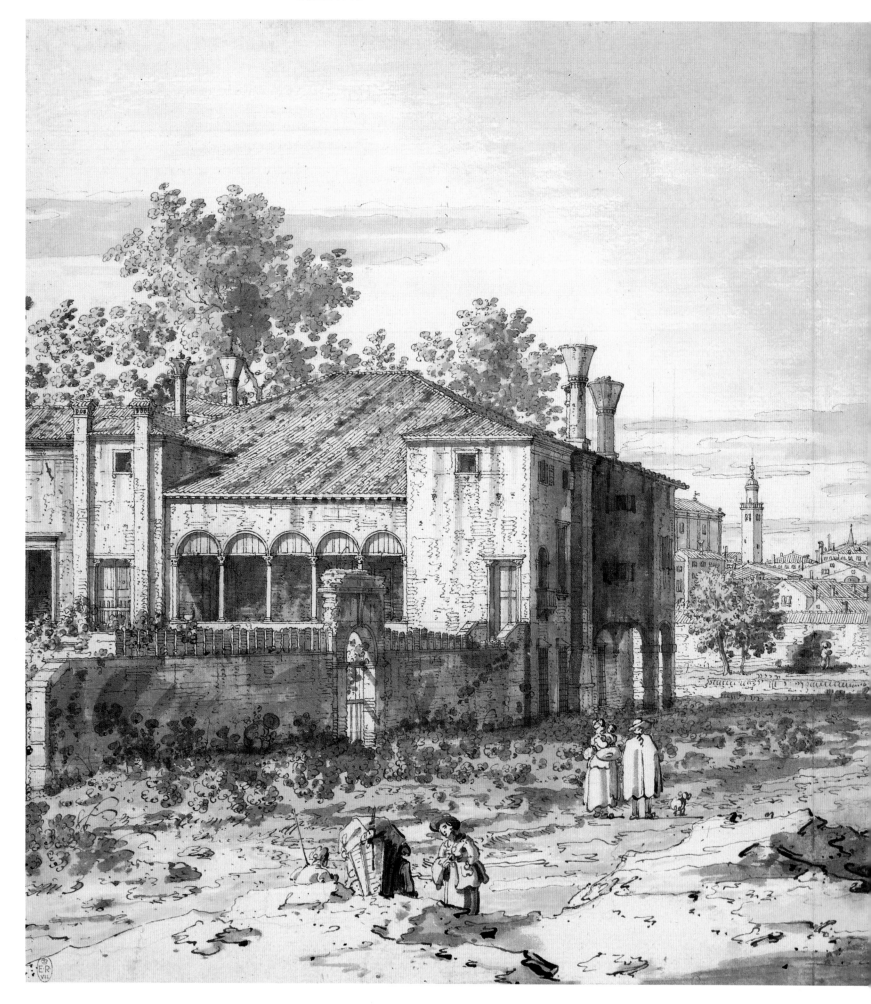

drawings of the outskirts of Venice which stand as an ample demonstration of the freshness, indeed excitement, with which he approached this new phase of his career. No part of Venice has changed as much as its eastern extremity. Here now are the Public Gardens, which Napoleon laid out and on which were later built the pavilions to house the Biennale exhibitions in art. In Canaletto's day the area had become one of sand dunes, but it was surrounded by churches, as befitted its past. For it was on the island of Olivolo, which later became Castello, that the forerunners of the Venetians had chosen to live. In the ninth century they joined the newcomers to the other islands of Rialto to form a lagoon confederation and their own island became the seat of the first bishopric of the Venetians. So it remained for a thousand years, the church of S. Pietro di Castello remaining the Cathedral of Venice until 1807, when the title passed to St Mark's, until then the chapel of the Doge's Palace.

Canaletto first drew the panorama of Venice as it can still be seen from the entrance to the Gardens, with the campanile of S. Francesco della Vigna on the right and the distant Euganean hills on the left (Pl. 97), putting on a single sheet of paper an impression rivalling his great painting of the Bacino (Pl. 78). Then he turned north and made a drawing of the island of Castello with S. Pietro and the churches of S. Antonio and S. Giuseppe (Pl. 98), both of which he had painted in Sir Robert Grenville Harvey's group. Hardly changing his viewpoint, he then drew the view to the east with the island of Certosa (Pl. 99). The fourth drawing was from a point farther north,

showing the island of S. Elena and the Lido with S. Maria Elisabetta, which still stands (Pl. 100). Having completed these moving and beautiful drawings, there was no more to be said about the subject and no painting or etching exists which can be connected with them.

Needless to say the four drawings went to Smith. He did not need to be reminded of Canaletto's mastery of the pen; he already owned more than sixty examples, among them the finest drawings of Venice hitherto made, which have seldom, if ever, been surpassed. Nevertheless he cannot have failed to be surprised by the artist's sensitive response to what was, to a Venetian, an almost pastoral subject. Canaletto had painted capriccios with rural settings by this time, how many it is impossible to say, but only once had he gone on to the mainland and made drawings from nature which resulted in a painting. The drawings, or sketches, have not survived, but the painting is the view of *Dolo on the Brenta* of which there are two versions, one in the Ashmolean Museum, Oxford. This is generally regarded as belonging to the period around 1730, the dating being based on style and on the supposition that Canaletto would not in the early 1740s have painted with the free brushstrokes he had by that time abandoned in favour of the crisper style which he had been developing throughout the 1730s. It is no more than a supposition, though, and assumes that Canaletto paid a visit to the mainland at a time when he was at his busiest, painted one picture only and then returned. This was an easy journey – the *burchiello*, which often appears in the paintings, plied between Padua and Venice every

101
A Farm on the Outskirts of Padua

Pen and ink with washes,
31.5 x 40 cm
(12⅜ x 15¾ in)
The Royal Collection

The buildings of Padua in the background are identifiable; the farmhouse may be real or imaginary.

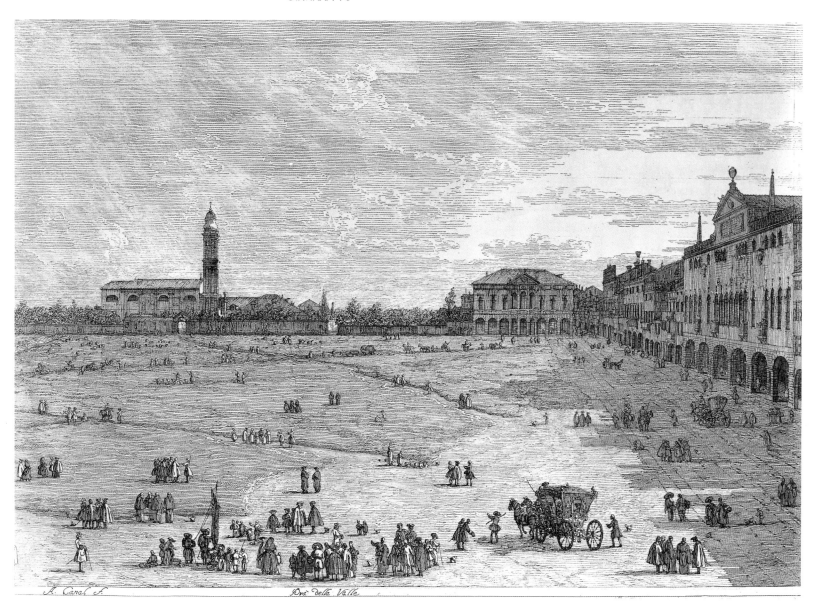

A. Canal F. Prà della Valle

day – and a generous commission might well have made it worth while. Nothing is known of the picture's early history and the problem is complicated by the existence of another version, in much better condition than the Ashmolean Museum's, which looks as if it might date from 1740 or 1741 (Pls 105 and 106). Nor is it made any easier by the fact that Bellotto, who was a child in 1730, painted a third version, which has topographical features present in Canaletto's second, but not his first, painting.

The explanation which fits in best with such evidence as there is must be that Smith encouraged Canaletto to make a tour of the Brenta as far as Padua, to take his 20-year-old nephew with him and to see what came of the journey. All that came of it in the way of painting was one, or just possibly both, versions of *Dolo on the Brenta* together with Bellotto's, and a painting

of *Padua: the Brenta Canal and the Porta Portello* (Pl. 104), which may not have been done until much later.

But the journey was fully justified. There were 30 or so drawings from nature which show Canaletto extending his range of subject in a way that might have seemed impossible during the 1730s. Then there were scenes and details which were stored in his memory and provided material for the capriccios which he was to produce throughout the rest of his career. Above all, the freshness of the scenes along that fascinating stretch of water, lined with the country houses to which the Venetians hurried when the summer heat became intolerable to them, stimulated Canaletto's imagination prodigiously. It is to the inspiration of this breath of the countryside, away from the pressures of the studio, that we must owe many of the marvellous series of

102
'Prà della Valle'

One of the two etchings that followed Plate 103.

103
Padua: the Prato della Valle with S. Giustina and the Church of the Misericordia
c. 1740

Pen and ink,
27.1 x 74.3 cm
(10¾ x 29½ in)
The Royal Collection

Originally two sheets of paper joined together, later separated. Now the Piazza Vittorio Emanuele, most of the buildings are still identifiable.

Overleaf:
104
Padua: the Brenta Canal and the Porta Portello
c. 1740

Oil on canvas,
59.7 x 106.7 cm
(23½ x 42 in)
Washington, DC, National Gallery of Art (Samuel H Kress Collection)

The Porta Portello (now the Porta Venezia), in the centre, still stands on the eastern edge of Padua and there are traces of some other buildings.

etchings even though they may not have been completed until after the travellers' return.

Bellotto's apprenticeship was by now almost over; there was little more that his uncle could teach him about painting, and the moment was approaching for him to leave the studio and make his own voyage of discovery. As a draughtsman he had already learnt a great deal, but the opportunity of learning more by accompanying Canaletto to Padua must have been irresistible, even at the cost of delaying the start of his career as an individual painter. As to etching, he had had no experience – but there is no certainty that Canaletto himself had done more than toy with the needle before 1740. There are no diaries, letters or dated drawings to prove that in 1740 or 1741 the two artists were together on the mainland; on the other hand there are many drawings by Bellotto of the same subjects that Canaletto drew and there are even a number of etchings which are signed *B.B.detto Canaleto fe. 1741–2*. The evidence seems enough to justify an assumption that they were together.

Bellotto's use at this early stage of the name 'Canaleto' is of interest in the light of later events. It shows almost conclusively that he had his uncle's approval for the practice, and there may even have been some idea in the minds of both of setting up a studio in that name. The suggestion was later made that there was an intention to deceive and this has persisted until the present day. Confusion has certainly been caused and in Poland the name 'Canaletto' is generally taken to mean Bellotto even now; this can even be said of Germany and Austria. On his mother's side Bellotto was of course a Canal and, being a generation younger

than Antonio Giovanni Canal, it might have been logical for him to take the diminutive and expect his uncle to drop it. His use of the word '*detto*' (called) in the signature implies that he was used to being called Canaletto and this may well have been true. It is difficult to be precise about the use of names at a time when there was so little precision, and even less about their spelling (like his uncle, Bellotto was at times also called Canaletto, Canaleto and Canaletti). When Bellotto later travelled to eastern Europe, the celebrated name of Canaletto would certainly have been no handicap and, again like his uncle, he came to abbreviate the word '*detto*' into '*de*' with a clear implication of aristocratic descent. It was later said that uncle and nephew quarrelled and that a prime cause of the quarrel was Bellotto's exploitation of Canaletto's name. There is no evidence that a quarrel ever took place, and the etchings provide good reason to believe that the nephew took the name with his uncle's blessing. In due course Bellotto's son, Lorenzo, was known as 'the young Canaletto', also doubtless with his father's blessing.

As in the case of the etchings, the drawings of Canaletto which derived from the Brenta journey can be easily divided into scenes from nature, or reality, and those which are entirely from the imagination. There are in addition those which cannot with any certainty be placed in either group. These drawings seem to result from the stimulation of the artist's imagination by the country and the buildings he had seen, while leaving him free to design a harmonious composition depending solely on pictorial quality.

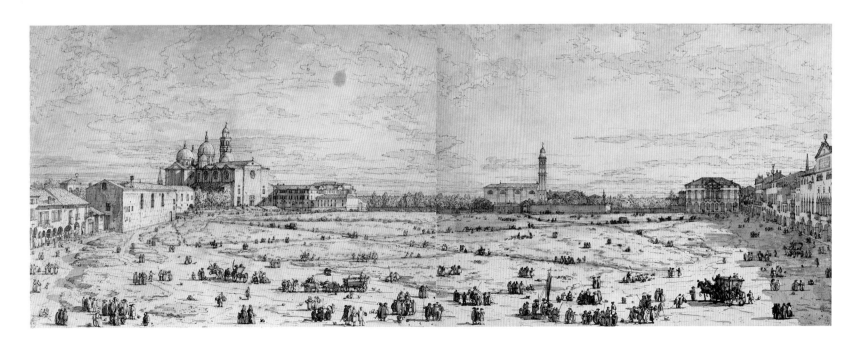

An example is *A Farm on the outskirts of Padua* (Pl. 101), in which few known buildings have been identified although there is a distinct sense of their having existed and been seen. The drawing is in ink and pencil, over which a grey wash, and in some places double wash, has been added. Dividers have been used to make the curves of the arches accurate and a ruled ink border-line has been added as a kind of frame. All the signs of a studio product are evident, but no one can say whether Canaletto used his own studio after returning to Venice or a makeshift one in an inn or in a friend's house in Padua. Splendid in design and execution, the drawing stands on its own, having no association with any of the etchings or other drawings, nor was it copied by Bellotto, as were so many others.

Best known of all the drawings of the journey is the *Prato della Valle* (Pl. 103) in Padua, a gigantic

open space now called Piazza Vittorio Emanuele, but it is not easy to believe one is in the same place or that so many of the buildings have survived. It was drawn on two sheets so that it was three-quarters of a metre wide although only 27 centimetres high; not surprisingly, the sheets were soon divided and so they remained until shown together in the 1981 exhibition of Smith's collection in the Queen's Gallery, London. Wash has been added, as in the *Farm on the outskirts of Padua*, and red chalk and pencil have also been used. In spite of the width of the paper, Canaletto found it necessary to cram the figures and some of the buildings into the composition and it must have been with relief that he turned to making a pair of etchings of the scene almost half as big again in both height and width (Pl. 102). The difficulties of dating either the mainland drawings or the etchings with accuracy are insuperable, but

105
Dolo on the Brenta

Oil on canvas,
80 x 95.3 cm
(31½ x 37½ in)
Stuttgart, Staatsgalerie

Canaletto painted two versions of this rural scene and was followed by Bellotto and Francesco Guardi. Although much has changed, the viewpoint is easily identifiable today.

106
Detail of Plate 105.

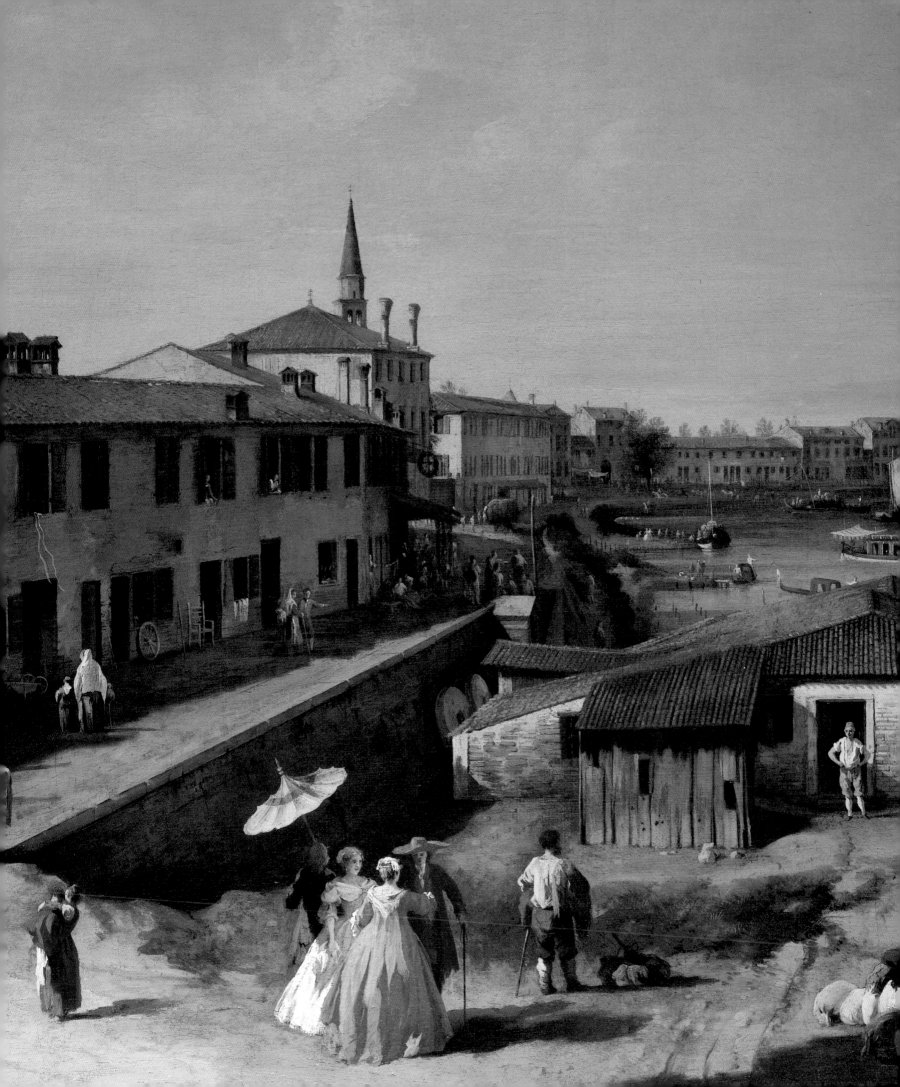

the *Prato della Valle* drawing seems certainly earlier than the etching, itself one of the earlier of those to be executed.

Much later, Canaletto returned to this rather ungainly subject; perhaps it was the profusion of figures which endeared it to both artist and patron. There are at least six paintings which derive either from the drawing or the etchings. One of them was bought by no less a connoisseur than G.B. Tiepolo, an almost exact contemporary of Canaletto who survived him by two years. This is as wide as the two etchings together, but was given added height to provide a more balanced proportion. Some of the paintings have been attributed to Bellotto, but without convincing reasons, nor can they all be ascribed to Canaletto with any certainty. As has been seen in the case of Visentini's engravings of the Grand Canal paintings, once a picture has been reproduced and proved popular, a number of paintings are apt to appear, some of sufficiently high quality to justify attribution to the master himself, some that are obviously the work of imitators, and a few that cause some scratching of the head. The *Prà della Valle* (the title, for once, is Canaletto's, added in his own hand to the etching, as was his practice in the case of etchings of real subjects) is not the only painting to have derived from the Brenta journey; at least four other etchings which came from it later became the subjects of paintings. *Dolo on the Brenta* stands alone, though, as the only painting for which there is neither drawing nor etching, and the earliest version of this, as has been seen, may have been painted long before 1740. The assumed sequence of events before 1742 has

already been set out. The only firm date is that of *MDCCXLI* which, followed by the initials *A.C.*, appears on a house in one of the etchings; since we do not know which drawings or etchings came before it, and which after, this is not very informative.

An event of some significance took place in 1741. This was the appearance of a competitor, the first since the death of Carlevaris in 1730. Michele Marieschi was born in Venice in 1710; in 1731 he designed the structure for the Giovedi Grasso festival in the Piazzetta (see Pl. 4), the only known justification for the title of '*Architectus*' which he claimed. His marriage and the birth of a daughter are recorded and from 1736 to 1741 his name was entered in the *Fraglia* of Venetian painters. His only known patron as an artist was Marshal Schulenburg who bought 12 of his paintings. In 1741 Marieschi published 21 etchings of Venetian views. They would seem to be original works of art in that none follows any known painting which can claim to be by Marieschi – unlike Visentini's engravings which were all described as done from paintings in Joseph Smith's house. Nevertheless, the title-page of the etchings (Pls 107 and 108), which were published under the name *Magnificentiores Selectioresque Urbis Venetiarum Prospectus*, described the etchings as 'for the most part' based on his paintings. No such picture has been identified although there are plenty which follow the engravings; this is hardly surprising, bearing in mind the well-known practice of unimaginative, though skilful, painters of copying available subjects. The matter is complicated by

the discovery a few years ago that Marieschi's assistant, Francesco Albotto, married his master's widow after Marieschi's untimely death and carried on his practice. There is no shortage of scholars who claim to be able to distinguish between the paintings of Marieschi himself, Albotto, and mere followers but the ordinary admirer of Marieschi's work will be content to acknowledge that, although he must have been a painter, we are able to judge him only by his etchings which are of a high, in some cases, superb standard. He was attracted, as the early Canaletto had been, by the theatricality of a scene which he exaggerated by taking a close viewpoint. This resulted in steep foreshortening and a wide angle of vision (Pls 109–111); in a way he anticipated the romantic or picturesque taste of a later period. His figures are curiously unrelated to their background and he may well have turned to other artists for them. It has even been suggested that he worked with Francesco Guardi, but the only recorded link between the two came nearly 50 years later when the aged Guardi was called in to express an opinion as to whether some pictures were or were not of the 'Marieschi school'.

Publication of Marieschi's etchings must surely have led to commissions for paintings which would otherwise have gone to Canaletto and it can hardly have been coincidence that in the following year Smith issued the second edition of Visentini's *Prospectus*, which he must have had available for several years. If the intention was to draw attention to Canaletto's continued availability as a view painter, nothing came of it. If such work as there was went to Marieschi he had

but a short time to enjoy his success for by January 1744 he was dead after an eight-day illness; this was said to be due to overwork, but we have no indication of what kind of work he was doing. Marieschi's departure from the scene was as sudden as his entrance and we can but guess how news of it was received by Smith and Canaletto.

Canaletto's five large paintings of Rome in Smith's collection have already been mentioned (p. 120). All are signed, *ANT. CANAL* and dated 1742 or 1743 – the first paintings Canaletto had signed and dated. In addition, Smith had 11 Roman drawings, some partly fanciful, which must belong to much the same date and a few paintings of Rome have since been found in other collections.

Were they painted or drawn in Rome following a visit there in the early 1740s? There is no evidence of such a visit although every likely source has been explored; Canaletto was one of the most celebrated artists in Italy at the time and it is hard to believe that he could have been in Rome without any reference surviving in a diary, newspaper or official document.

Bellotto certainly left Venice at this time and visited Rome. He also went to Florence, most probably on the way to Rome, and left six paintings of that city as evidence (Pl. 112) – the first paintings he had had to compose for himself, unless the Academy view of the *Rio dei Mendicanti* (Pl. 95) is really his own work. From Florence Bellotto went on to Lucca, where he made five drawings, one of them used for a painting, and thence to Rome. There he may have met Piranesi, who had been living in Rome since 1740 and had

108
Dedication page of Marieschi's album of etchings, with a view of the Molo from the Mint to the Prison.

Platea ac Templum D:D: Joannis et Pauli et proxime magnum Sodalitium D: Marco Eu: dicatum: eminet in medio statua equestris ænea Bartholomæo Colleonio erecta ex S.C. Michl Marieschi dell et inci

109
Michele Marieschi
SS. Giovanni e Paolo and the Scuola di S. Marco
Etching

See Plate 25 for Canaletto's version. Two very small horses are standing below the Colleoni statue.

Forum minus Divi Marci publicis ædificiis utrinque insigne. Michl Marieschi del et inci

110
Michele Marieschi
The Piazzetta to the South
Etching

The steep foreshortening is characteristic of Marieschi's work.

111
Michele Marieschi
S. Geremia, Palazzo Labia and the entrance to the Cannaregio
Etching

In the foreground passengers from and for the *traghetto* (ferry) are crossing the Riva di Biasio.

Pars Canalis magni se extendens a læua usquè ad palatium familiæ Valaressæ; at è fronte caput Canalis regij, et ultrà pontem Hebræorum Domicilium

112
Bernardo Bellotto
(1720–80)
Florence: Piazza della Signoria towards the Palazzo Vecchio
c. 1740

Oil on canvas,
62 x 90 cm
(24½ x 34½ in)
Budapest, Museum of Fine Arts

Probably painted in Florence or later from drawings made during Bellotto's first journey on his own.

just returned after a short visit to Venice; he was born in the same year as Bellotto and both were at the threshold of their careers.

More than 15 paintings and a number of drawings came out of Bellotto's visit to Rome, apart from the many sketches he would have made and which have not survived. Some of the paintings are naturally devoted to the ancient monuments, the Forum with its ruined temples and arches, but he also painted parts of modern Rome such as the Capitol, the Piazza Navona and the Spanish Steps, and there were views of the Tiber and capriccios.

Not all these paintings were necessarily finished in Rome. Some may have been painted, at least partly, in Venice in Canaletto's studio, which Bellotto was probably still sharing. If Bellotto could paint Roman subjects away from the city, using his drawings made on the spot (as he certainly was to do years later, after he had left Italy for good), why then should Canaletto not base his paintings on the same drawings? The difficulty here is the date on Canaletto's five paintings (Pls 113–115). Bellotto is recorded as having exhibited two paintings at the Scuola di S. Rocco in August 1743, but he cannot have been back in Venice much before the end of 1742 at the earliest.

They therefore remain somewhat of a mystery, but this does not detract from their quality. Their lack of atmosphere, the stiffness of the figures and their decorative nature incline a visitor to Windsor to turn away from them in favour of the surrounding masterpieces. Nevertheless, these five paintings are masterpieces of their own kind.

Their cool harmony, their luminosity, especially now that they can be seen in pristine condition, and the technical mastery of the architectural painting establish that Canaletto had lost little of his cunning. He may have said all that he had to say about Venice, and he would never paint another 'Stonemason's Yard', but as a view painter he still, in the words of Charles de Brosses in 1739, surpassed everyone there had ever been.

Canaletto had not quite done with Venice and in each of the following two years he painted a pair of views for Smith which may have been their joint reply to the appearance of Marieschi's book of etchings. Each of the first pair is inscribed *A.Canal Fecit XXIV Octobris. MDCCXLII*, perhaps the date of delivery to Smith; the month is omitted from the second pair, dated 1744. All four were copied by Visentini and engravings from them were duly published. These engravings were much larger than those of *Prospectus*, and were no doubt intended both to provide publishable material for Smith's firm of Pasquali and to announce that Canaletto was available to accept commissions if there were any collectors still requiring Venice views.[4] To emphasize this, under each title (in Latin) the engraving added *apud* [at the house of] *Josephum Smithium*.

One of the 1743 paintings shows the view along the Molo from a point in the Lagoon opposite the present Danieli hotel (Pl. 116). It embraces far more than any previous view of *The Molo to the West*, showing the whole of the Prison on the right and part of the Granaries on the left. However, this is the view that the eye sees without moving, or that a normal camera lens can

NOTE
4 Visentini's drawings still exist in the Correr Museum, Venice, together with his drawings for the engravings in *Prospectus* and for four other paintings which were not in the event published. In the British Museum is a second set of the drawings, in much greater detail and almost indistinguishable from the engravings themselves (which for many years they were thought to be); this set does not include drawings for the four larger engravings from the set of 1743–4 paintings.

113
Rome: Ruins of the Forum, looking towards the Capitol
Signed and dated 1742

Oil on canvas,
188 x 104 cm
(74 x 41 in)
The Royal Collection

Visitors on the Grand Tour are studying the ruins of the Temple of Castor and Pollux; beyond is the Temple of Saturn.

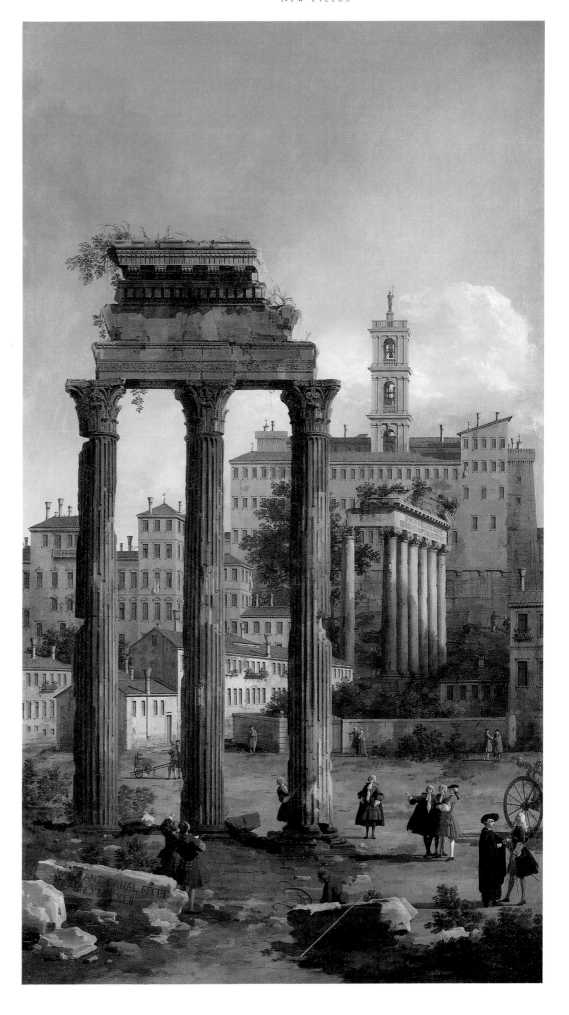

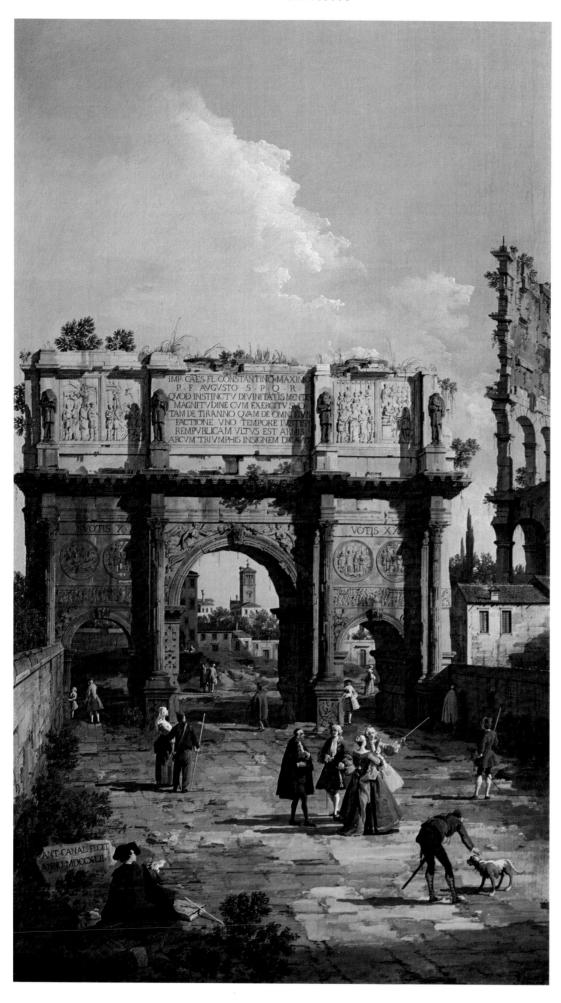

114
Rome: the Arch of Constantine
Signed and dated 1742

Oil on canvas,
181.5 x 103 cm
(71½ x 40½ in)
The Royal Collection

Through the arch, which has been
reversed in order to show the
inscription, is the church of
S. Pietro in Vincoli. Perhaps the
figure in the foreground is a self-
portrait.

SENATVS
POPVLVS QVE ROMANVS
DIVO TITO DIVI VESPASIANI F
VESPASIANO AVGVSTO

ANT. CANAL FECIT
ANNO MDCCXLII

115
Rome: the Arch of Titus
Signed and dated 1742 on the
foreground stone

Oil on canvas,
190 x 104 cm
(74¾ x 41 in)
The Royal Collection

Through the arch is the wall of the
Farnese Gardens; in the distance
the Temple of Castor and Pollux.
The Grand Tourists contrast with
the beggars in the foreground.

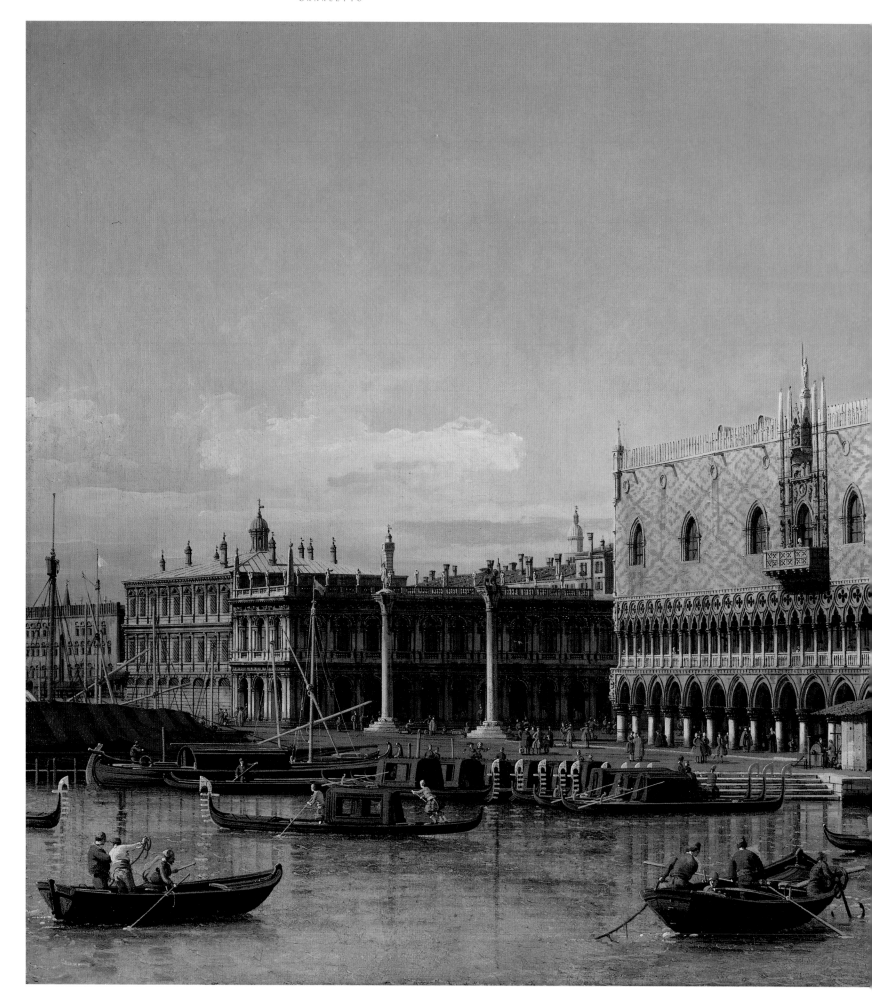

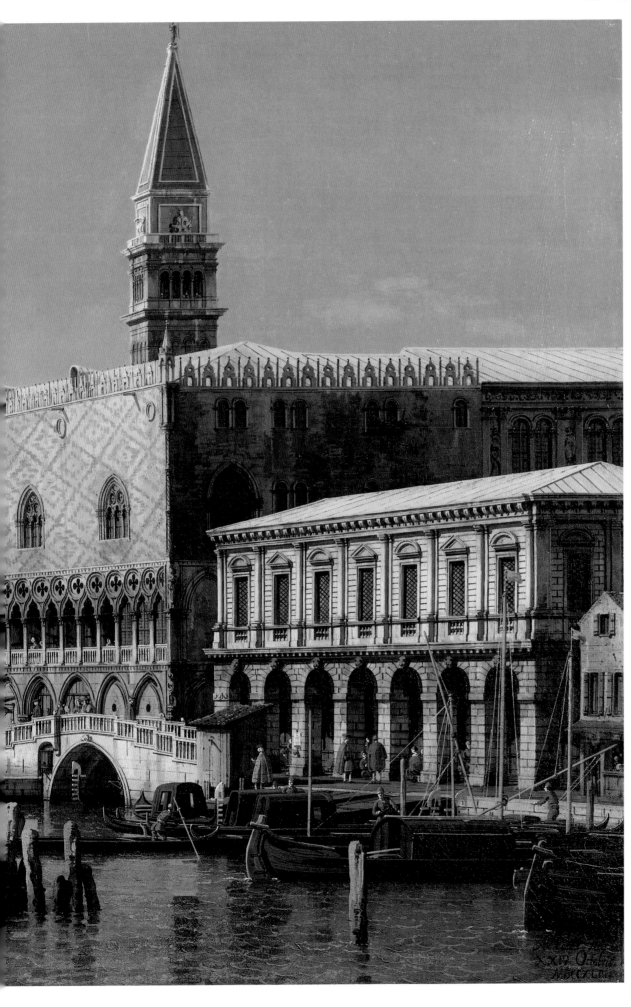

116
*The Molo: looking West, with the Doge's
Palace and the Prison*
Signed and dated 24 October 1743

Oil on canvas,
60.5 x 95.5 cm
(23¾ x 37½ in)
The Royal Collection

Probably Canaletto's last portrayal
of this familiar group of buildings.

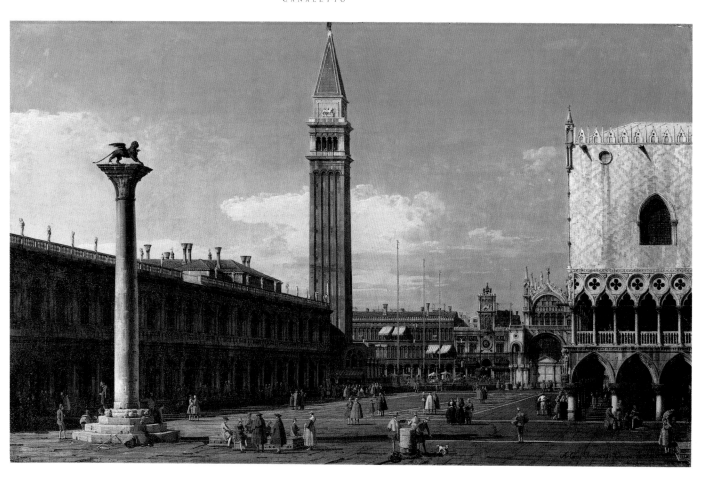

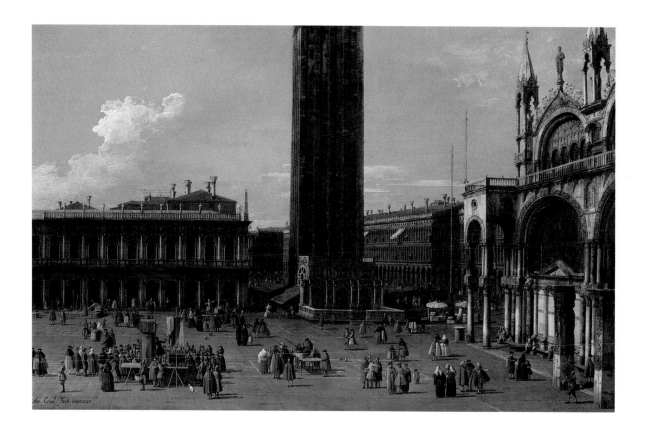

117
The Piazzetta: looking North
1743

Oil on canvas,
58.5 x 94 cm
(23 x 37 in)
The Royal Collection

Signed and dated as Plate 116 but
closer to Plates 118 and 121. In the
foreground is a group examining
the birds in coops. The Column of
St Mark is out of place.

118
Piazza S. Marco: looking West from the
North End of the Piazzetta
Signed and dated 1744

Oil on canvas,
77.5 x 119.5 cm
(30½ x 47½ in)
The Royal Collection

An artificially wide-angled picture
with an unusually large number of
figures.

119
Detail of Plate 117.

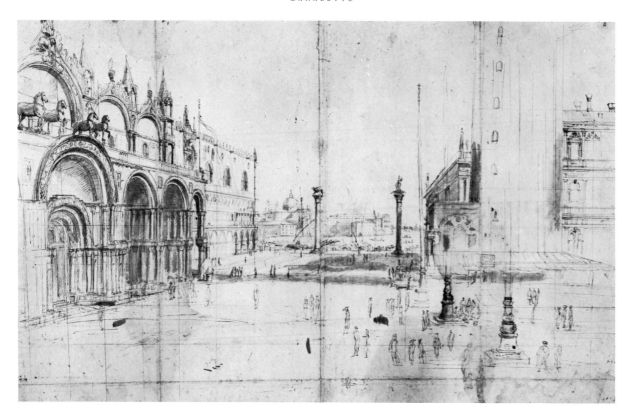

include. It is topographically accurate to an extent hardly paralleled in Canaletto's panoramic pictures and would make a highly desirable memento of any traveller's visit to Venice. It is surprising that Canaletto had never painted the scene before and not at all surprising that a host of imitators seized on the engraving and made copies of it from the eighteenth century until the present day. Lord Carlisle found himself with one of the copies in his miscellany (see p. 95); this went up in flames at Castle Howard in 1940. Only one other version by Canaletto himself seems to have found a buyer; these were hard times for suppliers of the genuine article to the few who could afford to buy it.

The picture bearing the same date, and therefore intended as companion, is *The Piazzetta: looking North* (Pl. 117). It is in fact in no way companionable and fits in better with the first of the later pair, *The Piazza from the Piazzetta* (Pl. 118). The 1744 date on this second pair presents another puzzle. The Venetian year began on 1 April and within two months of this date in 1744 Smith was to realize his life ambition of becoming Consul to His Britannic Majesty, a title he proudly displayed on the title-page of Canaletto's etchings. Being Joseph Smith, it is almost inconceivable that he would have omitted the title on the four Visentini engravings if he was justified in using it, or that he would have published them without the title if he had known how soon the prize would be his. Either the date of the paintings is not the date of execution or they were copied, engraved and published between 1 April and 9 June, by which date Smith certainly knew of his appointment.

Both Piazzetta pictures are unsatisfactory. They have the 'wide-angle' appearance that Marieschi

120
Vanvitelli (1653-1736)
Piazza S. Marco: looking South

Pen and ink,
47 x 77 cm
(18½ x 30¼ in)
Rome, Biblioteca Nazionale

Probably drawn before Canaletto's birth, yet the resemblance to his painting (Plate 121) is striking. Perhaps a preparatory drawing for a lost painting.

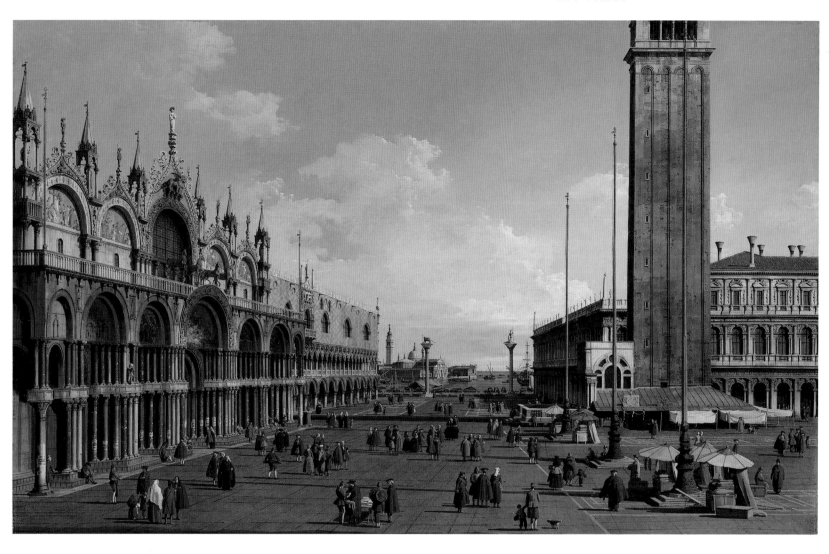

121
Piazza S. Marco: looking South
Signed and dated 1744

Oil on canvas,
76 x 119.5 cm
(30 x 47 in)
The Royal Collection

Surprisingly close in composition
to Vanvitelli's drawing (Plate 120).

favoured; that is to say, the observer purports to
be standing close in to the scene but taking in far
more than his eyes can see without moving
around. The effect can be achieved by taking two
widely separated viewpoints (impracticable in the
case of the second picture), but Canaletto is more
likely to have built up his composition entirely in
the studio. He has put the St Mark column in a
place of his own choosing, made the window of
the Doge's Palace too small and put it too far to
the left. The second picture gives the impression
of being a view from the loggia of the Doge's
Palace but it has again been built up arbitrarily.
None of these topographical inaccuracies is of any
consequence; they do no more than exaggerate a
practice Canaletto had long been following. The
paintings fail for quite other reasons: the figures
are puppets rather than people but, more
important, the Venetian light is missing for the

first time in Canaletto's work. There is a
temptation to say that these two paintings mark
the beginning of Canaletto's decline.

The same mannerism in the figures pervades
the last of the second pair, *The Piazza: looking
South* (Pl. 121), but the interest here is historical
rather than pictorial. For the picture bears a quite
uncanny resemblance to Vanvitelli's drawing of
half a century earlier (Pl. 120). Both purport to
be from a window in the Clocktower, but in fact
take two viewpoints. Both make the background
seem farther away than it is but Canaletto takes an
additional step: he brings in the Campanile of
S. Giorgio Maggiore, which is invisible from
either viewpoint. Vanvitelli showed no more of
the Campanile (of St Mark's) than would in fact
be visible, whereas Canaletto includes the lower
part of the windows (Visentini went higher still
in his engraving and showed the belfry and

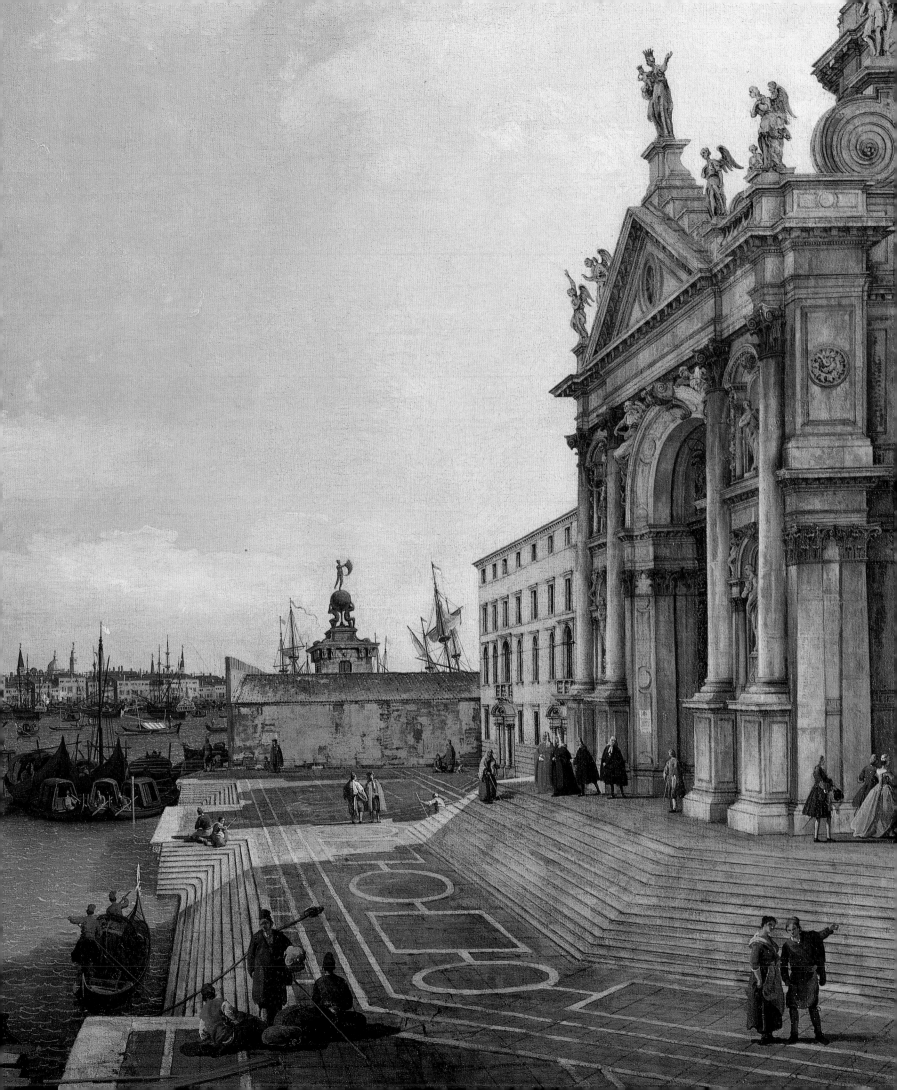

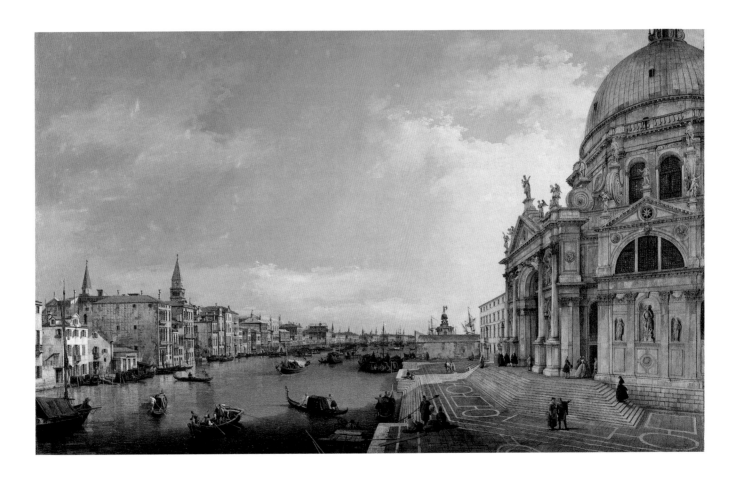

122
Detail of Plate 123.

123
Entrance to the Grand Canal: looking East
Signed and dated 1744

Oil on canvas,
127 x 203 cm
(50 x 80 in)
The Royal Collection

Canaletto's last, and in many ways his finest, version of this familiar subject. Compare the buildings on the left with those in Plate 67.

Canaletto, it will be remembered, had shown the entire Campanile 20 years earlier – see Pl. 23). Yet Canaletto can hardly have seen Vanvitelli's drawing; either he had seen a painting based on it which has not survived or, more probably, the resemblance is coincidental.

Canaletto painted one other Venice view for Smith which he inscribed *A Canal F. 1744* (the initials in monogram), *The Grand Canal: looking East* (Pl. 123). If the Piazzetta pictures mark the beginning of his decline, this, painted in the same year, might be said to be the climax of his career as a view painter. The viewpoint appears to be much the same as one of the original 12 Grand Canal pictures in *Prospectus* (Pl. 67), but instead of being less than half a metre high it is more than a metre and a quarter and correspondingly wide. From the beginning it must have been conceived as a painting of high

importance, on a grander scale than any Venice view except *The Grand Canal with S. Simeone Piccolo* (Pl. 92) in the National Gallery, London, which is much the same size. It differs from the *Prospectus* version not only in scale, but in taking the spectator farther up the Grand Canal on the left so as to include a series of palaces (mostly now hotels) which would not really be visible from the assumed viewpoint. Canaletto was generally at his best when working on a large scale, as this picture superbly demonstrates. A shaft of sunlight strikes the steps of the Salute and the Canal just in front of the Patriarchal Seminary in a way that recalls the shaft which the artist saw when making his drawing for Stefano Conti's Rialto Bridge picture, and which he marked *Sole*. After 20 years he could still make the sun shine in his pictures as could no other artist of his time.

CANALETTO'S DRAWINGS of the eastern outskirts of Venice, of the Brenta and of Padua cannot have been conceived with the tourist-collector in mind. More probably they came from a wish on Smith's part to find an occupation for Canaletto after his abandonment by the English and at the same time to enlarge his own collection; the respite after ten years of studio pressure may well have been welcomed by both. Nor can Smith have wanted or expected to sell the Roman paintings; they show every mark of an integrated decorative scheme for one room. The four paintings engraved by Visentini, on the other hand, seem to have come into being purely as a commercial venture. Smith can hardly have wanted any more views of Venice – if he had, he would scarcely have sold all the originals but one of the second edition of *Prospectus*. He may have wanted the huge view from the Salute as the pinnacle of his collection of views, but the others were clearly designed for sale, both as engravings and paintings, quite possibly with Marieschi's success in mind. The object does not seem to have been achieved. All four original paintings remained in Smith's collection and, if any other version was commissioned, it has not survived except for one version of the *Molo* painting – the others do not appear even to have attracted the imitators. The engravings, too, were a failure. Within seven years yet another edition of the *Prospectus* series was to be called for and in 1833 another (to this day they are being printed, occasionally from the original plates). Yet the four large engravings are such a rarity that at one time it was doubted whether any had survived.

Smith's loyalty to Canaletto was now under test. He no longer had first call on the services of an artist who was 'so much followed' that all were 'ready to pay him his own price for his work'. Instead, he had an associate, if not a friend, of 20 years standing, for whose work there was little demand but for whom he must have felt some responsibility. Canaletto evidently had little saved from the good years; records of family transactions involving settlement of debts are concerned with pathetically small sums and the properties in the Corte Perini were bringing in less annually than the price of one picture. Moreover his father had died of apoplexy on 12 March 1744, leaving two unmarried daughters unprovided for, and perhaps a widow (we do not know when Artemisia died). From a financial point of view this may have been a relief: Bernardo Canal was 70 and his assistance in the studio was no longer needed.

It is hard to judge Smith's own circumstances at the time. War was liable to flare up at any point in Europe and in the same week as Bernardo died France declared war on England. Smith's international business must have been reduced in some directions, but war generally brings opportunities to a shrewd man of affairs. There are records of his selling unidentifiable paintings to the Elector of Saxony in 1741; they may have been treasures he was unwillingly forced to part with, but they may equally have been the culmination of some profitable business deal. The latter is perhaps more likely, since he soon after bought a collection of Dutch and Flemish pictures from the widow of the artist Pellegrini and found himself in possession of Vermeer's *Lady at the Virginals* (or

124
Detail of Plate 128.

8 *A Friend in Need*

The Music Lesson, now one of the glories of the Queen's collection). Either out of kindness towards a friend in reduced circumstances or (as his enemies would no doubt have said) to satisfy his acquisitiveness, he now gave Canaletto a commission which m ust have kept him busy for quite a time.

This was for 13 'pieces over doors', as Smith described them in his own catalogue, which were to 'contain the following most admir'd Buildings at Venice, elegantly Historiz'd with Figures and Adjacencys to the Painters Fancy'. The list that followed varied from a terse naming of the monument ('The Publick Prison at St Mark's') to a flowery description of the various elements which made up the picture, turning it from a straightforward view to a capriccio. For capriccios they all were, some more than others, and it was at about the same time that Smith commissioned a series of English Palladian buildings from Zuccarelli and Visentini, all in caprice settings. Eight of the latter remain in The Royal Collection, whereas four of Canaletto's pieces have been separated or lost.

The quality of the 'overdoors' varies and there is throughout an absence of liveliness or, in some cases, of care. It must be remembered, though, that they were intended as decoration and to be seen from a distance; the mannerism of the figures may therefore be forgiven. Technically one of the poorest is *The Ponte della Pescaria* (Pl. 125), to which have been added, in Smith's words, the 'two Colossal Statues by Titian Ospetti [in fact Aspetti] which now stand obscurely behind the doors of the entrance into the Zecca'. The Zecca

now houses the Marciana Library, still guarded by the statues, and if, as seems probable, the rest of the picture follows the facts, it is at least of topographical interest. Venice lovers are forever intrigued by the changes that have taken place in that short stretch on the Molo between the Library and the little coffee-house erected by Napoleon just in front of the Fonteghetto della Farina (originally the office of the Magistrato della Farina, the wheatmaster, then the first home of the Academy of Fine Arts and now the Port Authority's offices). Between the Zecca (Mint) and the Granary, both of which appear in so many of Canaletto's paintings and drawings, we catch a glimpse of the back of the buildings of the Procuratie Nuove in the Piazza before they were converted into a royal palace and the present gardens laid out in front of them. The Ponte della Pescaria is the bridge which Canaletto was so apt to move according to his fancy in his pictures of this part of the Molo (see Pl. 48) and which can still be seen in early photographs. Since no one now needs to use the Rio di Zecca to get to the water entrance of the palace (still to be seen, its glory faded), it has been removed and replaced by a ramp which few notice. The bridge took its name from the fish market which was held here for centuries and which, by Canaletto's time, seems to have had a general market added to it (poultry in cages are often seen in his pictures).

Another of the 'overdoors' (Pl. 126) is apparently from a point close to the north side of the Rialto Bridge with a glimpse of the Fondaco dei Tedeschi on the left and the Palazzo dei Camerlenghi on the right (closer in than the

125
Capriccio: the Ponte della Pescaria and Buildings on the Quay
1742-4

Oil on canvas,
84.5 x 129.5 cm
(33¼ x 51 in)
The Royal Collection

One of Smith's 13 'overdoors'. Apart from the statues, which have been taken from the Library, the painting substantially follows the facts.

126
*Capriccio: a Palladian Design for the
Rialto Bridge*
Signed 1742-4

Oil on canvas,
90 x 130 cm
(35½ x 51⅛ in)
The Royal Collection

The design follows Palladio's
published engraving of his
proposed bridge but the other
buildings accord with the facts.

viewpoint of the other versions of *The Rialto
Bridge from the North*). However, instead of the
bridge we know, there is the bridge designed by
Palladio for 'a city which is one of the greatest
and most noble in Italy', by which he could mean
only Venice. Neither Palladio's design, nor that
of Michelangelo, who also competed, was
chosen, the contract going to Antonio da Ponte,
who built the bridge in 1588–90. With all its faults
(due more to the shops on it than to the bridge
itself) da Ponte's single-arch bridge seems
preferable to Palladio's, but it was an ingenious
idea of Smith's to have Canaletto show what
might have been.

But was the idea Smith's? In 1759 Francesco
Algarotti wrote a puzzling letter to a friend about
'a new kind of painting in which a site is
ornamented with buildings taken from here and
there, or just imagined'. New? He might well

have been describing Smith's overdoors of 15 years
earlier. Algarotti went on:

> The first picture I had painted for me in such a
> manner was a view of our Rialto Bridge from the
> side facing northeast. Little or nothing was changed
> in the bend of the Canal, in the position of its banks
> or of the buildings situated along it. We only changed
> a good many of those buildings.

He then explained why he had substituted
Palladio's 'most beautiful and decorated' bridge for
the 'great pile of stones' with its heavy and squat
architecture which da Ponte had built. He
continued:

> Such a building, painted and given light by the brush
> of Canaletto, of which I made use, I cannot tell you
> the beautiful effect it makes, especially when it is
> reflected in the water underneath. To its right, in the

127
Capriccio: a Palladian Design for the
Rialto Bridge, with buildings at Vicenza

Oil on canvas,
60.5 x 82 cm
(23¾ x 32¼ in)
Parma, National Gallery

Perhaps painted for Francesco
Algarotti, who added two famous
buildings in Vicenza to Smith's
version.

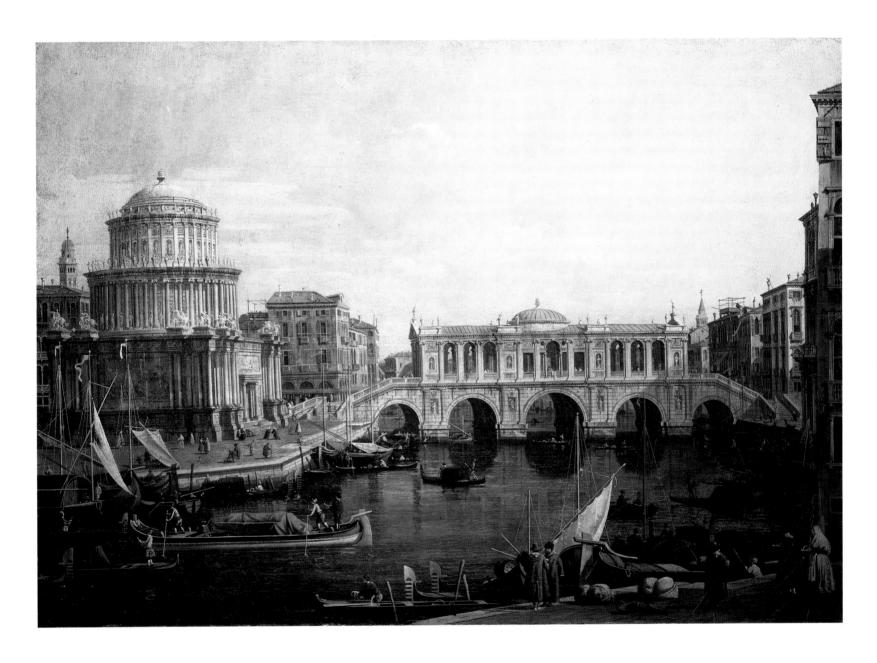

128
*Capriccio: the Grand Canal, with an
Imaginary Rialto Bridge and Other
Buildings*

Oil on canvas,
60 x 82 cm
(23¾ x 32¼ in)
Parma, National Gallery

Companion to Plate 127. Both the
bridge and the circular building
appear to be imaginary.

place of the Fondaco, we put the Palazzo Chiericato by the same Palladio... and in the middle there stands the Basilica of Vicenza, known as the Palazzo della Ragione... Between the Basilica and the bridge our eye goes through and travels a long way over a view along the Canal at the other side of the same bridge.

Algarotti's painting cannot be identified, but there can be little doubt that Plate 127 is one of several versions of it. The Basilica is hardly 'in the middle', but the Palazzo Chiericato is on the bridge's (not the viewer's) right and the vista between the Basilica and the Bridge is as described. Some versions have a companion (Pl. 128) which is equally intriguing.

It is often assumed that Algarotti had commissioned his picture about the time he wrote this letter, but it seems equally probable that he was referring to the period when Smith's overdoors were being painted. He was in Venice at this time, buying works of art for the Elector of Saxony, and it would have been a rebuff to Canaletto if he had left without taking anything with him. There is no record of the two having met, either in 1744 or in 1759, and 'the first picture I had painted for me...' could have been commissioned at either date. If it was in 1744, the question arises whether the original idea came from Smith or from Algarotti and, if the latter, whether this aesthetic busybody, who knew everybody who mattered in Europe, was the true begetter of the overdoor capriccios.

Best known of all perhaps is 'St Mark's Church before which... are here seen the 4 Horses and elegant Pedestals with allusive ornaments' as

Smith described Plate 130. Stolen by Doge Enrico Dandolo from Constantinople in 1204 after the Fourth Crusade, the antique bronze horses found themselves in Paris, after being again stolen by Napoleon, back in Venice after Napoleon's fall, in Rome for safety during the First World War and now hidden away inside St Mark's whilst copies in modern materials make do for them in the position they occupied for more than six hundred years.

Taken as a whole, the overdoors were not an unqualified success. Sir Michael Levey has suggested that the project caused embarrassment to Canaletto, hence the impression of hasty, perfunctory, improvised decoration. Sir Oliver Millar, under whose care they fell as Surveyor of the Queen's Pictures (how such closeness to royalty would have gratified Smith), found them bold, lucid and admirably designed; the two descriptions are not wholly incompatible. No one can fit the pictures easily into a period when Canaletto was creating etchings of a subtlety and sensitivity, especially to distance, that his many competitors in the medium were unable to equal. Yet it is to this period that both expressions of the artist's temperament belong.

All that can be said as to the date of the etchings is that they were completed by June 1744 and even this assumes that the title-page (Pl. 129) was the last to be etched. This title-page was dedicated by Antonio Canal 'humbly/to the most illustrious Signor/Joseph Smith/Consul of his Britannic Majesty attached to the Most Serene/Republic of Venice/as a mark of esteem and homage'. Smith

129
Title-page of Canaletto's etchings, dedicated to Smith 'as a mark of esteem and homage'. Smith is addressed as 'Consul', a post he had long hoped for and was appointed to in June 1744. Some of the views were 'taken from the places', whereas others were described as *ideate*.

130
Capriccio: the Horses of S. Marco in the Piazzetta
Signed and dated 1743

Oil on canvas,
108 x 129.5 cm
(42½ x 51 in)
The Royal Collection

The nearest plinth is inscribed with the date MCCCXXXII, signifying 1332 years after the traditional foundation date of Venice in 421. But Canaletto appears to have added an extra X by mistake, since the painting clearly dates from 1743.

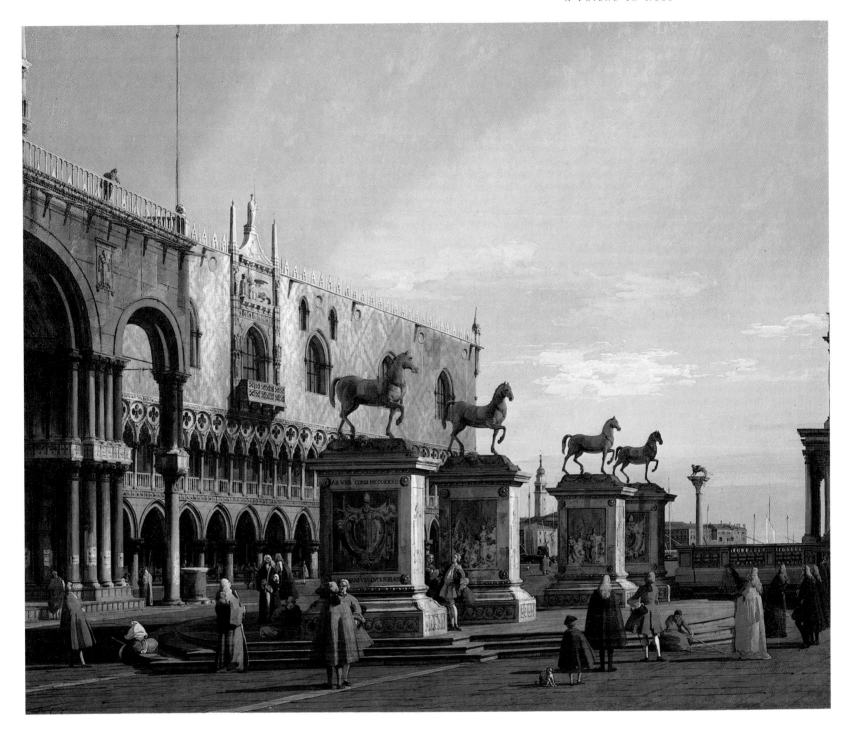

le Porte Del Dolo

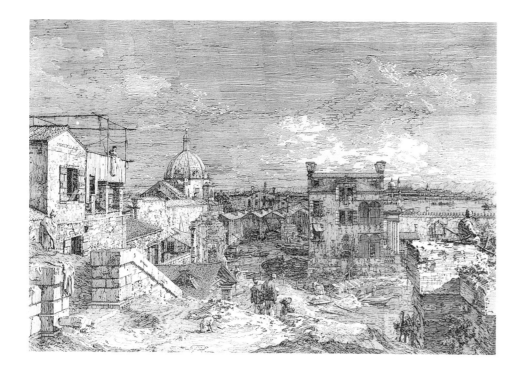

131
'le Porte Del Dolo'

Etching,
about 29.5 x 42.5 cm
(11½ x 16½ in)

One of three etchings of Dolo.
Although the lock is no longer
used, it is identifiable today and,
being a real view, bears a title in
Canaletto's own hand. The figures
are reminiscent of hie earliest work.

132
Imaginary View of Venice

Etching,
about 29.5 x 42.5 cm
(11½ x 16½ in)

The title is one of those given by
later writers.
The etching is shown in its very
rare original form, before the plate
was cut vertically in the centre and
later prints drawn from the two
halves.

was not appointed Consul until 6 June 1744. From the way in which the etchings were printed it seems likely that buyers were expected to mount them separately, but the existence of a title-page implies that the etchings were intended to form a book and a few copies exist in this form; it is therefore highly probable that all the etchings *were* finished by the time the dedication came to be made.

As to when they were begun, there is no evidence at all. The inscription *MDCCXLI A.C.* on a house in the foreground of an etching generally called *Imaginary View of Venice* (Pl. 132) suggests that that particular etching was completed in 1741. It is one of the most imaginative and accomplished of all and cannot represent Canaletto's earliest use of the medium; there is thus an implication that a number of others were finished well before that date (the mid-1730s has been suggested as the time when the earliest experiments were made). But the 1741 date may have quite another significance – when the house was first seen and sketched, when the whole project was initiated (or indeed when it was completed except for the title-page) – or no significance at all. No more can be said than that nearly all the large etchings and several of the small ones must have derived from the journey along the Brenta and that these must date from the 1740s – unless some earlier and unrecorded journey had taken place.

Thirteen of the etchings, including the title-page, occupy a full page, each being about 30 x 42.5 centimetres; another 12 were printed four to a page, each about 14 x 20.5 centimetres (a seventeenth page inexplicably contained a small etching and a piece of one of the large ones). According to the title-page, some of the etchings were *prese da i Luoghi* (taken from the places themselves); there were six large ones of this type and four small, all bearing Canaletto's own titles, etched in his own hand. The remainder were more or less imaginary views, *ideate* according to the title-page; they bear no titles on the plate and have been given various names by later commentators. These details, over-simplified though they are, may explain some of the perplexities that confront an admirer who comes fresh to these marvellous works of art in salerooms or in reproduction. Their quality can hardly be better described than in the words of W.G. Constable, who wrote: 'the needle moves with a complete response to conception and mood, manual skill always serving expression, to yield

an integrated design, irradiated with circum-ambient light.'

If Smith's own copies of the etchings were ever bound, they were long since broken up and put into an album which also contained Canaletto's drawings. In the reign of George III they were again removed and pasted into another album, after having been cut down to the plate-marks. However, the elder of the two cousins to bear the name Anton Maria Zanetti also owned a bound set which, like Smith's collection, contained the earliest 'states' of the etchings and a number which occur nowhere else. This Zanetti, a patron and connoisseur as well as a writer, is a shadowy figure in Canaletto's life; his ownership of these etchings alone suggests that he may have played an important part in it. (The younger cousin was a critic rather than a patron; his part was to include a short biography of the artist in a book on Venetian painters published just after Canaletto's death.) Although the Zanetti album was later bound in morocco, there is no reason to think that the order was changed, and the numbers now given to the etchings generally follow this sequence.

The first seven etchings, all large, are 'taken from real places', three of the village of Dolo on the Brenta, already seen in the paintings of that name, but none of the same scene (Pl. 131). A view of Mestre (already passed on the way to Dolo) follows and then the two of '*Prà della Valle*' in Padua, which became the subject of several later paintings as well as a drawing which probably preceded them (Pl. 103). Lest there be any doubt that this pair was meant to be joined together, part of the coat of one of the figures runs over the borderline of one plate and is repeated on the other. The seventh also bears Canaletto's own title, '*la Torre di Malghera*', but, unlike the earlier scenes, it cannot be seen today. The tower was built in the fifteenth century, appears in Jacopo de'Barbari's celebrated woodcut of Venice in 1500, and was demolished in the nineteenth century. As in many other cases, Canaletto worked on the plate of this etching, making several alterations and strengthenings in the later state, although it was probably one of the last to be executed. The scene, with its unusually choppy water, the fishermen with their eel-baskets, and the Euganean hills in the background, has caught the imagination of succeeding generations and made the etching, together with one generally called *The Portico with a Lantern*, the best known of all.

Two imaginary towns and one part-imagined

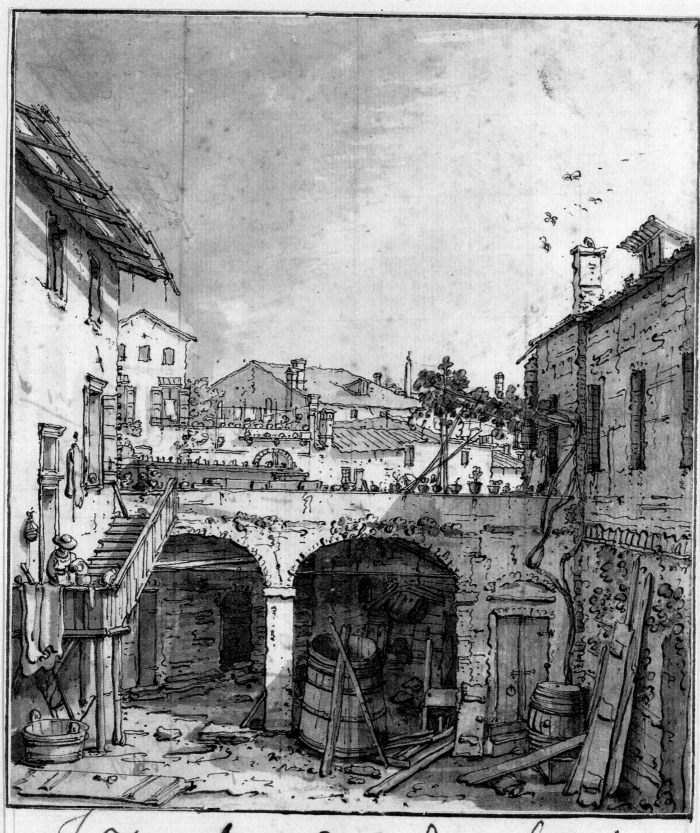

Jo Zuane Antonio da Canal, deto il Canaleto
lò Dissegnià è
fatto.

Vista in Padoua efata

133
Padua: houses
c. 1740

Pen and ink with grey wash,
18.3 x 15.8 cm
(7¼ x 6¼ in)
Berlin, Staatliche Museen
Preussischer Kulturbesitz,
Kupferstichkabinett

The etching (Plate 134) is in
reverse, as would be expected if this
is a preparatory drawing for it.

134
The Terrace

Etching,
about 14 x 20.5 cm
(5½ x 8 in)

An example of the small etchings
and, bearing no title in Canaletto's
hand, an imaginary subject.
Canaletto and his imitators later
copied the subject for paintings.

complete the group of large etchings, those to which the names of Venice and Padua are generally attached being among the most brilliantly conceived and deeply felt of the whole set. The *Imaginary View of Venice* (Pl. 132) (it is hard to understand how the title came to be assigned to it at the beginning of the present century), apart from bearing the unexplained date *MDCCXLI*, presents a puzzle. After a few prints had been drawn off the plate, it was cut vertically in half so that all later impressions are upright instead of in the usual horizontal form; if the intention was to improve the composition, it did not succeed. Both halves continued to be printed on the same page, the left part after several alterations, and a margin was left between them. Evidently collectors were expected to cut the etchings themselves rather than leave them in book form.

More bewildering cuts were applied to the *Town with a Bishop's Tomb*. A piece was cut off the left side, leaving only part of the canopied tomb of the bishop. The top of this piece was printed on a different page, with another etching, but only one impression was taken of the bottom and this unique etching survives in Smith's set now in the Royal Collection, Windsor. In addition to his signature, *A. Canal*, on the large piece, Canaletto added '*V*', presumably for *Venezia*, and, on the tomb, the Canal arms of a shield with a chevron.

Four of the 12 small etchings are straightforward topographical scenes of Venice; none had been the subject of a painting in the same form. Two of these placed together would form a view of *The Piazzetta to the South*, a subject which was never

painted as such although there is a drawing of about 1729 which could have been used for the etchings.

The rest are mostly imaginary landscapes with monuments, three of more interest than the others. *The Terrace* (Pl. 134) makes a captivating scene. There is also a drawing (Pl. 133) which Canaletto has inscribed in his best handwriting *Io Zuane Antonio da Canal, deto il Canaleto / lo dissegnià è / fatto*, and (not certainly in his hand) the words *Vista in Padoua esata*; the etching may well have been based on this drawing, itself based on something seen, if the inscription is to be relied on. An imaginary view into which S. Giacomo di Rialto has been fancifully placed has been given a much larger signature than usual, perhaps to mark the artist's approval of a wholly successful capriccio. Then there is a scene on the Molo, with the market in full swing, topographically entirely in order – except that it has been drawn on the plate in the correct 'sense'; the print is therefore reversed. Recognizing that it has thus become an imaginary scene, it has been given no title on the etching, so providing yet another puzzle for later students. But not the last. A scene with a church and houses, equal in quality to many although not to the best, was drawn off the plate apparently only twice, one copy going to Smith and the other to Zanetti; over a century later a third copy was found in a Rome bookshop. Finally, a mountain landscape which included, in reverse, a group of buildings also appearing in some of Smith's drawings, was drawn off once and the impression given to Smith; no other copy is known, even in Zanetti's collection.

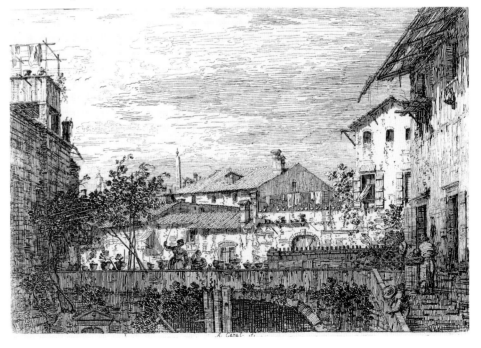

Canaletto's recorded output during the years 1741–4 gives some indication of the speed at which he was able to work, even without such studio assistance as he may have had during the view-painting years. Apart from the etchings, there were Smith's five Roman views, five Venice views, and 13 overdoors, all large canvases. Smith's drawings included all those of the mainland and Padua and a dozen or so of Rome. There were Roman views for other patrons and capriccios: these are impossible to date but many must have been executed during the period. Nothing is included for Algarotti, who was in Venice at the time, knew Canaletto well, and owned Venice views at his death: can he have bought nothing from Canaletto?

It must clearly have been impossible for Smith to sustain an artist of such productivity on his own. His resources were not unlimited, particularly at this period, and Canaletto was not the only artist in whom he was interested. His Britannic Majesty's Consul in Venice would not be overburdened with work on His Majesty's behalf, but some work there must have been to distract the great collector from his gems, his books, his publishing and his pictures. He can never be accused of disloyalty to Canaletto, but there must have been a limit to the support he could give him.

A curtain falls after the paintings dated 1744, but it does not require much imagination to picture the questions and anxieties that must have filled the artist's mind during the following year or so.

According to George Vertue, on whose notebooks we rely for some valuable information about Canaletto in England, it was Jacopo Amigoni who told him of the prospects in London. These must have seemed bright compared with those in Venice. The new bridge at Westminster was on the point of completion and would surely call for a view painter of repute to portray it. It would not be such a goal as the commission to paint the interior of St Paul's, which had attracted so many Venetian painters to

London earlier on, but there would be less competition. The Duke of Richmond and the Duke of Bedford were both commissioners for the new bridge and both of course had been patrons (although, if McSwiney was right, the former had been badly treated in the matter of delivery); no Italian artist could be better known among the English nobility. As for personal contacts, McSwiney had been back in London for several years; he was well aware of Canaletto's merits in spite of any reservations he may have expressed. But the project of leaving Venice for England must have depended most on Smith's attitude to it; he had always seemed to know everyone in England and, now that he was Consul, his influence would presumably be even greater. (In fact it may well have been less since the Senate discouraged contacts between the nobility of Venice and foreign representatives; a consul, though, was fairly low in the diplomatic hierarchy and Smith was not a man to be inhibited by his new position.) In the event Smith evidently smiled on the proposal, if indeed it had not been he who initiated it, and did what he could to ensure its success.

There was one more commission for which Canaletto's services were required in Venice. On 23 April 1745 the Campanile was struck by lightning. It was St George's Day and Smith the Englishman saw significance in the event taking place on the day of his country's patron saint (although George's acts, it had been said in 494, were 'known only to God' and he has since had a fall in status). Canaletto was accordingly commissioned to portray the repairs being carried out and to record in his own hand that it had in fact been 'Adi 23 aprile 1745 giorno di S. Giorgio diede la saeta nel Campanil di S. Marco' (Pl. 135).

It is a splendid drawing, over 40 centimetres high, and from all appearances a faithful record of an event that foreshadowed the ultimate fall of the thousand-year-old bell tower 157 years later. As for the artist who drew it, he would be at least ten years older before returning to live in the city that had been his home for almost 50 years.

135
The Piazzetta: looking North, the Campanile under repair
1745

Pen and ink with washes,
42.5 x 29.2 cm
(16¾ x 11½ in)
The Royal Collection

The damage to the corner of the Campanile appears to have been added after some erasure. Canaletto made another drawing of the subject, probably while in London.

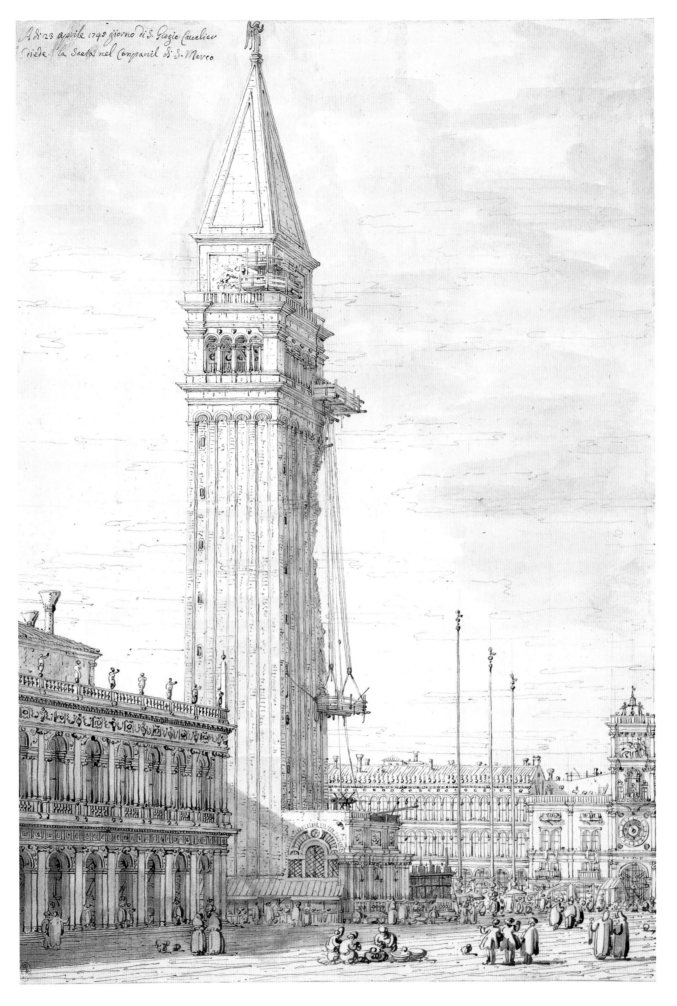

A dì 23 aprile 1745 giorno di S. Giogio Cavalier
viede l la Saeta nel Companil di S. Marco

REPEATED PROPOSALS TO build a second bridge across the River Thames at Westminster had been successfully resisted for over a hundred years; eventually the Watermen of London, renowned for their obscene language, and the City Corporation, renowned for its jealousy of anything that went on outside its own square mile, were obliged to concede defeat. What the Watermen said is not recorded in documents; the City insisted that its own London Bridge would fall into decay and that the new bridge would cause the river to rise three feet higher and flood the buildings on its banks (including even the King's own Whitehall Palace). Then the river would silt up altogether and be no longer navigable, to the evil of the 30,000 watermen earning their living on it, and finally new building outside the City would be encouraged, only to pollute what was left of the river by sewage, soil and filth. Allies were called in from as far away as Abingdon in Berkshire, whose Mayor gave warning that thousands would be ruined; the proprietors of the London Bridge Waterworks said that they would be unable to supply the City with water any longer, and St Thomas's Hospital said it would be flooded and drowned, together with 5,000 poor, sick and diseased people. Nevertheless Parliament, wise in the ways of those whose privileges are threatened, set up a Bridge Committee and by 1736 was able to pass 'An Act for Building a Bridge across the River Thames...'

On 29 January 1739 the first stone, 'upwards of a Ton Weight', was sunk in the middle of the river (it would be misleading to suggest that all had gone smoothly up to then but tedious to pursue in detail the arguments about the type of bridge and the designer to be responsible for it). The engineer in charge was the designer, a Swiss named Labelye, of whom little is known; for 12 years the eyes of London were fixed on him as on a general in time of war. By 1740 the central arch was built and the following year another on either side of it; by 1744 the Westminster land abutment had been reached and the roadway over the arches built. The work then continued towards the Lambeth side (the east, since at this point the river is running from south to north). In April 1746 the last arch but two was finished, the timber frame (centering) on which this arch was built being left in position until the whole bridge was complete.

George Vertue, an antiquary and engraver, was collecting material for a history of art in England and kept a series of notebooks recording the current goings-on. In one of these he wrote:

> Latter end of May [1746], came to London from Venice the Famous Painter of Views Cannalletti of Venice the multitude of his works done abroad for English noblemen and Gentlemen has procured a great reputation & his great merit and excellence in that way, he is much esteemed and no doubt but what his Views and works he doth here will give the same satisfaction – tho' many persons already have so many of his paintings.

There can be no question as to the state of Westminster Bridge in May 1746: every step in the construction is fully documented. Nor is there any reason to doubt Vertue's record of late May as the date of Canaletto's arrival; it was but a year since he had been drawing the damaged Campanile. It is

136
Detail of Plate 162.

9 *London, That Spacious City*

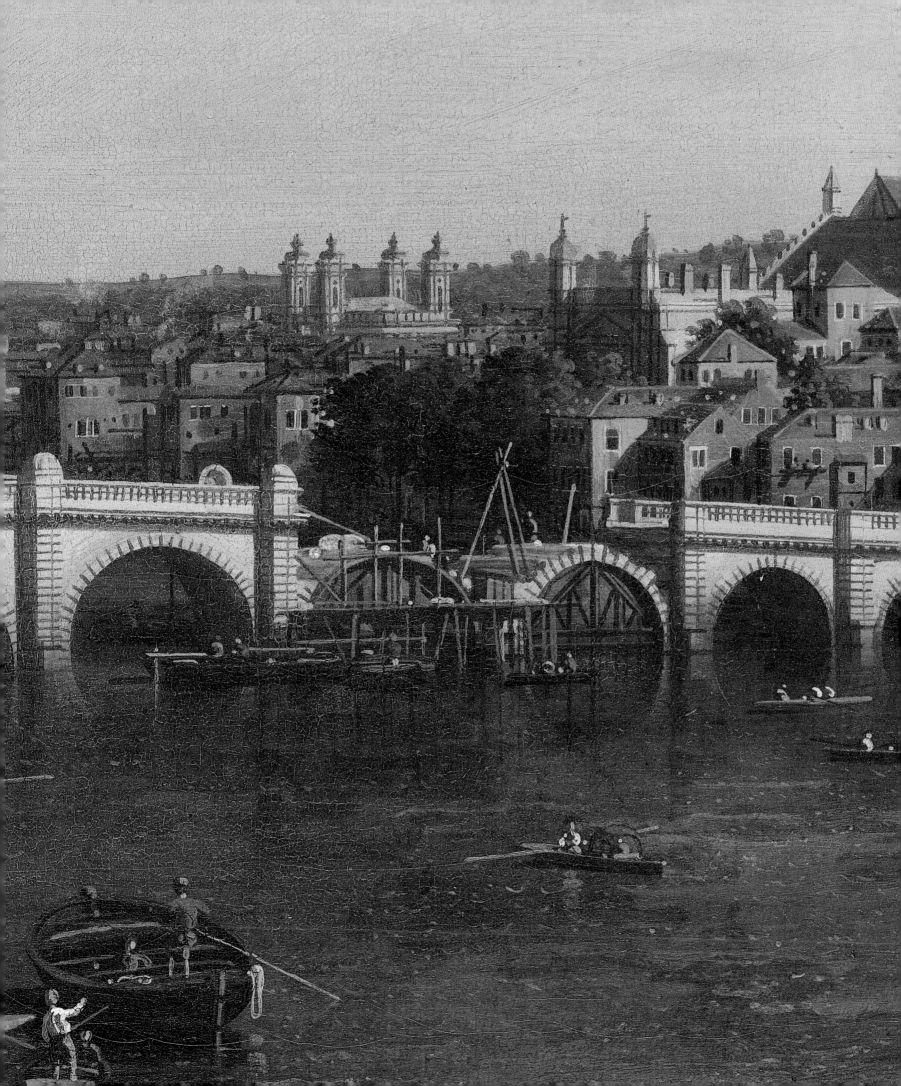

therefore disconcerting to find a painting and a drawing (Pl. 138) in both of which Canaletto has played a major, if not the whole, part, showing the bridge with only five arches complete; moreover they are all on the Westminster side, as if the bridge has been begun there and not in the centre, as in fact it was. As with other Canaletto puzzles we can but guess at the solution and pass on. He may have copied another drawing, itself inaccurate, or, having been asked for a picture of the bridge being built, have imagined the course the construction would have taken. He certainly was not drawing or painting what he saw, or what anyone could have seen, and there is no reason to believe that either work came from the beginning of his stay in London; they could have been done at any time.

Hardly had Canaletto arrived in London than the first seed that Smith planted on his behalf began to sprout. Smith had been wise enough not to choose his own clients to write to; they had all had opportunity enough to buy Canalettos and it would be best for them to make the first approach once the artist had made a new reputation as a painter of English views. The Duke of Richmond, on the other hand, had been McSwiney's client, not Smith's, and had bought no Canaletto since the copper plates. McSwiney had long been back in London. There could be no better first patron and Smith sensibly wrote to McSwiney for his help with the Duke.

McSwiney was able to act immediately and did so. He was dining with Thomas Hill, the Duke's former tutor, at Montagu House, next door to Richmond House, and, since the Duke of Richmond was evidently in the country, asked Hill to act as intermediary. On 20 May Hill wrote to the Duke:

The only news I know to send you, is what I had this day from Swiney at the Duke of Montagu's, where we dined, & he, I think got almost drunk. Canales, alias Canaletti, is come over with a letter of recommendation from our old acquaintance the Consul of Venice to Mac in order to [have] his introduction to your Grace... I told him the best service I thought you could do him wᵈ be to let him draw a view of the river from yʳ dining-room, which in my opinion would give him as much reputation as any of his Venetian prospects.

This was indeed the best service that could be done for Canaletto – and for the Duke, his descendants and us – but it was to be some time before the seed bore fruit and Canaletto could not

wait. By a stroke of good fortune that cannot be accounted for he came to know a Bohemian nobleman, Prince Lobkowicz, who was visiting England in the summer of 1746 to buy breeding stock for his racing stable – 'a travelling boy of twenty... under the care of an apothecary and surgeon', according to Walpole. The Prince commissioned, or at any rate bought, what were probably Canaletto's first paintings of the Thames, later taking them back with him to Bohemia, where they have remained ever since, still owned by the Lobkowicz family.

Canaletto was certainly painting what he saw now. The view downstream from Lambeth Palace (Pl. 141), probably with the nearby church of St Mary's as viewpoint, shows the work on the bridge in meticulous detail. It is nearly complete but with the timber centres still under five arches on the Lambeth side (the first of these was removed in September, dating the picture July or August). Stone is still being hoisted from below by derricks mounted on scaffolding on this side whereas on the Westminster side the balustrade is already going up. There is far more to see than Westminster Bridge – glimpses of Georgian London in the neighbourhood of Westminster Palace and a view of St Paul's, almost two miles away and occupying only a few inches of canvas, but clear evidence of how Canaletto had already fallen under the spell of London. The pall of smoke which hung permanently over London did not appear to disconcert him when preparing either the picture or its companion, which showed a procession on Lord Mayor's Day further downstream, close to St Paul's.

Canaletto may well have turned to a publisher for his next commission and proposed a view of the same event but upstream and showing the new bridge in all its glory. A published engraving could not fail to make him better known and in the Lobkowicz paintings he had two admirable examples of his capacity. Whether the decision to engrave his next picture came before or after it was painted, the subject was again the Lord Mayor's Day of 29 October 1746 with the City Barge conveying the Lord Mayor to Westminster Hall to take his oath (Pl. 139).

Knowing that the bridge would be finished by the time his engraving was ready, the publisher not unnaturally required a certain amount of anticipation. Here Canaletto made an unfortunate mistake. The bridge is shown complete, with all its centres removed (in fact the last one was not taken down until five years later) and the balustrade

137
Whitehall, Somerset House and the Thames at the time of Canaletto's arrival in London. From John Rocque's *Plan of the Cities of London & Westminster, 1746.* Parliament Street (lower left) is shown although its building was not begun until 1749. The sites of most of Canaletto's London subjects appear in this detail.

finished. Over the middle arch this balustrade is decorated with large statues of the two river gods, Thames and Isis, which were intended as a centrepiece; drawings of them existed and may have been published, but Canaletto was not to know that in the event they were never to take their place on the bridge. Perhaps the publisher, John Brindley, delayed Remigius Parr's engraving of the painting in the hope that it would become topical: it was not published until six months later.

Meanwhile Vertue was making another entry in October 1746, reflecting on the reasons for Canaletto's visit. 'Of late few persons travel to Italy from hence during the wars,' he noted, and he then remarked on the 'great numbers bought by dealers' of Canaletto's works. A curious reference this, the first to the idea that dealers had been buying his pictures. One wonders how many of the dealers' Canalettos had ever been touched by the master's hand. Vertue continued about the artist's 'desire to come to England being persuaded to it by Sig^nor Amiconi History painter' and by the prospect of making views of the Thames, ending: 'of them he has begun some views, its said he has already made himself easy in his fortune and likewise that he had brought most part to putt into the Stocks here for better security, or better interest than abroad.' This was guesswork. If Canaletto had been easy in his fortune it is unlikely that he would have left home, and as soon as he had any savings to invest he went back to Venice to invest them.

He had begun reasonably well, but print publishers do not pay for paintings as collectors do and his Lord Mayor's Day picture does not seem

to have found an immediate buyer. As for tourists like Prince Lobkowicz, they go home and do not become loyal patrons as Canaletto well knew from experience. He needed a loyal patron and, somehow or other, he landed the biggest prize of them all – Sir Hugh Smithson.

Sir Hugh's fortunes had changed spectacularly three years earlier when his wife's brother had died at 19 and Lady Smithson became heir to the six oldest baronies in the kingdom, including that of Percy, and all the Percy seats. This made Sir Hugh so powerful that, before Canaletto left England, he had become the Earl of Northumberland (and later the first Duke of Northumberland) after changing his name to Percy and so taking the name of his wife's ancestor Sir Harry Hotspur. Like the Dukes of Bedford and Richmond, Sir Hugh was one of the commissioners for the new bridge and so had a special interest in its final stages and the beginning of its useful life.

Sir Hugh's first Canaletto painting (Pl. 140 and jacket) showed 'A Most beautiful view of the City of London, taken through one of the Centers of the Arches of the New Bridge at Westminster' as it was described by John Brindley when advertising Parr's engraving of the picture. It was a companion to the Lord Mayor's Day print, but was dedicated 'To Sr Hugh Smithson Bar^t' whereas the other had no dedication. Brindley may have commissioned the painting and sold it to Sir Hugh; if so, he rendered good service to Canaletto. On the other hand Sir Hugh may have commissioned it and proposed the engraving to Brindley. The arch was probably the fourth from the Lambeth side which still had its timber centre

138
London: the Thames: looking towards Westminster from near York Water Gate

Pen and brown ink with grey wash, 38.8 x 71.8 cm
(15¼ x 28½ in)
New Haven, Conn., Yale Center for British Art (Paul Mellon Collection)

From right to left: the gate and wooden water-tower, Westminster Abbey and Bridge. But the bridge was begun from the middle and was almost finished before Canaletto's arrival.

139
London: Westminster Bridge from the North on Lord Mayor's Day
1746

Oil on canvas,
96 x 137.5 cm
(37¾ x 50¼ in)
New Haven, Conn., Yale Center
for British Art (Paul Mellon
Collection)

Lambeth Palace in the distance,
Westminster Abbey and
Westminster Hall on the right.

until April 1747; Canaletto used the centre as a framework and showed a bucket hanging down as an indication of work in progress. Later he made two drawings of the subject, but without the timber centring to the arch, and one of these ended in Smith's collection.

This led quickly to another commission, either from Sir Hugh himself or from his wife's kinsman, Sir Edward Seymour. This was a view (Pl. 142) of Windsor Castle which bears a label describing the cottage from which the view was taken. The label adds that 'the Figures were added at Percy Lodge. It was finished June the Eleventh 1747.' Percy Lodge belonged to Sir Edward Seymour, later eighth Duke of Somerset, and it was there that Sir Hugh, a squire with no prospects at all, had made his fortunate marriage in 1740. It was an admirable idea to get Canaletto out of London and the scene by the river at Windsor evidently stimulated his

imagination in a way the Thames had so far failed to do. St Paul's and the other buildings by its banks, yes, and the excitement of the final stages of the bridge: he was able to see these with a fresh eye and to convey his interest to canvas, as in the Windsor picture. But London lacked all the essentials for a water festival that Venice had in abundance – the shimmering light, the incomparable constellation of architecture and the variety of viewpoints from which the ceremonies and regattas could be seen. It was not surprising that the Thames paintings and drawings lacked the sense of conviction that Canaletto was still able to convey in Venice even after painting half a dozen versions of the same event.

It can also be argued that he did not find his feet in London until he had spent more than a year in the city, for his English masterpieces were still to come. The Duke of Richmond took a long time

to respond to Tom Hill's hint as to the best service he could do Canaletto; like many of his fellow noblemen he was more interested in horses than in art. On the whole, though, he graced the dukedom Charles II had bestowed on his father while still a child and seems to have been happily married to the wife his father had married him off to in settlement of a gambling debt. He was now 45 and had only three more years to live.

There were probably hints that a commission would soon be forthcoming, for in the late summer of 1747 Canaletto was apparently allowed to make drawings from the windows of Richmond House overlooking the Thames just north of Westminster Bridge; one of these showed the terrace with St Paul's and the City in the background (Pl. 143). A few weeks later, perhaps with his easel set up in the Duke's dining-room, he was working on the view of *Whitehall and the Privy Garden* and its companion, *The Thames and the City of London*.

The Thames painting (Pl. 144) is sometimes said to show Canaletto seeing London through the eyes of a Venetian, which was of course inevitable, and the state barges rather pathetically recall the Doge's Bucintoro. On the left is the terrace of the Duke of Montagu's house, where McSwiney had got almost drunk, and St Paul's rises majestically in the background. The Whitehall painting (Pl. 148), on the other hand, is full of atmosphere and has a delicacy and luminosity all its own. Despite the mannerism of some of the figures (Pl. 149), Canaletto had never painted better, nor would he again.

Until now things had been going well for the visiting artist; for the unfortunate visiting engineer of Westminster Bridge they were going far from well. In the summer, when the bridge was virtually finished, and just before it was to be opened to traffic, one of the piers began to settle and it was to be three more years before the troubles could be overcome. After almost two years, in April 1749, it was decided to dismantle one of the arches and Canaletto made a drawing of the scene from the Lambeth side (Pl. 145). Between the Richmond paintings and this drawing we would have no knowledge of what he had been doing but for Vertue's notebooks, in which he reappears in June 1749. Vertue writes that, in addition to producing views of London, Canaletto has painted 'in the country for the Duke of Beaufort, Views of Badminton', and the pictures are still to be seen in the rooms where they originally hung.

Vertue was evidently not aware that Canaletto had had another important commission. This was to paint Warwick Castle for Lord Brooke, who later (in 1759) became Earl of Warwick. The commission can be explained by the fact that Lord Brooke had been orphaned at the age of eight and brought up by his aunt whose daughter later married Sir Hugh Smithson. On 19 July 1748, Hoare's Bank recorded a payment of £58 'To Sigʳ Canall' on behalf of Lord Brooke, and there can be no doubt that this was for one or, more probably, two of five paintings of the Castle, four of which remained there until quite recently. Two paintings, a large one which was later disposed of, and a smaller version (Pl. 151), show the South Front before alterations were carried out by Lancelot ('Capability') Brown, and the amount paid seems to be about right from what is known of Canaletto's prices.

On 3 March 1749 there was another payment 'To Sigʳ G. Antᵒ Canale', this time of 30 guineas (£31 10s), and this was probably for one of the two pictures of the East Front, both of which are now in the Birmingham Art Gallery (Pls 146 and 147). Canaletto may have painted this in London from drawings made the previous year or he may have paid another visit to the Castle. Certainly he was to return three years later and during these visits he also made some drawings, one with a label inscribed in his own hand: *Ingresso nella Piazza de Varik* (Pl. 150) – the 'Piazza' was the square in front of St Mary's Church.

To return to Vertue, he then recorded what he had been hearing about Canaletto: 'On the whole of him something is obscure or strange. he does not produce works so well done as those of Venice...which are in collections here...especially his figures...are apparently much inferior to those done abroad...his water & his skies at no time excellent or with natural freedom...his prospects of Trees woods... not so skillfull as might be expected.' There followed the astonishing rumour that 'he is not the veritable Cannelleti of Venice...he has some unknown assistant in makeing up... his works with figures'. This 'conjecture' was strengthened by the artist's 'reservedness & shyness in being seen at work, at any time, or anywhere'.

The following month Vertue corrected himself and noted the facts as he now believed them to be. The artist had a nephew 'who having some Genius was instructed by this his uncle Cannali and this young stripling by degrees came on forward in his proffession...but in time getting some degree of

140
London: seen through an Arch of Westminster Bridge
1746-7

Oil on canvas,
57 x 95 cm
(22½ x 37½ in)
The Duke of Northumberland

In the right background is St Paul's, with a rare view of the south bank in front of it; on the left, the water-tower, seen in Plate 138.

Overleaf:
141
London: the Thames, with Westminster Bridge in the distance
1746

Oil on canvas,
188 x 238 cm
(46½ x 93¾ in)
Prague, Roudnice Lobkowicz Collection

Lambeth Palace in the right foreground, with St Paul's in the distance; St John's Smith Square, and Westminster Abbey on the left.

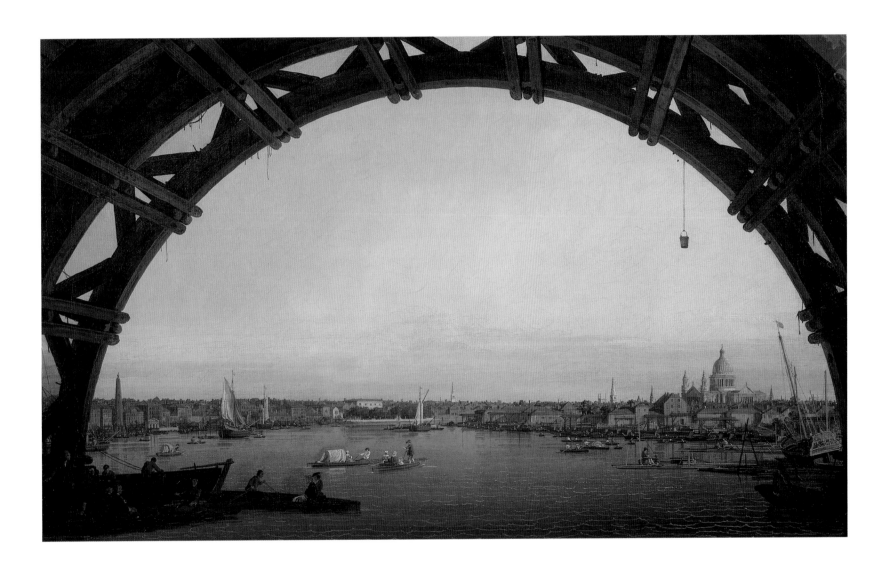

merrit, he being puff'd up disobliged his uncle who turned him adrift. but well Imitating his uncles manner of painting became reputed and the name of Cannaletti was indifferently used by both uncle and nephew...so that this caused the report of two Cannelittis.'

Like most rumours this was a mixture of fact and fiction. There is no evidence that Canaletto ever turned Bellotto 'adrift' (although he may of course possibly have done so) and we know that Bellotto was already using the name of Canaletto while still working with his uncle. Moreover, as far as exhaustive research has been able to establish, Bellotto was still in Venice when Canaletto left and he stayed there until 1747, when he went straight to Dresden at the invitation of the Elector, Frederick Augustus II, who was also Augustus III of Poland.

Vertue was soon at pains to correct any

misunderstanding he may have caused. He noted that Canaletto had put an advertisement in one of the newspapers and supposed that this was because he had been told of the rumours his shyness was causing. Vertue then quoted the advertisement which invited 'any Gentleman that will be pleased to come to his house to see a picture done by him being a View of St James's Park'. It was on view at 'Signor Canaleto's lodgings Mr Wiggan Cabinet maker in Silver street Golden Square'. This has since become Beak Street, off Regent Street, and the house, no. 41, bears a plaque recording Canaletto's stay there.

Demolition of the Old Horse Guards Building in St James's Park began in 1749 and there are two paintings of it which can be called views of St James's Park. One can be traced back to 1756, when its owner, Lord Radnor, wrote that it 'is, I think, the most capital picture I ever saw of that

142
Windsor Castle
1747

Oil on canvas,
84 x 137 cm
(33 x 54 in)
The Duke of Northumberland

On the right is the Thames with Windsor Bridge in the distance. Left to right: the State Apartments, Norman Gateway, Round Tower, Henry III's Tower and, in the background, St George's Chapel.

143
London: the Thames and the City of London from the Terrace of Richmond House
Probably 1747

Pen and ink with wash,
33.7 x 54 cm
(13¼ x 21¼ in)
The Earl of Onslow

Probably a preparatory drawing for Plate 144.

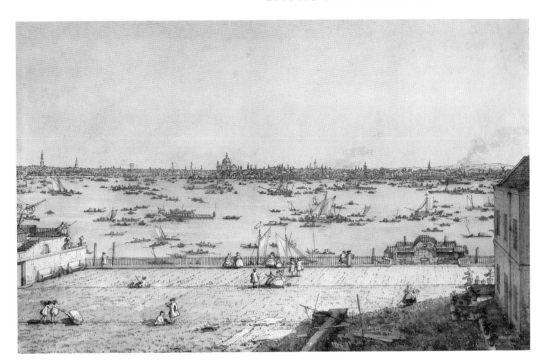

master [Canaletto]' (Pl. 152). There is a drawing from the same viewpoint, now in the British Museum, which can also probably be traced back to Canaletto's lifetime. The other painting (Pl. 154) has no early history, but is of greater interest since there is a sketch for it in a sketchbook which also contains drawings of Venetian and Paduan subjects (Pl. 153); Canaletto must therefore have taken the sketchbook to London with him. This sketch shows the Banqueting Hall and the Holbein Gate (both of which appear prominently in the Duke of Richmond's Whitehall painting) behind the Old Horse Guards building. It is full of Canaletto's characteristic notes – *C* for *copi* (tiles), *tole* (boards), *P* for *Piombo* (lead roof) and, above the capitals of the columns, *ionico* and *composito*.

It is reasonable to associate one of these two paintings with the advertisement, with a slight preference for Lord Radnor's version because of

its early provenance. Two other paintings can be assigned to the year 1749 with near certainty. On 2 July Sir Hugh Smithson wrote to his mother-in-law, the Duchess of Somerset: 'Mr Canaletti has begun the picture of Syon and by the Outlines upon the Canvass I think it will have a noble effect and he seems himself to be much pleased with the subject...' The following year the Duke of Somerset died, soon after being created Earl of Northumberland so that his son-in-law could inherit the title together with Syon and the other Percy seats (two more of which Canaletto was later to paint).

Then there was a commission from the Dean of Westminster, perhaps as a result of the advertisement. This was to paint the procession of the Knights of the Bath on their way from Westminster Abbey to the House of Lords on 26 June 1749, not a particularly sensitive rendering of

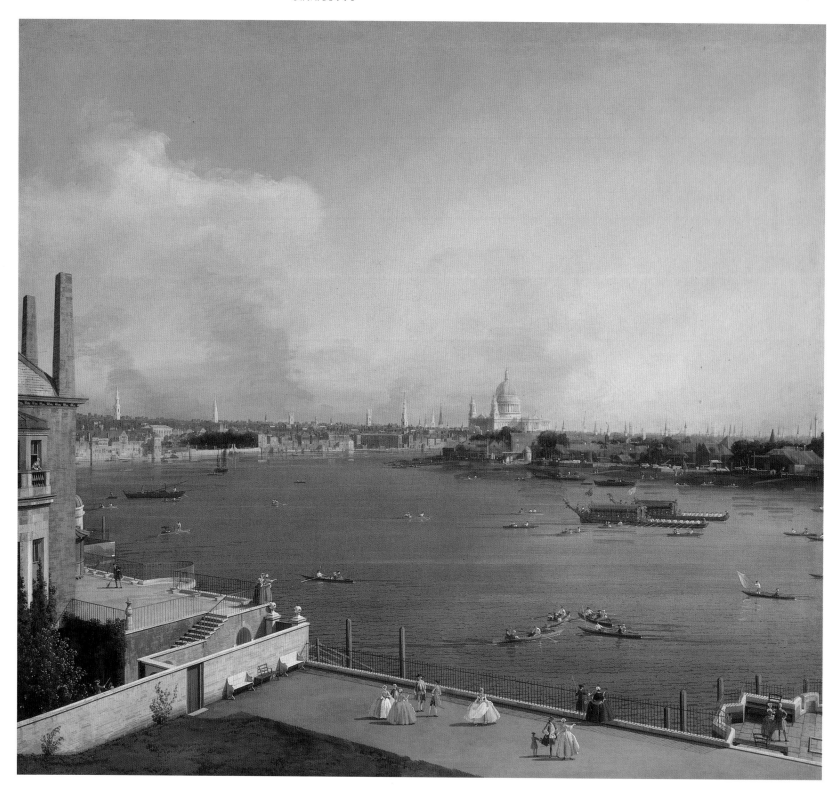

144
*London: the Thames and the City of
London from Richmond House*
1747

Oil on canvas,
105 x 117.5 cm
(41¾ x 46¼ in)
From Goodwood House by
Courtesy of the Trustees

The view from the Duke of
Richmond's dining-room, looking
downstream to the northeast. On
the left is the terrace of the Duke
of Montagu's house.

145
*London: Westminster Bridge under
Repair; from the South-West*
1749

Pen and ink with washes,
29.3 x 48.4 cm
(11½ x 19 in)
The Royal Collection

The arch which had begun to settle
two years earlier is being
dismantled. Canaletto took his
drawing back to Venice for Consul
Smith.

146
Warwick Castle: the East Front
1748-9

Oil on canvas,
73 x 122 cm
(28¾ x 48 in)
Birmingham Museums and Art
Gallery

From left to right: Caesar's Tower,
the gateway and clocktower, Guy's
Tower, a toll-house and houses of
Warwick town. One of four
paintings of the castle.

147
*Warwick Castle: the East Front from the
Courtyard*
1748-9

Oil on canvas,
75 x 122 cm
(29½ x 48 in)
Birmingham Museums and Art
Gallery

Pendant to Plate 146, which is in
the opposite direction.

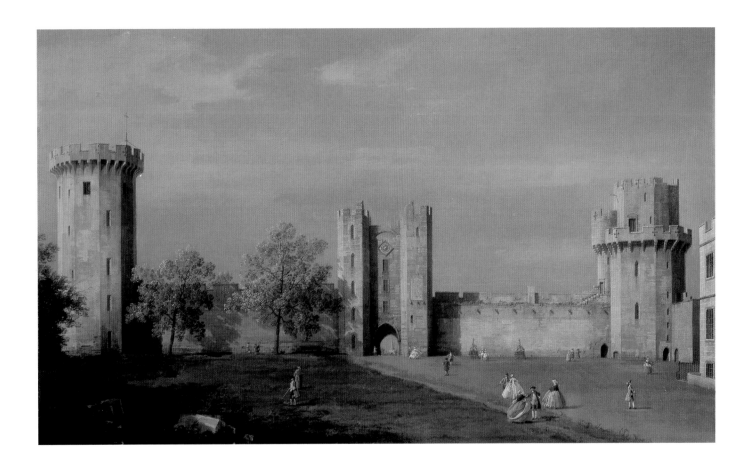

Gothic architecture or a very lively portrayal of the worthy knights, but with some precious glimpses of London topography in the background (Pl. 155).

No solution to the problem of subsidence at Westminster Bridge had yet been found (to the glee of those who had warned against the appointment of a foreign engineer with advanced ideas as well as of those who had not wanted a second bridge at all). In May 1750 Canaletto was called upon to record the ceremony for the swearing-in of the Master of the Goldsmiths' Company and naturally did not draw attention to the unhappy situation. He chose a nearer (imaginary) viewpoint than for his earlier Lord Mayor's Day picture, and showed the bridge in its finished state although it was to be six months before the work would be done. By that time he was back in Venice.

He may well have decided to return for good. Successful as the English visit had been at the beginning, after four years there was undoubtedly a falling-off in commissions and he may have felt that conditions would now be better in Venice. He took back a number of London drawings, all of which the loyal Smith added to his collection; he probably commissioned paintings from two of them – the views of the Thames from the terrace of Somerset House (Pls 156 and 157). One of Canaletto's biographers noted at about this time that the artist had returned to Venice and taken back with him drawings of London, 'that spacious city which, it is to be hoped, he will at his leisure transfer to canvas'. The Thames views may, on the other hand, have been painted in London and taken back as canvases. All that is certain is that they entered Smith's collection and returned to England only

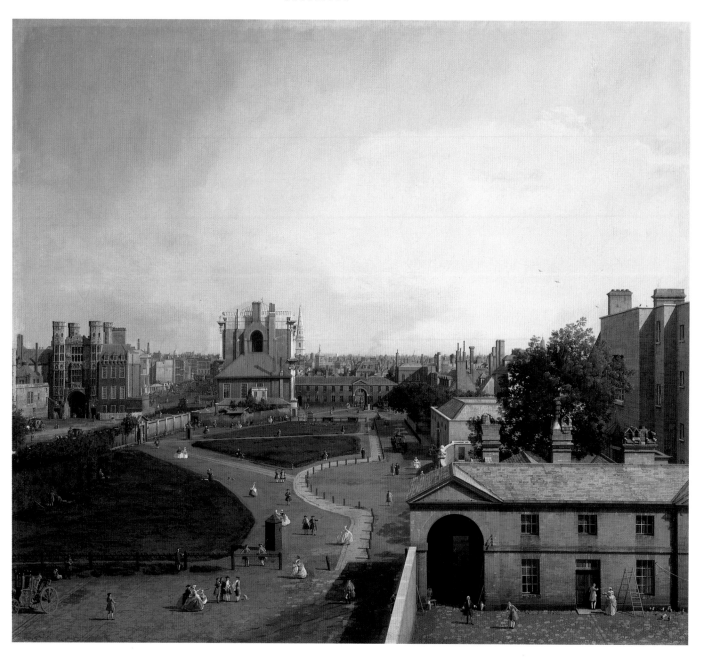

148
*London: Whitehall and the Privy
Garden from Richmond House*
1747

Oil on canvas,
109 x 119.5 cm
(43 x 47 in)

From Goodwood House by
Courtesy of the Trustees

From left to right: the Holbein
Gate with Whitehall beyond it, the
Banqueting Hall by Inigo Jones,
the Privy Garden, the stables of
Richmond House and, beyond
them, the back of Montagu House.

149
Detail of Plate 148.

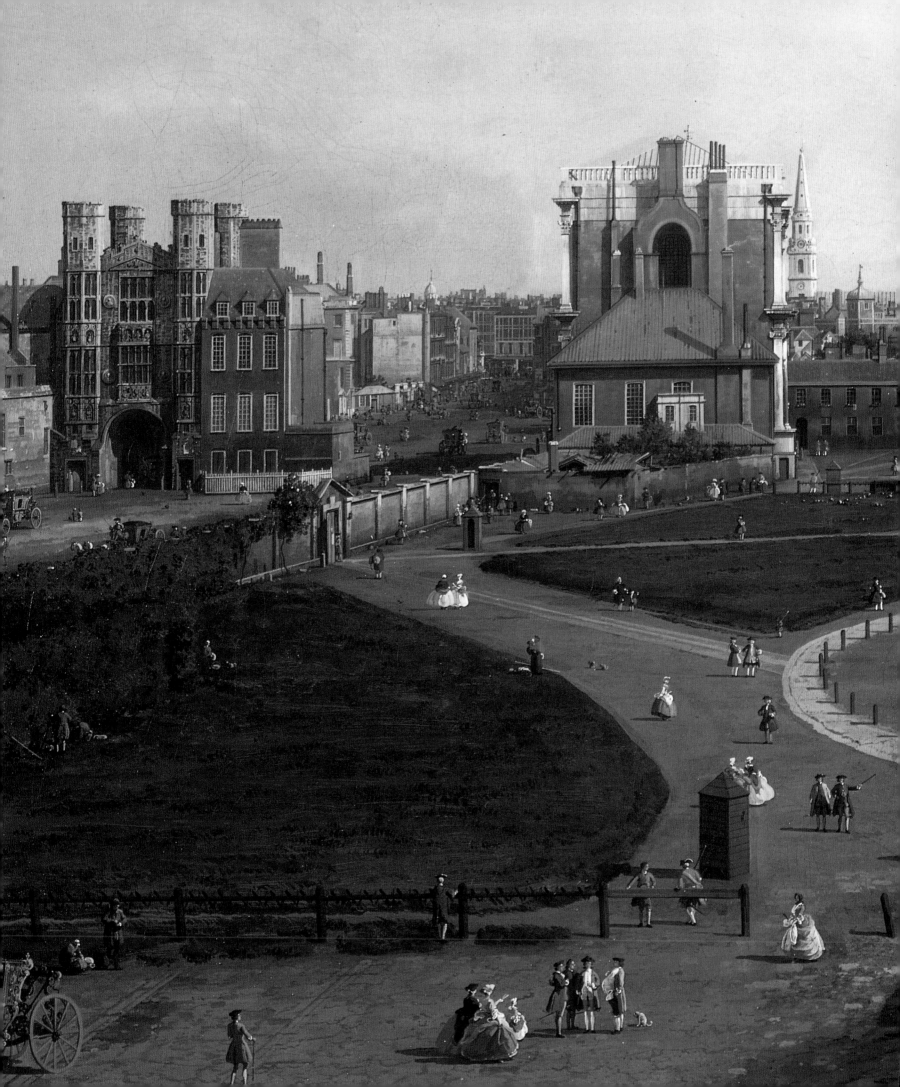

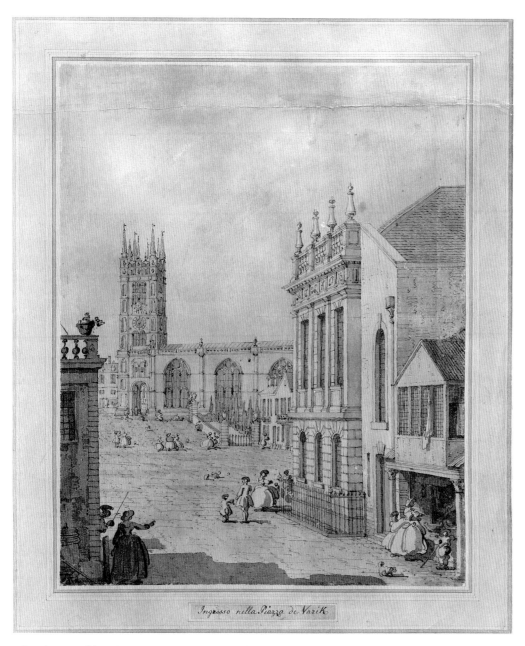

Ingresso nella Piazza de Varik

150
Warwick: St Mary's Church
1748-9

Pen and ink with washes,
35.4 x 28.2 cm
(14 x 11⅛ in)
London, British Museum

Inscribed: *Ingresso nella Piazza de Varik*. On the right is the present Public Library.

151
Warwick Castle: the South Front
(distant view)
1748

Oil on canvas,
42 x 71 cm
(16½ x 28 in)
Private collection

In the foreground is the River Avon and, in the left background, Ethelfleda's Mount. Painted before the planned removal of the old mill at the foot of the tower on the right and before other changes which appear in Plate 166.

Overleaf:
152
London: the Old Horse Guards from St James's Park
1749

Oil on canvas,
122 x 249 cm
(48 x 98 in)
London, The Tate Gallery
(Sir Andrew Lloyd Webber Art Foundation)

On the right is the entrance to Downing Street; nearby, footmen are beating a large carpet.

when it was sold to George III some ten years later.

While Canaletto was in Venice he invested 2,150 ducats (about £360 sterling) in some property on the Zattere (so much for Vertue's theory that he intended to put his fortune into English stocks for better security: when he died this property was virtually all he had to leave). Some time in 1751, probably while Canaletto was still in Venice, Smith published a third edition of the *Prospectus*. If he expected that this would result in a fresh flow of commissions, both must have been disappointed, and by mid-1751 Canaletto had decided to return to London.

It would have been a busy year for Smith because at last the house he had rebuilt on the Grand Canal was, according to the diarist Pietro Gradenigo, to be seen without its scaVolding and ready to move into. It was the fourth palace from the right in the view *Looking North from near the*

Rialto Bridge (Pl. 159), now known as the Palazzo Mangilli-Valmarana, and Smith had for many years leased it from the Balbi family. Some years earlier he had employed Visentini, who could turn his hand to architecture, painting and drawing as well as to engraving, to design a modern façade for the Gothic palace. Paintings attributed to Marieschi and his successor Albotto (see p. 132) show the house in various stages of demolition but the attributions are not really secure enough to draw conclusions about the progress of the work from them.

Naturally the house appeared with its old façade in the 1735 and 1742 editions of *Prospectus*. It is a little surprising that Smith did not have Visentini alter it for the 1751 edition, particularly since he had had the engraving of *S. Geremia and the Entrance to the Cannaregio* changed to show a statue and balustrade which were not set up until 1742.

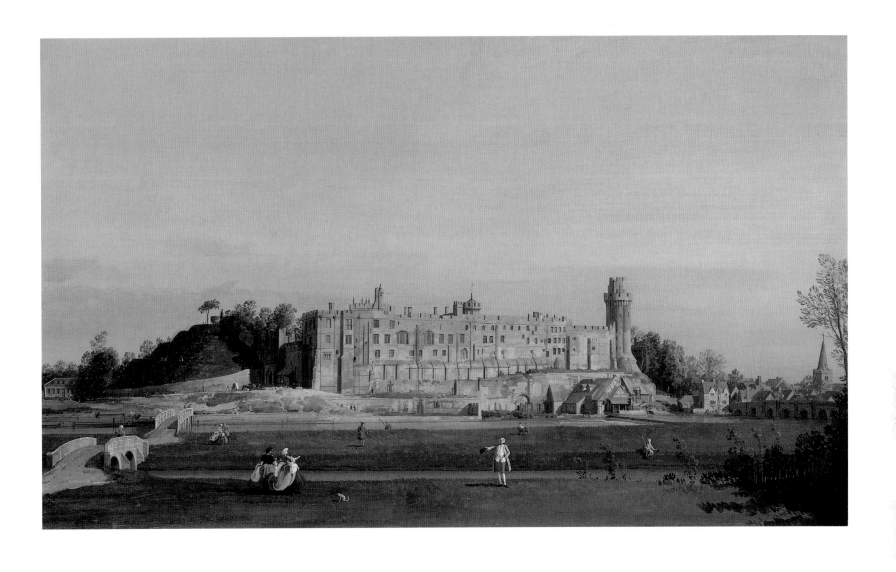

Much more surprising is the fact that the original painting showing Smith's house had been altered by painting the new façade over the old one (Pl. 161). The work seems to have been done by Canaletto himself, although there is always the possibility that Visentini was able to imitate him to this extent. If it was Canaletto, the strange commission would have been carried out just before the building work was completed since he was back in London by July 1751. It was rather an appealing whim of Smith's, a man whose vanity was so often remarked upon but who never included himself as a subject of the portraits he commissioned.

Once back in his old lodgings in Silver Street, Canaletto placed another advertisement in the newspaper. He announced that he had painted a representation of Chelsea College (now called Chelsea Hospital), Ranelagh House and the Thames, which Gentlemen (and others, he now added) could attend and see. Vertue noted the advertisement and the fact that Canaletto had been away for eight months (which we would not otherwise have known). He also added the interesting information that the painting was worth £60 to £70. This, with Lord Brooke's payments, is all we know about Canaletto's prices while in England. He may have seen the painting himself, for he added a critical comment without suggesting that it came from reports he had heard. The painting he thought was 'not so well as some works of Canaletti formerly brought to England nor does it appear to be better than some painters in England can do'.

The painting (Pl. 158) was more than two metres wide and only a metre high and, not surprisingly, was at some time cut in half, one half finding its way to Cuba and the other remaining in England. It was true that Canaletto had done better in the past, but there can have been only one painter in England whom Vertue could have regarded as able to do as well. This must have been Samuel Scott who, Vertue had written many years earlier, was among the best artists working in London. At that time Scott was almost exclusively a marine painter – hence he was sometimes nicknamed 'The English Van de Velde', but by the time Westminster Bridge was well under construction, he had made many drawings and a painting of the work in progress. This shows the two middle arches finished and two others in hand and can be dated to the spring or summer of 1742; Scott made a number of versions of the picture, of which the only fully documented one is in the Bank of England (Pl. 162). Scott himself described this, with its companion, as 'thought to be the two best Pictures I Ever Painted', so it is not unreasonable to judge his capacity as a topographical painter by it. Apart from the many inaccuracies in the buildings as shown, the picture entirely lacks Canaletto's feeling for architecture, his luminosity and the skill in composition that even his more mechanical paintings display. Later on (probably as he became more familiar with Canaletto's technique) Scott became increasingly skilful as a painter of townscapes and turned to the city as a subject in preference even to the sea. At this period, though, Vertue's judgement must have been coloured by the resistance of the dealers to

153
London: the Old Horse Guards and the Banqueting Hall, Whitehall
1749

Pen and ink,
11.4 x 21.7 cm
(4½ x 8½ in)
Venice, Accademia

A leaf from Canaletto's sketchbook with many notes by him; used for the central part of Plate 154.

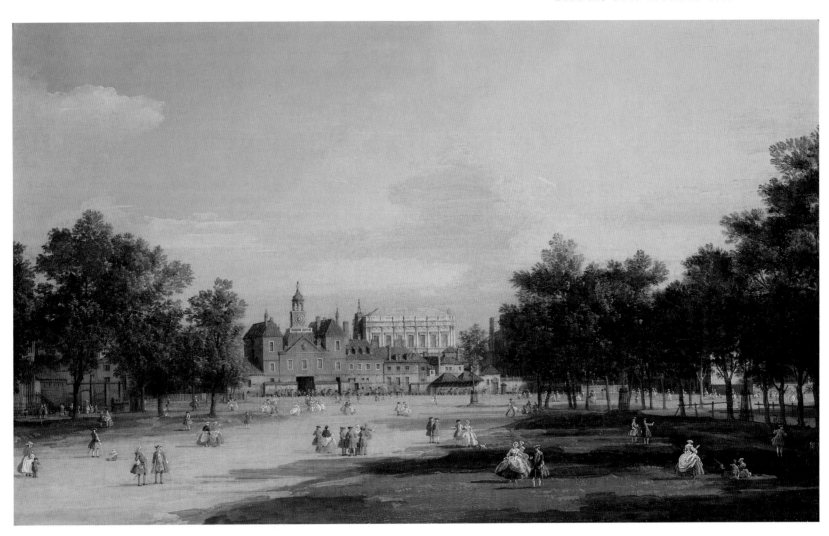

154
London: the Old Horse Guards and the Banqueting Hall, from St James's Park
1749

Oil on canvas,
45.5 x 76 cm
(18 x 30 in)
Private collection

To the right of the Old Horse Guards building, but on the far side of Whitehall, is the Banqueting Hall.

Canaletto's presence in London, particularly at a time when they thought they had rid themselves of him for good.

In spite of the absence of competition, Canaletto's advertisement announcing his return does not seem to have attracted new patrons except perhaps print publishers. One of these published an engraving of Vauxhall Gardens which had become very popular when the opening of Westminster Bridge made it an easy walk to be followed by music and a meal in one of the supper boxes. The engraving was inscribed *Canaletto delin't* which implied that it was from a drawing, rather than a painting, by Canaletto. A painting followed (Pl. 164), in the reverse direction and so probably based on the drawing, but with many differences. The rather stilted figures hardly accord with accounts of how rich and poor mixed in the Gardens but the octagonal orchestra pavilion and

other buildings on the right make the scene seem agreeably inviting. Another published three views of the Rotunda and gardens at Ranelagh, the Rotunda also being followed by a painting (Pl. 168) and an engraving of *The Monument* (Pl. 163) is dated 1751-2. This is inscribed '*Signor Canaleti Delin't*, but no drawing or painting of the subject has survived; it shows that narrow lane, Fish Street Hill, which used to lead to London Bridge but now leads nowhere, magically widened so that we are inevitably reminded of the Piazza Navona in Rome. There exists a painting after this engraving which bears the name W. James. If this was William James it is the only known work by this shadowy artist to whom much is still attributed.

Of all Canaletto's old patrons, two remained faithful. Following the 1748–9 payments by Hoare's Bank on Lord Brooke's behalf (p. 168), two more appear in March and July 1752, one of

155
London: Westminster Abbey, with a Procession of Knights of the Bath
1749

Oil on canvas,
99 x 101.5 cm
(39 x 40 in)
London, Dean and Chapter of Westminster

To the left of the Abbey is St Margaret's Church. The roof of Westminster Hall and the houses of King Street can also be seen.

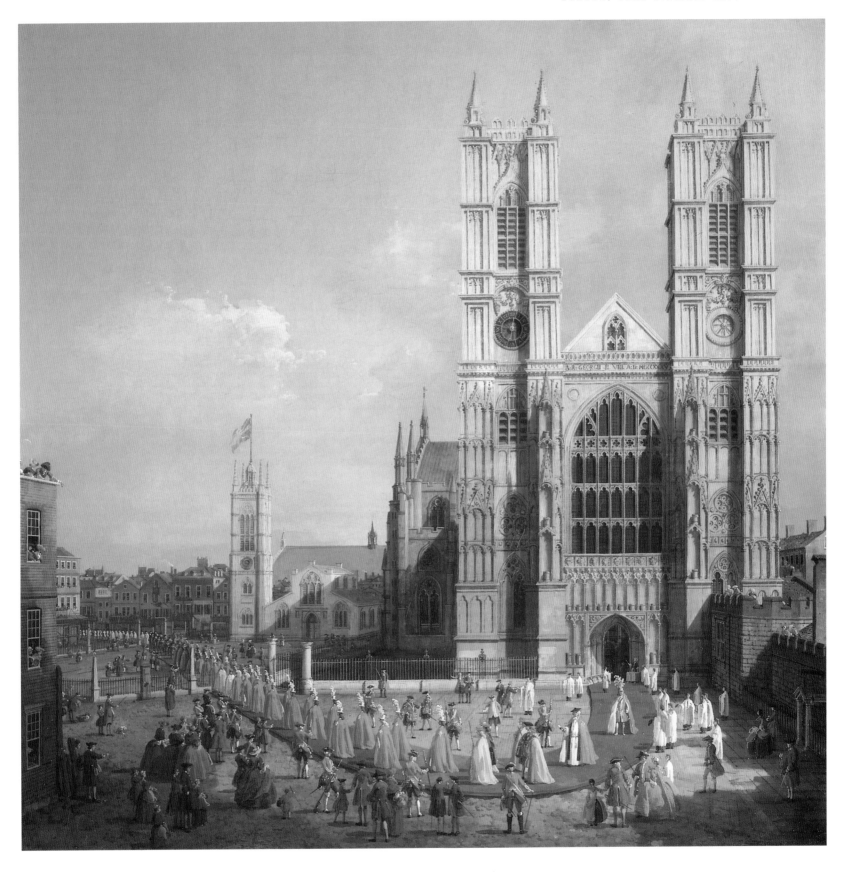

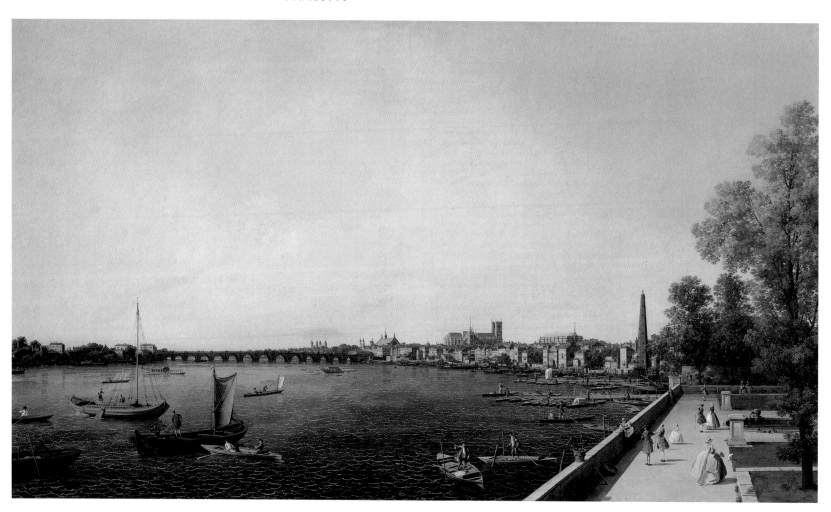

156
London: the Thames from the Terrace of Somerset House, Westminster Bridge in the Distance

Oil on canvas,
106.5 x 185.5 cm
(42 x 73 in)
The Royal Collection

Companion to Plate 157 and in the opposite direction; the viewpoint is slightly downstream.

£33 12s (32 guineas) 'To Sig.ʳ Canaletti' and the other of £30 'To Antonio Canal' (four different spellings for the four payments). One of these must have been for another painting of the South Front of Warwick Castle (Pl. 166), which had been 'tidied up' by Capability Brown since the earlier visit; new trees have been planted and some small buildings removed. The other payment would have been for one of the two pictures of the East Front; there are no clues in these to indicate whether the one painted from inside the Courtyard (Pl. 147) or the exterior view (Pl. 146) came first.

The other faithful patron was the new Earl of Northumberland. By 1752 he had inherited and reconstructed Northumberland House at Charing Cross and he called in his old artist to record the house (Pl. 167) – and, more important for later generations, one of those street scenes of Georgian London which one wishes he had painted more often. This was to prove the favourite picture of Canaletto's imitators. Then there was Alnwick Castle (Pl. 165), perhaps the grandest of all the Percy seats. It was nine days journey overland from London and it is not easy to believe that Canaletto went there to paint but one picture and a replica; an engraving (or even perhaps a watercolour by one of the Percy ladies) seems a more likely source but so far none has appeared.

By 1753 the building of the new Horse Guards had been completed and an engraving inscribed *Canaletti delin* was published in November. For this Canaletto merely altered his picture of the Old Horse Guards; two paintings of the subject, different in detail, may either have followed or preceded the engraver's drawing, which has not itself survived.

A usually reliable Venetian diarist, Pietro

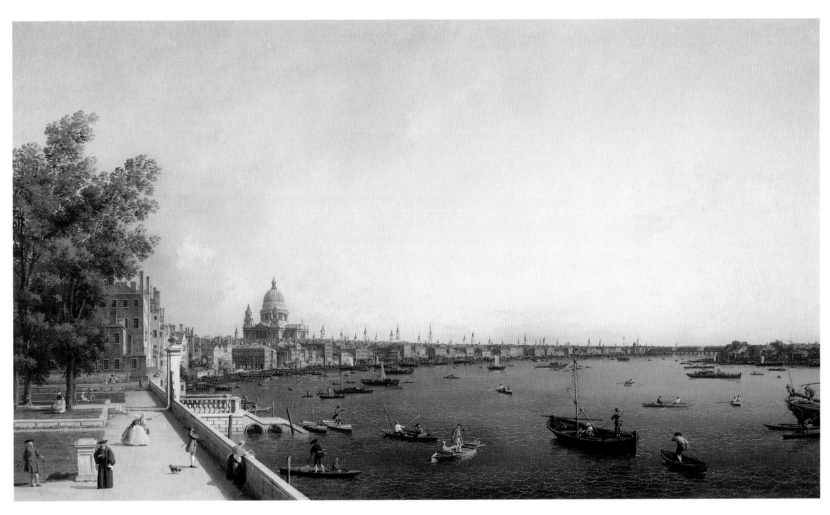

157
London: the Thames from the Terrace of Somerset House, the City in the Distance

Oil on canvas,
105.5 x 186.5 cm
(41½ x 73½ in)
The Royal Collection

Perhaps painted for Smith in Venice during Canaletto's visit of 1750-1.

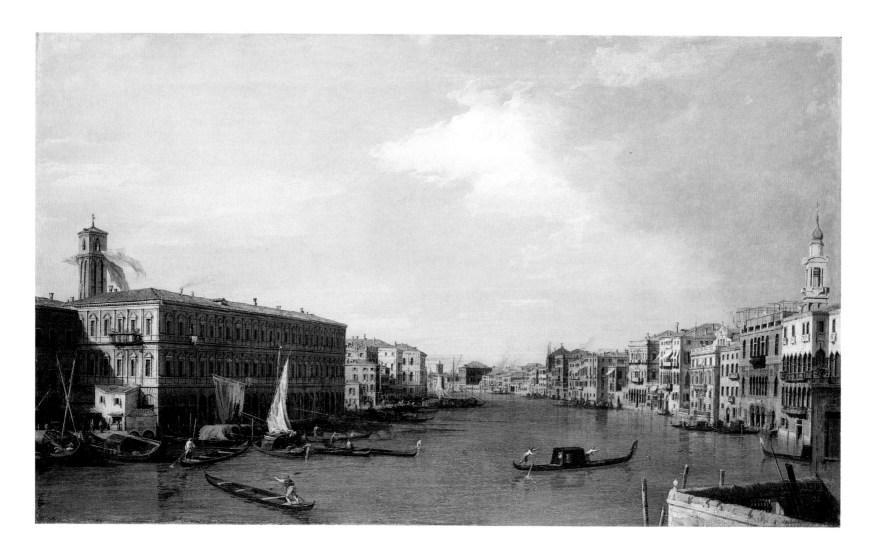

Gradenigo, recorded in July 1753 that Canaletto had returned from England to his native city. Whereas there is plenty of confirmation of his first visit, this is the only evidence of a second and it is possible that Gradenigo was referring to the visit of 1750–1. What is certain is that Canaletto was in England during 1753 and 1754 and that he had one major commission during this period. He may also have painted his two pictures of Greenwich (Pl. 173) at about this time. They provide an instructive demonstration of one of his favourite devices – the use of two viewpoints some ten degrees apart so as to give the impression of a wide-angle view, in other words a view taken from a much closer viewpoint not really attainable in practice.

The major commission that came to Canaletto as his long stay in England drew to a close was from Thomas Hollis, a rich eccentric, who had met Consul Smith in Venice and perhaps had an introduction to the artist from him. Hollis commissioned six paintings, which formed a very mixed bag. One of them was based on an old engraving of the Piazza del Campidoglio in Rome and another on one of Canaletto's own drawings of Ranelagh (Pl. 168), published three years earlier. A third was an uninspired but lucid portrait of St Paul's Cathedral (Pl. 169). There was a capriccio based on buildings around Whitehall, in the manner of Smith's overdoors, and then an enchanting picture of *Old Walton Bridge* (Pl. 170).

Here was the perfect combination of a fairy-tale structure and an artist who responded to it with the sensitivity he had shown in the finest of his etchings. But how much had Canaletto himself

contributed to the fairy-tale setting? The delicate, latticed structure of the bridge appears to be curved and wider in the centre but old plans show it to have been straight and the road across it of equal width throughout. Canaletto, it seems, had cast his own spell over the scene and made a capriccio of his picture. As with all Hollis's paintings, the back of the canvas was inscribed with a statement in Italian that it been 'done in London in 1754 for the first and last time with all good care' for Cavaliere Hollis and signed *Antonio Canal detto il Canaletto*. According to Hollis's own catalogue he appears in the foreground with his servant, a friend, and his dog which was called Malta. One cannot help wondering whether the picture may have been painted closer to 1750, when the bridge was first opened, for Canaletto's own pleasure, the figures (including the artist himself, wearing an eye shade) being added later at Hollis's request.

Hollis's sixth painting was a view of Westminster Bridge from the north (Pl. 172), very similar to the one of May 1750 (see p. 166). But for Hollis, Canaletto showed the repairs being carried out to the sinking arches four years earlier, as he had in the drawing which he took back to Venice and gave or sold to Smith. When Hollis's set was dispersed in 1884, the picture was described by the auctioneers as 'Westminster during the building of the bridge' and it was assumed that Canaletto had again been exercising his imagination until it reappeared quite recently, only then was it discovered that in this case he had been painting what he had seen, albeit more than four years earlier.

162
Samuel Scott (1710?-72)
London: Westminster from the North-East
1742

Oil on canvas
London, The Bank of England

The Bridge is shown with only the four central arches built, as seen from the Surrey side.

163
London: the Monument
1751-2

Engraving inscribed *Sign.r Canaleti Delin* and *G. Bickham Sculpt*, published by Robert Sayer and Henry Overton. Later copied by C. or W. James.

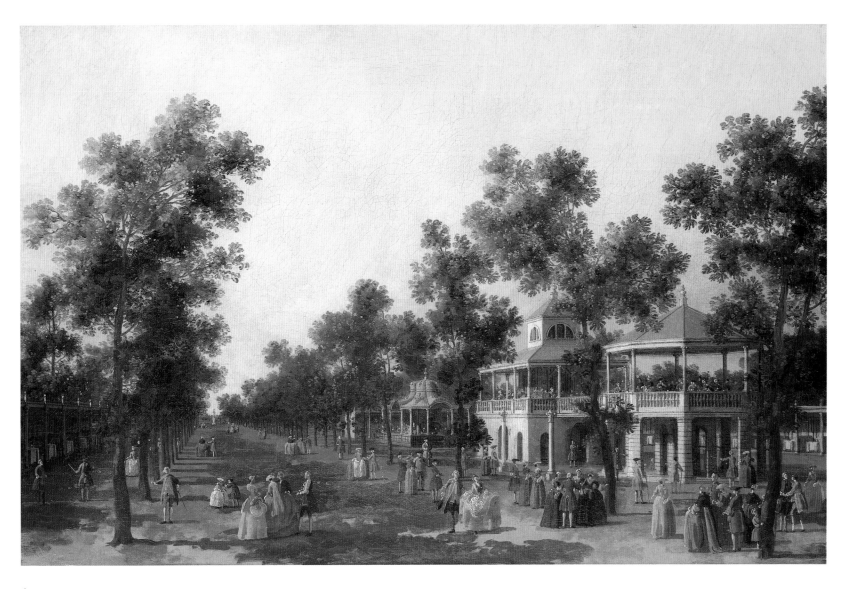

164
London: Vauxhall Gardens; the
Grand Walk
Probably 1751

Oil on canvas,
50 x 75.3 cm
(19¾ c 20 3.4 in)
Private collection

Vauxhall Gardens were on the
south bank of the Thames, close to
the present Lambeth Bridge, but
would have been reached in 1750 by
the new Westminster Bridge. The
ease of approach revived its
popularity.

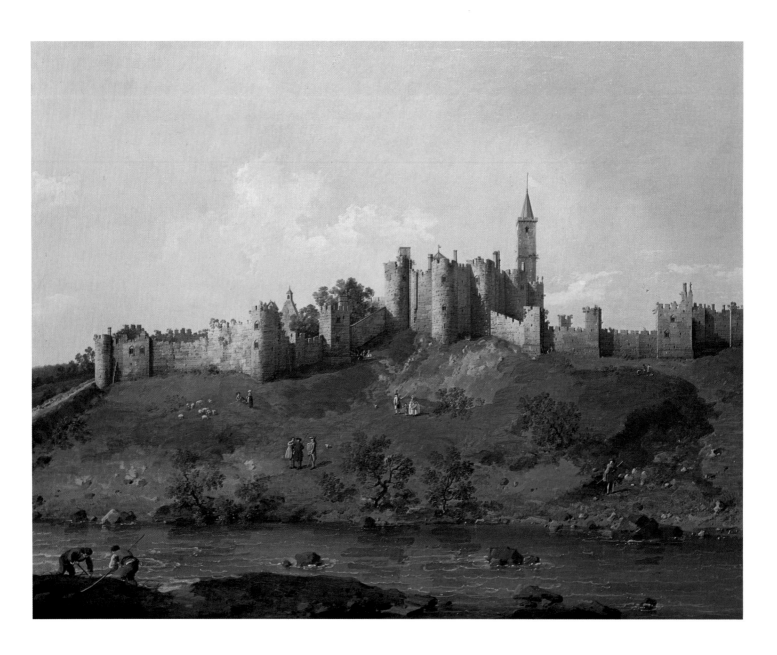

165
Alnwick Castle, Northumberland
c. 1752

Oil on canvas,
113.5 x 139.5 cm
(44¾ x 55 in)
The Duke of Northumberland

Commissioned by Sir Hugh
Smithson, who had by 1752
inherited the earldom of
Northumberland but had not yet
been created first Duke.

166
Warwick Castle: the South Front
(near view)
1752

Oil on canvas,
75 x 102.5 cm
(29½ x 47½ in)
Madrid, Thyssen-Bornemisza
Collection

The old mill shown in Plate 151
has disappeared; trees have been
planted, and a new 'gothick' porch
has been added by the hill on the
left. These show the improvements
carried out by Capability Brown
since Canaletto's visit in 1748.

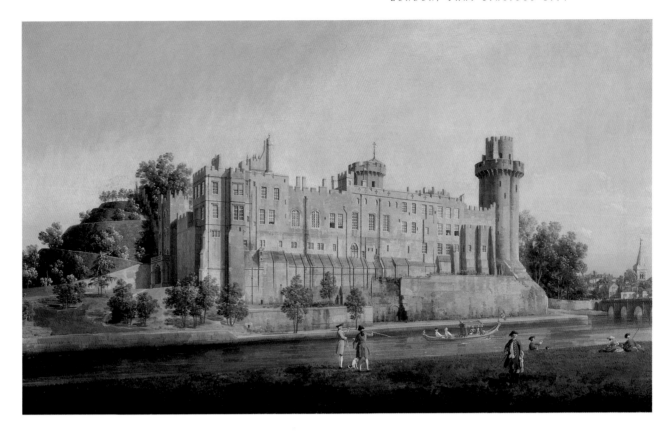

167
London: Northumberland House
1752

Oil on canvas,
84 x 137 cm
(33 x 54 in)
The Duke of Northumberland

Left to right: the Golden Cross Inn
(with free-standing sign), entrance
to The Strand, Northumberland
House, statue of Charles I.

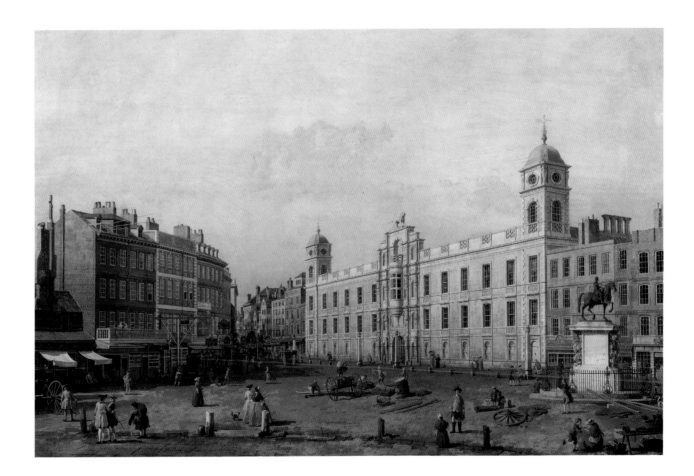

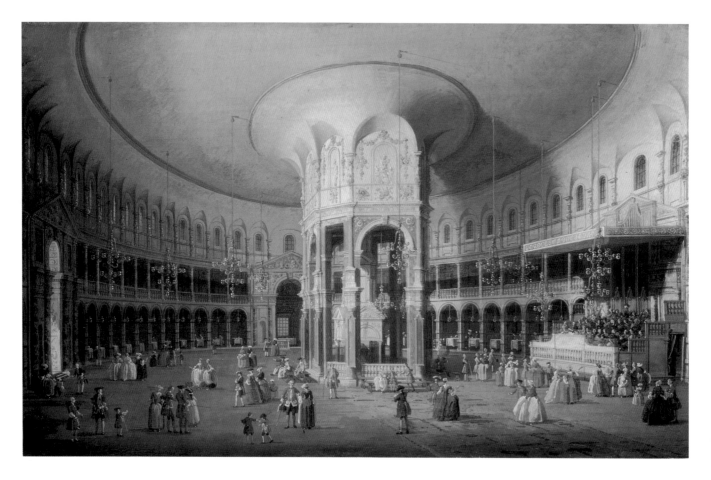

To return to *Old Walton Bridge*, the picture must have been seen by Samuel Dicker, a Member of Parliament who had paid for the erection of the bridge. Not unnaturally he seems to have wanted a picture of it for himself and in due course he received one with a label in almost identical terms to those on Hollis's pictures, only the name being changed to that of Dicker and the date to 1755. Dicker allowed a drawing to be made (Pl. 171), which was published as an engraving, 'after my picture painted in London 1755 for Cavaliere Dickers'. By this time an extension in stone had been added to the bridge (taking away much of its charm) so that Hollis could scarcely complain that his painting had been copied.

Dicker's drawing is the last that we know of Canaletto in England, indeed the last that we know of the artist with certainty for another five years. Probably quite soon afterwards he decided there was no longer enough work to justify his staying away from home; he was almost 60 and had been in England for nine years apart from his one certain and one doubtful break in his native city.

These years had neither made his fortune nor enhanced the very great reputation he had had when he arrived. But they can by no means be written off as a failure. They have left us some precious paintings and drawings which throw a shaft of light on what mid-Georgian London was really like as well as showing the impression it made on an observant, perceptive and immensely skilled Venetian. In Venice today a journey down the Grand Canal will take us past the same palaces as Canaletto saw; we can see for ourselves how faithfully his pictures caught the fabric of the buildings, the fall of light and the reflections of the

168
London: Ranelagh, Interior of the Rotunda
1754

Oil on canvas,
46 x 75.5 cm
(18½ x 29¾ in)
London, National Gallery

One of six paintings for Thomas Hollis. Ranelagh was a pleasure resort and the Rotunda appears in Plate 158.

169
London: St Paul's Cathedral
1754

Oil on canvas,
51 x 61 cm
(20 x 24 in)
New Haven, Conn., Yale Center for British Art (Paul Mellon Collection)

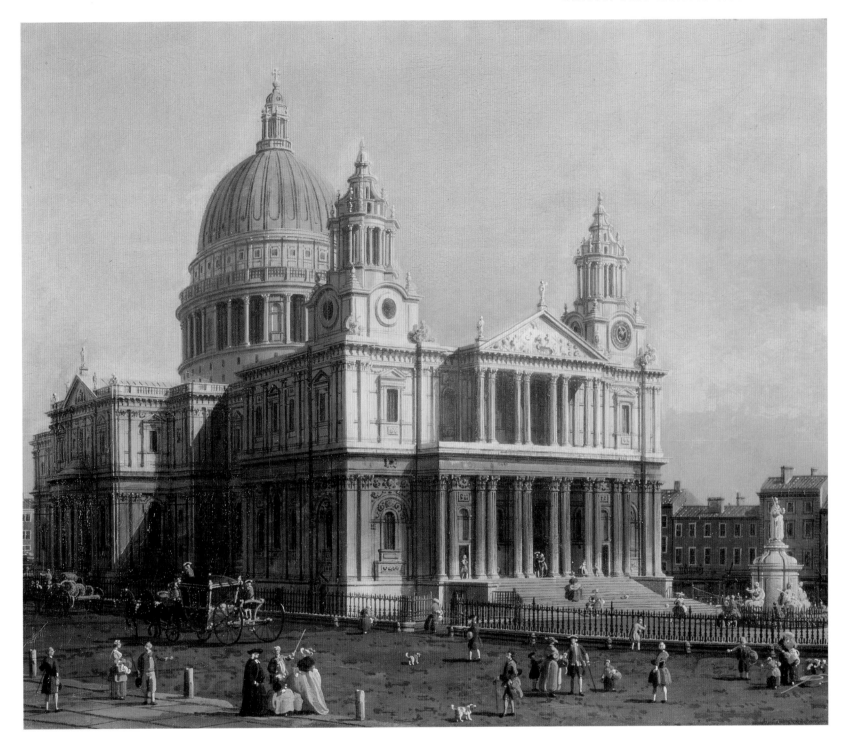

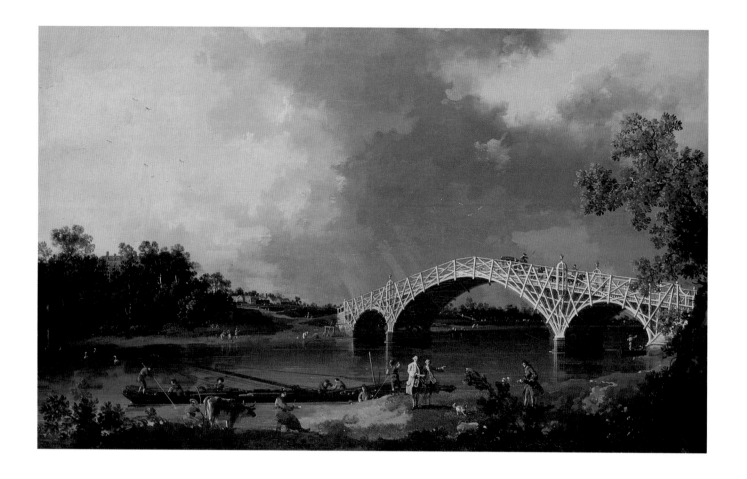

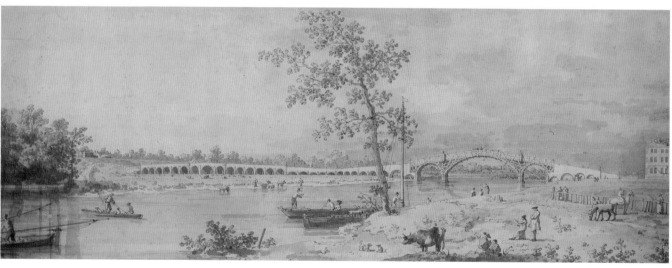

170
Old Walton Bridge
1754

Oil on canvas,
46.5 x 75 cm
(18¼ x 29½ in)
London, Dulwich Picture Gallery

The Bridge crossed the Thames
some 25 miles by water upstream
from Westminster and was built by
Samuel Dicker, whose house is
seen among the trees on the left.

171
Old Walton Bridge
1755

Pen and brown ink and grey wash,
29 x 63 cm
(11½ x 24¾ in)
New Haven Conn., Yale Center for
British Art (Paul Mellon
Collection)

Probably Canaletto's last work in
England. Later used for an
engraving but sheep were then
substituted for the dogs in the
foreground.

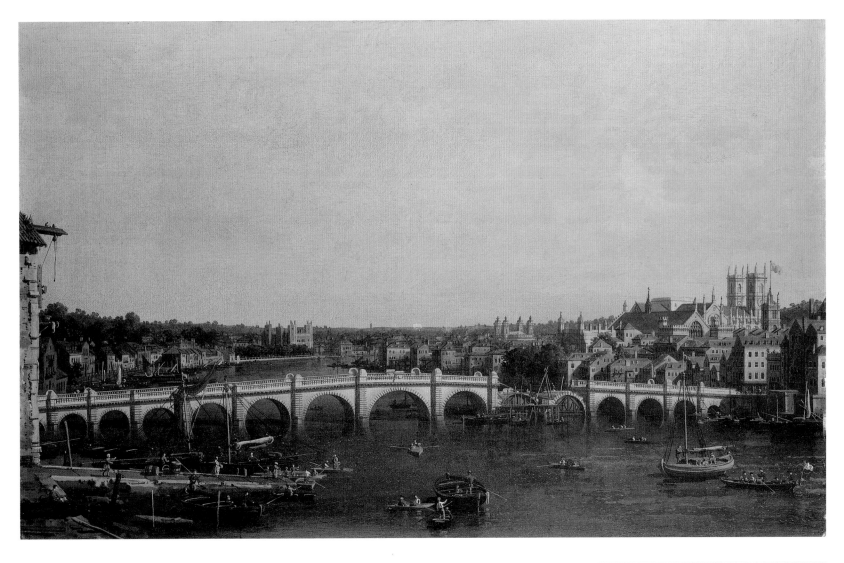

172
London: Westminster Bridge under Repair
1754

Oil on canvas,
about 46 x 75 cm
(18 x 29 in)
Private collection

Canaletto has followed an earlier
painting of the bridge but has
shown it under repair in 1750, as in
Plate 145. From the Surrey bank
and the north side of the bridge.

173
*London: Greenwich Hospital from the
North Bank of the Thames*
c. 1753

Oil on canvas,
66 x 112.5 cm
(26 x 41¼ in)
London, National Maritime
Museum

From two viewpoints on the Isle of
Dogs.

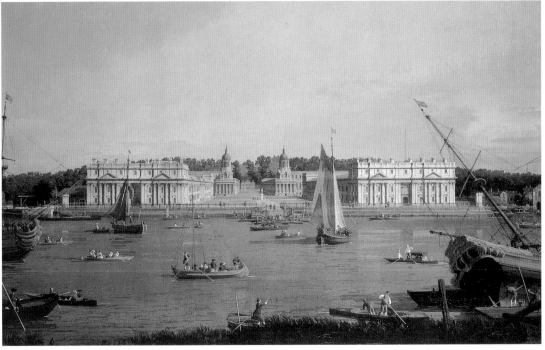

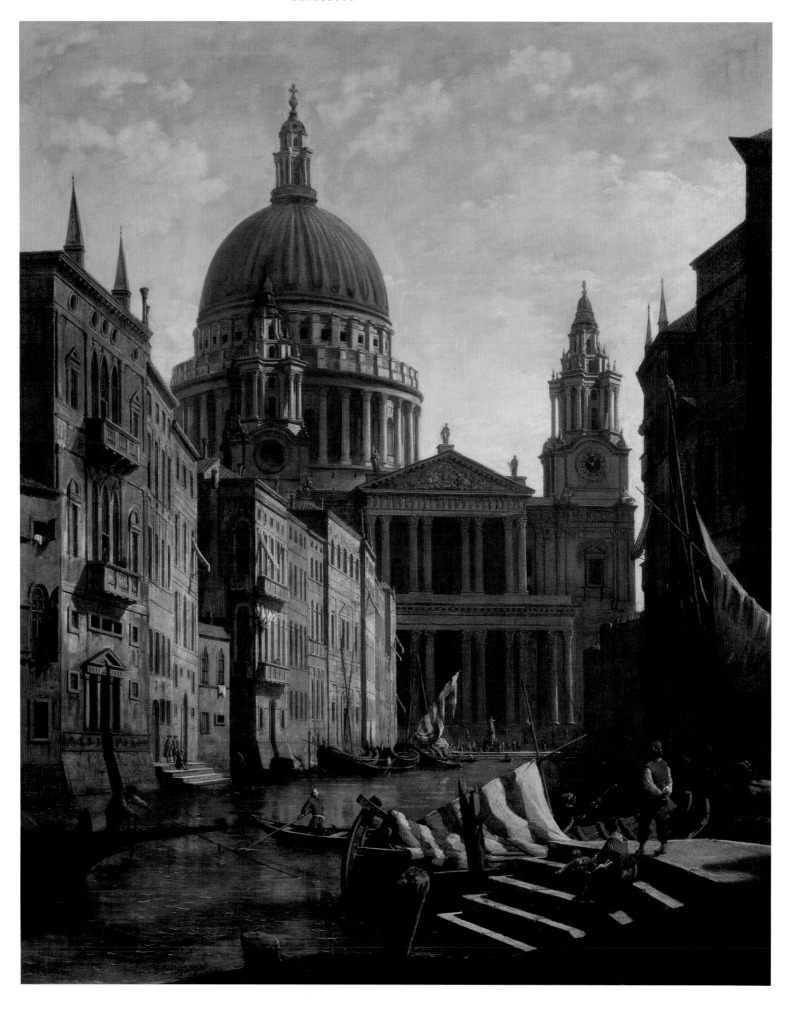

water. In London, between Lambeth Palace and Greenwich Hospital, which still stand, not a building on the banks of the Thames remains as it was in Canaletto's day. Charing Cross has been swept away by Trafalgar Square. Ranelagh, the Privy Garden in Whitehall, the ill-fated Westminster Bridge, the delectable Old Walton Bridge, have all gone except in Canaletto's pictures. We cannot trust his light: he dispersed the infamous London smoke and bathed its buildings in Venetian sunshine. As had always been his practice in Venice, he placed himself at unattainable viewpoints and adjusted the positions of the monuments to suit his pictorial requirements. Nevertheless he carried conviction and always persuades us that he painted what he saw.

When Canaletto left England in 1755 or 1756, he left more behind him than the paintings and drawings he had sold. The school of topographical art, which was only just beginning to flower, could not fail to be influenced by so experienced and successful an exponent of its aspirations. Samuel Scott had only been toying with topography before Canaletto's arrival in England and, but for Canaletto's example, might well have remained a marine painter for the rest of his career. The Sandby brothers, Paul and Thomas, formerly military draughtsmen, began their careers as artists by being little more than imitators of Canaletto; only later did they develop their own style, Paul particularly, and become so influential in the revival of watercolour drawing for architectural and topographical subjects.

Paradoxically, although Canaletto had made free use of monochrome washes on his drawings, he had never experimented with 'tinted' or 'stained' drawing, as the work of the watercolourists was at first called. Yet these were the artists who most came under his influence.

William Marlow, born in 1740, who became a pupil of Scott just after Canaletto left England, remarked on how 'much business' Scott had, perhaps as a result of Canaletto's departure. (Marlow's greatest tribute to Canaletto may well be his popular pastiche (Pl. 174) showing the Grand Canal flowing up a Fleet Street lined with Venetian palaces towards St Paul's Cathedral in London.) Joseph Farington, better known as a diarist, made many London views in pen and wash, some coloured; he followed Canaletto's broken and dotted lines faithfully and on one drawing noted that it must be 'Canaletti brick'. Thomas Malton, who taught perspective to Turner, was another watercolourist who owed much to Canaletto. Turner, of course, was too original a genius to follow anybody, but he began his career, together with the brilliant Thomas Girtin, by copying the work of Canaletto and others in the Adelphi houses of Dr Monro and John Henderson. (These two connoisseurs had other would-be artists copying their drawings; their copies of Canaletto drawings, which have long plagued the market, bear even less evidence of the hand of Turner or Girtin than of Canaletto.) Turner's own tribute to Canaletto was even wryer than Marlow's. He called his first oil painting of Venice in 1833 *Ducal Palace and Bridge of Sighs, Canaletto painting* and showed the artist (or, rather, *an* artist) in operatic costume standing on a plank in the water in front of a huge, gilt-framed canvas on an easel, acting as foreground to a highly inaccurately painted view of the Molo.

Canaletto's work had always appealed to the English more than to other Europeans. Partly no doubt on this account, and partly because of the rise of the topographical watercolourists from the 1760s onwards, his influence was far greater in England than it was to be after his death in Italy.

174
William Marlow (1740–1813)
Capriccio: St Paul's and a Venetian Canal
c. 1795?

Oil on canvas,
130 x 104 cm
(51 x 41 in)
London, Tate Gallery

Marlow travelled in Italy in the 1760s and was, presumably, familiar with Italian capriccios.

No aspect of Canaletto's work presents such problems as the imaginary view, or capriccio. It is seldom difficult to recognize his hand in view paintings and drawings, even when the hands of others seem also to have played a part. In the capriccio, though, he was generally departing deliberately from his normal practices, exercising his imagination, and administering a mild shock to the spectator. By removing much of the Canaletto we know, he often leaves us wondering how much of the true Canaletto is left, if any. It is moreover easier to copy a capriccio than a good view painting, hence the vast number of versions that exist of some of them. Often these were painted by artists of talent, although perhaps lacking in imagination, so that the original becomes hard to identify.

When the question of attribution is settled, however confidently, there remains that of date. Most of the imaginary views seem to have been produced after 1740 and little more can be attempted than to separate those of the pre-England period from those which came after the return to Venice. There are few who would claim to be able to identify those executed *in* England or even to say whether these account for a large or small proportion of the whole. It is not a matter of great importance whether a particular capriccio was painted soon or long after 1740, but one would dearly like to know more of the part this type of work played in Canaletto's life before 1740, particularly in the years before 1730. All that can be said with certainty is that he was painting part of two imaginary tombs for McSwiney (p. 48) in about 1726 but we do not even know which parts.

There are few imaginary views of Rome which, it has been suggested, were painted before Canaletto's return to Venice in the early 1720s but hardly any of these have appeared in public and until they can be studied, and preferably compared, judgement must be reserved. Apart from the tomb paintings, the earliest capriccio that can be identified with confidence belonged, as might be expected, to Smith.

When George III bought Smith's collection in 1762 there was included in it a list of pictures, and among those of the Italian school was one described as 'The Ruins of the Temple of Peace at Rome' by Canaletto. From the measurements given (14 x 15 ½ inches) it was evidently a very small picture, but not until quite recently was it recognized as being a capriccio of approximately the same size (31.4 x 40.3 cm.) hitherto attributed to Marco Ricci. The view shows *Ruins based on the Forum in Rome* (Pl. 179), including the Basilica of Constantine and the campanile of S. Francesca Romana. It is in poor condition, but the architecture is unmistakably by Canaletto. The figures are less characteristic but on the whole the picture seems likely to have been painted soon after 1730.

Two other imaginary views were described by Smith as 'Ideal Ruins, a bold frank manner' but without any attribution. A pair of larger pictures (Pls 176 and 177), half a metre high, showing unidentifiable ruins, fits the description and size in the list and bears every indication of Canaletto's hand. These were also attributed in the past to Marco Ricci, who painted many pictures of this type, a number of them in Smith's collection (one,

175
Detail of Plate 185.

10 *Escape from Reality*

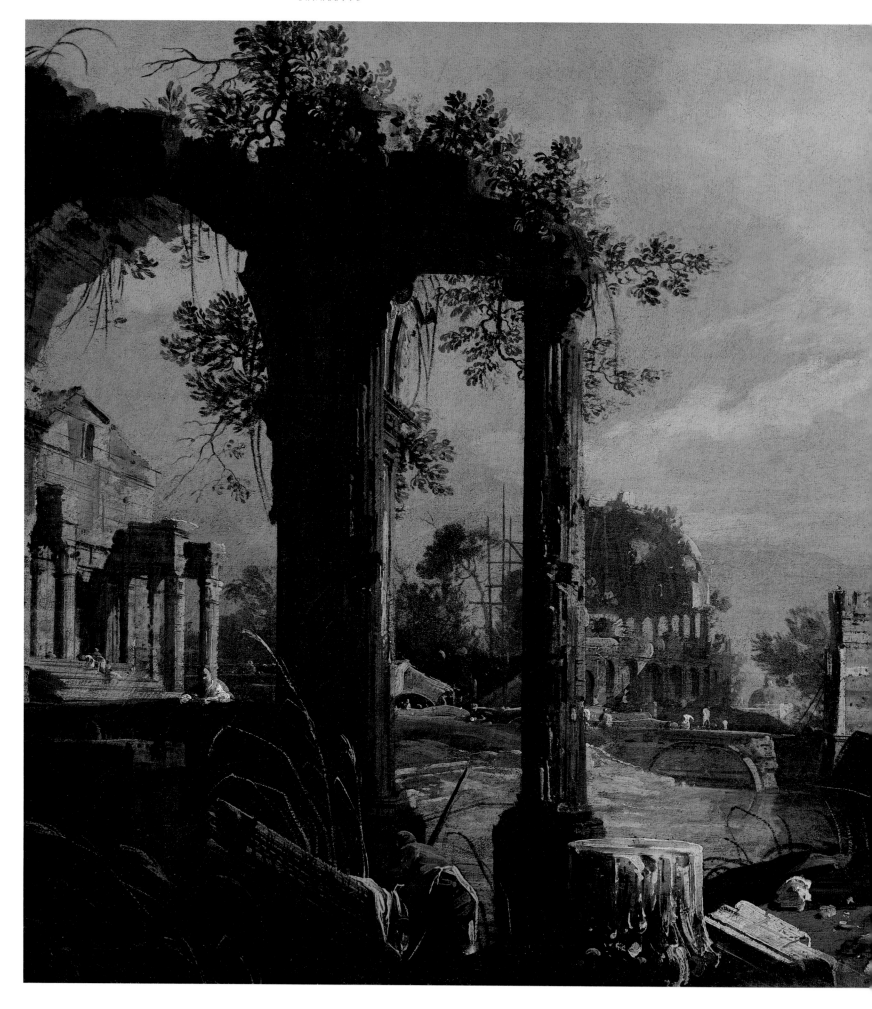

176
Capriccio: with Ruins of a Pointed Arch
Perhaps c. 1735

Oil on canvas,
53 x 66.7 cm
(20¾ x 26¼ in)
The Royal Collection

Behind the arch, some buildings of
Padua; centre, part of the
Colosseum with a theatrical shaft
of light.

177
Capriccio: Classical Ruins
Perhaps c. 1735

Oil on canvas,
53 x 66.7 cm
(20½ x 26¼ in)
The Royal Collection

As in the case of Plate 179, long
attributed to Marco Ricci. Some
of the ruins seem Roman, others
Paduan.

perhaps a wedding present, inscribed: *Per Madama Smit*). They have also been attributed to Bellotto with less justification; probably painted after the little *Ruins* picture, they seem to belong to a date well before Bellotto was capable of such work.

The presence of three generally acceptable Canaletto capriccios of the 1730s in Smith's collection gives credibility to the same attribution in the case of several other pictures of the same kind. Two of these (Pls 178 and 180) raise enormous difficulties simply by reason of the number of versions extant. In both it is possible to see recollections of certain Paduan monuments, and in one (Pl. 178) a church which might be St Peter's, Rome. There are not less than 50 known versions of these two pictures, many of which can easily be seen as having come from a studio presided over by Canaletto, none likely to be wholly by his hand. When were they produced,

and where? The sheer difficulty of seeing all these pictures, with new versions still appearing, makes it impossible to answer the questions and one can only speculate. A 'factory' in London for the systematic copying of imaginary views which had been painted in the 1730s is a possibility. It would account for Canaletto's time at periods when he is not known to have been doing any other work. The idea has another attraction: after the first year or so in England he can seldom have been fully occupied for long, yet some of his work bears evidence of studio assistance. Why should an under-employed artist have studio assistants? If they were in fact employed to copy popular imaginary views by the score, their services may also have been brought into use for other purposes. The suggestion can only be put forward half-seriously. There is no evidence to support it – but the possibility exists.

178
Capriccio: Ruins and Classic Buildings

Oil on canvas,
87.5 x 120.5 cm
(34½ x 47½ in)
Milan, Museo Poldi Pezzoli

This and Plate 180 are examples of
a pair of subjects which exist in
very many versions all
approximately alike, varying in
height from 50 to 90 cm and in
width from 75 to 125 cm. None is
certainly by Canaletto; some are
possibly by Bellotto.

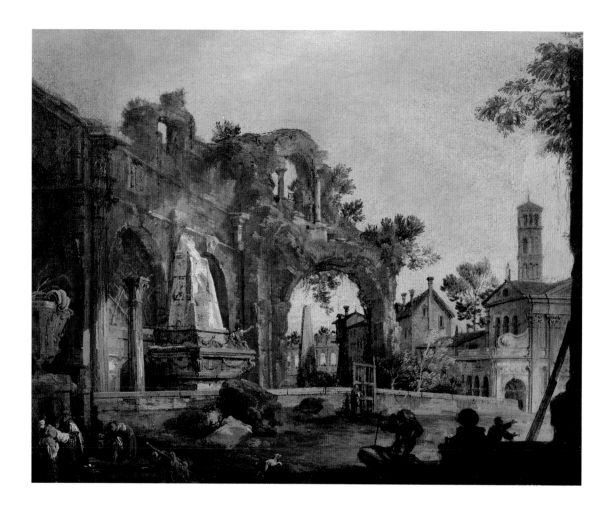

179
*Rome: a Caprice View with Ruins based
on the Forum*
Perhaps c. 1730

Oil on canvas,
31.4 x 40.3 cm
(12⅜ x 15¾ in)
The Royal Collection

Reminiscences of the Basilica of
Constantine and S. Francesca
Romana. Now attributed to
Canaletto but formerly to Marco
Ricci.

180
Capriccio: Ruins with Paduan Reminiscences

Oil on canvas,
116 x 166 cm
(45¾ x 65⅜ in)
Hamburg, Kunsthalle

In the centre is perhaps the Porta Portello, Padua (compare Plate 104) and in the background some other Paduan buildings. The ruins are Roman in character. See Plate 178.

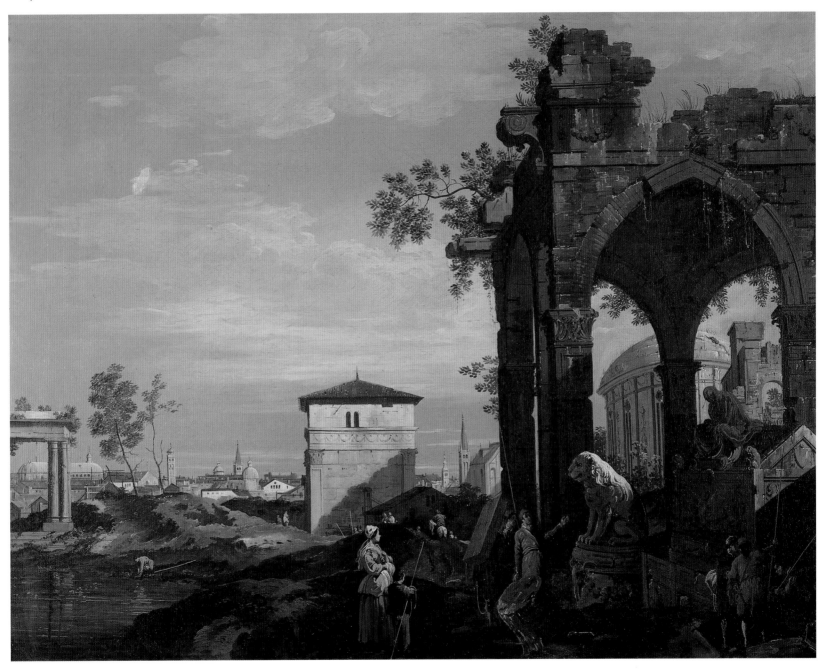

Canaletto himself divided his etchings into two groups – views taken from the places and *vedute ideate* – and he would no doubt have accepted this division as applying to his whole output. The *vedute ideate* were not all of one kind, though, and the splitting of them into subgroups raises problems.

The true capriccio consists, in Algarotti's words (p. 151), of 'a site ornamented with buildings taken from here and there, or just imagined'. Examples of such work have already been seen in Smith's overdoors and Algarotti's own *Palladian Design for the Rialto Bridge*. Sometimes the element of caprice is so slight that one wonders why it was introduced at all, for example in the factual painting of the Molo in which the flagstaffs have been removed from the Piazza and placed in front of the Doge's Palace (Pl. 181). In some cases there may be doubt as to whether a capriccio was intended at all, or whether the departures from fact were due to lapses of memory. *Eton College Chapel* (Pl. 187) is an example which has led to the suggestion that the picture was painted in Venice from rough sketches made while Canaletto was in England, and that these sketches were misinterpreted.

In some cases buildings are 'taken from here or there' to form a truly whimsical grouping. *S. Giorgio Maggiore and the Rialto Bridge* (Pl. 182) is an example of such dubious attempts to shock. When the great art historian G.F. Waagen saw the picture in the Earl of Northbrook's house a century ago he thought it 'as far as the insufficient light enabled me to judge...a good picture by Bellotto', and Bellotto may well have had a hand in it. More

probably it was part of a commission given to Canaletto in England for a decorative scheme, perhaps to stimulate conversation over the dinner table. He was certainly painting this kind of picture while in England, as we know from one of Thomas Hollis's group in which *Buildings in Whitehall, London* (Pl. 184) appear in a relationship Hollis would have known to be entirely false. Inigo Jones's Banqueting Hall is painted with all the accuracy and care that stemmed from Canaletto's notes for his painting of *The Old Horse Guards* and the drawings he made for it. The building on the right is part of the Holbein Gate, which was seen in the Duke of Richmond's celebrated painting of *Whitehall and the Privy Garden*. The statue of Charles I was in the same picture, but facing down Whitehall (as it still does) and not painted, as here, from a side viewpoint. The Duke of Richmond's own house is seen in the distance and all the elements have been shuffled together to form an entirely arbitrary composition, and a not very pleasing one at that.

At the other end of the scale is the true imaginary view. Such views were already being painted by Canaletto's contemporaries such as Marco Ricci, Piranesi and G.B. Tiepolo, to each of whom it gave different opportunities to exercise his skills. To Canaletto it must have given most satisfaction when he allowed himself to imagine a city, as in his deeply felt etchings *An Imaginary View of Venice* (Pl. 132) or of *Padua*, which have scant relationship to either city. McSwiney's tomb paintings were also entirely imaginary, although we cannot judge which artist's imagination was at work – or whether it was McSwiney's.

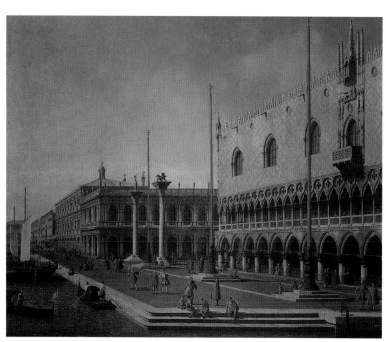

181
Capriccio: the Molo with the flagstaffs from the Piazza S. Marco
1743-4

Oil on canvas,
109 x 131 cm
(43 x 51½ in)
The Royal Collection

One of Smith's 'overdoors' but a capriccio only in the position of the flagstaffs; there is no other painting of the subject from the same viewpoint.

182
Capriccio: with S. Giorgio Maggiore and the Rialto Bridge

Oil on canvas,
165 x 114.5 cm
(65 x 45 in)
Raleigh, NC, North Carolina Museum of Art

Both the bridge and S. Giorgio are seen from the southwest. The pointed spire of S. Bartolomeo, which shows above the bridge, was demolished in 1747, but the picture was perhaps painted in England from memory and drawings.

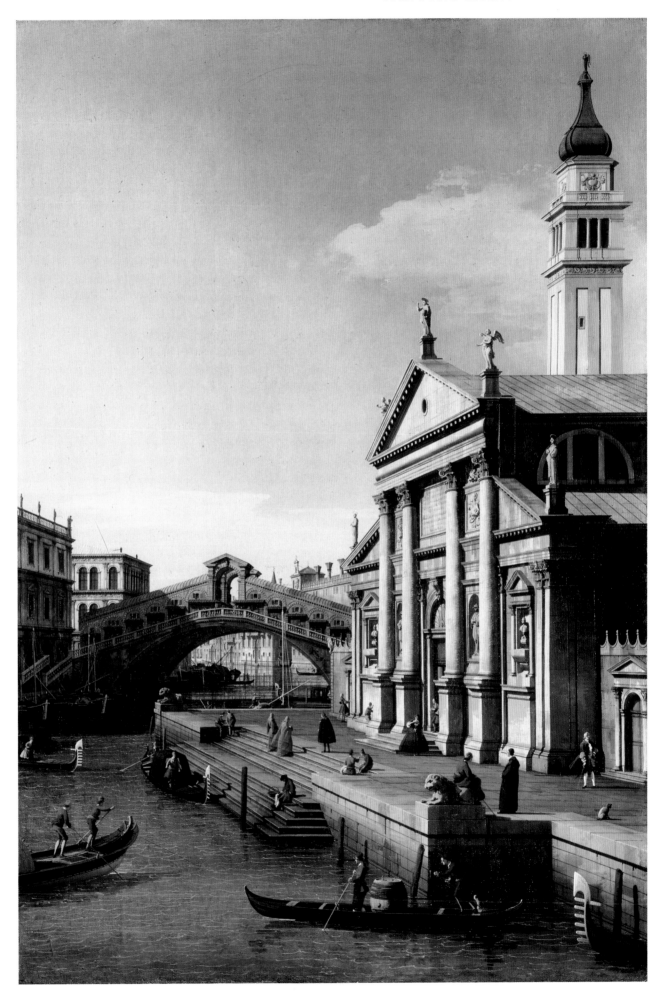

Some of these wholly imaginary views were architectural such as the *Terrace and Loggia of a Palace on the Lagoon* (Pl. 183). This drawing, as masterly in conception as it is in execution, must be one of Canaletto's last drawings, certainly one of the last to have entered Smith's collection before its sale in 1762. The chevron of the Canal arms has been placed on a shield which appears at the angle to the loggia, and in the distance a suggestion of the Dogana and the Salute is made, just enough to imply that this magical palace is not on some enchanted island, but on the Lagoon itself.

Even the non-architectural imaginary views have some buildings in them; Canaletto could not have painted or drawn a truly rural scene such as Marco Ricci or Zuccarelli took in their stride. In some paintings, drawings and etchings, though, the emphasis is on trees or water rather than on the ruined arches or bridges that punctuate them. These are the true *vedute ideate* and the most elusive of all in the sense that they offer no clue by which they can be dated and seldom have a history which tells anything of their origins. Nor, for the most part, do they give an impression of profound feeling.

The majority of Canaletto's imaginary views are neither simple regroupings of well-known buildings nor wholly imagined compositions, either architectural or rural. They are fantasies in which half-remembered scenes are used as a base on which to build an ideal view, widely varying in quality and imaginativeness, often tantalizing in their temptation to discover more of the artist's mind than the pictures are able to yield. It is not surprising that an artist normally so concerned with reality should sometimes have felt an urge to escape from it, and Canaletto seems to have indulged the whim on occasion from the beginning to the end of his career.

Memories of Rome naturally influenced the earliest work of this kind, as in the case of Smith's imaginary views; there may be much earlier views, but the attributions can only be tentative. In contrast, those which derive from scenes on the mainland between Mestre and Padua or Vicenza present little difficulty in attribution and, in the case of drawings in Smith's collection, virtually none. Even the dates are reasonably certain: they must have been drawn in the early 1740s, or at latest by 1746, when Canaletto left for England. They vary in inventiveness and quality, the best showing freshness and technical skill, the poorest seeming tired and mannered.

Following the same path, an appearance of 'Englishness' is firm evidence of a date after 1746. The Earls of Lovelace owned six Canalettos, which included the *Eton College Chapel* (Pl. 187), now in the National Gallery, London. It is really a capriccio, containing much that did not exist and altering much that did; nevertheless it shows that Canaletto had seen Eton, doubtless when he was painting Windsor Castle (Pl. 142) for Sir Hugh Smithson. He had only to turn his chair to the right and the view of Eton would confront him. Another pair must surely have been painted in Surrey, where one of the Lovelace ancestors lived. The *River Landscape with a Column* (Pl. 186) and its companion the *River Landscape with a Ruin* (Pl. 185) both give the impression that the artist

183
Capriccio: Terrace and Loggia of a Palace on the Lagoon
c. 1763

Pen and ink with washes,
36 x 53 cm
(14⅛ x 21 in)
The Royal Collection

One of Canaletto's last and most accomplished drawings.

184
Capriccio: Buildings in Whitehall, London
1754

Oil on canvas,
52 x 61 cm
(20½ x 24 in)
Private collection

One of Hollis's six paintings, the only capriccio. Compare the Banqueting Hall in Plates 153 and 154.

185
*Capriccio: River Landscape with a Ruin
and Reminiscences of England*
c. 1754

Oil on canvas,
132 x 106.5 cm
(52 x 42 in)
Washington, DC, National
Gallery of Art

Both this and its companion, Plate
186, have an English air, although
the buildings are Italian and
imaginary.

186
*Capriccio: River Landscape with a
Column, a Ruined Roman Arch, and
Reminiscences of England*
c. 1754

Oil on canvas,
132 x 104 cm
(52 x 41 in)
Washington, DC, National
Gallery of Art

Companion to Plate 185.

was invited to show the neighbourhood of Box Hill as it might have looked had some Italian architects been building there. All three pictures seem to have been painted towards the end of Canaletto's English visit and reassurance is given by another of the set which bears the monogram and date, *A.C./1754*.

Three series of engravings, each of six imaginary views after Canaletto, were published in Venice by Josef Wagner and Fabio Berardi. Berardi was not born until 1728 and would have been only 18 when Canaletto left for England, so it seems almost certain that the project was begun after he had returned to Venice. One series is entitled *Sei Villeggi Campestri* (six rural villages), but all are in fact capriccios, most of them with buildings of Venice or the mainland in fanciful surroundings. A second series consists also of capriccios, each based on a well-known church. The third, and most interesting, series owes little to reality, consisting of imaginary scenes with towers, churches and ruins, for the most part set in the Venetian Lagoon. Later, it seems, Canaletto made use of these subjects for paintings in the same way as he made paintings from some of his own etchings.

Best known of all Canaletto's imaginary views was his last, the *Colonnade opening on to the Courtyard of a Palace* (Pl. 188), which he gave to the Academy two years after his election in 1763. It is a purely architectural capriccio, a form in which he was more at home with pen than with brush; the handling is mechanical, but the picture is a brilliant exercise in the art of perspective, an art by which his fellow academicians set great store.

More than 50 paintings and 100 drawings of imaginary views have survived, without taking into account those attributed tentatively to Canaletto or the almost uncountable versions of some subjects which may well bear the mark of his hand. Nor does this take account of the etchings, the best of which surpass in imaginative quality all but the rarest paintings or drawings. Taken together they provide an elusive but challenging approach to the study of the artist's mind and character. Some have the freshness and wit of a Mozart divertimento. Others, such as McSwiney's tomb paintings or some of Smith's overdoors, have a ponderousness which one feels the artist must have assumed unwillingly. Palaces, churches, pavilions and villas; terraces, loggias, colonnades and porticoes, some ruined, some intact, some real, others altered or invented – these are the ingredients which Canaletto mixed throughout his career in these most personal expressions of an art which was always decorative and occasionally profound.

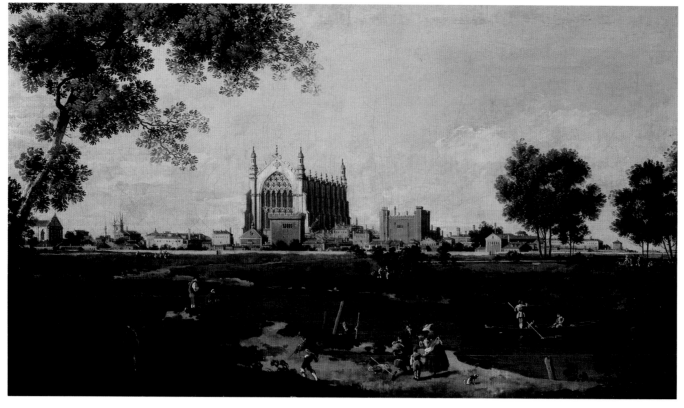

187
Eton College Chapel
c. 1754

Oil on canvas,
61.5 x 107.5 cm
(24¼ x 42⅜ in)
London, National Gallery

Many details of the Chapel are wrong and the church on the left did not exist, but the picture accords generally with the view from across the Thames, looking west.

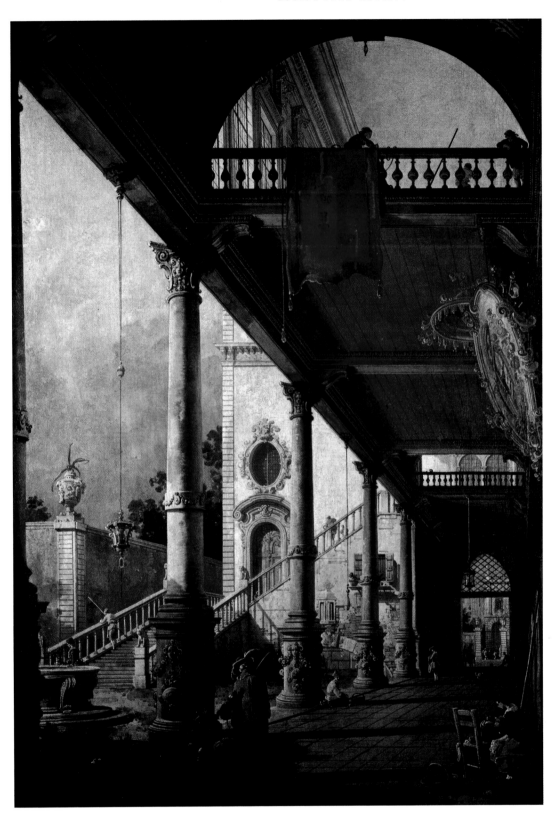

188
*Capriccio: a Colonnade opening on to
the Courtyard of a Palace*
Signed and dated 1765

Oil on canvas,
131 x 93 cm
(52½ x 35½ in)
Venice, Accademia

Canaletto's reception piece on
election to the Venetian Academy.
Many replicas exist, a few by
Canaletto himself.

WHENEVER IT WAS THAT Canaletto finally reached Venice from England he seems to have slipped in unobtrusively. Pietro Gradenigo had recorded in July 1753 that 'the celebrated painter returned from England to his native city' although there is no other such evidence and there must be the possibility that he was noting an event that had occurred three years earlier. Gradenigo continued his diary for another 23 years, but never again mentioned Canaletto except to record his death (and to compare Francesco Guardi to him). Hollis's six canvases inscribed with the words 'done in 1754 [or 1755] in London' and Dicker's *Old Walton Bridge*, also dated, must be accepted as proof of Canaletto's presence in London in those years, whether or not he was in Venice in 1753.

A gap follows until 1759–60 and even the evidence of his presence in Venice in those years is not entirely satisfactory. Algarotti's letter of 1759 refers to 'the first picture I had painted for me in such a manner... a view of our Rialto Bridge... by the brush of Canaletto', but it has already been suggested that Algarotti may have been referring to a picture commissioned almost 20 years earlier (p. 151). The story that follows was said to have taken place in 1760, but was not told until a hundred years later and was certainly not told accurately. However, there is no reason to doubt the 1760 date, the first mention of Canaletto since he himself inscribed Dicker's painting in 1755.

According to the Rev. Edward Hinchliffe, who in 1856 published a book about the Crewe family, his grandfather was in Venice in 1760 with John Crewe. One day they:

... chanced to see a little man making a sketch of the Campanile in St Mark's Place: Hinchliffe took the liberty – not an offensive one abroad, as I myself can testify – to look at what he was doing. Straightway he discovered a masterhand and hazarded the artist's name 'Canaletti'. The man looked up and replied '*mi conosce*'. Thereupon a conversation ensued, and Canaletti, pleased to find so enthusiastic a judge of drawing, invited Hinchliffe to his studio, who waited upon him there the following day, and inspected his paintings and drawings. The visit terminated most agreeably to the traveller. Having requested Canaletti to allow him to purchase the painting about to be made from the sketch he had seen the artist take, Canaletti not only agreed to this, but, in addition, presented him with the sketch itself, as a complimentary gift: and a very valuable one my grandfather esteemed it, and so did his eldest son, at whose death it became the property of the present Lord Crewe, by purchase, and is now at Crewe Hall.

No doubt it all happened as Hinchliffe heard it from his father who had heard it from *his* father (who became Bishop of Peterborough). Indeed, there is confirmation in that Lord Crewe sold a painting of the Piazza (Pl. 192) in 1836 which is very close to a drawing (Pl. 193) still belonging to one of his descendants. The drawing is no 'sketch of the Campanile' but an outline drawing clearly made in the studio and finished off with ruled lines as framework. It is not impossible that there was once also a sketch which has disappeared. Nor is it impossible that Canaletto, having decided on painting the Piazza from the arcade, had no suitable sketches in his studio and, at the age of

189
Detail of Plate 198.

11 *The Last Years*

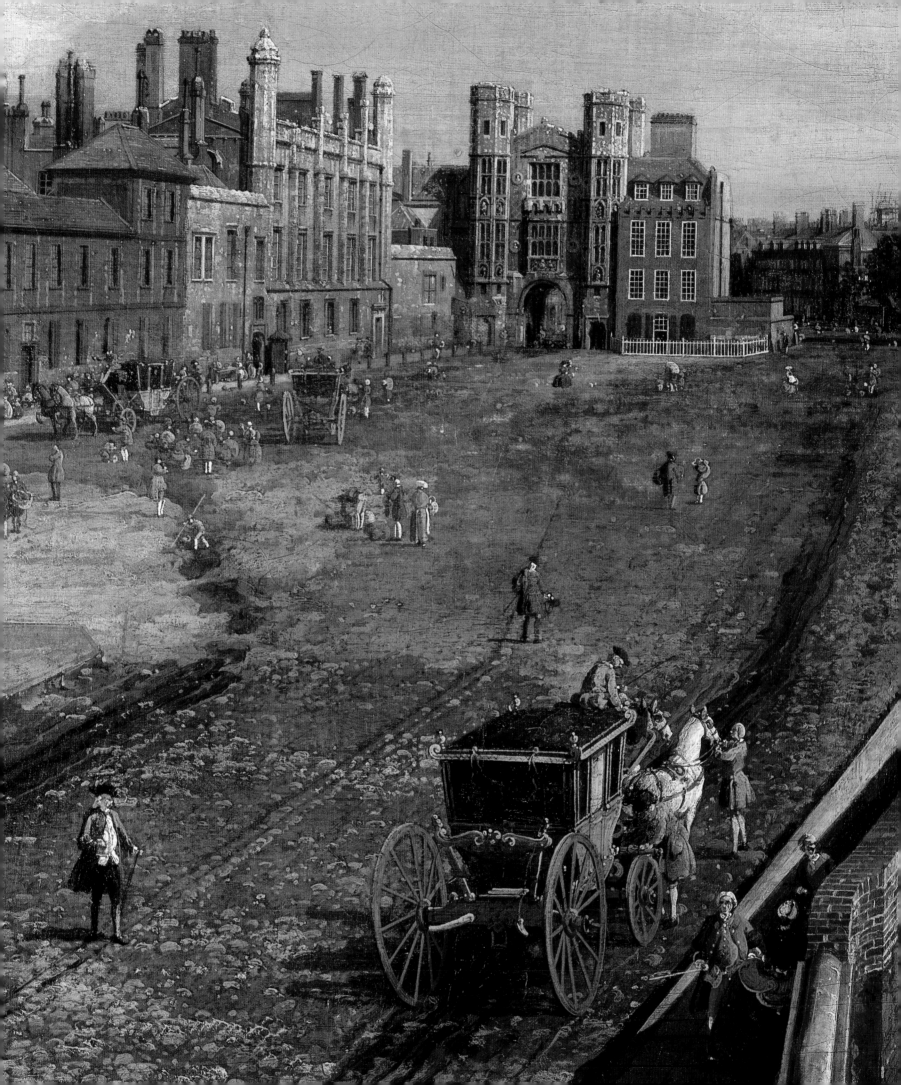

190
Detail of Plate 191.

191
London: Whitehall and the Privy Garden looking North
Probably 1751

Oil on canvas,
118.5 x 273.5 cm
(46¾ x 93½ in)
Bowhill, Duke of Buccleuch and Queensberry, KT

Compare Plates 144 and 148.

The scaffolding on the left is for the first house of the new Parliament Street; further to the left would be the houses in the background of Plate 155. Sold to John Crewe in Venice by Canaletto.

63, had to return to the spot he knew so well and start again. It is unhappily much more probable that he was allowing himself to be seen sketching in the Piazza in the hope of bringing about precisely the sequence of events that occurred.

If he was in fact reduced to these straits in order to catch the eye of the passing tourist, it is at least pleasant to learn from Hinchliffe that he was particularly successful on this occasion. Not only did he allow himself to be persuaded to sell his painting when he had finished it, together with a drawing: he showed his new friends a magnificent painting of *Whitehall and the Privy Gardens: looking North* (Pl. 191) which he told them he had refused to sell while in England, wishing to keep it as a memento of his visit to their country. Nearly three metres wide and little more than one metre high, the picture combines much that is in the pair painted for the Duke of Richmond. The painting of the wall receding from the centre towards the Banqueting Hall in the background is a *tour de force* of perspective and the building work beginning on the left is a mine of information for the London topographers, who are able to date the picture to the summer of 1751. All in all it is one of the most successful paintings of Canaletto's entire English period.

Vertue had commented on Canaletto's 'reservedness & shyness in being seen at work, at any time, or anywhere', but John Crewe and Edward Hinchliffe's grandfather seem to have had little difficulty on this score. Canaletto freely told them the view 'was from the garret of a little shop on the site of what is now the corner house in Richmond Terrace, in which humble apartment

the great painter lived during his stay in London'. Either Canaletto had forgotten that in 1749 and again in 1751 he was publicly inviting visitors to his apartment in Silver Street or the story had suffered in the telling by 1856, when it was first published.

Whatever the truth may have been, it had a happy ending. Canaletto gave way to the blandishments of John Crewe and allowed himself to part with the huge picture he had kept for nearly ten years and taken back to Venice with him 'as a memento'. But perhaps its width was against it. The *Chelsea College* painting (Pl. 158), of much the same dimensions, was soon divided by its owner into two parts, which have remained separated ever since. John Crewe fortunately did not divide the *Whitehall*; instead, he 'exchanged it for a battle piece' with his old tutor Dr Hinchliffe, who had by then married his sister. It later returned to the Crewe family, where it remained until 1839, when the Duke of Buccleuch bought it, and his descendant owns it still. By this circuitous route Canaletto's last English patrons found themselves possessed of one of his finest pictures and returned it to the country where it belonged.

Canaletto had of necessity to find his own ways of selling his work at this time; he could no longer look to Smith to take whatever he chose to paint or draw, or to propose new schemes to keep him employed. Smith was now in his mid-80s, but this had not prevented his marrying, some two years previously, a Miss Murray, described by the ever-spiteful Lady Mary Wortley Montagu as 'a

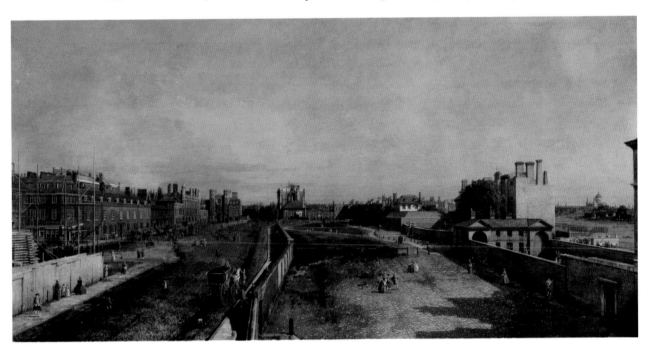

beauteous virgin of forty' who had remained unmarried 'till the charm of that fine gentleman, Mr Smith, who is only eighty-two determined her to change her condition'. Smith deserved whatever happiness his marriage may have brought him. Forty years earlier he had married Catherine Tofts, a successful singer who had retired to Venice. She was rich but mentally unstable, and Smith's enemies naturally said he had married her for her money. As time went on, she seems to have become madder and eventually had to be confined until her death in 1755. Regardless of his age, Smith lost no time in seeking a partner in his new freedom and had serious hopes of winning the hand of Giustiniana Wynne, an already celebrated young beauty. This pathetic ambition faded when he met the competition of his former friend and disciple, Andrea Memmo, who, as well as being an enlightened and wealthy patrician, was 54 years younger. Smith's second choice was an unlikely one. Elizabeth Murray was the sister of John Murray, who had succeeded where Smith had failed in securing the post of British Resident in Venice. Already in 1752 Smith had expressed his willingness to give up his business if he could be promoted from Consul to Resident, so Murray's appointment must have been a blow to him. Lady Mary Wortley Montagu thought even less of Murray than of Smith. 'Such a scandalous fellow,' she wrote, 'in every sense of the word, he is not to be trusted to change a sequin, despised by the Government for his smuggling, which was his original profession, and always surrounded with pimps and brokers.'

Smith's marriage seems to have gone well and in 1760, the year Hinchliffe and Crewe met Canaletto, he resigned the consulship and wrote of his intention to see something of the rest of Italy and eventually return to England. Nothing came of this; instead he began negotiations with a view to selling the best of his collection to George III, who had come to the throne in 1760 at the age of 22. If James Adam is to be believed, there was little alternative. Adam visited Smith at his Mogliano house (where, it will be remembered, he was received with 'much flummery') and was shown the collection but, he wrote to his brother Robert, Smith 'ought to sell if vanity would allow him, but he is literally eaten up with it'. He was 'devlish poor and should he live a few years longer, which he may do, he will die a Bankrupt'.

Smith did sell, but not until 1762 and not the whole of his collection – at any rate, when he died in 1770 he owned several hundred paintings; it is

hardly possible that he should have used the £20,000 he received from the King in starting another collection. The pictures were sold at Christie's by Smith's widow in 1776 and, according to the catalogue, included 14 Venice views by Canaletto, which it is impossible to identify. Even before that, the widow is recorded in the diary of a young Scot, Patrick Home, as selling him a series of pictures to decorate his house. These included some which Home oddly described as having been 'retouched several times by Canaletto himself'.

Smith had by no means abandoned Canaletto after his return from England. He seems moreover to have been able to stimulate the artist to achieve a higher standard than was normal for him at this period. The *Terrace and Loggia of a Palace* (Pl. 184) was by no means the work of a tired or dispirited man, and a handful of drawings of the Piazza, as well as other imaginary views, are proof that the old skill and cunning were still there.

Unless the two London views were done in Venice, Smith commissioned only one painting, an *Interior of S. Marco* looking towards the High Altar (Pl. 196). It is an elaborate, almost square picture from two quite widely separated viewpoints near the entrance. Coats of arms and trophies are shown hanging in the nave although they had been removed in 1722–3 to avoid danger to the structure – perhaps they were rehung on special occasions. On the other hand the mosaics are very inaccurately painted and there is a possibility that Canaletto was working from old drawings. The stiff figures, drawn rather than painted, and the scattered dots to represent highlights are typical of his style since the 1740s and 50s, and the picture contrasts strangely with another *Interior of S. Marco* (Pl. 195) which he painted, also for Smith. This tiny picture must have been painted when Canaletto was at the height of his powers, perhaps even well before 1730; it has an intensity of feeling and atmosphere that recalls his greatest masterpieces. The view is across the Basilica, with the high altar on the right, and ecclesiologists find it hard to explain the service that is taking place. This is made more difficult by Smith's own description of the two pictures, one of which he called 'Inside of St Mark's Church on Good Friday' and the other 'Inside of St Mark's Church with innumerable figures by Night'. Neither, it seems, shows a Good Friday service and it is surprising to be told that the small picture is intended to show a night scene (the larger and later one must be by day).

192
Piazza S. Marco: looking East from the South-West Corner
1760

Oil on canvas,
69 x 60.5 cm
(27¼ x 23¾ in)
Private collection

In all probability the painting bought by John Crewe from Canaletto, who gave him the sketch he had seen being made.

193
Piazza S. Marco: looking East
1760

Pen and ink,
36.4 x 22.6 cm
(14¾ x 8¾ in)
Private collection

Drawn in outline only, perhaps to emphasize the architectural details. Clearly not the 'sketch' that Canaletto is said to have given the present owner's ancestor.

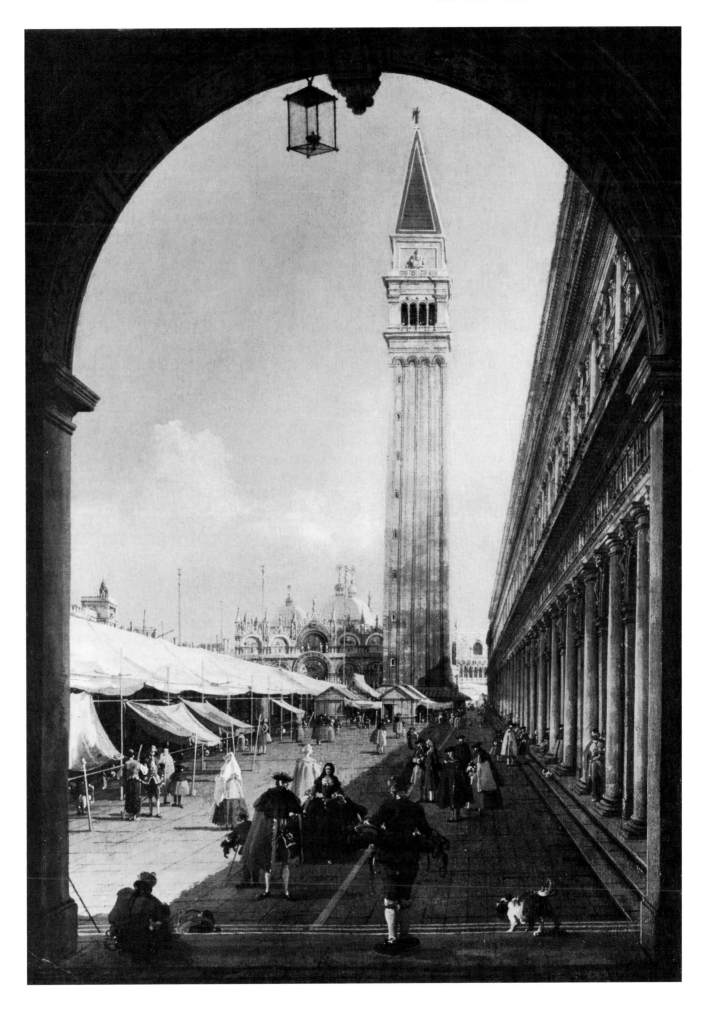

194
S. Marco: the Crossing and North Transept

Pen and ink,
27.1 x 18.7 cm
(10¾ x 7⅜ in)
The Royal Collection

This heavily hatched drawing seems very close to Plate 195 and may be of the 1730s; a date after the return from England has also been suggested for it.

195
S. Marco: (an evening service)
c. 1730, perhaps much earlier

Oil on canvas,
28.6 x 19.7 cm
(11¼ x 7¾ in) (painted surface)
The Royal Collection

Looking across the nave to the north transept. Smith listed this little masterpiece as 'Inside of St Marks... by Night', but the light seems too strong for candlelight.

196
S. Marco: the Interior
c. 1755

Oil on canvas,
36.5 x 33.5 cm
(14⅜ x 13¼ in)
The Royal Collection

Looking towards the High Altar from near the main entrance. Some of the mosaics on the arches are inaccurate.

So rare are Canaletto's interiors that a drawing (Pl. 194) showing the crossing, but from farther away than does the little painting, might be fairly early or very late in date; sensitively as the tightly packed crowd is drawn, the effect is far less impressive than the subtle suggestion of movement in the painting. With these pictures, spanning 30 years of Canaletto's career, Smith passes from the scene. In 1766, although nearly 90, he temporarily became Consul again when his successor became bankrupt. In 1770 he died and, being a Protestant, was buried on the Lido, where his grave may still be seen.

The identification of Canaletto's work after his return to Venice is full of difficulties. On style alone it is sometimes impossible to be certain whether a picture was painted before or after the stay in England, so lacking is there any consistent

development of technique. Fortunately there are other clues – dated engravings, topographical changes, recorded commissions and, very rarely, a dated signature. Taken together these enable a picture to be built up of the artist's life in his later years, a different picture, it must be said, from that prevailing until recently, when virtually nothing could be attributed to these dozen years with any confidence. They cannot have been easy years for Canaletto, and it is understandable that he welcomed the appearance of Crewe and Hinchliffe, so like the English patrons of the past.

Only one such patron materialized during these years, a German whose business career was not unlike Smith's. Sigmund Streit was about the same age as Smith and went to Venice when he was rather older, in 1709. He does not seem to have been much of a collector but he prospered in

197
Grand Canal: looking South-East from the Campo S. Sofia to the Rialto Bridge
c. 1756

Oil on canvas,
119 x 185 cm
(46¾ x 73 in)
Berlin, Staatliche Museen
Preussischer Kulturbesitz
Gemäldegalerie

Painted for Sigmund Streit, whose house is on the left. On the right is the fish market (*pescaria*) and the *burchiello*, which plied between Venice and Padua.

198
Campo di Rialto
c. 1756

Oil on canvas,
119 x 185 cm
(46¾ x 72¾ in)
Berlin, Staatliche Museen
Preussischer Kulturbesitz
Gemäldegalerie

The spectator has his back to
S. Giacomo di Rialto. Today the
stalls have spread to cover the whole
area. Officials of the original Banco
del Giro are seen under the arches.

Overleaf:
199
Piazza S. Marco: looking South and West
Signed and dated 1763

Oil on canvas,
56.5 x 102.2 cm
(22¼ x 40¼ in)
Los Angeles County Museum of Art

Possibly intended as Canaletto's
reception piece for the Academy,
which may have found a view
painting unacceptable. There is no
point from which so wide a view is
visible.

business and retired in 1750, remaining in Venice
in the winters and spending the rest of the year in
Padua. He never married and in his early 70s
decided to give most of his property to his old
school, the *Gymnasium zum Grauen Kloster* in
Berlin. In 1763, when he was approaching 80, he
gave the *Gymnasium* a catalogue of his gift, which
included four paintings by Canaletto. One of these
was a view of *The Grand Canal: looking down from
the Campo S. Sofia to the Rialto Bridge* (Pl. 197) and
the left foreground is dominated by the Palazzo
Foscari (not of course the better-known palace of
that name at the turn of the Canal). This is a fine
Gothic palace (occupied by the Duke of Mantua
in 1520) which, as Streit explained in his
catalogue, was his home in Venice. He went into
further detail, pointing out that the two round-
topped windows on the ground floor, looking on
to the campo, were two of the four windows of

his study and office, that the window with the
white sunblind on the Canal was that of his music-
room, and the window with flowers on the
balcony that of the room where he received
visitors in the summer (in the winter he used an
adjoining room, which had a fireplace). Streit
went on at much greater length, drawing attention
to the man cleaning the chimney of his house,
the *traghetto* (ferry) which plied across the Canal,
and the shrine at which the gondoliers of the
traghetto said their morning prayers. He then
turned to the right bank and noted the *burchiello*,
which left for Padua every morning and evening
(and which is so often seen in other paintings and
drawings) and the toll-office for fish on the
extreme right. He gives the names of four taverns
among the buildings – these were demolished
early this century for the imitation-Gothic
Pescheria (fish-market building) – and remarks

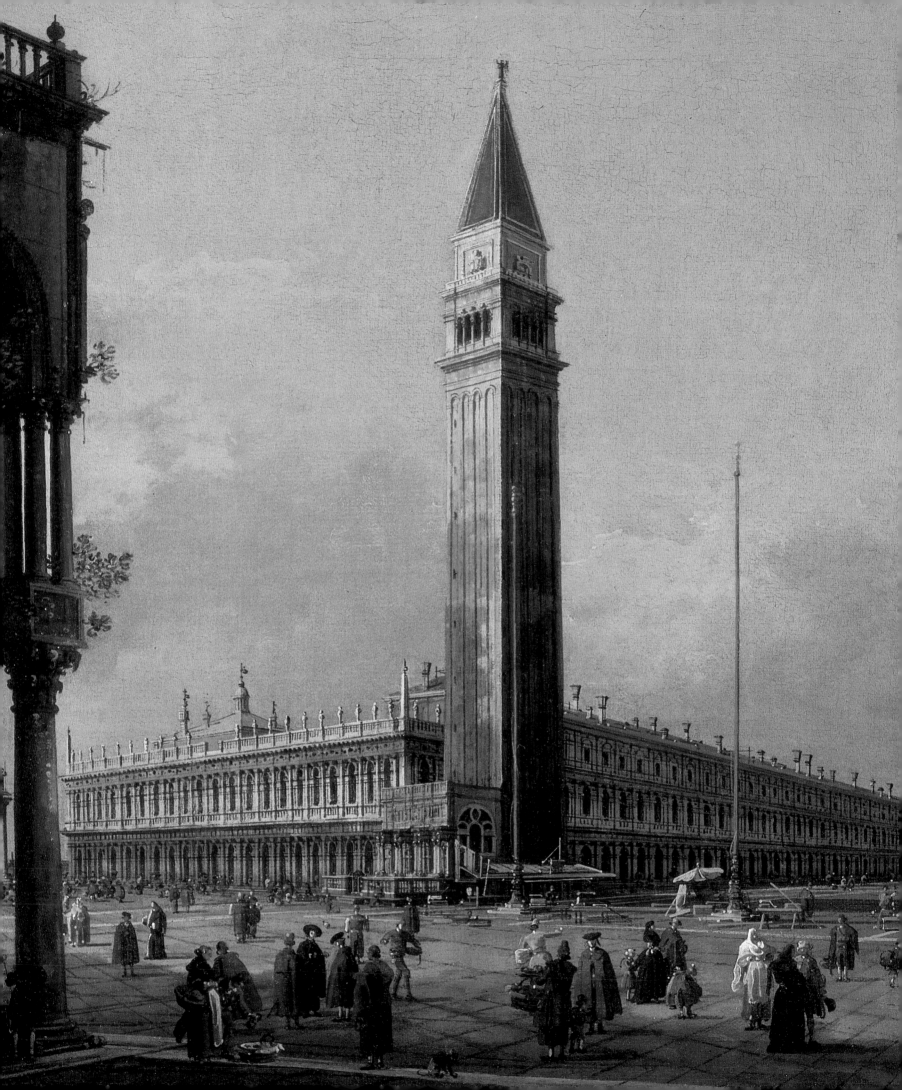

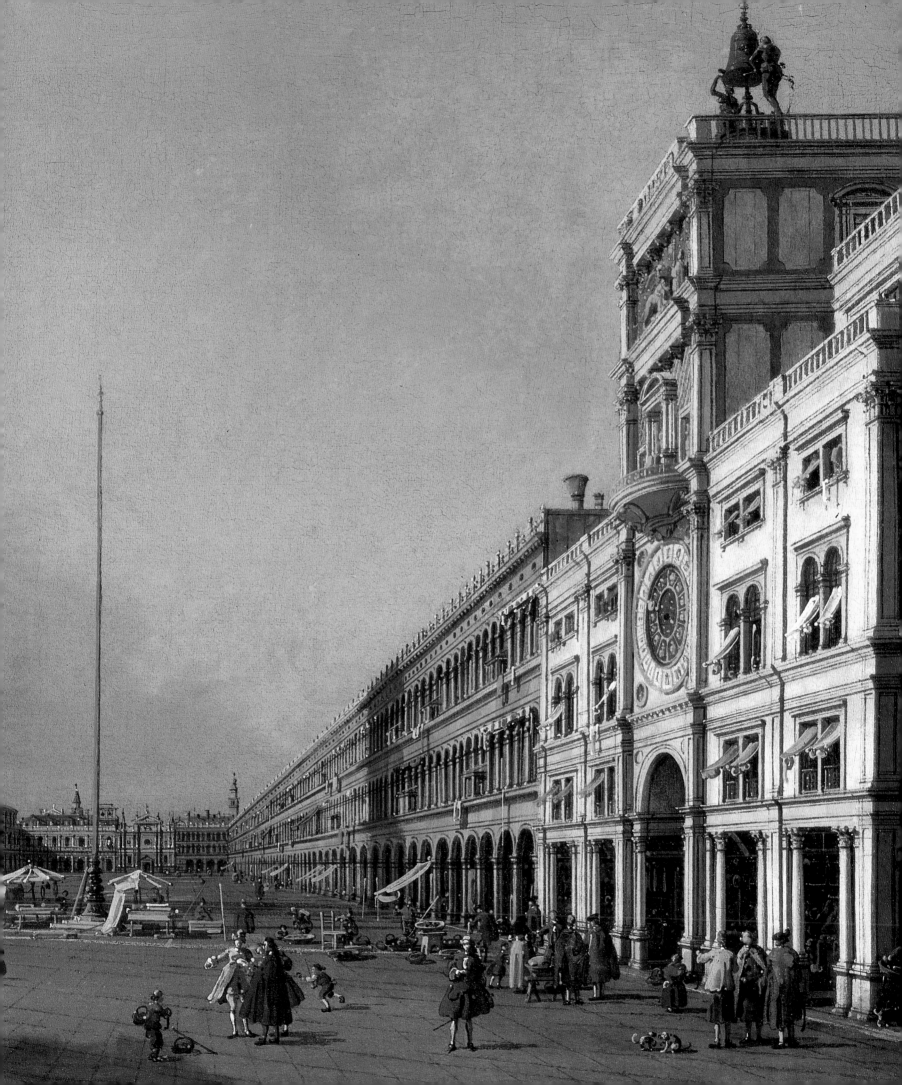

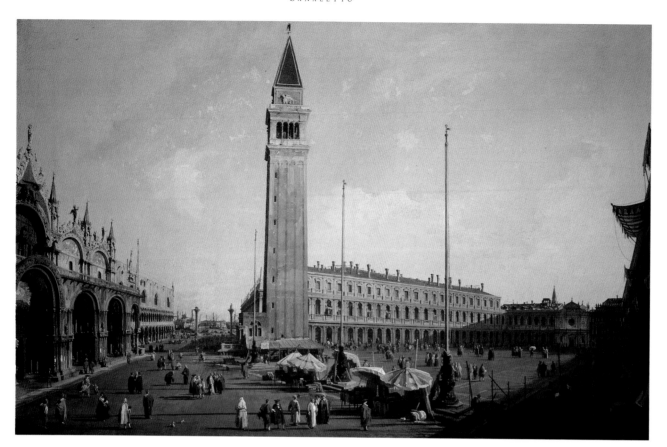

200
Piazza S. Marco: looking South-West
1730-41?

Oil on canvas,
67.3 x 102 cm
(26½ x 40½ in)
Hartford, Conn., Wadsworth
Atheneum

Here Canaletto has emphasized
the impossibility of his view by
foreshortening, so that the
spectator has no sense of being far
away.

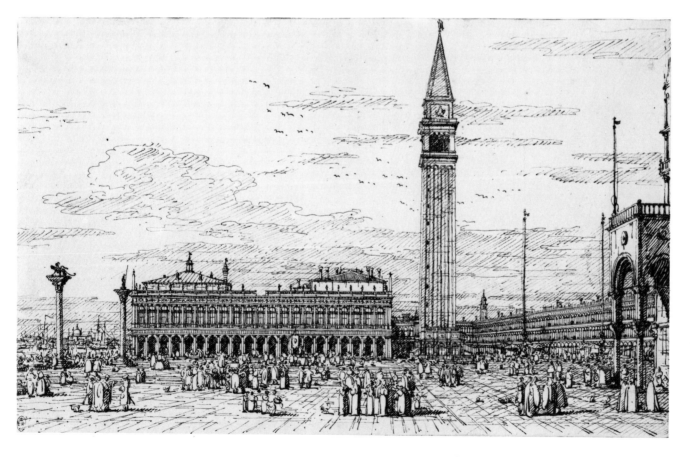

201
*The Piazzetta: looking West, with the
Library and Campanile*
c. 1735

Pen and ink,
22.7 x 37.5 cm
(9 x 14¾ in)
The Royal Collection

Most complex of all Canaletto's
wide-angle experiments. Wherever
the spectator stands he will see
only part of the view as it appears
here.

on the splendid view down the Canal which he could get from his side window.

One thing Streit omitted from all this detail was the fifth palace down from his own, which was Consul Smith's house on the corner of the Rio dei SS. Apostoli. It unmistakably bears the façade designed by Visentini, which Smith had had painted over Canaletto's depiction of his old house (p. 180). There can be no doubt about the date when this façade was first visible: Gradenigo, whose diary has been referred to, noted on 22 October 1751 that the house of Giorgio (*sic*) Smith, English merchant, with its fine marble façade, was that day unveiled (*scoperta*), that it was generally praised and well suited for its use. At this time Canaletto had returned to England after his visit to Venice so, unless Streit's commission was executed during a 1753 visit, of which there is little evidence, it must date from after Canaletto's final return from England.

So, presumably, must the other three pictures. One shows the *Campo di Rialto* (Pls 189 and 198), about which Streit also gave a detailed description of the food, pottery, furniture and paintings on sale and of the people who included 'men at desks, others seated in black robes with white bands (officials of the Bando del Giro), men doing repairs, Armenians in long coats and pointed hats, and Jews in red caps' – no other contemporary descriptions of Canaletto's paintings compare with Streit's, not even those given to Stefano Conti by the artist himself. The group was completed by a pair of scenes of night festivals, one at S. Pietro di Castello on the extreme east of Venice and the other at S. Marta on the extreme west (now the Maritime Station). Moonlight scenes were well outside Canaletto's range and were an idiosyncratic and unfortunate choice of Streit's. Nevertheless, there is no question of their authenticity: three drawings from one of Canaletto's own sketchbooks are clearly preliminary drawings for the S. Marta picture.

Streit's paintings were nearly two metres wide, each an original subject with no other versions; hardly any other work of this kind can be assigned to Canaletto's last years in Venice. For the most part he painted small pictures based on his own etchings or on well-known old engravings, some on his earlier paintings of the Piazza or the Molo but on a much smaller scale, and capriccios which tourists could take away in their baggage or even in some cases carry in their pockets. There was work for the engravers such as Wagner and Berardi. (There may have been Algarotti's

capriccio 'with buildings taken from here and there' and at least one known companion to the *Palladian Design for the Rialto Bridge*; the likelihood is perhaps that these were finished before the visit to England.) There were the fine architectural drawings that went to Smith and some drawings based on those of C-L Clérisseau which Robert Adam had brought back from Dalmatia (and perhaps left in safe keeping with Smith at Mogliano).

Only once in this period did Canaletto sign and date a painting (other than his Academy reception piece); this was a *Piazza S. Marco: looking South and West* (Pl. 199), a view of so wide an angle that it can reasonably be called a capriccio. It was by no means his first essay into this realm of 'fish-eye' views. Once he had stood in his picture with his back to the Clocktower and pretended he could see the north side of the Piazza and S. Geminiano on the right whereas on the left he could see almost the whole of St Mark's (Pl. 200). In a drawing towards the Library he showed the south side of St Mark's on the right and the column carrying the Lion of St Mark on the left. The spectator would need more than eyes capable of taking in a full semicircle to see all this at the same time: he would need several pairs of eyes in different positions (Pl. 201).

It used to be suggested that these pictures were a kind of optical joke, perpetrated by the use of some instrument such as a camera obscura (which would of course be useless for the purpose). The 'panoramic' picture had a respectable history by Canaletto's day, though, and it was soon to become a fashionable cult when Robert Barker showed a 360-degree painting of Edinburgh in 1787 in a special building. Only then was the word 'panorama' (meaning 'entire view') coined, but landscapes wound on to handrolls had existed in China for centuries and by 1486 Erhard Reuwich's view of Venice was published in Bernhard von Breydenbach's *Peregrinationes in Terram Sanctam*. This was over one and a half metres wide and a quarter metre high; it showed all Venice from east to west from a viewpoint the height of a roof-top so that it was in no sense a bird's-eye view. Reuwich later showed other cities, including Jerusalem, in much the same form, and by the seventeenth century the 'long view' had become an established form of landscape; by 1803 John Constable was writing: 'Panorama painting seems all the rage.'

Canaletto's 'impossible' views followed those of Carlevaris in his 1703 book of engravings and

others which appeared in Domenico Lovisa's *Il Gran Teatro...* of 1721. They were part of the pursuit of illusion, demanding a suspension of disbelief in the spectator. Far less outrageous, sometimes even barely noticeable, was the use of a wider than normal angle of vision, or of an unusually wide canvas in relation to its height, as in the case of the Chelsea and Whitehall paintings (Pls 158 and 191). (It may have been chance, rather than a public distaste for the form, that resulted in the Chelsea picture being subsequently cut in half and that of Whitehall failing to find a buyer until Crewe and Hinchliffe saw it in the artist's studio in Venice.)

The signed and dated wide-angle view (Pl. 199) was probably Canaletto's last of the Piazza, a metre-wide painting in cool, muted tones which he signed on the back of the canvas: '*Io Antonio Canal, detto il Canalletto, fecit. 1763.*' He is standing in the Campo S. Basso, or Piazzetta dei Leoncini, where the red marble lions had been standing since 1722, no doubt used for riding by small children as they are today.

On the right is a fine view of the Clocktower, newly refurbished in 1753 and carrying an extra storey, which makes the dating of some post-England work simple. On the left is a glimpse of the Lagoon! In between is almost everything the visitor would wish to remember of the centre of Venice, with more than 50 figures painted in the familiar shorthand brushstrokes. If Canaletto had wanted to sum up his work as a painter of Venice he could hardly have done better than with this picture and, as if to make the point that he must not be taken too seriously, the northern column of St Mark's (the S. Alipiero column) has foliage sprouting from it.

In the year that this picture was painted the Venetian Academy met to consider the filling of three vacancies that had arisen. Canaletto had been in England when it was founded in 1750 and so could not have become a member. Although officially recognized in 1756, it was still housed in the little Fonteghetto della Farina at the west end of the Molo, which appears in so many of Canaletto's paintings and drawings (it was moved to its present home in the Carità church and *scuola* by Eugéne Beauharnais, Napoleon's stepson, in 1807, the year Napoleon made his only brief visit to the city which had given itself up to him ten years earlier). The Academy was not a very effective body, and its members objected to being compelled by the Government to put on shows in the Piazza on Ascension Day while still being forbidden to sell their pictures there. Nevertheless Canaletto wanted to be a member and became a candidate. For some reason he was not elected, a humiliating rebuff for the man who had been one of Venice's most celebrated artists for 40 years. Instead, the choice fell on Francesco Zuccarelli, who was later to become President, and on two artists who were hardly to be heard of again. In September of the same year there was another vacancy and Canaletto, surprisingly risking another snub, was elected – still with four votes against him out of 14.

It would be instructive to know something of the discussions that then took place about the obligatory reception piece, but nothing has survived. *The Piazza: looking South and West* would

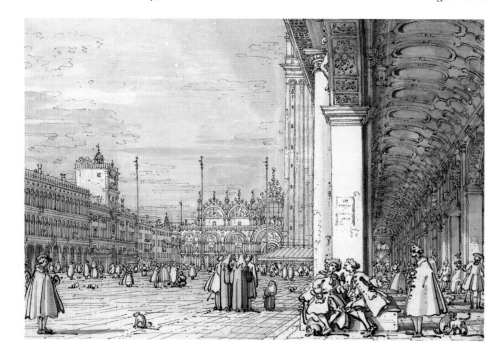

202
Piazza S. Marco: looking East from the South-West Corner
c. 1760

Pen and ink with washes,
19 x 28.2 cm
(7½ x 11 in)
The Royal Collection

In his drawing for Smith of the scene depicted in Plate 203, Canaletto added the north side of the Piazza – but not the additional storey to the Clocktower, which had been built by then.

203
Piazza S. Marco: looking East from the South-West Corner
c. 1760

Oil on canvas,
45 x 35 cm
(18 x 14 in)
London, National Gallery

Here Canaletto is in his favourite position, outside Florian's café, where Crewe and Hinchliffe met him. See also Plates 192 and 193.

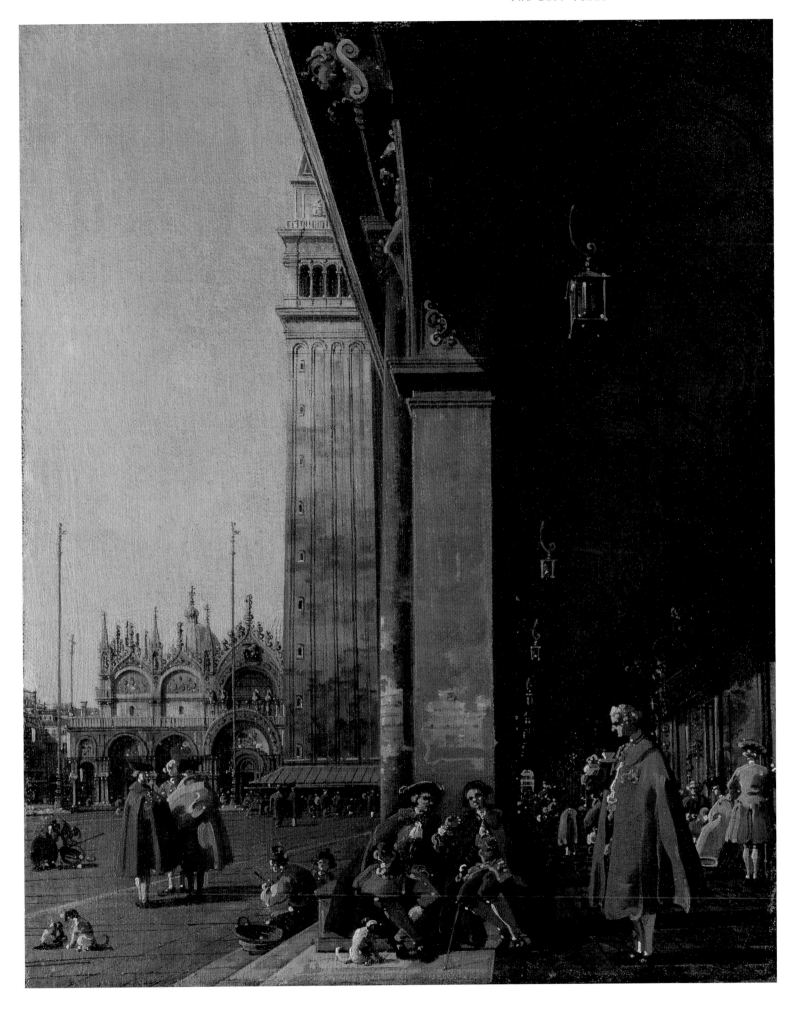

204
Piazza S. Marco: looking East from the North-West Corner
c. 1760

Oil on canvas,
46.5 x 38 cm
(18¼ x 14¾ in)
London, National Gallery

Although aged over 60, Canaletto had never before drawn or painted from this part of the Piazza. The flagstaffs have been omitted.

seem to have been ideal as representing all that had been done for the cause of view painting. Perhaps the speculation might be permitted that it was painted with this in mind, hence the signature and date. However, there is no evidence to justify the suggestion and view painting, even landscape painting, was generally looked down upon by the history painters, who had considered themselves the arbiters of taste since the beginning of the century. Perspective was a different matter, a science perhaps rather than an art, but a necessary science for artists and therefore taught at the Academy. So admirable an exercise in lighting and in the principles of perspective as the *Capriccio: a Colonnade opening on to the Courtyard of a Palace* (Pl. 188), already noted, may well have been acceptable as a compromise. But Canaletto took two years to deliver the picture and it was probably the last he ever painted; the Academy was perhaps fortunate to get anything at all from him.

The two little upright paintings of the Piazza, now in the National Gallery, London, were probably considerably earlier; they are typical of the kind of work Canaletto was doing in the years after his return from England, although of higher quality than most. The *Piazza S. Marco: looking East from the North-West Corner* (Pl. 204), not far from the spot Gentile Bellini had chosen for his principal viewpoint more than 250 years earlier, evidently did not appeal greatly as a subject to Canaletto; he preferred Florian's side (Pl. 203). From that side he made a number of paintings and drawings in the final years, including one of each for Crewe and Hinchliffe (Pls 192 and 193). There

were at least two other versions of the same period as well as one in Smith's collection which, being oblong in shape, was able to accommodate the north side of the Piazza as well (Pl. 202); this must have been drawn before the collection was sold in 1762. Canaletto could still make the sun shine with his pen as well as with his brush.

It is hard to resist the temptation to become sentimental over the National Gallery painting from outside Florian's (Pl. 203). There is a sketch for it (or for one of the drawings) in which the man in the centre is doing the talking; in the painting he has become listener to the man on the left, the standing man being always the onlooker. Can one of them be Canaletto himself in the place he must have spent so many hours in the previous forty or fifty years? Might they be talking of those great days when his work was astounding everybody in Venice, when he was so much followed that even Smith had to pay him his price or go without his pictures?

He was still well short of 70 in 1763 and had five years of life left. If there were no more paintings to be done there must have been drawings. A set of engravings of ceremonies and festivals published soon after 1763 were inscribed *Antonius Canal pinxit*, which suggests they were after a group of paintings. No such paintings are known and it is hard to believe that all could have perished if they had existed. Much more probably the publisher, Lodovico Furlanetto, used the word loosely since drawings by Canaletto were found 20 years after his death and these seem to have been made for engravers.

The drawings are very elaborate, with two or

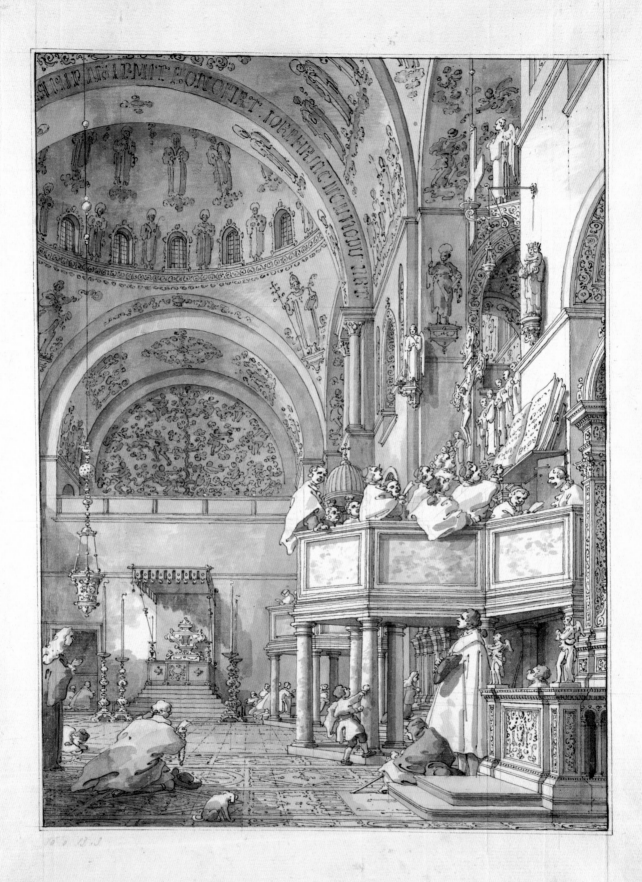

Io Zuane Antonio da Canal, Hô fatto il presente disegnio delti Musici che Canta nella Chiesa Ducal di S. Marco in Venezia in'età de
Anni 68 Cenzza Ochiali, Lanno 1766.

three washes in places, and more than half a metre
wide; it was reasonable enough for the celebrated
dealer and collector, G.M. Sasso, to tell their
purchaser, Sir Richard Hoare, in 1789 that they
were 'as fine as paintings'. They lack the freshness
and vitality of Canaletto's finest early drawings and
in some cases the engravings are more impressive
than the drawings themselves. On the other hand
they are proof that Canaletto had kept his skill of
hand and was still capable of handling crowd
scenes with great effectiveness. We see the Doge
being crowned on the Giants' Staircase in the
courtyard of his Palace, giving thanks in the Great
Council Chamber, being presented to the people
in St Mark's and carried round the Piazza. Then
he performs his annual tasks, by this time, one
suspects, more for the benefit of the tourists than
of the Venetians: departing for the Ascension Day
ceremonies in his *Bucintoro* and leaving the Lido
on their completion, attending the Maundy
Thursday festival in the Piazzetta, with its human
pyramid and gymnastic display (Pl. 4), the Corpus
Christi Day procession round the Piazza, S.
Zaccaria on Easter Day and the Salute on 21
November (Pl. 3), when the bridge of boats was
thrown across the Grand Canal (a ceremony only
very recently suspended). Finally there were two
interiors of the Doge's Palace showing foreign
ambassadors being received and given a banquet;
the drawings for these engravings have been lost
and they may have been by Guardi.

Although there are no paintings by Canaletto
of these scenes, there are, as would be expected,
many by his imitators. Francesco Guardi made
paintings from all 12, most of which can now be
seen in the Louvre; these have been the cause of
confusion for many years and were attributed to
Canaletto when, in 1797, they were seized from
their owner by the French Government.

Gradenigo gave the publication of the first eight
engravings an enthusiastic entry in his diary for 8
April 1766, noting how the ceremonies would be
preserved for future generations; at half a sequin
each the price seems on the high side compared
with Ughi's huge plan of Venice (Pl. 1 and the
endpapers of this book) at two sequins, which
Smith thought was far too much. In the same year
Furlanetto received permission to print four more,
so Canaletto may have been working on the
drawings until quite near the date of publication;
against this, he may have finished them some years
before Furlanetto was able to publish.

The truth is that we know nothing whatever
of Canaletto between 1763 and his death in 1768
with the exception of one drawing, *S. Marco: the
Crossing and North Transept, with Musicians singing*
(Pl. 205). The viewpoint is close to that of Smith's
delectable little painting (Pl. 195), but nothing
could be farther from the closely hatched and
rather lugubrious drawing related to that painting
(Pl. 194). The musicians are singing in a light and
air-filled area, uncluttered by crowds, although a
few worshippers are present. The lines are ruled,
and perhaps hard, but the washes give a sense of
space which removes any stiffness or rigidity. A
margin has been drawn as a frame and below it
Canaletto has written, in his best handwriting,
very different from that of the notes on his
sketches: 'I, Zuane Antonio da Canal, made the
present drawing of the musicians who sing in the
ducal church of St Mark at the age of 68, without
spectacles, in the year 1766.' So much, he seems to
be saying, for the idea that he could not work
without optical instruments such as the camera
obscura: he did not even need glasses.

In August 1767 he attended a meeting of the
Academy. Seven months later, on 19 April 1768,
he died of inflammation of the bladder. His
funeral, with 12 priests and candles, was fitting for
an *Origine Civis Venetus* who bore the name of the
Canal family. But all he left his sisters was his old
clothes and bed, the modest investment in the
Zattere property which he had had since 1750,
and 28 unsold pictures.

WHEN CANALETTO died, his nephew, Bernardo Bellotto, had been settled in Warsaw for just over a year and was to stay there until his death in 1780. He had remained in Venice for only a year after Canaletto's departure for England and was then invited to Dresden by Augustus II, Elector of Saxony, who was also King Augustus III of Poland. (It was reliably reported that Augustus sent for Bellotto only when he was convinced that Canaletto could not be enticed from England.) Bellotto stayed in Dresden for eleven years, painting views of the city and of Pirna and Königstein, as well as making many fine etchings.

Towards the end of 1758 he left for Vienna, where he remained for nearly two years, working mainly for the Empress Maria Theresa, but also for Josef Wenzel, Prince of Liechtenstein (whose house he painted). The War of the Austrian Succession had been followed by the Seven Years War, then half way through its course, and in 1760 Bellotto learnt that his house in Dresden had been destroyed during the Prussian bombardment. He returned to Dresden in 1761, after a short stay in Munich, and stayed until 1766, painting (Pl. 208), drawing and etching. He then, it seems, intended to go to the Court of Catherine II in Russia but stopped in Warsaw, hoping to get letters of recommendation from the King, Stanislaus Poniatowski, successor to Augustus, who had died in 1763. But the King offered him employment in Poland, and Bellotto finally decided to remain in his service. He sent for his wife and three daughters from Dresden and stayed in Warsaw (Pls 209 and 210) until his death after 14 years of relative comfort and security.

In the best of Bellotto's works, particularly his landscapes, he often surpassed the later paintings of Canaletto. He developed a style of his own as soon as he left Venice, his three views of Verona (with several later versions) displaying quite extraordinary maturity and originality (Pl. 207). He was never able to acquire the lightness of touch or subtlety of Canaletto at his best, and the coolness of his colours, as well as the lack of aerial perspective, deprive his townscapes of a sense of atmosphere. This is to some extent compensated by their narrative quality; his pictures are brim-full of incident. The intensity of sunshine in most of his town-scapes give them a dazzling effect, especially when seen side by side with those of other artists. He was apt to choose a high viewpoint, making his figures rather stunted and providing somewhat of a puzzle to those determined to believe in his sustained use of the camera obscura. As a court painter, comparatively few of his works went into private hands; they consequently seldom enter the market nowadays and, when they do, command very high prices. As would be expected, Bellotto's work can only be studied effectively in Warsaw, Dresden or Vienna (certainly not in England or the United States except when lent for exhibitions).

Venice was not without a view painter when Bellotto left for Dresden although Francesco Guardi, at 55, had had far less experience than the 27-year-old Bellotto. Guardi had been born in 1712, the much younger brother of Gianantonio Guardi, who was only two years younger than Canaletto. Their father was an obscure painter

206
Detail of Plate 208.

12 Epilogue

207
Bernardo Bellotto
(1720-80)
Verona: the Ponte delle Navi from the North
c. 1741

Oil on canvas,
133 x 234 cm
(52⅜ x 92¼ in)
Dresden, Gemäldegalerie Alte Meister

Bellotto left Canaletto's studio for a tour of northen Italy in the early 1740s and was on his own for the first time.

208
Bernardo Bellotto
(1720-80)
The Market-Place, Pirna
c. 1753

Oil on canvas,
134 x 238 cm
(52¼ x 93¼ in)
Dresden, Gemäldegalerie Alte Meister

Pirna is 11 miles from Dresden, where Bellotto lived after leaving Venice in 1747; while in Pirna he stayed in the house at the far end of the square.

who had moved to Venice from Vienna and, when Francesco was a child, he had died, leaving the 17-year-old Gianantonio to keep his family, which included another brother as well as Francesco and a sister, Cecilia. Three years later Cecilia married Giambattista Tiepolo, then at the threshold of the career which was to make him the greatest Italian painter of his age.

When Francesco was old enough he joined his brother's studio and there he remained until 1760, when Gianantonio died and Francesco was 48. The work of a studio was sold under the name of its head, which was registered in the painters' Guild; if one of the assistants, such as Francesco, wished to attach his name to his work it would be customary for him to leave the studio and register his own name in the Guild. Since he did not do this nothing was heard of him at all; indeed, the firm itself, or workshop, of Gianantonio Guardi remained almost unrecorded in any surviving documents outside the Guild.

They were journeymen painters employed on such humble commissions as the copying of old masters from engravings for such patrons as Marshal Schulenburg, for whom 'Guardi' is recorded as having painted over 100 canvases, mostly now unidentifiable. A certain Count Giovanelli was also a patron and referred in his will to copies executed by the *brothers* Guardi, evidence of Francesco's presence in the workshop by 1731. Very occasionally Gianantonio signed a painting or altarpiece of small significance, and in 1750 Francesco painted a signboard for a jeweller. In 1756 Gianantonio was elected to the newly formed Academy, of which his brother-in-law, G.B. Tiepolo, was the first president. Four years later he died and Francesco, who had recently married, was enrolled in the Guild in his place.

At this point there is no proof that Francesco had ever painted a view. Canaletto had been back in Venice for only three or four years, and there is no evidence of any association between the two except a note in Gradenigo's diary of 25 April 1764. This referred to Guardi, 'a good pupil of the celebrated Canaletto', having exhibited two fairly large canvases in the Piazza, a commission from an English visitor. One was a view of the Piazza itself and the other of the Rialto Bridge; neither the pictures nor the English visitor can be identified with any confidence. Gradenigo also implied that the success of the pictures ('universally praised') was due to the use of the camera obscura, no doubt a tribute to their realism.

The description of Guardi as a 'good pupil'

(*buon scolare*) of the *rinomato* Canaletto is capable of different interpretations. It may have meant that he was a 'good member of the Canaletto school' or that he had been a pupil in the master's studio. It is impossible to judge which Gradenigo meant and quite probable that Gradenigo himself did not know. There may have been collaboration of a sort, but there was scarcely enough work for Canaletto to need an assistant. Nor would it seem necessary for Guardi to go to Canaletto to learn his secrets if he saw himself as a possible successor to the 63-year-old artist. Guardi had himself been a painter for nearly 40 years and must have seen plenty of Canaletto's work in Venice.

The strongest evidence against any form of direct instruction is the fact that Guardi's first view paintings were in the style of Canaletto's work of the 1720s, not the mannered, calligraphic painting that Canaletto had for so long adopted. It is hard to imagine that the Canaletto of the 1760s, of such paintings as Plates 203 and 204, *could* have taught Guardi to paint in the style of his *Piazza S. Marco* (Pl. 212). Forty years earlier, yes: there is much in common with the Prince of Liechtenstein's *Piazza* (Pl. 23) and when the Guardi first entered the National Gallery, London, in 1846, it was not unreasonably attributed to Canaletto.

Once set on his new course as a view painter, Guardi produced a vast number of small paintings and drawings, hardly any of which can be securely dated with the exception of a few, painted towards the end of his career, commemorating events, and some in which topographical changes or developments of fashion give clues as to when they may have been executed. He composed hardly any original views himself, preferring to rely on the paintings and engravings of his predecessors (as had Canaletto in a number of cases). His copies of Canaletto's ten drawings of the Doge's ceremonies (or of the engravings from them) have already been noted.

It was Guardi's power of subtly evoking the shimmer and luminosity of the Venetian scene, the association of water and building materials and sunlight, that eventually captivated Venice-lovers. Above all, he became the master of the imaginary view, which to Canaletto was little more than a by-product of his paintings and drawings of the Venetian scene. The facility that Guardi developed was even more appropriate to the ruined arch covered in weeds (Pl. 214) than to the solid buildings of Venice, which he made appear to lie upon the water rather than to grow out of it.

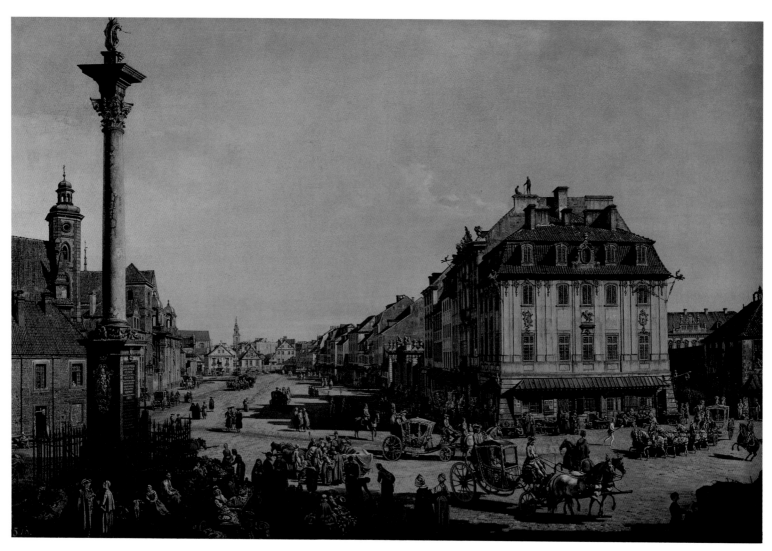

Guardi's life almost covered the span of the eighteenth century, and his career as a view painter lasted for thirty years after the death of his brother Gianantonio. He produced many more paintings in this period than Canaletto in his 50-year career, and his drawings cannot be counted. Yet in his lifetime he had hardly any success at all. He sold to dealers and middle-class Italians and was unknown to the English, having no Smith to ensure that he became known to them. Those of the English who did see his pictures were apt to distrust the atmospheric evanescence which is now so much admired. John Murray's successor as British Resident, John Strange, employed the dealer, G.M. Sasso, to commission from Guardi a painting of Strange's villa at Paese near Treviso; he had misgivings, though, and wrote to Sasso that although Guardi was 'spirited' he was apt to miss the 'truth' of the views he painted.

Guardi did not become a member of the Academy until 1784, when he was 72 years old, and his work of the previous 25 years was so little understood by the Academicians that they described him as a 'painter of perspective views'. At this time he was at the summit of his success and, as the leading artist of his kind in Venice, had been commissioned by the Senate to record the visit of Pope Pius VI to Venice two years before. This commission had come from Pietro Edwards, the Inspector-General of the Republic's collections, and for the four paintings Guardi was paid but ten sequins each, less than five pounds sterling. Francesco Guardi died on 1 January 1793, four years before Napoleon brought an end to the 1,100-year-old Republic. His son Giacomo inherited thousands of drawings, which, years later, he was still trying to sell for less than half a sequin each.

209
Bernardo Bellotto
(1720–80)
Warsaw: View from the Cracow Gate
c. 1767

Oil on canvas,
112 x 170 cm
(44 x 67 in)
Warsaw, Zamek Królewski (Royal Castle Collection)

On the left is the Sigismund Column with the Bernadine church behind it. The house on the corner, right of centre, belonged to a well-known merchant called John.

210
Photograph of Warsaw from the Cracow Gate. 1960.

After the destruction of Warsaw in the Second World War, Bellotto's work was followed in some of the rebuilding. Here the Sigismund Column and the merchant John's house have been reconstructed after Plate 209.

NOTE

5 So did Canaletto. John Ruskin, near the end of his life in 1888, was reported as saying: 'I may as well make a clean breast of it, I even found myself admiring Canaletto's pictures of Venice.' Then he added: 'It was Canaletto's good workmanship I found myself admiring. After all, the old painter of Venice was a good craftsman in oils whereas so much of Turner's work is going to rack and ruin.' Ruskin had followed a policy of 'determined depreciation' of Canaletto (his own words) throughout his writings, although there is no record of his ever having seen a good Canaletto until he saw 'The Stonemason's Yard' in the National Gallery and made the comment quoted above. Of the only three Canaletto paintings he mentions specifically, one (in the Louvre) is now attributed to Marieschi, another (in the Venice Academy, Pl. 95) is now generally attributed to Bellotto, and the third (in the Manfrini collection in Venice until its dispersal) was of so little consequence that it has been allowed to disappear without trace.

Pietro Edwards was still in Venice in 1804 when the sculptor Antonio Canova wrote from Rome asking him to buy some Venetian views on his behalf. Edwards replied that this was going to be difficult. There were no longer any by Canaletto, nor by his nephew Bellotto, although Bellotto had done nothing special and had for the most part copied his uncle's work. If anything could be found by Marieschi it was by now turning black. The only views by Visentini, Joli or Battaglioli were imaginary, or based on scenes on the mainland rather than Venice. All that could be hoped for were Guardis, and Edwards repeated Strange's criticism: they were spirited but very inaccurate. Moreover, whoever bought Guardi's pictures must resign himself to losing them in ten years or so: Guardi was known to have been so poor that he had bought defective canvases and used wretched priming and, to save time, very oily

colours. Still, he was trying to deal on two although he could not agree with the seller on the price (the familiar words of the agent to his principal). In any case they were no more than pretty (*graziosetti*). 'What a pity it is,' Edwards ends, 'even this branch of our tree of painting is drying up in Venice. There are no more view painters of repute'.

Edwards misjudged Guardi's technical competence. Perhaps his pictures were intended to look transient, but two centuries experience of them has proved that he did know how to make them last.[5] It is curious that Edwards had ever hoped to find real views by Visentini or Battaglioli; they had been born between 80 and 120 years earlier, and it is doubtful if either had ever painted the kind of view Canova was looking for.

Visentini was the oldest, having been born

before 1690. He lived to be nearly 100 and could do competently almost anything he turned his hand to, although there is no reason to suppose he ever attempted view painting. He was virtually a member of Smith's staff for the greater part of his life and Smith already had the greatest view painter in the world at his disposal. He employed Visentini to work with Zuccarelli on a series of capriccios based on English Palladian buildings at a time (1746) when Smith had a passion for anything he regarded as 'Palladian'. No journey to England was involved since Smith already had engravings, which were all that was needed (as is fairly evident from the results). Visentini taught perspective at the Academy from 1772 to 1778, and James Wyatt, the architect, studied under him for a time. Wyatt seems to have owned a picture by Visentini, for Joseph Farington, the topographical painter, made a curious observation in a letter after visiting Wyatt. 'This picture', he wrote, 'was so much in the style of Canaletto and Marieski, that if they were younger it must be
concluded that they formed themselves in his [Visentini's] manner'. There is really no other evidence that Visentini was ever a view painter.

Nor was Francesco Battaglioli, who was born about 1722 in Modena. He succeeded Visentini at the Venice Academy as professor of perspective and specialized in painting buildings, ruins, fountains and columns with considerable skill and charm. His account of the arrival of King Ferdinand VI of Spain at his palace (Pl. 216) suggests that he might well have become a view painter had he had any encouragement; in the event, as far as is known, he never painted the

kind of picture Canova was looking for.

Edwards might have been successful in finding a Joli view of Venice although Canova would not have had much satisfaction from it, judging by anything that is known of Joli's. (Canova had a pupil called Count Roberto Roberti, who could, and did, copy Canalettos with more fidelity than could have been expected from Joli or most other professional painters; his work, which can be seen at Bassano and which occasionally reaches the salerooms, indicates that he was no more than a copyist.) Antonio Joli (or Jolli or Iolli) was born, like Battaglioli, at Modena, but very much earlier, in 1700. He worked with Pannini in Rome and then lived in Venice almost without interruption until 1746, the year Canaletto left for England. He then travelled in Europe and was in London while Canaletto was still there. He was back in Venice by 1754 and, with Visentini, was one of the founder members of the Academy. In 1762 he went to Naples, where he died in 1777. He was a follower of Canaletto and not, like Roberti, a mere copyist and he learned enough from his master to produce agreeable, but not very accomplished views of Venice and London. Like Canaletto, he had been trained as a scene painter and this shows in the fantastically-proportioned foreground architecture of his *Capriccio with a view of the Thames and St Paul's* (Pl. 211). He makes no attempt, though, to show the London skyline with topographical accuracy. Joli painted three versions of this impressive scene, only the one illustrated being signed. Venice views played a small part in his life and it is not surprising that Edwards was unable to find any in 1804; he may have been

212
Francesco Guardi
(1712-93)
Venice: Piazza S. Marco
c. 1760

Oil on canvas,
72.4 x 119 cm
(28½ x 46¾ in)
London, National Gallery

Painted early in Guardi's view-painting career but closer to Canaletto's Plate 23 of 35 years earlier than to his Plate 202 of the 1760s.

211
Antonio Joli
(c. 1700-77)
Capriccio with a view of the Thames and St Paul's
c. 1740

Oil on canvas,
115 x 105 cm
(45 x 43 in)
Private collection

Perhaps it was intended to contrast the ruinous classical arcading with modern London seen as the new Rome.

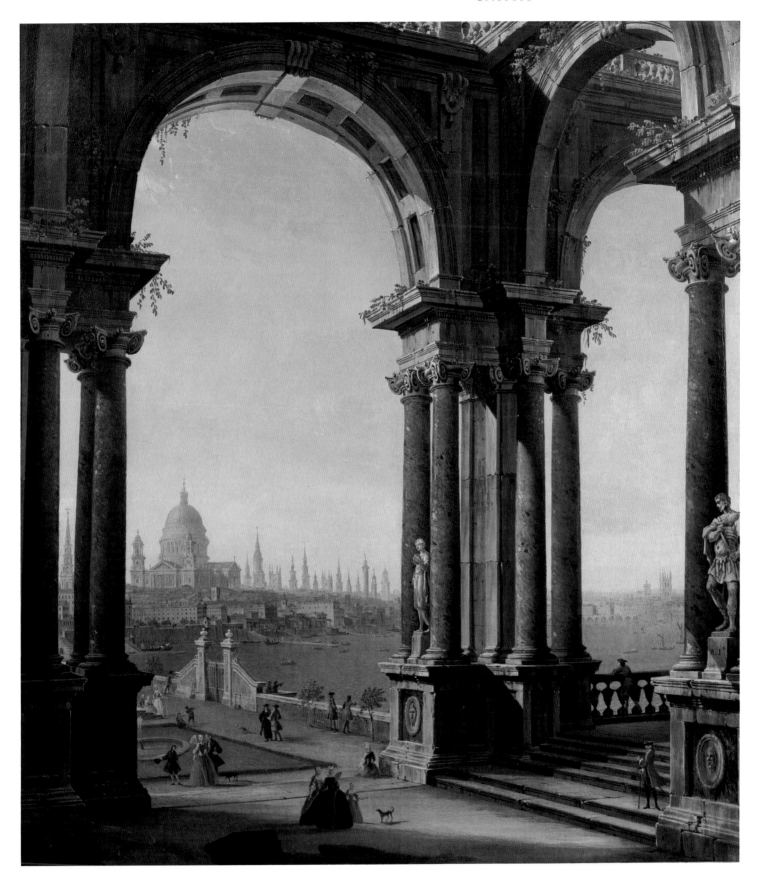

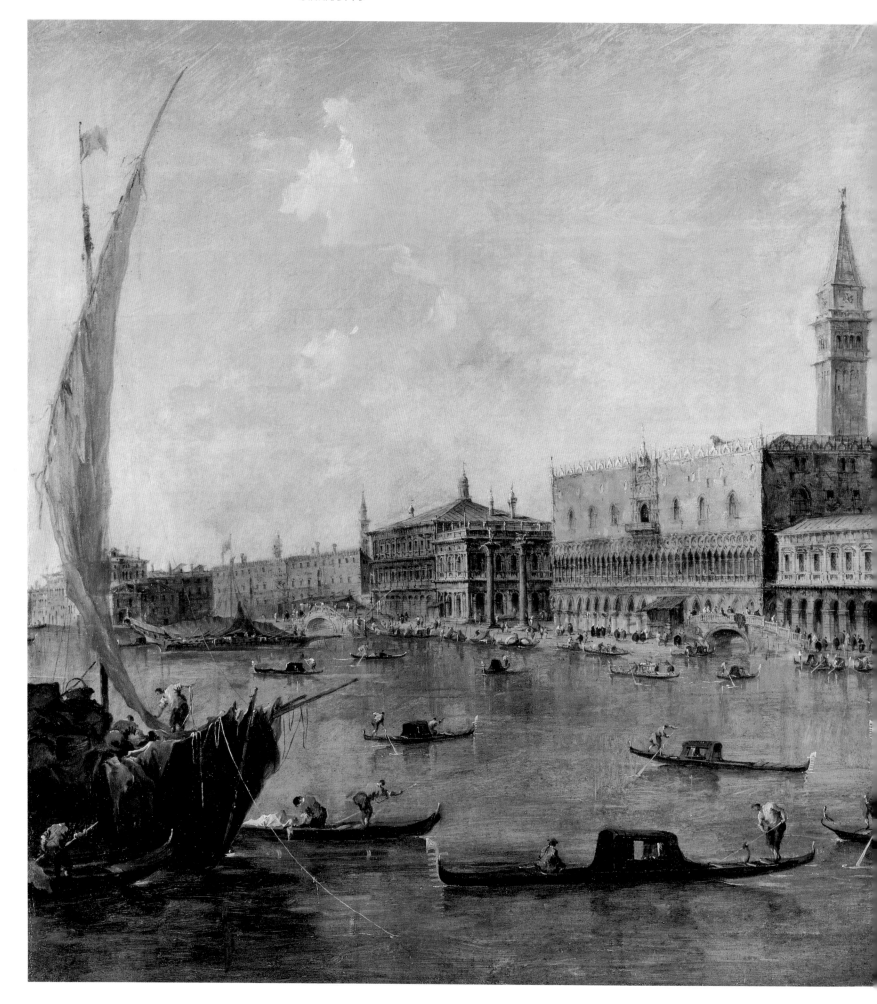

213
Francesco Guardi
(1712–93)
*Venice: the Doge's Palace and the Molo
from the Bacino*
c. 1770

Oil on canvas,
58 x 76.4 cm
(22¾ x 30 in)
London, National Gallery

Guardi's vibrant light and
architecture at its best.

214
Francesco Guardi
(1712–93)
A Caprice, with Ruins on the Seashore
c. 1755

Oil on canvas,
36.8 x 26 cm
(14½ x 10¼ in)
London, National Gallery

The ruined arch on the Lagoon
with men digging (eel-catchers?)
became a favourite theme of
Guardi's.

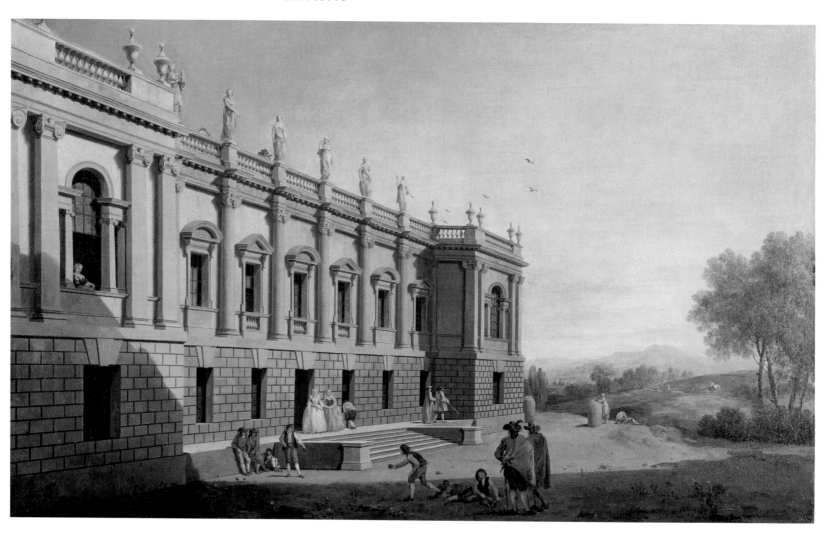

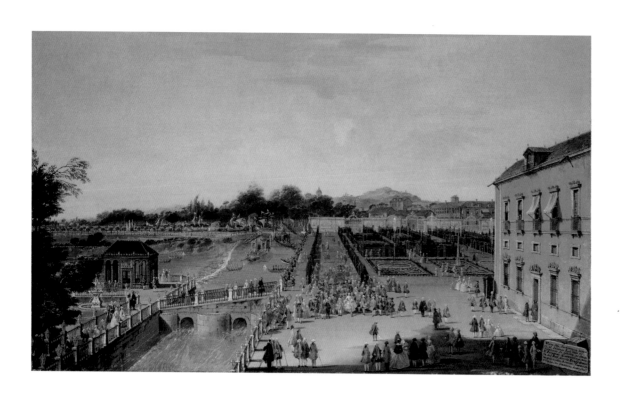

215
Antonio Visentini (1688-1782) and
Francesco Zuccarelli (1702-88)
View of Burlington House
Signed and dated 1746

Oil on canvas,
80 x 130.8 cm
(31½ x 51½ in)
The Royal Collection

The *piano nobile* of the house in
Piccadilly, London, which was
designed by Lord Burlington
himself, imitates Palladio's Palazzo
Porto in Vicenza. It is now the
headquarters of the Royal
Academy of Arts, having been
considerably altered, and is shown
here in an Italian landscape setting
with bowls players in the
foreground.

216
Francesco Battaglioli
(c. 1722-90)
*King Ferdinand VI of Spain at the
Palace of Aranjuez*
1756

Oil on canvas,
68 x 112 cm
(26½ x 44 in)
Madrid, The Prado

Clearly painted under Canaletto's
influence, but Battaglioli was not a
view painter.

more successful in London, where most of them found their home.

To what other artists might Edwards have turned for acceptable views? They are but shadowy figures, all of them following Canaletto to the best of their ability. Giuseppe Moretti was one of the most competent, to judge by his reception piece in the Venice Academy. Moreover Algarotti, a good judge of a picture, wrote of one of Moretti's views that he had 'imitated the manner of Canaletto to perfection'. Then there was G.B. Cimaroli, of whom Count Tessin (p. 91) wrote that he 'paints in the same style as Canaletto, but has not yet reached the top of the ladder' (and imagined his smallest pictures to be worth 30 sequins, 'not at all the same as our ideas'). But if Cimaroli had been an architectural painter, would McSwiney have turned to Canaletto in 1726 to collaborate on the Tomb of Lord Somers (Pl. 39)? There is a picture of a bullfight in the Piazza which has had the names of Cimaroli and Canaletto attached to it, but there seems little reason to regard Cimaroli as anything but a landscape painter. In this field he earned the confidence of Smith, and three of his landscapes are now in the Royal Collection.

The rest – Gaspari, Diziani, Fabris and others – are just names as far as view painting is concerned, although they had a part to play in other fields. After Guardi's death a new generation of view painters began to make their mark in a minor way – Tironi, Bisson, Chilone and Borsato, of whom

an English visitor to Venice wrote in 1816 that he 'paints views of Venice in the style of Canaletto, the perspective is excellent but he wants that breadth of touch which distinguished the works of the great artist'. She continued, 'Gardi the son of the painter of that name does views in distemper and in the same style.' This was Giacomo Guardi, born in 1768, who must have produced thousands of little gouaches which frequently appear in the salerooms; each has a description on the back together with his name and address – but just occasionally he was tempted to sign his father's name instead. The last Venetian view painter to be born in the eighteenth century was Giovanni Migliara; before he died at the age of 52 in 1837 he was able to show steam-boats in the lagoon.

By that time Nièpce had discovered how to take the image out of his camera obscura and preserve it. Photography had been born. View painting, it seemed, was dead. Turner went further: 'This is the end of Art,' he said on seeing his first daguerreotype, 'I am glad I have had my day.'

It did not take long for them all to learn that the camera's excellence lay only in recording what fell immediately under its eye; to deceive the eye, and make it truly believe it was the real thing it saw, called, in Guarienti's words, for accuracy and cunning – cunning such as only Canaletto, Turner himself and their fellow artists before and since, really understood.

1674	Birth of Bernardo Canal; probably also of Joseph Smith.	
1697	(28 Oct.) Birth of Giovanni Antonio Canal (Canaletto).	
1700	Birth of Fiorenza Domenica Canal (mother of Bernardo Bellotto).	
1703	Publication of Carlevaris's etchings, *Le Fabriche e Vedute Di Venezia*.	
1712	Birth of Francesco Guardi.	
1720	(30 Jan.) Birth of Bernardo Bellotto; Bernardo and Antonio Canal design scenery for operas by Scarlatti in Rome; name of Antonio Canal appears in Venice *Fraglia*.	
1721	*Il gran teatro...*, book of engravings, published in Venice.	
1723	Repaving of Piazza begun.	
1725	Stefano Conti commissions two paintings by Canaletto through Alessandro Marchesini and later two more. Marchesini refers to Sagredo and the Imperial Ambassador as having bought from Canaletto.	
1726	(8 Mar.) Owen McSwiney refers to Canaletto participating in two paintings of imaginary tombs; (15 June) Canaletto signs final receipt for fee from Conti.	
1727	(28 Nov.) McSwiney refers to two completed copper plates for the Duke of Richmond and to two completed previously for 'Mr Southwell'.	
1728	A.M. Zanetti pays Canaletto 15 sequins for a small painting on behalf of Cav. Gaburri.	
1729	Canaletto inscribes and dates two sketches for views.	
1730	(17 July) Joseph Smith tells Samuel Hill two	

Canaletto paintings have been ordered and refers to engravings soon to be finished; (22 Aug.) payment to Smith noted in Howard family papers for two 'pictures of Canaletti'; (22 Sept.) McSwiney complains to John Conduit of Canaletto's delays and poor work.

1731	Marshal Schulenburg pays Canaletto 62 sequins for two paintings of the Piazza.
1732	(July) Canaletto inscribes perspective drawing 'for England' of painting in the Duke of Bedford's collection.
1734	(16 July) He inscribes and dates two drawings in Smith's collection.
1735	Publication of 14 engravings by Antonio Visentini after Canaletto in *Prospectus Magni Canalis....*
1732–36	Three bills drawn on the Duke of Bedford for a total of £188 2s 3d by 'Jos. Smith'.
1736	(22 Apr.) Publication by Joseph Baudin in London of six engravings after Canaletto (of much earlier paintings); (16 June) Count Tessin writes that Canaletto is engaged for four years to work '*pour un merchand Anglais, nommé Smitt*'. Schulenburg pays Canaletto 100 sequins on account of 120 for painting of *Riva* now in Sir John Soane's Museum, London.
1738	Bellotto's name entered in *Fraglia*.
1739	(26 June) Baudin publishes six more engravings; (24 Nov.) Charles de Brosses writes that, in view painting, Canaletto '*surpasse tout ce qu'il y a jamais eu*' but is impossible to do business with.
1741	Outbreak of War of the Austrian Succession;

Chronology

date on house in an etching by Canaletto; album of 21 etchings by Michele Marieschi published; Bonomo Algarotti writes to his brother, Francesco, that Canaletto took several years to finish paintings, so pressed was he.

1741-2 Bellotto signs etchings *B. B. detto Canaleto fe.*

1742 Canaletto signs and dates five large views of Rome; publication of second edition of *Prospectus* with 24 additional engravings.

1743 Francesco Algarotti in Venice; death of Marieschi; Canaletto signs and dates two large Venice views for Smith.

1744 Canaletto signs and dates two more large Venice views, a very large *Entrance to the Grand Canal: looking East*, and several overdoors, all for Smith; death of Bernardo Canal; (June) Smith appointed British Consul.

1745 (23 Apr.) Canaletto inscribes drawing of Campanile under repair.

1746 ('latter end of May') George Vertue records Canaletto's arrival in London; (20 May) Tom Hill suggests Duke of Richmond should let Canaletto paint view from Richmond House. (29 Oct.) Lord Mayor's procession to Westminster Hall, later painted by Canaletto.

1747 (11 June) Painting of Windsor Castle for Sir Hugh Smithson finished; (probably late summer) two Richmond House paintings begun.

1748 (19 July) Lord Brooke of Warwick Castle pays 'Sig^r Canall' £58.

1749 (3 Mar.) and a further £31 10s to 'Sig^r G. Ant° Canale';

(Apr.) dismantling of subsiding arch of Westminster Bridge, later drawn by Canaletto; (June) Vertue records paintings of Badminton and Warwick; also advertisement by Canaletto of St James's Park view; (26 June) Knights of the Bath procession from Westminster Abbey, later painted by Canaletto; (July) Sir Hugh Smithson reports beginning of Syon House painting.

1750 (May) Swearing-in of Master of Goldsmiths' Company, later painted by Canaletto.

1751 (8 Mar.) Canaletto invests 2,150 ducats in building on Zattere in Venice; third edition of *Prospectus* (as second edition) published; (30 July) Canaletto advertises Chelsea College picture; Vertue records advertisement and Canaletto's eight-month absence in Venice; (22 Oct.) Gradenigo records that Smith's house on the Grand Canal visible for the first time.

1752 Lord Brooke pays 'Sig^r Canaletti' £33 12s on 14 Mar. and 'Antonio Canal' £30 on 27 July. Northumberland House reconstructed, later painted by Canaletto.

1753 New Horse Guards finished, later painted by Canaletto; (July) Gradenigo records Canaletto's return to Venice (unconfirmed).

1754 Canaletto inscribes and dates four pictures for Thomas Hollis; he also initials and dates a capriccio later belonging to Lord Lovelace.

1755 Canaletto inscribes and dates Samuel Dicker's *Old Walton Bridge* painting and a drawing after it.

1759 Algarotti refers to picture of Palladio's Rialto Bridge, which Canaletto had painted for him.

1760 (According to E. Hinchliffe in 1856) Edward Hinchliffe and John Crewe meet Canaletto in Piazza; Smith retires from being Consul; George III becomes King.

1762 Smith sells his collection to George III.

1763 (Sept.) Canaletto elected to Academy of Fine Arts, Venice (after rejection in Jan.); he signs and dates a wide-angle *Piazza* view.

1765 Canaletto signs (partially) and dates his reception piece for the Academy

1766 Canaletto inscribes and dates a drawing of St Mark's 'without spectacles'.

1768 (19 Apr.) Death of Canaletto.

1770 Death of Joseph Smith.

1780 Death of Bellotto.

1793 Death of Guardi.

1797 Fall of Venice to Napoleon.

Biographical details on Canaletto are based on W.G. Constable's *Canaletto*, Oxford, 1962, revised by me in 1976 and 1989 ('C/L'), vol. 1. All original sources are acknowledged in that volume and are not repeated here. Titles of pictures and catalogue details generally follow vol. 2 of the same work.

Standard works on their subjects include: National Gallery, London, catalogue *The Later Italian Pictures* by Michael Levey, London, 1971; *Canaletto, Paintings and Drawings* by Oliver Millar (drawings by Charlotte Miller), exhibition catalogue, the Queen's Gallery, London, 1980–1 (contains the first detailed description of Canaletto's compositional 'distortions'; *Canaletto Drawings at Windsor Castle* by K.T. Parker (1st edition, Phaidon, Oxford, 1948), with Appendix by Charlotte Crawley (née Miller), Bologna, 1990; *The Later Italian Pictures* (of The Royal Collection) by Michael Levey (1st edition, Phaidon, 1964), 2nd edition, Cambridge, 1991; *Canaletto*, by Katharine Baetjer and J.G. Links, exhibition catalogue, Metropolitan Museum of Art, New York, 1989 (contains essays by Levey, Haskell, Bettagno and Pemberton-Pigott, colour illustrations and entries for 85 paintings and 42 drawings). For Canaletto's patrons see *Canaletto*, catalogue of exhibition at Venice, ed. Alessandro Bettagno, with 17 essays, Vicenza, 1982.

Chapter 1. For a short history of eighteenth-century Venice see the final chapters of *Venice: the Greatness and the Fall*, by John Julius Norwich, London, 1981, with bibliography. The works of F.C. Lane should be especially noted. The standard works on their subjects are: *Painting in 18th-century Venice* by Michael Levey, Phaidon, 1980; *Patrons and Painters, Art and Society in Baroque Italy* by Francis Haskell, Yale U.P., 1980; *Luca Carlevaris* by Aldo Rizzi, Venice 1967; *Gaspar Van Wittel* by G. Briganti, Rome, 1966. (This book went to press before the exhibition, *The Glory of Venice: Art in the 18th Century* opened at the Royal Academy, London, and National Gallery, Washington.)

Chapter 2. For Morassi/Pallucchini capriccios see C/L 501. The sale of *The Piazza: looking South* (Pl. 17) was reported in the *Giornale dell'Arte*, July, 1991, and the painting appeared in the winter, 1991 catalogue of Galleria Salamon, Milan. The latest work on Visentini is the catalogue of the exhibition *Canaletto & Visentini* by Dario Succi, Venice, 1986.

Chapter 3. The latest works on Joseph Smith are *The Consul Smith Collection* by Frances Vivian, Munich, 1989 and *A King's Purchase*, catalogue of an exhibition at the Queen's Gallery, London, 1993 (with bibliography). Frances Vivian's *Il Console Smith*, Vicenza, 1971 remains the only biography.

Chapter 4. For Schulenburg see *La Galleria scomparsi del...Schulenburg* by Alice Binion, Milan, 1990.

Chapter 5. For the drawings see Parker, Millar and Crawley above. Also works by Terisio Pignatti including *Canaletto, Selected Drawings*, Pennsylvania, 1970 and *Il Quaderno di Disegni*, Venice, 1958.

Chapter 6. For the subjects dealt with in this and Chapter 10 particularly, see *Canaletto: Una Venezia immaginaria* by André Corboz (2 vols.), Milan, 1985. The standard work on *Bernardo Bellotto* is by S. Kozakiewicz, London (English edition), 1971 to which may be added catalogues of exhibitions *Le Vedute di Dresda* by Angelo Walther, S. Giorgio Maggiore, Venice, 1986, and *Verona e le città europee*, ed. Sergio Marinelli, Verona, 1990. My *Canaletto and his Patrons*, London, 1977 contains a select bibliography on the use of the camera obscura (pp. 107–8). For dating of the Boston *Bacino* see Baetjer & Links, 1989, *op. cit.*, p. 196.

Chapter 7. Recent book on *Marieschi* and Albotto are by Ralph Toledano, Milan, 1988 and Mario Manzelli, Venice, 1991. See also exhibition catalogues by Dario Succi in Bergamo, 1987, and Gorizia, 1989.

Chapter 8. The standard work on the subject is *Canaletto's Etchings* by Ruth Bromberg, London, 1971.

Chapter 9. This chapter relies much on *Old Westminster Bridge* by R.J.B. Walker, Newton Abbot, 1979. See also *Canaletto and Warwick Castle* by David Buttery, Chichester, Sussex, 1992; Baetjer & Links, 1989, *op. cit.*, nos. 63–74 and 111–15; *Canaletto & England*, exhibition catalogue, ed. Michael Liversidge and Jane Farrington, Birmingham, 1994; *The Image of London*, exhibition catalogue by Malcolm Warner, (Barbican Art Gallery), London, 1987.

Chapter 10. The standard work on Francesco Guardi is *L'Opera completa di...Guardi* by Antonio Morassi, Venice, 1973. Latest works: *Francesco Guardi* by Dario Succi, Sylvana, 1993; exhibition catalogues: Gorizia, 1987; S. Giorgio Maggiore, Venice, 1993, by Alessandro Bettagno.

Sources and Acknowledgements

List of Plates

90 x 132 cm (35½ x 52½ in).
Private collection.

37
Jean-Baptiste van Loo,
Portrait of Owen McSwiney, c. 1738.
Oil on canvas.
112 x 84.5 cm (44 x 33¼ in).
Private collection.
Photo: P. and D. Colnaghi &
Co. Ltd, London.

38
Detail of Plate 62.

39
Canaletto, G.B. Cimaroli and
G.B. Piazzetta.
*Capriccio: Tomb of Lord Somers, with
ruins and landscape*, 1726.
Oil on canvas,
218.5 x 142.2 cm (86 x 56 in).
The Earl of Plymouth.

40
Canaletto, G.B. Cimaroli and
G.B. Pittoni.
Capriccio: Tomb of Archbishop Tillotson,
1726.
Oil on canvas,
218 x 138.5 cm (85¾ x 54½ in).
Private collection.

41
Detail of Plate 40.

42
*Grand Canal: the Rialto Bridge from
the North*, 1727.
Oil on copper,
46 x 58.5 cm (18 x 23 in).
From Goodwood House by
courtesy of the Trustees.

43
Piazza S. Marco: looking West, c. 1726.
Pen and ink,
18.1 x 23.2 cm (7⅛ x 9⅛ in).
The Royal Collection © 1993
Her Majesty The Queen.

44
Piazza S. Marco: looking West, c. 1726.
Oil on canvas,
133.5 x 170 cm (52½ x 67 in).
The Royal Collection © 1993
Her Majesty The Queen.

45
Piazza S. Marco: looking East,
c. 1727.
Pen and ink,
18 x 23.4 cm (7 x 9¼ in).
The Royal Collection © 1993
Her Majesty The Queen.

46
Piazza S. Marco: looking East, c. 1727.
Oil on canvas,
133.3 x 170.7 cm (52½ x 67¼ in).
The Royal Collection © 1993
Her Majesty The Queen.

47
*Entrance to the Grand Canal: from the
Piazzetta*, c. 1727.
Pen and ink,
23.3 x 18.2 cm (9⅛ x 7⅛ in).
The Royal Collection © 1993
Her Majesty The Queen.

48
*Entrance to the Grand Canal: from the
Piazzetta*, c. 1727.
Oil on canvas,
170 x 133.5 cm (67 x 52½ in).
The Royal Collection © 1993
Her Majesty The Queen.

49
*Piazza S. Marco: looking West from the
North End of the Piazzetta*, c. 1727.
Oil on canvas,
170 x 129.3 cm (67 x 51 in).
The Royal Collection © 1993
Her Majesty The Queen.

50
*Piazza S. Marco: looking West from the
North End of the Piazzetta*, c. 1727.
Pen and ink,
23.4 x 18 cm (9⅛ x 7 in).
The Royal Collection © 1993
Her Majesty The Queen.

51
The Piazzetta: looking North, c. 1727.
Oil on canvas,
170.2 x 129.5 cm (67 x 51 in).
The Royal Collection © 1993
Her Majesty The Queen.

52
The Piazzetta: looking South, c. 1727.
Oil on canvas,
170.2 x 132 cm (67 x 52 in).
The Royal Collection © 1993
Her Majesty The Queen.

53
The Molo: looking West, 1730.
Oil on canvas,
58.5 x 102 cm (23 x 40 in).
Tatton Park, Cheshire,
The National Trust.

54
Detail of Plate 53.

55
Detail of Plate 56.

56
Riva degli Schiavoni: looking East, 1730.
Oil on canvas,
58.5 x 102 cm (23 x 40 in).
Tatton Park, Cheshire,
The National Trust.

57
Riva degli Schiavoni: looking East,
March 1729 (dated).
Pen and bistre,
21 x 31.5 cm (8¼ x 12⅜ in).
Darmstadt, Kupferstichkabinett.

58
The Molo: looking West, c. 1727.
Oil on copper,
43 x 58.5 cm (17 x 23 in).
Private collection.

59
*The Molo and Riva degli Schiavoni:
looking East*, c. 1727.
Oil on copper,
43 x 58.5 cm (17 x 23 in).
Private collection.

60
*Grand Canal: the Rialto Bridge from the
South*, c. 1727.

Oil on copper,
45.5 x 62.5 cm (18 x 24½ in).
Holkham Hall, Norfolk,
by courtesy of Viscount Coke.

61
*Grand Canal: 'The Stonemason's Yard';
S. Maria della Carità from the Campo
S. Vidal*, c. 1728.
Oil on canvas,
124 x 163 cm (48¾ x 64⅛ in).
London, The National Gallery.

62
The Clocktower in the Piazza S. Marco,
c. 1730.
Oil on canvas,
52.7 x 70.5 cm (20¾ x 27¾ in).
Kansas City, Mo., Nelson-Atkins
Museum of Art (Purchase:
Nelson Trust).

63
*Entrance to the Grand Canal: looking
West*, 1730.
Oil on canvas,
49.5 x 72.5 cm (19½ x 28½ in).
Houston, Texas, Museum of
Fine Arts (Blaffer Collection).

64
*Grand Canal: looking South-West
from the Rialto Bridge to the Palazzo
Foscari*, 1730.
Oil on canvas,
49.5 x 72.5 cm (19½ x 28½ in).
Houston, Texas, Museum of
Fine Arts (Blaffer Collection).

65
Detail of Plate 70.

66
*Grand Canal: looking South-West from
the Rialto Bridge to the Palazzo Foscari*,
c. 1727.
Oil on canvas,
47 x 78 cm (18½ x 30¾ in).
The Royal Collection © 1993
Her Majesty The Queen.

67
*Entrance to the Grand Canal: looking
East*, published 1735.
Pen and ink,
27.3 x 43.2 cm (10¾ x 17 in).
Reproduced by courtesy of the
Trustees of The British Museum.

68
*S. Chiara Canal: looking North-West
from the Fondamenta della Croce to the
Lagoon*.
Oil on canvas,
46.5 x 80.6 cm (18¼ x 31¾ in).
The Royal Collection © 1993
Her Majesty The Queen.

69
A Regatta on the Grand Canal.
Oil on canvas,
77 x 126 cm (30¼ x 49½ in).
The Royal Collection © 1993
Her Majesty The Queen.

70
*The Bucintoro at the Molo on Ascension
Day*, c. 1732.
Oil on canvas,

77 x 126 cm (30¼ x 49½ in).
The Royal Collection © 1993
Her Majesty The Queen.

71
Title-page to the second edition
of *Prospectus*.

72
The Arsenal: the Water Entrance, c. 1732.
Oil on canvas,
47 x 78.8 cm (18½ x 31 in).
Woburn Abbey, by kind
permission of the Marquess of
Tavistock and the Trustees of the
Bedford Estates.

73
Campo S. Angelo, c. 1732.
Oil on canvas,
46.5 x 77.5 cm (18¼ x 30½ in).
Private collection.

74
S. Maria Zobenigo, c. 1732.
Oil on canvas,
47 x 78 cm (18½ x 30¼ in).
Private collection.

75
Piazza S. Marco: looking South-East,
1735–40.
Oil on canvas,
114.2 x 153.5 cm (45 x 60½ in).
Photo © 1994 Board of Trustees,
Washington DC National Gallery
of Art (Gift of Mrs Barbara
Hutton).

76
Riva degli Schiavoni: looking West,
before 1736.
Oil on canvas,
122 x 201 cm (48 x 79 in).
London, Sir John Soane's
Museum.

77
*Entrance to the Grand Canal: from the
West End of the Molo*, 1735-40.
Oil on canvas,
114.5 x 153 cm (45 x 60¼ in).
Photo © 1994 Board of Trustees,
Washington DC National Gallery
of Art (Gift of Mrs Barbara
Hutton).

78
The Bacino di S. Marco: looking East,
c. 1735.
Oil on canvas,
125 x 204 cm (49¼ x 80¼ in).
Boston, Museum of Fine Arts.

79
*SS. Giovanni e Paolo and the Monument
to Bartolommeo Colleoni*, c. 1735.
Oil on canvas,
46 x 78 cm (18 x 30¾ in).
The Royal Collection © 1993
Her Majesty The Queen.

80
Detail of Plate 85.

81
*The Molo: looking West, with the
Fonteghetto della Farina*, c. 1735.
Pen and ink with wash,
18.7 x 26.7 cm (7⅜ x 10½ in).

The Royal Collection © 1993
Her Majesty The Queen.

82
*Grand Canal: looking North-East from
S. Croce to S. Geremia*, c. 1732.
Pen and ink,
27 x 37.7 cm (10¾ x 14¾ in).
The Royal Collection © 1993
Her Majesty The Queen.

83
*The Molo: looking West, the Library
Right*, c. 1729.
Pen and ink,
19.5 x 30.1 cm (7¾ x 12 in).
The Royal Collection © 1993
Her Majesty The Queen.

84 a–d
SS. Giovanni e Paolo.
Leaves from Canaletto's
sketchbook, each 22.8 x 17 cm
(9 x 6¾ in).
Venice, Accademia.

85
*Grand Canal: looking South-West from
the Palazzo Grimani to the Palazzo
Foscari*, c. 1735.
Oil on canvas,
57.2 x 92.7 cm (26½ x 36½ in).
Private collection.
Photo: Richard Green, London.

86 a–h
Grand Canal:...to the Palazzo Foscari.
Leaves from sketchbook.
Venice, Accademia.

87
Roofs and Chimneys in Venice.
Pen and ink with wash,
30.4 x 43.8 cm (12 x 17¼ in).
Reproduced by courtesy of the
Trustees of The British Museum.

88
*View from Canaletto's Window in Corte
Perini, S. Lio.*
Pen and ink with wash,
30.4 x 44.4 cm (12 x 17½ in).
Private collection.

89
Modern photograph, taken from
a window, of the view seen in
Plate 87.

90
Modern photograph, taken from a
window adjacent to that in Plate
89, of the view seen in Plate 88.

91
Detail of Plate 92.

92
*Grand Canal: looking South-West from
the Chiesa degli Scalzi to the Fondamenta
della Croce, with S. Simeone Piccolo*,
c. 1738.
Oil on canvas,
124 x 204 cm (49 x 80½ in).
London, The National Gallery.

93
Detail of Plate 92.

94
Camera obscura.
Venice, Correr Museum.

Oil on canvas,
45.5 x 76 cm (18 x 30 in).
Private collection.

155
London: Westminster Abbey, with a Procession of Knights of the Bath, 1749.
Oil on canvas,
99 x 101.5 cm (39 x 40 in).
By courtesy of the Dean and Chapter of Westminster.

156
London: the Thames from the Terrace of Somerset House, Westminster Bridge in the Distance.
Oil on canvas,
106.5 x 185.5 cm (42 x 73 in).
The Royal Collection © 1993 Her Majesty The Queen.

157
London: the Thames from the Terrace of Somerset House, the City in the Distance.
Oil on canvas,
105.5 x 186.5 cm (41½ x 73½ in).
The Royal Collection © 1993 Her Majesty The Queen.

158
London: Chelsea College with Ranelagh House and the Rotunda, 1751.
Oil on canvas, right part
95.5 x 127 cm (37½ x 50 in).
Private collection;
left part 86.5 x 106.5 cm
(34 x 42 in).
Blickling Hall, Norfolk,
The National Trust.

159
Venice: Grand Canal: looking North from near the Rialto Bridge, c. 1730.
Oil on canvas,
47.5 x 78 cm (18¾ x 30¾ in).
The Royal Collection © 1993 Her Majesty The Queen.

160
Detail of Visentini's engraving of Plate 159.

161
Detail of Plate 159, showing Smith's house.

162
Samuel Scott,
London: Westminster from the North-East, 1742.
Oil on canvas.
Governor and Company of the Bank of England.

163
London: the Monument, 1751-2.
Engraving inscribed *Sign.r Canaleti Delin.* and *G. Bickham Sculp.t*,
published by Robert Sayer and Henry Overton.

164
London: Vauxhall Gardens, the Grand Walk, probably 1751.
Oil on canvas,
50.8 x 75.3 cm (19¾ x 20¾ in).
Private collection.
Photo: Courtesy Hazlitt, Gooden & Fox Ltd, London.

165
Alnwick Castle, Northumberland,
c. 1752.
Oil on canvas,
113.5 x 139.5 cm (44¾ x 55 in).
The Duke of Northumberland.

166
Warwick Castle: the South Front (near view), 1752.
Oil on canvas,
75 x 120.5 cm (29½ x 47½ in).
Madrid, © Fundacion Coleccion Thyssen-Bornemisza. All Rights Reserved.

167
London: Northumberland House, 1752.
Oil on canvas,
84 x 137 cm (33 x 54 in).
The Duke of Northumberland.

168
London: Ranelagh, Interior of the Rotunda, 1754.
Oil on canvas,
46 x 75.5 cm (18½ x 29¾ in).
London, The National Gallery.

169
London: St Paul's Cathedral, 1754.
Oil on canvas,
51 x 61 cm (20 x 24 in).
New Haven, Conn., Yale Center for British Art (Paul Mellon Collection).

170
Old Walton Bridge, 1754.
Oil on canvas,
46.5 x 75 cm (18¼ x 29½ in).
By permission of the Trustees of Dulwich Picture Gallery, London.

171
Old Walton Bridge, 1755.
Pen and brown ink with grey wash,
29 x 63 cm (11½ x 24¾ in).
New Haven, Conn., Yale Center for British Art (Paul Mellon Collection).

172
London: Westminster Bridge under Repair, 1754.
Oil on canvas,
about 46 x 75 cm (18 x 29 in).
Private collection.

173
London: Greenwich Hospital from the North Bank of the Thames,
c. 1753.
Oil on canvas,
66 x 112.5 cm (26 x 41¼ in).
London, National Maritime Museum.

174
William Marlow,
Capriccio: St Paul's and a Venetian Canal, c. 1795?
Oil on canvas,
130 x 104 cm (51 x 41 in).
London, The Tate Gallery.

175
Detail of Plate 185.

176
Capriccio: with Ruins of a Pointed Arch,
perhaps c. 1735.
Oil on canvas,
53 x 66.7 cm (20¾ x 26¼ in).
The Royal Collection © 1993 Her Majesty The Queen.

177
Capriccio: Classical Ruins, perhaps
c. 1735.
Oil on canvas,
53 x 66.7 cm (20½ x 26¼ in).
The Royal Collection © 1993 Her Majesty The Queen.

178
Capriccio: Ruins and Classic Buildings.
Oil on canvas,
87.5 x 120.5 cm (34½ x 47½ in).
Milan, Museo Poldi Pezzoli.

179
Rome: a Caprice View with Ruins based on the Forum, perhaps c. 1730.
Oil on canvas,
31.4 x 40.3 cm (12⅜ x 15¾ in).
The Royal Collection © 1993 Her Majesty The Queen.

180
Capriccio: Ruins with Paduan Reminiscences.
Oil on canvas,
116 x 166 cm (45¾ x 65⅜ in).
Hamburg, Kunsthalle.

181
Capriccio: the Molo with the flagstaffs from the Piazza S. Marco, 1743-4.
Oil on canvas,
109 x 131 cm (43 x 51½ in).
The Royal Collection © 1993 Her Majesty The Queen.

182
Capriccio: with S. Giorgio Maggiore and the Rialto Bridge.
Oil on canvas,
165 x 114.5 cm (65 x 45 in).
Raleigh, NC, North Carolina Museum of Art, (purchased with the funds from the State of North Carolina).

183
Capriccio: Terrace and Loggia of a Palace on the Lagoon, c. 1763.
Pen and ink with washes,
36 x 53 cm (14⅛ x 21 in).
The Royal Collection © 1993 Her Majesty The Queen.

184
Capriccio: Buildings in Whitehall, London, 1754.
Oil on canvas,
52 x 61 cm (20½ x 24 in).
Private collection.

185
Capriccio: River Landscape with a Ruin and Reminiscences of England, c. 1754.
Oil on canvas,
132 x 106.5 cm (52 x 42 in).
Photo © 1994 Board of Trustees, Washington DC National Gallery of Art (Paul Mellon Collection).

186
Capriccio: River Landscape with a Column, a Ruined Roman Arch, and Reminiscences of England, c. 1754.
Oil on canvas,
132 x 104 cm (52 x 41 in).
Photo © 1994 Board of Trustees, Washington DC National Gallery of Art (Paul Mellon Collection).

187
Eton College Chapel, c. 1754.
Oil on canvas,
61.5 x 107.5 m (24¼ x 42⅜ in).
London, The National Gallery.

188
Capriccio: a Colonnade opening on to the Courtyard of a Palace, signed and dated 1765.
Oil on canvas,
131 x 93 cm (52½ x 35½ in).
Venice, Accademia.

189
Detail of Plate 198.

190
Detail of Plate 191.

191
London: Whitehall and the Privy Garden looking North, probably 1751.
Oil on canvas,
118.5 x 273.5 cm (46¾ x 93½ in).
Duke of Buccleuch and Queensberry, K.T.

192
Piazza S. Marco: looking East from the South-West Corner, 1760.
Oil on canvas,
69 x 60.5 cm (27¼ x 23¾ in).
Private collection.

193
Piazza S. Marco: looking East, 1760.
Pen and ink,
36.4 x 22.6 cm (14¾ x 8¾ in).
Private collection.

194
S. Marco: the Crossing and North Transept.
Pen and ink,
27.1 x 18.7 cm (10¾ x 7⅜ in).
The Royal Collection © 1993 Her Majesty The Queen.

195
S. Marco: (an evening service),
c. 1730, perhaps much earlier.
Oil on canvas,
28.6 x 19.7 cm (11¼ x 7¾ in),
(painted surface).
The Royal Collection © 1993 Her Majesty The Queen.

196
S. Marco: the Interior, c. 1755.
Oil on canvas,
36.5 x 33.5 cm (14⅜ x 13¼ in).
The Royal Collection © 1993 Her Majesty The Queen.

197
Grand Canal: looking South-East from the Campo S. Sofia to the Rialto Bridge,
c. 1756.
Oil on canvas,

119 x 185 cm (46¾ x 73 in).
Berlin, Staatliche Museen Preussischer Kulturbesitz Gemäldegalerie.

198
Campo di Rialto, c. 1756.
Oil on canvas,
119 x 185 cm (46¾ x 72¾ in).
Berlin, Staatliche Museen Preussischer Kulturbesitz Gemäldegalerie.

199
Piazza S. Marco: looking South and West,
signed and dated 1763.
Oil on canvas,
56.5 x 102.2 cm (22¼ x 40¼ in).
Los Angeles, County Museum of Art (Gift of the Ahmanson Foundation).

200
Piazza S. Marco: looking South-West,
1730-41?
Oil on canvas,
67.3 x 102 cm (26½ x 40½ in).
Hartford, Conn., Wadsworth Atheneum (The Ella Gallup Sumner Fund and Mary Caitlin Sumner Collection Fund).

201
The Piazzetta: looking West, with the Library and Campanile, c. 1735.
Pen and ink,
22.7 x 37.5 cm (9 x 14¾ in).
The Royal Collection © 1993 Her Majesty The Queen.

202
Piazza S. Marco: looking East from the South-West Corner, c. 1760.
Pen and ink with washes,
19 x 28.2 cm (7½ x 11 in).
The Royal Collection © 1993 Her Majesty The Queen.

203
Piazza S. Marco: looking East from the South-West Corner,
c. 1760.
Oil on canvas,
45 x 35 cm (18 x 14 in).
London, The National Gallery.

204
Piazza S. Marco: looking East from the North-West Corner,
c. 1760.
Oil on canvas,
46.5 x 38 cm (18¼ x 14¾ in).
London, The National Gallery.

205
S. Marco: the Crossing and North Transept, with Musicians singing,
signed and dated 1766.
Pen and ink with washes,
47 x 36 cm (18½ x 14⅛ in).
Hamburg, Kunsthalle.

206
Detail of Plate 208.

207
Bernardo Bellotto,
Verona: the Ponte delle Navi from the North, c. 1741.

Oil on canvas,
133 x 234 cm (52⅜ x 92¼ in).
Dresden, Gemäldegalerie Alte Meister.

208
Bernardo Bellotto,
The Market-Place, Pirna, c. 1753.
Oil on canvas,
134 x 238 cm (52¾ x 93¼ in).
Dresden, Gemäldegalerie Alte Meister.

209
Bernardo Bellotto,
Warsaw: view from the Cracow Gate,
c. 1767.
Oil on canvas,
112 x 170 cm (44 x 67 in).
Warsaw, Zamek Królewski (Royal Castle Collection, Warsaw).

210
Photograph of Warsaw from the Cracow Gate, 1960.

211
Antonio Joli,
Capriccio with a view of the Thames and St Paul's, c. 1740.
Oil on canvas,
115 x 105 cm (45 x 43 in).
Private collection.
Photo: Harari and Johns Ltd, London.

212
Francesco Guardi,
Venice: Piazza S. Marco, c. 1760.
Oil on canvas,
72.4 x 119 cm (28½ x 46¾ in).
London, The National Gallery.

213
Francesco Guardi,
Venice: the Doge's Palace and the Molo from the Bacino, c. 1770.
Oil on canvas,
58 x 76.4 cm (22¾ x 30 in).
London, The National Gallery.

214
Francesco Guardi,
A Caprice, with Ruins on the Seashore,
c. 1775.
Oil on canvas,
36.8 x 26 cm (14½ x 10¼ in).
London, The National Gallery.

215
Antonio Visentini and Francesco Zuccarelli,
View of Burlington House, signed and dated 1746.
Oil on canvas,
80 x 130.8 cm (31½ x 51½ in).
The Royal Collection © 1993 Her Majesty The Queen.

216
Francesco Battaglioli,
King Ferdinand VI of Spain at the Palace of Aranjuez, 1756.
Oil on canvas,
68 x 112 cm (26½ x 44 in).
Madrid, The Prado.
Photo: P. and D. Colnaghi & Co. Ltd, London.

Index

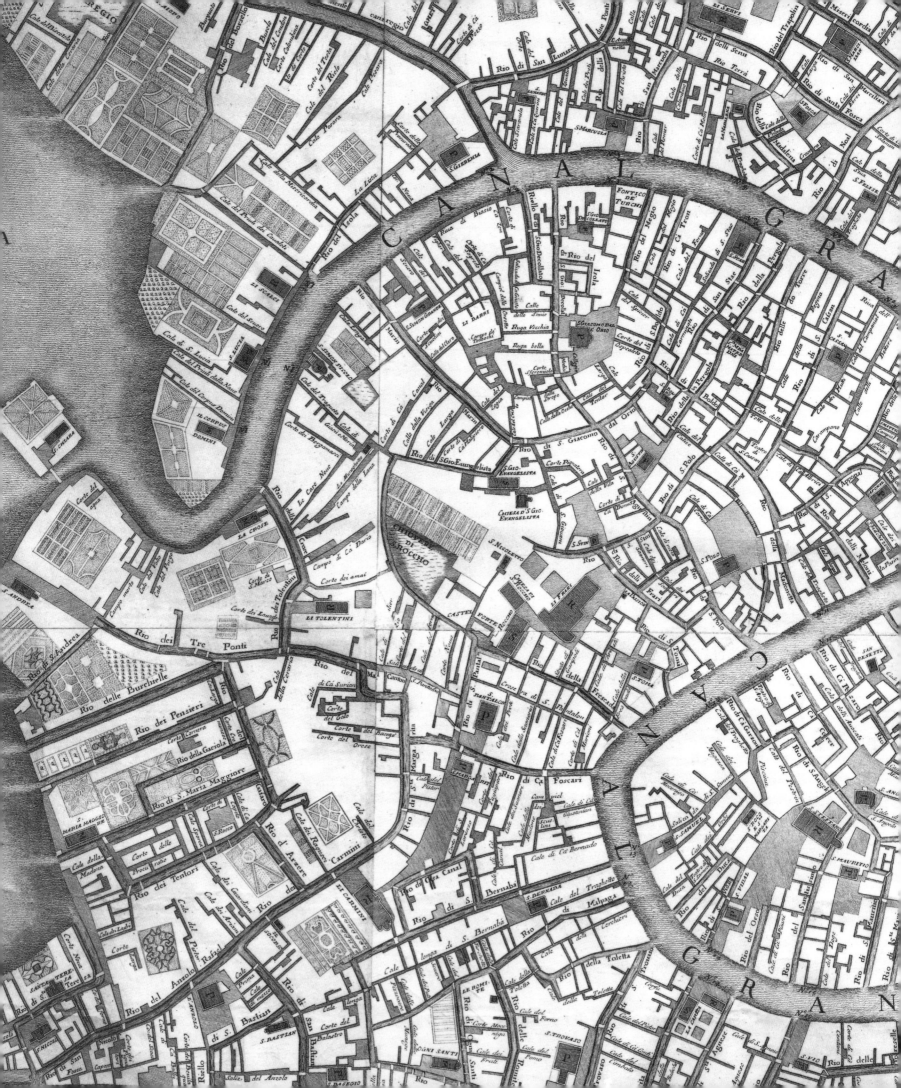